VISION ANEW

VISION ANEW

The Lens and Screen Arts

EDITED BY

Adam Bell and Charles H. Traub

UNIVERSITY OF CALIFORNIA PRESS

770
VIS

University of California Press, one of the most distinguished university presses in the United States, enriches lives around the world by advancing scholarship in the humanities, social sciences, and natural sciences. Its activities are supported by the UC Press Foundation and by philanthropic contributions from individuals and institutions. For more information, visit www.ucpress.edu.

University of California Press
Oakland, California

Library of Congress Cataloging-in-Publication Data

 Vision anew : the lens and screen arts / edited by Adam Bell and Charles H. Traub.
 p. cm.
 Includes bibliographical references.
 ISBN 978-0-520-28469-2 (cloth : alk. paper)
 ISBN 978-0-520-28470-8 (pbk. : alk. paper)
 1. Photography, Artistic. 2. Photographic criticism. 3. Photography— Digital techniques. 4. Video art. 5. Interactive art. 6. Internet videos. I. Bell, Adam B., editor. II. Traub, Charles, 1945– editor.
 TR642.V57 2015
 770—dc23

 2014045927

Manufactured in the United States of America

24 23 22 21 20 19 18 17 16 15
10 9 8 7 6 5 4 3 2 1

For Cara and Ramona
—A. B.

For Kathy
—C. T.

CONTENTS

ACKNOWLEDGMENTS

This project began nearly four years ago and was born out of series of discussions about the state of the lens-based arts. From our initial inquiry for papers and search for relevant material, it has been a long road from inception to final publication. We would like to thank all the contributors who enthusiastically responded to our requests for papers, interviews, and essays. Without their excellent contributions and patience, this project would not have been possible.

Special thanks are due to the staff of the MFA Photography, Video and Related Media Department at the School of Visual Arts (Randy West, Michelle Leftheris, Seth Lambert, and Kelly Sullivan) for their support and enthusiasm for the project. We would also like to thank the faculty of the MFA Photography, Video and Related Media Department for their suggestions, contributions, and ideas about the book. We would also like to thank Deborah Hussey, whose keen editorial eye helped us edit many of the essays herein; Luigi Ballerini for his help in getting a publisher and directing us to the University of California Press; and Bob Lobe for his assistance using the SVA's library to track down material.

Thanks are also due to our editors and staff at the University of California Press: Kari Dalhgren, Editor, Art History, who first ushered the project into existence; Mary C. Francis, Executive Editor, Music, Cinema, and Media Studies, and Karen A. Levine, Senior Editor, Art History, who both assisted greatly in the book's final stages; Jack Young, for his tireless assistance compiling all the information and permissions needed for the book; Chalon Emmons, Production Editor, who also helped enormously to edit

and finalize the book; Barbara Armentrout, whose excellent copyediting skills helped clean up the manuscript and its numerous essays; and all at the University of California Press for their constant support and encouragement.

We would also like to thank our families, whose love and support helped make this book a reality.

Lastly, we would like to thank David Rhodes and the School of Visual Arts for their generous support of this project.

FOREWORD

Adam Bell

Over eight years ago, Charles H. Traub, Steven Heller, and I edited *The Education of a Photographer*. In that book, we attempted to assemble an eclectic and inspirational collection of essays, interviews, and writings by photographers, writers, editors, and critics about photography. This new book arose out of a series of discussions about the state of the lens arts, as well as the feeling that we needed to expand upon our original collection and address new changes in the medium. Although the medium is constantly changing, we are at a particularly exciting time where the still image and the moving image have begun to converge in new ways—profoundly changing not only the practice and work of artists but the meaning and use of lens-based images across all fields.

Vision Anew broadens the discussion about what constitutes the lens-based arts, what they can do, and their significance in the world. Consequently, we have cast a decidedly wide net and solicited pieces by artists, designers, critics, historians, editors, and videographers. No single anthology can encompass the entirety or diversity of the lens arts. Such a task would be as foolish as it would be impossible. Instead, this book is an attempt to expand the field, shake up old assumptions, and point in new directions. More importantly, it aims to inspire and provoke further discussion.

Employed across a wide range of fields and permeating every aspect of our lives, the lens arts are a slippery matrix for innumerable activities. From the fine arts to the sciences to multiple social uses, the ubiquity and constantly changing applications of the lens arts force us to remain vigilant and mindful about the changing nature of the lens arts. The anxiety that accompanies this unstable ground gives rise to not only wild and

fanciful speculation about the future but also dread-filled proclamations on the state of the medium. While theorists and academics continually reinvent, declare dead, and resurrect photography, only to kill it off dramatically moments later, the uses for lens-based images continue to grow and revitalize the medium. This seemingly constant mutability prevents simple standards or definitions, which can lead to feelings of existential crisis but can also give rise to hope and excitement about the evolving nature of the medium.

From the wet-plate to the 35mm film camera to digital, anxious ruminations have surrounded the evolution of photography. If the tools do not stay the same for more than a generation, how can we define what we do? How do we master our medium? How do we delineate and describe a field of practice that is constantly evolving and growing? In many ways, our obsession with photography's demise and progression is as closely tied to notions of modernist artistic and technological progress as it is to the medium's technological nature. If the tools keep changing, so too must the art. In the end, the anxiety always reveals more about ourselves than it does about the medium.

As much as photographers obsess about the tools of their trade, in the end, it is what we do with them and what they do to our vision of the world that matters. Photographers and lens-based artists have always tested the limits of their tools—pushing these boundaries in creative ways. However, artists and practitioners are also enslaved by market-driven changes. New technology is not always better, but it is often different and usually displaces the old, inconvenient, and expensive. Analog gelatin-silver or C-prints or celluloid may become boutique (and expensive, if not extinct) practices of the few, but yearning for the past does little to address the present. The digital revolution happened more than fifteen years ago. To speak now of *digital* photography or movies is redundant. The point is to recognize these changes and accept them as new possibilities and realities.

This unapologetically modernist assertion echoes Pound's famous dictum. However, the point is not merely to make it *new* but to use new tools in old ways or old tools in new ways. Freedom lies in moving beyond the assumed uses and forms of the lens arts. Such changes are not dependent solely on technology, but it can provide the catalyst. As still images increasingly compete with video and other multimedia, and clear-cut boundaries between historically separate mediums blur, what does that mean for practitioners? With so much to learn, where does one start? What does it mean for art photographers (working in a particularly narrow field to begin with)? Does art photography become increasingly conservative and moribund, or does its changing role offer greater freedom? Is the era of the photographer as "artiste" over and, if so, what is the new role? How does one build upon and remain in dialogue with such an expansive and evolving field?

As technical barriers fall and the number of images increases, another challenge is how to identify quality and deal with quantity. As Chuck Close said, "While photography is the easiest medium in which to be competent, I think it is the hardest medium in which to have a distinctive personal vision."[1] We need to be more discerning, while at the same time remaining aware that the use of images, both still and moving, is, and always was, as important as their subject. Likewise, editing has always played a cru-

cial role for the individual's work, but this important role now extends outwards. With the massive proliferation of images, the process of editing and making sense of it all becomes critically important and is a challenge for all who choose to accept.

Given photography's promiscuous nature, we also need to acknowledge the multiple roles and niches it occupies. Acceptance within the arts and the academy has led to a narrower and more particular definition and history of the lens arts that obscures their broader use and meaning. When we talk about photography, video, or other hybrid image forms, do we mean the art world? advertising? journalism? scientific or military applications? or the endlessly multiplying images on Facebook, SnapChat, Tumblr, and other online social networks? Although we can't entirely separate these uses, their different contexts and circumstances are crucial and often reveal intelligent ways forward.

As a broad term, we've decided to use "lens and screen arts." How else can one account for work as diverse as traditional large format color photography on one end of the spectrum to appropriated images (from Google Street View to found imagery online) or electronic images that exist solely on the screen? The term also acknowledges the technological shift that artists are now embracing—namely, the convergence of the still and the moving image in DSLRs. The fact that most cameras are now equipped to take both still and moving images is a great boon and new reality. Historically, the still and moving images have a long and complicated relationship, but these new tools have brought them closer than ever before. Although there are technical hurdles to overcome when mastering these cameras, it is no longer an either/or proposition of still versus moving images. For most, it is more likely an either/and decision. Given this new flexibility, what does it mean that a camera can just as easily be a film camera, a high-end digital motion picture camera, camera-fitted drone, or a screen grab? Has the screen grab turned the computer into a camera? As Trevor Paglen recently wrote, we're living in a world of machine-seeing and seeing-machines.[2] If the default presentation for a photographic image is no longer the print or the movie screen, we must also account for new platforms of distribution whether they're a smartphone or a Tumblr blog. The traditional arguments and theoretical models that have defined photography and the lens arts have only begun to account for these shifting realities.

Any change or attempt to address the lens arts' evolving nature often means the doubling down on tradition by many. However, it is important to note that this does not preclude artists from still identifying primarily as photographers, exploring analog practices, and rejecting or embracing the moving image, nor does it deny the history of the medium. The lens-based arts are not a zero-sum game. Just as it is absurd to separate video artists from the larger history of the moving image, or artists who use acrylic from those who use oil paint, limiting our vision does a disservice to the diversity of artistic practices within the medium. At a time when images can come from an anonymous satellite, a Google Camera, or a cell phone, we should celebrate the diversity of the lens arts as a strength and a source for continual renewal rather than a source of embarrassment and confusion.

INTRODUCTION

Charles H. Traub

What will come? What will the future bring? I do not know. I have no
presentiment. When a spider plunges from a fixed point to its consequences,
it always sees before it an empty space where it can never set foot, no matter
how it wriggles. It is that way with me: before me always an empty space; what
drives me forward is a consequence that lies behind me.

SØREN KIERKEGAARD, *EITHER/OR*, 1843

The camera is everywhere. Almost nothing in the web of human endeavor goes unre-
corded and therefore unseen. Thus the conscious makers and consumers of imagery
must embrace the complication of messages brought by the always-omnipotent lens.
Like Kierkegaard, we dare not go back.

To understand our relationship to the entangled ecosystem of never-ending strings
of imagery, we have to reconsider who or what generates this imagery—and why. The
present generation of digitally savvy networkers has created a new literacy, but one that
is often lacking in critical understanding. Lens imagery constitutes a central part of
our communication, yet even schools of art and media studies give little attention to the
syntactic, semantic, and pragmatic concerns of lens practices. For students, teachers,
and inquiring people, this collection of essays, interviews, and manifestos prescribes,
navigates, and projects what we call a *Vision Anew*. The young and adept hardly question
the ease of their social exchanges. (I text, therefore I am! I am a camera. And so on.)
So assuming there is something in the saying "If youth but knew what age could tell,"
herein are the musings of venerable artists, writers, scholars, and the like about our
present camera culture.

Although the individual writers in this volume make distinctions among photog-
raphy, video, film, and digital recording, this volume treats all these forms as equally
valuable and important. As creative users and receivers, we need to understand the
procedures and protocols, as well as the aesthetic differences and similarities of the
many products that constitute the lens arts. We can become dummies very fast: social

networks evolve rapidly, then morph, and often become obsolete. It is easy to become fully engaged in a system of exchange and then quickly overwhelmed or disinterested. Such is the concern of our intellectually adept contributors.

The photographer Alec Soth cultivated a number of digital strategies for his creative expressions, and our interview (chapter 27) reflects his return to the simple delights of looking and why too many options overwhelmed his muse. Such examples may help us to decipher what has changed, what was lost, and what is gained. The lens is the tool of human observation extended by both art and science. Our perspectives rapidly change with new technologies, and by who, what, where, and why they are used. The invention in the mid-nineteenth century of the stereopticon and 3-D vision underlines the fact that we function in a world of multiple perspectives. The "magic lantern" popularized visual storytelling and projected realistic pictures into the realms of history, science, and travel. Historian and critic David Campany's article (chapter 10) investigates the significance for today's digital practice through the interconnections of moving and still images and their narratives, which have existed since Muybridge invented the Zoo-praxiscope in 1879.

Robert Bowen (chapter 6) and Grahame Weinbren (chapter 15) each delve into the historical evolution of optical perspective. The latter underlines the futurist William Gibson's notion that motion, not stillness, is the foundation of the information we gather from the world through our sense of vision. Weinbren references the films of Pat O'Neill, Jennifer Reeves, and Stan Brakhage in which these artists re-prescribe the viewer's physical place in the world. Likewise, Bowen concludes that the study of vision and the development of a seamless, plastic imagery extend our neural processing. This proposition furthers our call for more investigation of a new visual literacy.

In *Vision Anew,* time is of the essence. When we talk of the photograph, we talk of memory, the past, the decisive moment, and the arresting motion. Something of reality is caught in time, leaving us to believe there is some truth in the image. Likewise in film, compounded sequences lead us to suspend disbelief. (As Godard stated, "Cinema is truth at twenty-four frames per second.") With video we talk about seamless time. In experimental video we are often aware of a riff between the still and the moving, as many video makers shift our attention from one to the other. Watching the screen, we can be fully engaged in the presence of movement and at the same time observing the stillness of an object changing imperceptibly from frame to frame. Bill Viola's prescient epigraph after chapter 21 expresses the cutting edge of this idea.

Time has mutability in the new experiments of pliable cameras and their menus. In his article "Moving Away from the Index" (chapter 17), Tom Gunning thus argues that the new media of the digital motion arts have trajectories that require study and understanding that differ from those of analog cinema or photography. In reframing the world on the virtual screen, we have created another time frame for our existence, so proven by critic Amy Taubin's interview with Christian Marclay (chapter 22). His twenty-four-hour moving-image installation *The Clock* is clearly one of the masterpieces

of editing and appropriation—a new experience of time. Amid the many conceptions that artists, philosophers, and scientists posit about time, one thing is true: time passes and, with it, so do our ideas of truth and reality.

The near real-time experience of photography and video sharing often disguises the politic imbedded in the exchange. Whether in agreement or critique, conflict or contradiction, grafted to the image is an exchange of values in the pursuit of *communitas* and the pursuit or restriction of liberty and happiness. In a controlled and politically charged image culture, we must ask ourselves which side we are on and how we respond. Fred Ritchin reframes the issue in a recent interview (chapter 30): "The digital age is about environment. . . . Being surrounded by digital media is accelerating a reconceptualization of a worldview."[1] Ritchin is echoed by Ken Schles (chapter 3). In *A New History of Photography,* he says that the lens is engaged in an ongoing experiment, projecting the image of what has been and what it is to be. What is to be included and what is to be removed are the big questions that drive the discovery and creation of meaning. This lesson should not be lost on the viewer, whether looking at the continuous frame or the single one.

The former authoritarian structures have been replaced with networked webs, woven by many for many. Too often the complicated interweaving within the communities we view hides these new structures. Just think of the visual clutter in our ever-growing social networks. All is recorded, sent, and commented upon—but with what thought for cause and effect? The narcissism through which we see our world can be overcome by the cultivation of thoughtful looking and recording. In "A Little History of Photography Criticism" (chapter 7), Susie Linfield chronicles the critic's loss of ability to think and feel. She reminds the captious of the need to respond as citizens seeking to learn. There is a lot of freedom of expression, but is there consideration in a global network of imagery, sound, and text that has been reduced to the same common denominator of the digit? Is there dynamic unity or just dissociative disorder? Is there a structure that can be trusted? Such are the questions addressed in the dialogue of Claudine Boeglin and Paul Pangaro (chapter 31) as they consider the constraints of contemporary journalism. Are we not all citizen journalists?

The apocryphal adage that "one image is worth a thousand words" has nevertheless driven the efficacy and popularity of the camera image. Yet, a good picture, still or moving, can ironically stand in its indexical gesture for something our conscious mind could not heretofore conceive or put to words. The record of the lens and its implied connection to reality or our own need for verification seduces us, but there is no real fact. Most often the camera's recording is just a representation of an idea or an experience that is perhaps out of context, maybe manipulated by the maker or someone presenting it, selectively delivered or biased by preconception. In "Photography and the Future" (chapter 23), Tom Huhn reveals his fear that the camera may disinherit us from images that have their sole origin with the human hand, thus positing a loss of some fundamental humanism, and indeed truth. The camera product is plastic and malleable for

anyone and everyone's politic. Or, as Trevor Paglen quips in this volume (chapter 24), an image is worth one thousand lies.

For me, the real humanism lies with the *creative interlocutor*—the individual who facilitates others' engagement in the web of media that is a constant of our world. He or she provides structure. This person is the programmer, gatekeeper, curator, teacher, facilitator, or conductor. In the essay from *A Blink of an Eye* (chapter 18), Walter Murch, one of the greatest film editors, describes such a person, the film editor, as an ombudsman for the audience. Content has to be framed by editing. The creative interlocutor discovers strings, makes cuts or additions, and manages content, allowing us the further means of making our own. Therein is the art, in channeling understanding through the creation of new frames of reference. In "There Is Only Software" (chapter 25), Lev Manovich stresses the need to look past the products of our creation and see how the tools shape and limit our vision and allow it to take form. As Douglas Rushkoff warns in the epigraph after chapter 25, one must program, or be programmed.

The best artist allows the imagination to enter the frame on its own terms. In the essay "On " (chapter 28), Charlie White defines the contemporary image as a codified operation for a new form of discourse. In so doing, the social networks of our spider's web can be embraced not only as channels of communications but also as forms of both vernacular and high visual art. Making art can be the choice of the sender as well as that of the receiver. Throughout *Vision Anew* it becomes evident that the lens arts and their multimedia interchange create a new discourse that crosses the boundaries of the sciences, humanities, and the arts. What is made for one reason may find a place in another domain, revealing if nothing else new data for analysis.

If one picture is not worth a thousand words and if indeed one thousand words tell us little, one thousand pictures do tell us something. Many events of our very recent past evidence the point, whether it is the depiction of 9/11, Abu Ghraib, the Arab Spring, or the recent Atlantic storms. The accumulative images—videos, telecasts, and stills—collectively relate something that a single frame or clip could not fairly illustrate. When an event is experienced from diverse vantage points and by a multitude of citizens from multiple perspectives in a given time frame, the witness of the many bears some truth of what took place. In this case, more is more—more images to edit and sort through. I, for one, would rather have too many choices than a limited number selected by an omnipotent authority for whom there is no recall. Perhaps our real humanism is in our collective ability to more readily engage the digital means that are at hand.

The means of interpreting events are enhanced by the proliferation of cameras displayed throughout all of our networks. How do we filter and negotiate all of the digital stimuli with which we are bombarded from countless media sources? In "Google Street View: The World Is Our Studio" (chapter 26), Lisa Kereszi makes it clear that part of being human involves using our hand to select, view, or take, and thus manage for our own use all that is out there. Doug Rickard's appropriated pictures from Google Street View reveal a commonality of issues regarding the disenfranchised caught randomly

throughout our nation. The lens threads the spider's web and creates unpredictable patterns into spaces unavailable to the unaided human eye. Observations snapped, appropriated, or made by anonymous or authorless creators need human intervention for structure.

The visual recording of the human experience is constant but always in flux, making all that we can now see require vigilance and discernment, as well as willingness to dispense with perceived boundaries. We've organized this book under three loose headings: "From the Lens," "Vision and Motion," and "Old Medium/New Forms." Dialogues and interviews are mixed with critical and historical essays, and many are illustrated with photographs. Aphorisms and quotes are spread throughout to spark the reader to think outside conventional paradigms.

"From the Lens" discusses the evolution and history of the camera recording. We open with Arthur Siegel's poem "Photography Is" from 1961 (chapter 1). One of the central figures in the New Bauhaus, Siegel points to the lens's multiple roles and possibilities, which still exist today, over fifty years later. Although the lure of the new is great, the act of taking and making a good picture still holds great importance. In his text, Gerry Badger reminds us of the complexity of making a straight photograph (chapter 2). Ken Schles looks at the future of photography as a reflection of language and culture (chapter 3), and Adam Bell explores current debates about abstraction, modernism, and materiality (chapter 4). Our interview with Ofer Wolberger and Jason Fulford looks at photobooks and self-publishing and addresses the challenge of matching form and content in this digital age (chapter 5). Robert Bowen looks back at the contribution of science in the early 1800s to the development of photography (chapter 6), and Susie Linfield considers the history of photography criticism (chapter 7). Marvin Heiferman concludes this part with a call for visual literacy in this digital age (chapter 8).

"Vision and Motion" discusses the intrinsic connection between still and moving images and their relationship to the meaning of time and space. In chapter 9, László Moholy-Nagy enumerates the photographic techniques that enhance the power of sight and issues his famous proclamation that the literacy of the future will require knowledge of the camera as well as the pen. David Campany meditates on motion and stillness in photography and the cinema from Muybridge to the Hollywood freeze frame (chapter 10), while Rebecca Solnit takes a closer look at Muybridge, the man who "split the second" (chapter 11). Wolf Koenig considers the influence of Cartier-Bresson's photographs on his films and the importance of structure (chapter 12). Ai Weiwei compares Chinese cinema from his youth with today's and pays homage to Andrei Tarkovsky, who was able to "unify individual faith, literature, poetry, and the cinematic language" (chapter 13). For Hollis Frampton, "the art of making films consists in devising things to put into our projector" (chapter 14). Grahame Weinbren uses the theories of Erwin Panofsky and J. J. Gibson to explore perspective and perception in contemporary photography and film (chapter 15). Our discussion with Bob Giraldi, Christopher Walters, and Ethan David Kent parses the impact of technology on filmmaking (chapter 16). Tom Gunning's essay

focuses on the complexities of "indexical realism" in relation to motion in cinema (chapter 17). Oscar-winner Walter Murch explains the challenges of film editing (chapter 18), while film historian Scott MacDonald explores the making of two documentaries from Harvard's Sensory Ethnography Lab (chapter 19). The section ends with interviews with several contemporary artists who work with the moving image. Pipilotti Rist converses with Doug Aitken about the challenges and joys of video installation art (chapter 20). Claire Barliant interviews Shelly Silver about narrative, genre, and "watching" in the construction of Silver's films (chapter 21), and Christopher Marclay talks with Amy Taubin about both his music and his art, especially *The Clock* (chapter 22).

The third part, "Old Medium/New Forms" explores how camera-based creators cannot escape the expectations of the past as they grapple with the changes of their medium. It starts with Tom Huhn's provocative challenge that "photography is now the largest impediment to human advancement" (chapter 23). For artist/geographer Trevor Paglen, interviewed by the photographer Aaron Schuman, the key issue is how "cameras" such as spy satellites and drones sculpt society (chapter 24). Lev Manovich's argument that "there is no such thing as 'digital media.' There is only software" (chapter 25) is followed by Lisa Kereszi's look at works created with Google Street View, especially the use and authorship of these new images (chapter 26). Alec Soth and I talk about Soth's work and the challenge of sustaining one's curiosity in an evolving image culture (chapter 27). Charlie White analyzes authorless and authored online images through the lens of linguistics (chapter 28), and Barry Salzman explores the effect of social media networks on photography (chapter 29). Fred Ritchin and Brian Palmer dialogue about media literacy in the twenty-first century (chapter 30), and Claudine Boeglin and Paul Pangaro discuss journalism in the digital age, including photojournalism and data journalism (chapter 31). This volume concludes with four manifestos: Joan Fontcuberta's post-photographic manifesto (chapter 32), David Joselit's *Feedback* manifesto (chapter 33), Katja Stuke's and Oliver Sieber's graphic *Antifoto Manifesto* (chapter 34), and my own 1997 manifesto, "Creative Interlocutors" (chapter 35).

Given the broad and diverse field of the lens and screen arts and their dominance over our visual landscape, there is an infinite range of discourse for a book like this to engage. As artists, we are concerned with posing the relevant questions. As daunting as the possibilities may be for selecting that which is telling for our humanity, we are limited only by how we spin the strings about us. I do not know exactly what it is I want or should want to find or see, but I am reasonably sure that everything is out there being recorded by everyone, anyone, any device, everywhere and anywhere. With unknown consequence, it is up to me to gaze anew.

FROM THE LENS

The practice of photography is no longer for recording reality.
Instead it has become reality itself.

AI WEIWEI, BLOG POST, JANUARY 16, 2006

Photography must realize its destiny as the "language" of the twentieth century.

BERENICE ABBOTT, "THE COMING WORLD OF PHOTOGRAPHY," 1944

1

PHOTOGRAPHY IS
1961

Arthur Siegel

A venerated teacher and photographer's prescient prose poem on photography's multifaceted nature is particularly relevant today as the lens-based image becomes central to the discourse of all aspects of contemporary society.

Photography is
science
system
process
technique
tool
documentation
pages from life
creative treatment of actuality
archives of memory
mirrors of memory
extensions of the eye
enlargement of image
hobby
business
profession
means of expression
way of life
poor man's Rorschach
language
art
etc.
etc.
etc.

2

KEEP IT SIMPLE STUPID, JUST MAKE A GOOD PICTURE
The Basics of Photography
2012

Gerry Badger

Badger outlines the simple, but complex, means for making a straight photograph—perhaps an endangered activity in a world where the photograph can be so easily manipulated.

What is photography? That is a simple question with a complex answer. Indeed, the answer is probably different for each person asked, so I can answer only for myself and try to describe what excites me about the medium and, therefore, the qualities I discern in the photographers I particularly admire. Because I feel on the same wavelength with a certain group of photographers and am friends with some of them, what I shall be saying, although personal, should nevertheless accord with a community of like-minded lovers of the medium.

There is a simplicity about photography that appeals to me, and I feel that too often people complicate it in an effort to make it intellectually credible and justify its presence in the museum and gallery as a fully fledged "fine art." When I first became interested in the medium, it had very little status in fine art terms. The goal then was to prove its worth, led, of course by John Szarkowski at MoMA, photography's most powerful ally. Now, more than forty-five years later, I don't care two cents whether it is regarded as an art or not. I believe that photography can be a great art, and that certain photographers are among the greatest of artists—Evans, Atget, Arbus, Robert Adams, Shore, and so on—you can add your own names, as different from mine as you like.

But I have a firm belief about one thing. I feel that the further photographers get away from photography's basic simplicity and attempt consciously to make "art," the less of an art it can be. That of course is not true for everyone, but in my book it's true for most. I hate fake photography—photographers creating fake worlds, evoking fake emotions, talking about little except their own career positions within the hermetic

art market world. Recently, in a review of an exhibition full of that kind of work, the London art critic Charles Darwent said the following about the work of a well-known photographic portraitist: "The last thing her portraits seem to be about is revelation or engagement."[1] I heartily concur with Darwent's sentiments, for I believe there is so much photographic work around that has forgotten to engage with the world or reveal anything very much about it.

But I don't want to be negative here; I want to focus upon the positive, so back to the idea of simplicity. Photography began when scientific experimenters found that the action of light upon certain chemicals, if focused into the back of a box called a camera, produced a trace image of what the light outside was falling upon. Coming up to date, you point a camera at something; it makes a faithful image of that thing. At first, such an image was called a "photogenic drawing," later a photograph.

So, one of the earliest photographs, by J. L. Daguerre, one of the medium's inventors—typically, the medium had a number of inventors—shows a boulevard in Paris in 1840. In one corner of the picture is a man in a top hat having his shoes shined by a bootblack. A simple everyday act, but we can look at that picture and see (after a fashion) an actual trace of the two men making that commercial transaction in 1840. A great work of art? Probably not. An amazing image? It sure is. It doesn't matter a jot whether it's art or not. As Roland Barthes rightly remarked of photography's faculty to reproduce a trace of the actual, "This is a strictly scandalous effect. Always, the Photograph *astonishes* me, with an astonishment which endures and renews itself inexhaustibly." And he was moved further to proclaim that photography is "a *magic*, not an art."[2]

To make that leap in time and space is quite a thing, and that is what photography does. It puts the viewer into direct contact with everything from people long dead to the surface of the Moon—with the long ago and the far away.

And yet I feel it's an aspect of the medium that we take for granted. We shouldn't. It is the first thing that draws people to photography. Who among us who has ever made a print can forget the moment when that first image of the world started to appear in the developer? We shouldn't, because it is the first thing that should occupy any photographer—to make a plausible transcription of the scene in front of the camera.

It was a quality that was never lost on Walker Evans. In 1974, he wrote the following about a postcard of a small-town Main Street, an area of vernacular photography that he collected assiduously: "Made as a routine chore by heaven knows what anonymous photographer, the picture survives as a passable composition, a competent handling of color, and a well-nigh perfect rendering of place."[3] For "well-nigh perfect rendering of place," read "plausible transcription"—but what do I mean by *plausible*?

The plausible photograph is not an unmediated take on reality; it is an image, a *picture*. The photographer's task, or problem, although completely different, of course, in its mechanics, is no different in image-making terms from that of the painter or any other kind of visual artist. In essence, making a photograph is about line and shape, color and tone, proportion and perspective. And to say that is not to denigrate the vital

importance of subject matter, to which the photographer is joined at the hip. But subject without form is just as lacking as form without subject. Form and subject, or form and content in photography, have a complex, symbiotic relationship.

The photograph is not a mirror of the world nor a window onto the world, although one can certainly look at the conceptual approach of the photographer in those terms. The photograph is a representation of the world, a re-presentation. That is to say, it is a *picture* of the world, which may be mirrorlike, or windowlike, or a combination of both. It might be truthful or untruthful, but it is always a fiction—not necessarily a lie, but a fiction. The photographer's task is to make that picture plausible, convincing, and—because I believe that photographers, like anyone else, have moral obligations—authentic and honest.

Consider this image by Stephen Shore. Shore is one of those photographers who tries to make pictures that are as seamless as possible in their transcription of reality—photographs that look almost as if they were taken by the camera working by itself, like CCTV. But this image was not taken by a CCTV camera, nor by Evans's anonymous postcard photographer. It was made by a highly sophisticated, highly conscious, major photographic artist—a major photographic *picture-maker*.

Shore has subtly reconstructed, or rather molded, the world inside the picture frame by choosing where he stood, taking account of the light and the way the different elements within the frame arranged themselves. Shore couldn't arrange them, but he could notice how they *were* arranged and place his camera accordingly. Above all, he could pay close attention to the edges of the frame, because what photographers do is place a frame around the world. The way the automobile on the left is cut off, the way we can't read all of the sign at the top—they are no accidents. Shore is using them to hint at things outside the frame and also to make the image look slightly more accidental, although it is anything but. The result is an extremely plausible transcription of the reality, a transcription that is intended not to fool but to persuade us of its authenticity—and, without shouting about it, to persuade us that we are almost looking at the actuality itself.

This is not trickery. It is simply what a photographer must do to get to that state described by Evans as "a well-nigh perfect rendering of place." Except that, as a work by a journeyman commercial photographer, the making of Evans's postcard was a much simpler, much less conscious process than the highly sophisticated one of Stephen Shore. The results, of course, are nominally similar, yet they are not. One is a beguiling postcard; the other is part of a major body of work by a major photographic artist. The postcard's meaning pretty well ends at the transcription of reality—an achievement in itself—but the meaning of the Shore just begins with that "capture" in the camera and is closely bound up with the other works in his extensive oeuvre.

Before I discuss that, I feel I need to note that, in our desire to discredit formalism somewhat, emanating from postmodernism, we have tended to throw the baby out with the bathwater by denigrating the process of arranging forms within the frame.

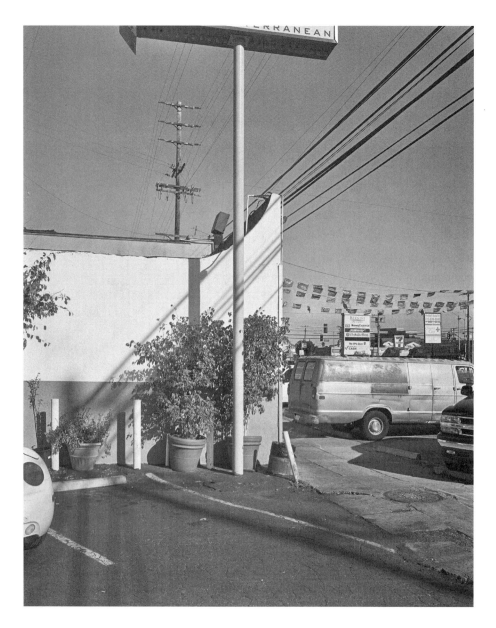

FIGURE 2.1

Stephen Shore, *Venice Boulevard, Los Angeles, California*, 2006. © Stephen Shore; courtesy of the artist and 303 Gallery, New York.

Formalism seems to have been thrown off the agenda. Indeed, many photographers have tended to neglect—some deliberately, some out of carelessness—the "picture-making" aspect of photography.

Let us consider the problem from another aspect, from an area of the medium where the overriding consideration surely ought to be *what* you are photographing rather than the *way* you photograph it: photojournalism, or reportage photography, and specifically, the photography of conflict. The Magnum photographer Paolo Pellegrin is one of the world's best conflict photographers. That is, he photographs some of the worst things mankind does to mankind, making memorable photographic images with the intention of drawing people's attention to what is happening. Pellegrin is under no illusion that his pictures will stop conflict, but they are part of the necessary and vitally important business of bearing witness and contribute, in however small a way, to a better and more peaceable future.

Pellegrin has a happy knack—or rather, he has been blessed with an immense talent—for making extremely well-composed pictures under the most difficult circumstances, risking his life to bring unpalatable facts to our attention in striking photographs. But because he makes well-composed pictures and produces prints that could be described as beautiful, Pellegrin is frequently accused of "beautifying" or "aestheticizing" war. Even though he is always careful to contextualize anything he does, he is condemned, in a sense, for doing his job too well.

I find it difficult myself to view beautifully printed and elegantly framed pictures of broken bodies in a gallery, but that is a matter of a particular context and presentation rather than the innate qualities of such imagery. Like any photographer, Pellegrin must do the best job of which he is capable. And that means making a coherently structured image that employs every means to hold viewers' attention as long as possible and make them think. Of course, we are now used to seeing conflict images coming from amateurs' phone cameras—grainy, badly composed, but straight from the heart of things. Bad photographs have become a new norm for the view that seems so much more immediate and "authentic" than that of the expensive professionals like Pellegrin.

However, Pellegrin *is* a professional. He has a different task, that of not simply being there and making an immediate documentary record but of securing images made—calculated even, with that word used in a nonpejorative way—to persuade the viewer of their authenticity, yes, but other considerations also, including the photographer's view of what he is photographing. Pellegrin, in short, has a duty to make more complex photographs, photographs that bear more than a moment's contemplation and evoke more complicated emotions than a simple, intuitive gut reaction, important though that is.

Pellegrin's work, and the criticism of it, is at a fairly exalted level. Down a notch or two in the talent and professionalism stakes, I see so much work nowadays that is curiously lacking in terms of picture-making, that does not do the things Pellegrin does— *sloppy* is the term I use for it. I think there are two reasons. Firstly, there are so many photographers around—including the iPhone amateurs producing their photobooks—

that people feel they need to be in the swim all the time and produce a project a year in order to keep attracting attention. That does not make, on the whole, for considered and thoughtful work. Everyone is seeking instant success and fame.

Secondly, digital cameras obviate the necessity, which film cameras required, to be careful with the shooting process. Film cost money, so photographers were forced to be careful. It costs nothing to make and process a digital picture, so photographers can make thousands of images without considering the cost. It has a positive aspect in that it encourages experiment. You can try something, and if it doesn't work, you can just delete it. But on the other hand, it also encourages a tendency to blast away and make far too many indifferent pictures, almost identical frame after almost identical frame. A shoot-first-and-ask-questions-later has always been part of photography, even with a large view camera. "How do I know what I think until I hear what I say?" as the saying went in literary circles. But if the taking is too unthinking—and just plain sloppy—frequently I find that the thought following the taking is also sloppy.

There is a balance between form and content in photography. You cannot neglect one at the expense of the other. I see the work of so many photographers where their subject and the subject matter are potentially of great interest and moment but the resulting photographs are not. The current sloppiness is not helped by the fact that it is not only so easy to make thousands of indifferent photographs (it actually always was), but also making a photobook has become a simple matter. It is great, it is democratic, but it has led to a lot of bad photobooks.

I cannot advise on the content of either individual photographs or groups of photographs, except to say this. I have quoted this before, but I keep drawing the attention of young photographers to it, because it is one of my "tests" for photography. It comes from Robert Adams (always a good guide). Writing specifically about landscape photography—but it applies to any photography—Adams wrote the following: "Landscape pictures can offer us, I think, three verities—geography, autobiography, and metaphor. Geography is, if taken alone, sometimes boring; autobiography is frequently trivial; and metaphor can be dubious. But taken together . . . the three kinds of representation strengthen each other and reinforce what we all work to keep intact—an affection for life."[4]

Add history or psychology, or even the medium itself, to this mix, and you begin to create an imagery that is layered in meaning, that is rich and complex rather than simple and superficial in the manner of far too much photography. At root, making a photograph is a simple act, but it is a complicated art. I firmly believe in photography that is "about" something in the world other than itself. It is sterile otherwise. If a photographer's work can start to interweave two or three or even four different issues, at different levels, then we are really beginning to get somewhere. But at the same time, it also has to be a formal art, about picture-making, about creating pictorial order out of chaos.

3

EXCERPT FROM *A NEW HISTORY OF PHOTOGRAPHY*

The World Outside and the Pictures in Our Heads

2008

Ken Schles

In this excerpt from an essay in his photobook *A New History of Photography*,
Schles imaginatively explores photography's purposes, potentials, and future.

Currently, the world of photography is undergoing profound changes. As we move from
analog to digital images, the way we use and consume images is shifting. Photography's
use and deployment is becoming ubiquitous, in turn changing the society that uses
those images. It is, therefore, a good time to reevaluate the way that history has looked
at images and the way images—including photographs—function.

Photography operates in many ways and for many purposes. It functions as a per-
sonal reference point, as an investigative scientific tool, as evidence, as fine art, as an
implement to propagandize aspects of culture through advertising for corporate gain,
political gain, and social status. Images grow and tear apart allegiances of various sorts:
familial, corporate, political, nationalist, religious, sectarian. We hold photographs dear
and throw them away. We look to photography to universalize experience and to record
our most private and personal moments. Of this we can say: how we use a photograph
and how we perceive a photograph determine its role. Perhaps, a photograph is just a
photograph—but its import has never been in what it is, but in what it does and how it
functions for (and transforms) us. Each role has a history and belongs to an idiom. Just
as a piece of text can be a traffic sign, a Bible, a love letter, a piece of literature, a political
declaration, a scientific paper, a philosophical treatise, a rant of the sane or insane—a
photograph lives and dies depending on how we see it, use it, and appreciate it. Now,
changes in culture and the technology that disseminates culture make the importance
of traditionally printed materials, like books and magazines and the advertisements they
contain, less clear. Transient, fluid, digital cultural signs and signals are now overtaking

traditionally "slower" media. The role of galleries and museums is shifting as well, as audiences grow larger and look to be entertained while being edified. The concomitant economics of the image industry, caught up in these transformations, invite greater change to the technologies of image creation and distribution, further increasing the presence of fluid, digitalized images in our everyday lives.

We "shoot" pictures to each other via mobile devices and use them to describe our world—a descriptive construction that in the recent past relied exclusively on voice, pen, and paper. The omnipresence of images intrinsically changes the speed, depth, and nature of our personal exchanges. We are being imaged almost universally, from satellites and street corners by government and private industry, while we shop and while we work, and for ourselves where we play and engage in the moments that make up our lives. Our political institutions attempt to control an individual's rights to photograph in public and semipublic places for security reasons; corporations monitor consumer behavior, worker efficiencies, and inanimate objects alike. There are ongoing political and economic fights as to who owns images, who has distribution rights to images, and who determines the way images describe various quarters of the world. The fight over language and culture is a political fight over influence and control. The image (or perception of an image) is an essential element of its use as propaganda. And who owns power over the image owns power over perceptions and the way people think. Because the image projects an ideation of the world, its primary use is in the field of influence over thought. Noam Chomsky eloquently noted, "But when you can't control people by force, you have to control what people think, and the standard way to do this is via propaganda (manufacture of consent, creation of necessary illusions), marginalizing the general public or reducing them to apathy of some fashion."[1] I can't say that those in power have been wholly effective, because the propaganda model in our country is focused on the political and economic realms—the political economy. But politics of fear, especially after 9/11, have allowed elite conservative partisans to rip the social, economic, and political fabric of the United States. Those in power just haven't been able to institutionalize their control very well, since they so despise governing.[2] But we need to realize that there are other social and private realms that are left out, or only marginally affected by the government and industry propaganda machines. Here, we have a multitude of competing images that usually include things such as material wealth, moral rectitude, and hedonistic abandon, which vie for dominance. Who is to say which image holds sway (to me, none of them seems compelling). We (the technologically enabled populace) also hold those strings and enthusiastically engage in playing with these and other images while in our pursuit of happiness—although I am sure we are generally unaware of the power we/they possess. Perhaps it is because ultimately images exist outside of language and it is hard to be circumspect and specific about a gestalt. We see an image and we *know* something, somehow. We believe, but we don't know why. The nonverbal quality of our image conversation places it in the realm of the emotional and prerational (i.e., outside of language), which is why, when our images "speak us," we

don't have a clue as to what's going on. It's not quite the Twinkie defense,[3] since we are morally and legally responsible for our actions, but by and large, I'm not sure that we generally should take credit for what we're doing or why we're doing it.

Since photography's inception, there have been tastemakers and gatekeepers who have controlled the context in which photographs appeared. They dictated how and if an image was seen or used. They controlled the conversation. Photography has been traditionally a profession controlled by regulators of some sort—the professional photographer, the editor, the critic, the gallery director, the historian, the creative director, the curator, the designer—all professionals working to control and delimit the ways and means by which the image was created, edited, distributed, seen, and understood. They chose, and for the most part the audience followed, many times raising the level of discourse by honing a way of seeing by an audience, even when pandering to a particular clientele. But access to their cabal was limited. Today, the technologies of mass creation and distribution are shifting power away from the professional classes, but what will the nonprofessionals do with these new powers they don't even know they possess—are we to become gatekeepers all, as we vote with our eyes? Here we are entering into new territories of culture: organic and Darwinian. But we also must remember: in the current capitalistic-fascistic environment, images function mostly to sell something, whether it is a perfume, or that I conform to certain cultural norms, like the fact that I had a pony ride when I was three.

There is a long and rich discourse that gives lip service to the notion that photography is a democratic medium, because of its nearly universal use. Talk proliferates around the possibilities that might get stirred up if everyone had the ability to image their world. When George Eastman opened photography to the masses, in 1889, by declaring, "You press the button, we do the rest," the idea was set that images were no longer just in the hands of the rich and powerful. Cameras, ever since, have been readily available and easy to use by the proletarian masses. But while the medium was used by the masses, it was never really a democratic form. Indeed, we do "press the button," but it is the corporate entity, the political establishment, language, and the culture at large that supply our expectations that then "speak us." Those are the elements that pretty much "do the rest." We consume images and we distribute images, but we don't truly create them (even if we do press "the button"). Intellectually, I don't see the creation or the consumption of images as being in any way democratic. It is just that we do these things. We seem to have little understanding of our impulses while doing so. It is part of who we are. That we all speak doesn't make speech democratic. That cows eat grass doesn't make cows eating grass democratic. That birds sing doesn't make birdsong democratic. It is the distribution and access to these externalized referents—and the political processes that enable their distribution and evaluation—that can be qualified as democratic or not. But image creation seems to be an animalistic and social-biological response as much as anything. At once alienating and seductively engaging,[4] image creation and consumption appear to be innately human acts as we transform our understandings and

reactions into signifiers. And once again, the image speaks us. The intellectual debates around these issues should tell us that professionals *should be* welcomed to oversee the creation, distribution, and interpretation of images and to debate image issues, since, as professionals, they should have something important to contribute, but economics and fashion conspire to wipe out most of the nonacademic components of the current professional class. I shouldn't complain too loudly though, since most image professionals, being more visual than verbal, are incapable of intellectually considering their own craft and act primarily in a mercenary capacity out of institutional or economic needs and justifications.

The image speaks us in many ways, through many voices. As we discuss and incorporate a diverse array of images into our worldview, our sense of who we are shifts. The ubiquity of amateur-created images actually adds to the diversity of vantage points. These lay images are increasingly being tapped via various crowd-sourcing strategies, like user-generated content schema or through image aggregators, to supply a higher and higher percentage of the images we consume. This is a very different situation than what was common only a few years ago where, almost exclusively, professionals supplied images.

Back in the day, images made by nonprofessionals—amateurs—usually stayed within tight confines of friends and family unless "revealed" by a discerning professional's curatorial eye.[5] The cost of making an image, the technical know-how needed to process an image, and severely limited distribution networks made the dissemination of photographs on a large scale nearly impossible. Even when relatively inexpensive means of printing books became available, the audience for artist works and books was quite small. Limited print runs and small, informal venues ruled the day. The image was, with few notable exceptions, controlled by a small number of dedicated professionals. Today, technology seems to possess the ability to challenge and change that equation, making the "person on the street" front and center of a new paradigm. But change may be slow to happen. And there will be no critical debates for the aforementioned reason: it is the image that speaks us. Images, most markedly those created by amateurs, primarily reiterate some form of status quo, even when they proclaim to be radical.

It is therefore uncertain where photography is going in these heady times. Indeed, a whole other book could be written on the deprofessionalization of the medium and the social and intellectual implications for recent technological transformations. What is increasingly evident is that the masses, aided by technological leaps, are creating new realities "on the ground." We are entering a new era of image making where, contrary to Garry Winogrand's understanding of the photograph qua photograph or Diane Arbus's image pointing us to the mysteries of understanding, we are fed an increasing flood of naïve images that, generally, simply point to the world at large. Contrarily, the commercial response to this phenomenon has been twofold. The first response seeks to separate the professional from the amateur by geekily exploiting expensive technologies—use of elaborate lighting, extensive use of image-editing tools and other digital technologies

to make the image superstylized and seductive. This ties the image directly to fantasy and the imaginary, which feeds well into the consumer's desires and fantasies. Or two: co-opt the enthusiasms of the amateur and exploit user-generated content, or simply replicate the offhanded, "naïve" qualities of the amateur.[6]

As we pass images back and forth in a kind of digital visual conversation, we think our images merely point to the object of our experience as it happened in real time. But our finger-pointing photographic virtualizations of experience are misleading and misunderstood. For it is not simply a virtual world that the image depicts, but a mediated world, an interpreted world that reflects real processes, both physical and mental. The photographic image should be recognized as the mediated signifier that it is, as choices and distinctions have already been made for the observer. The popular notion that the image simply conveys a virtual reading is more a primitive, more naïve understanding of the image—and a potentially false or misleading understanding, no doubt, since an image, no matter how "simple" it is, is still a mediated projection. Images present a complex and elusive series of signs and signifiers, which we filter and which get filtered through us.

The danger of not recognizing the photograph in any complex way, without an attempt to confront or critically look at the photograph as constructed image, opens the viewer up to certain manipulation. But to say that complexity exists is not to say that we cannot take simple delight in the image as well. The complexity of the image should delight and excite us. It exists easily within a simultaneity of simple and more sophisticated readings. The image is a virtual presence while it is a mediated presence. Let us delight in its formal qualities. It projects and reflects a direct relationship among individuals. The image, and specifically the photographic image, is the most human of forms.

Part of the enjoyment of images is to surrender to their seductions, an enjoyment that necessitates a suspension of disbelief. From time immemorial we have been warned and chastised about the dangers inherent in doing so—there are stories against idolatry in the Bible, such as the one in which Moses destroys the tablets upon seeing the children of Israel seduced by images of Baal. Conflict over the image led to the two iconoclastic periods in the Byzantine church, a conflict precipitated in part by a deep rejection of the image by Islam. In Plato's Allegory of the Cave, we learn that the reality we experience is merely a series of projected (false) images. Imprisoned and enslaved by our images, we are unable to see true reality, keeping us ignorant of the Good. In contemporary times we have taboos centered on sexualized images and images of the dead. And we mustn't forget the admonition from our parents not to watch too much TV or read comics. However, we do know that screen time should be severely limited for children under the age of two.[7] Images of atrocities keep its victims (and viewers) reliving disturbing moments over and over while generally desensitizing the public to certain brutalities, and images made by pedophiles both victimize and perpetuate victimization. I could go on. Suffice to say, images have sometimes profound, sometimes subtle, and usually differing effects on different psyches. Like anything, images have

their place and use while serving particular functions. And like anything, images can be misused and abused and used inappropriately.

Within an overwhelming flood of images, anecdote and cumulative advantage increasingly determine what we see.[8] Critics, curators, photo editors—the traditional arbiters for determining what gets seen and how—act less the part of style-setters and gatekeepers. Overwhelmed and overtaken by a vast visual bombardment, their opinions get marginalized in a progressively fragmented and visually amplified society. Commercial interests that were once thought able to transform and control the creative marketplace are now riding shotgun on a new electronic highway. Naïve, affluent collectors control the art market, buying into the latest fad to gorge collections and project their status among friends. Their money and influence are a draw for corporatized museums and their boards, desperate for infusions of cash and a link to exhibition sponsors. A strange dance ensues, perpetuating an almost arbitrary process that elevates and thrusts some very interesting work before the public. The process is not without some merit. There is much good work out there. It is just sad more possibilities can't be welcomed—if only we had the time to give it our diligent and due attentions. But I must confess, it is a strange sight to see an infinitely reproducible object commanding such fetishistic, obsessional behavior and speculative market excess. But so be it—our society seems to have no sane collective method to gauge worth and value. The art object is the most pure of capitalist market creations: limited, desired, and serving immaterial and elusive needs, focused mostly on desire fulfillment and having little intrinsic concrete value. But that is the world of mankind: full of abstracted and intangible relations. The collector may admire the elusive qualities of the image and the profundity of its ideas, but what cost is this beauty?

Witness to the evolution of ideas over the course of time, I greatly appreciate what years of scholarship have brought to understanding. Particular discourses shift emphasis and lines of thinking. And while old arguments may, at times, seem quaint, they may also shine a light on the folly of the latest excesses. It is striking what stays and what changes in the world. To say that something evolves is not to imply that what comes next is better in any absolute sense; it is only to say that the forms and ideas, which reflect their times, hold sway and act as an imprint of those times. Not necessarily the best or even the most elegant solutions, they are simply timely ideas that resonate and communicate through groups. History is a condensation of those reflections, of those snapshots. The images we hold dear communicate larger ideas, larger realities that we otherwise would be unable to share or communicate.

Time inexorably moves forward. It is the human mind that writes historical narratives. We sometimes falsely imbue history with a kind of revealed meaning. Since history is given form through language, I am led to think that the discourse of history is and will be forever mutating along with language use and the understandings language conveys. We are destined to revisit histories and rewrite them for as long as we use language and try to understand experience through language.

Time inexorably moves forward, leaving the creative acts of individuals and groups in its wake. As actions and activities are discussed, ideas are disseminated and replicated by others and movements grow. As the needs of individuals change, the imprints that individuals leave in the form of their creations reflect shifts in individual understanding and practice. By noting these shifts as history, we witness our humanity as it evolves and changes.

Meaning is enlivened by experience and therefore is best shared through living example. The significance of any one thing will change across time and across an observer's given set of experiences. Eventually, individuals come to revisit and re-image/re-imagine their conceptions. In the process, they reformulate their ideas on a given subject. Images allow us to both project and process our understandings. Our changing associations are reflective of the unique subjective nature of our experiences in time and space. Over time, as definitions subtly and subjectively change, language itself, and the meanings that underlie language, evolve and change.

THE IMAGE-MAKER

And that is the dilemma I am left with; the questions that arise are contained herein. Is my work my own? The obvious answer is yes, but as a lover of the photographic image and its traditions, I am on a peculiar journey in strange territory. I carry all those other ideas, all that other work, within me as well.

I decided to look through my images to separate out work where I could directly discern allusions to someone else's photographic work. After I began, I realized the near absurdity of doing this, because all my work (and everyone's work) is streaked with influences and references throughout. But some references are more direct and clearer than others. Here was a Gertrude Käsebier, or a Garry Winogrand, or a Roger Mayne, or a Man Ray, or an Alfred Stieglitz, or a Bill Brandt, or an August Sander, or a Paul Outerbridge, or a William Eggleston, or a William Gedney. My images called to mind images found in the canon of Western photographic tradition, a tradition I had internalized throughout all these years of repeated exposure. Edited and sequenced to conform to it, I could make another kind of history of photography: a compendium of influence, a reiteration of a history of photography as it functions for and resonates within me. Starting with the earliest experiments in photosensitive emulsion and on through to my idiosyncratic interests, this project recognizes that my personal journey contains a longer reach and explores meanings broader than I could ever conceive of on my own. It is informed by ideas outside my reckoning and outside my experience. It contains the influences of others. These influences remain vital living examples to me and continue a unique retelling of the history of photography as it appears to me in the world as I experience it.

These images then manifest not only what I have noticed and noted over the course of thirty-some-odd years but also dramatically show, since I use the language and visual

syntax of my culture, the way ideas of others have influenced me. They are about a truth not fully appreciated and largely ignored: I am biologically and socially predisposed to see and understand the world through the eyes and thoughts of others.

I am a product of unconscious projections, cultural movements, historical realities, and economic forces that I could not have imagined some thirty years ago when I took up the vocation of photography. I used to think I could direct my life through the opportunities I encountered or relationships I've formed, but now I see that we communicate and operate in an organic way beyond immediate comprehension. There is a subtext to every encounter, which is beyond reckoning, whose outcome may not ever be appreciated or understood, simply because our interactions are more than what any of us individually experiences and our exchanges may have meanings and repercussions beyond what can be understood. What we do understand of any encounter is pretty much predicated on how the language and culture "speak us." Because of this, we, perhaps foolishly, attach to ideas and identities that cause much isolation and strife. We are, as a species, unable to broadly nurture and nourish the best our humanity has to offer. The world is too dynamic and fluid a place to fully apprehend, let alone appreciate and cherish. Too often we try to control what it holds. We squander the resources of our humanity and of our planet.

Looking at my own life, I realize, like any good photographer, I can anticipate but I can't predict. I try to piece together an imperfect understanding of the past and then I use that imperfect understanding to anticipate things beyond my ken. And then I hope that it all works out. But I operate at a loss. The priorities of the dominant culture seem small and ill-placed. My efforts are out of step and too feeble to affect change as I watch historical events buffet my life.

They say that the victors of war are the ones that get to write history. So it must be that all of us are currently in a total war, an endless, ongoing war over the meaning and possession of language and culture. And those that hold and possess and disperse our culture and language get to pass along its history. Those who can manipulate the image and who can control the image will define history. Most of what gets said and done is forgotten. But we all move humanity to some other place as our lives take form and we reflect the language and the culture around us. It may be in small ways, as we all do, for ourselves or for our children or for our communities, or it may be in the service of larger groups across time and space. We are in a struggle to mold memes, to fashion ideas. Yet, I don't think that most of us are aware or capable of engaging consciously in that kind of war—but we do so, nonetheless, unaware. And most times we take delight in it. Because we are social creatures, we are fast to welcome ideas that transform us and bring us in alignment with others, which perform a social function, and ultimately give meaning to our lives. We are the vehicles for the ideas and images that "speak us." We are the vehicles for the ideas and images that guide and evolve our understandings, both individually and collectively. And so I present here a history of photography as it has spoken me and as I understand it.

4

PHOTOGRAPHS ABOUT PHOTOGRAPHS
2010

Adam Bell

This essay attempts to account for the resurgence of abstraction and formalism in contemporary photography and argues it was always there.

History does not repeat itself, but it rhymes.

MARK TWAIN

From the dry-plate negative to digital cameras, photographers have always been enthralled by the magical properties of their medium. Photography has constantly pushed and challenged photographers to fulfill its potential, but can it also be their subject? What do photographs about photographs have to say? John Szarkowski, the eminent curator of photography, once chastised a student, declaring that there was nothing inherently interesting in the materiality of photographs. Or is there? We seem caught at a moment when photography is looping back on itself and revisiting its modernist roots. Artists like Walead Beshty, Liz Deschenes, Carter Mull, Lisa Oppenheim, and Elad Lassry have turned photography back inwards to excavate its language, process, and materiality in new and familiar ways. Falling under the broad trend the critic Christopher Bedford has dubbed "New Formalism," the artists working in this vein loosely trace their roots to early- and mid-twentieth-century modernism, Constructivism, and Neue Sachlichkeit (New Objectivity).[1] Although not solely dealing in abstraction and materiality, the current revisitation of modernist language and practice embraces modernism's expansive and critical stance towards the media and culture, as well as the medium itself. In some ways, the resurgence of these pictures has something to do with a revitalized interest in merging modernist photography and conceptual practice. But it also has a lot to do with how history, and histories, are written and rewritten.

Within this new trend, numerous and often divergent contemporary practices exist, and distinctions should be made. While the color photograms of Beshty and the newspaper-based abstractions of Carter Mull draw upon different aesthetic and theoretical

concerns, they share roots in a long and diverse tradition. We can trace this thread from the photograms of Christian Shad and László Moholy-Nagy to the abstractions of Frederick Sommer and Aaron Siskind to the radical work created by photographers like Robert Heinecken and other artists from the 1960s to the "Pictures Generation" in the 1980s. A diverse and raucous bunch to be sure, and a crowd that many included would not see themselves as part of, but they are all linked by a similar concern to push photography past its indexical limits and explore its material and linguistic capabilities. While steeped in the postmodern discourse and post-conceptual practice of the 1970s and '80s, the more recent reiterations of abstraction and post-Pictures conceptualism stand at a distance from their historical precedents. Drawing piecemeal from these different traditions, something gets lost in the translation and the thread tying all the work together is frayed.

In comparing these different moments, the 1940s abstractions by Arthur Siegel and more recent reiterations by Beshty seem oddly familiar, yet markedly different. What was at stake in the Pictures Generation's emergence in the late 1970s and 1980s, and what was well-explored in the Metropolitan Museum of Art's show in 2009, seems clear not only because of historical hindsight but because of the parallel alignment of their aesthetic practices and critical discourse of the time. Similarly, hindsight gives us perspective on the practices and concerns of modernist photographers, such as Moholy-Nagy, Shad, and Alexander Rodchenko, in the early twentieth century. So, what is at stake now? Why the resurgence of modernist practice in photography? What makes the materiality of photographs and photographic abstraction new and relevant, if they are at all?

In some sense, it has never gone away and has always existed—under the surface, neglected or ignored. While long out of fashion, the kinds of abstractions and modernist-influenced art that grace the walls of Chelsea and are praised as radical have lain dormant, percolating below the surface, since the 1920s when they first arose. The so-called New Formalists draw on a long evolving tradition that is often overlooked by the artist, but more often the institutions and critics that support him and her. While it is important not to conflate their individual aesthetic and theoretical concerns, they are part of a long tradition that is constantly being rediscovered. Arthur Siegel often quipped, paraphrasing many at the time that "photography is the only medium that reinvents its history every ten years."[2]

The fertile period between World Wars I and II gave birth to photographic modernism and a period of radical experimentation. While abstraction slowly slipped out of favor and was officially quashed by the political institutions that initially fostered it in places like the former Soviet Union and Germany, eminent figures like Moholy-Nagy immigrated to the United States, where he continued the tradition of the Bauhaus by founding the Institute of Design in 1937. The students, teachers, and artists to emerge out of the Institute of Design in Chicago in the later part of the twentieth century (Siskind, Siegel, Harry Callahan, as well as artists like Kenneth Josephson, Ray K. Metzker,

Henry Holmes Smith, and others) built upon this tradition and have had a continued influence on the medium. Gone, but not forgotten, the roots of these images lie there and in their reverberations in Europe.

The history of abstract and modernist-influenced photography is a broad and diffuse subject.[3] In the United States, the seeds of the Bauhaus rested in Chicago with Moholy-Nagy and spread outwards to California and Rochester, both centers of education and photography, where places like RIT, the Visual Studies Workshop, the George Eastman House, and UCLA acted as hubs for alternative strains of photographic practice. The threads of abstraction and media-related art continued through the 1960s and '70s, predating the issues and concerns of Pictures Generation and later artists. At the same time, photography was being used a "dumb copying device," as artist Donald Huebler once joked, for conceptual artists in need of a simple record-keeping mechanism. While outside the proper photo world, the use of photography by these conceptual artists helped pave the way for photography's growing legitimacy. Ironically, in the process of separating and defining photography, curators and photographers alike have often obscured the fertile dialogue that existed between photographers and artists of other mediums.

In reconsidering this history, a few key figures are worth highlighting. A pivotal, and woefully neglected, figure in this continued narrative is Robert Heinecken. Along with seminal figures such as Robert Rauschenberg, Andy Warhol, and John Baldessari, and less well-known artists like Keith Smith, Heinecken pushed photography as a medium to radical new places. Through collage, photograms, Verifax prints, magazine pieces, and lithographs, Heinecken used photography to critique and deconstruct our media-saturated world. Degraded, cut-out, collaged, solarized, and hand-painted, Heinecken manipulated photographs and pushed their materiality to fit his needs. Long before the Pictures Generation, works like *Are You Rea* (1966–68) and his *Time* magazine series were astutely mining the media landscape and revealing its contradictions.

As the head and founder of UCLA's graduate photo department in the early 1960s, Heinecken influenced a generation of photographers and artists, and created work radically ahead of its time. Heinecken also regularly taught in Chicago in the 1960s and '70s connecting his brand of West Coast conceptualism with Siskind and the Chicago school. Despite his broad influence, Heinecken remained firmly within the photo world and labeled himself a "photographist" or "paraphotographer." Sadly, his unwavering commitment to photography meant he never received the acclaim of his contemporaries, who were labeled "artists."

During this time, we can also point to figures like Wallace Berman, a friend of Heinecken's and the center of a larger circle of artists (including Jess, Jack Smith, Edmund Teske, Dennis Hopper, Bruce Connor, and others) in California in the 1950s and '60s. Building upon the radical traditions of the Bauhaus, Berman and his friends embraced collage, photography, and sculpture in rebellion against the cultural landscape of the time. While aligned with the Beats and similar-minded artists in California, Berman's work and influence were a thread tying various art practices together. Educated and

media literate, Berman and other California-based artists like Baldessari and Rauschenberg challenged and inspired artists to "alter their medium both materially and conceptually from the inside out."[4] His work and broad influence is also illustrative of the porous boundaries between the arts.

Back on the East Coast, inspired by Berman and his contemporaries, Thomas Barrow, who was educated at the Institute of Design in the mid-1960s, challenged the hegemonic Szarkowski school of photography and created Verifax prints, photograms, and painted photographs from the mid-1960s onward.[5] Like Heinecken, Barrow used the material and pictorial limits of photography to push it to the breaking point. As Therese Mulligan notes, "to the dismay of photography purists, these photographers were photographic makers rather than photographic takers, self-consciously calling attention to the process or idea of the creative act. In this way, many photographers aligned themselves with the principles of Pop and conceptual art, exploring the changing role of photographic representation as well as cultural dominance."[6] Working outside the art world centers in New Mexico, Barrow also influenced a generation of photographers as an educator and artist. Along with contemporaries like Barbara Kasten, Edmund Teske, Betty Hahn, Robert Fitchter, and John Divola, Barrow played a pivotal role in continuing to push the medium—questioning its material and symbolic limitations.

One of my favorite photo history books is an obscure volume that seemed to slip under the radar called *Revisions* (Lund Humphries Publishers, 2000) by the British curator and historian Ian Jeffrey. Idiosyncratic and unexpected, Jeffrey traces a parallel history of vernacular photography complete with the rude interruptions of chronophotography, microphotography, wire photography, and other ruptures within the canonical history of photography. Exploring these different outmoded vernacular uses, such as wire photos, he reveals the rich and varied visual dialects of photography—a visual cacophony that would have scarcely been missed by visual artists of the time. While unrelated to the topic at hand, it reveals the ways in which parallel histories always exist below the surface—part of the woof and warp. Artists such as Heinecken and Barrow, who were clearly versant in the broader dialogues of their time, refused to reject the label "photographer," and in doing so paid the price. Pushed to the margins of photography, the artists most interested in radically redefining the medium existed between two worlds—neither fully embraced by the Szarkowski-dominated photo establishment nor the art world.[7]

Charlotte Cotton and Alex Klein's *Words Without Pictures* offers the best perspective into the current debate surrounding the issues of abstraction, modernism's revival, and materiality in contemporary photography. Essays by Christopher Bedford, Kevin Moore, Walead Beshty, and George Baker, along with the accompanying discussion forums and public lectures delve deeply into these issues. From an anxious attempt to create something new and familiar to a response to the current global economic crisis, numerous theories are presented for why artists have retreated to explore materiality and abstraction. While it is clear the artists engaged in this exploration are fluent in contemporary

theory and for many their work has political intentions, for others it is merely "trendy, market-savvy, and scarcely disguised by a veneer of easily digestible theory."[8]

Along with these critical discussions, critics and artists like Moore and Karl Haendel cite a loose chronology—the Bauhaus of the 1920s led to Siskind and the Chicago school in the 1950s, which led to James Welling in the 1980s. Welling, as an educator, artist, and source of inspiration, is placed at the center of this swirling debate. While recent work in this vein is rooted within the art practices from these periods, there is little acknowledgment of the odd, often unfashionable, precedents for the work that fills the gaps of that chronology. Alex Klein, in the aptly titled essay "Remembering and Forgetting Conceptual Art," talks about how, for many young artists, "art history is fluid and pluralism is a given . . . and histories are constructed at will among seemingly disparate elements and time periods."[9] In one of the numerous questionnaires throughout the book, Welling is asked, "What are the most important changes photography has undergone in the last few years?" Replying drolly, Welling writes "historical amnesia has grown rampant."[10] Fitting words from the source.

As Charles Traub wrote, only half joking, "All artists lie, particularly about their dates."[11] In many ways, the current influence of modernist practice reveals as much as it conceals. While legitimate influence is hard to refute, and should be acknowledged, the historical and continued "ghettoization" of photography and certain photo histories often reinforces willful ignorance and clouded perspective. As Moore points out in his excellent essay "foRm," we can no longer "assume a narrow track of influence, with photographers responding to photographers and building upon a canon of established approaches, techniques, and ideas in a linear fashion."[12] While the linear progression of influence was often true, it ignores the messy crossover that existed between the arts. Photographers may have been banished by parts of the art world, but that did not mean they remained woefully ignorant of it either. After all, Siskind was a close friend not only of Franz Kline but other artists and Abstract Expressionists. Likewise, the Pictures Generation would be loath to link themselves to the work created in the 1960s by Heinecken and Barrows, but they are part of that tradition. Postmodernism and the subsequent fracturing of disciplines in the arts may give permission to borrow freely and ignore history, but it does not obviate it.

Perhaps we can point to Szarkowski's waning influence, the recent dominance of staged photographs, the tired and ubiquitous 30" × 40" face-mounted C-prints that adorn galleries and museum alike, or the art world's amnesia-clouded search for the new, for this resurgence of modernist abstraction and post-Pictures pictures. Perhaps it's a regressive turn to photography's material and analog roots in the face of their impending obsolescence—a belated attempt to stem the tide against the relentless propagation of digital. The photographer Paul Graham has made the astute point that "directorial" photography, in contrast to "straight" photography, is more readily accepted by the art world because the hand of the artist is transparent.[13] With the exhaustion of the Crewdson-diCorcia-Wall legacy and the staged tableaus that they helped define, it

might seem logical that the art world would turn to abstraction for something to sink its teeth into. I'm skeptical that there is any such "movement," but something is there and it has always been there.

Besides a history lesson, what seems to be missing from the revisitations of the 1920s, '70s and '80s? What in the end is to be learned by excavating photography's limitations and various modes of production? As Charlotte Cotton notes, "A photographic print is no longer a default position; it is an act of will to make a photographic print."[14] For some, it never was. In the face of photography's constantly changing nature, where is the radical embrace of digital materiality, if such an oxymoron can be said to exist? Who's to say a photograph stops on the surface or should even represent? Where are the anarchic anti-art impulses that animated the conceptual artists using photography in the 1970s and '80s? Although they are aware of photo history, it is hard not to read these contemporary artists' gestures as postmodern appropriations—wry and anxious questions about an already transformed and constantly changing medium—questions, in some circles, people have been asking for a long time.

Photography, more so than other mediums, has always had a tortured relationship with its intent and meaning as a medium. *Do we emulate paintings? Do we depict the world? Do we deconstruct ourselves? What should we look like? Do we mean anything? Can people trust us? Can we trust ourselves?* Sometimes a picture is just a picture, but it is always so much more. Photography can never escape its abstract nature, nor will it ever stop questioning its boundaries. Photographs about photographs can tell us a lot about ourselves, or they can tell us something we already know, or forgot, or told ourselves to ignore, in a new or slightly familiar way.

The photograph is not a picture of, but an object about something.

Robert Heinecken, "The Photograph: Not a Picture of,
But an Object about Something," 1965

5

ON BOOKS AND PHOTOGRAPHY
2012

Ofer Wolberger, Jason Fulford,
and Adam Bell

Three contemporary artists discuss the opportunities, means, and ease
of independent bookmaking.

OFER WOLBERGER: Relating to the current explosion in photographic book publishing and self-publishing that we are experiencing right now, J&L Books, at least in my mind, seems to have had a big part in starting it all. I think many artists, photographers in particular, have been very inspired by what you have been able to do with your work and with J&L Books. I wonder if you could talk a bit about what motivated you and Leanne Shapton to start publishing in the first place, not only books of photography but also books of illustration as well as literature. I am also curious how you think things have changed over the past eleven years.

JASON FULFORD: Maybe I can shift the responsibility back a generation or two. Leanne and I started making books in 2000. We met in a film class at Pratt Institute in 1992, and around that time, I was spending many afternoons digging through boxes of small-edition artists' books at the New York City bookstore Printed Matter (which has been around since the mid-seventies). I was also introduced to the films of Werner Herzog, who had created his own production company to produce his films, and the self-published books of Ed Ruscha. *McSweeney's* was another inspiration for me in the late '90s. Dave Eggers was playing the dual role of author and editor/publisher. But the real catalyst was a conversation I had with Jack Woody in 1998. I had shown him some of my photographs, and he said, "Why don't you publish these yourself?" He introduced me to a printer, and I made *Sunbird*. That was the start of J&L. Next we turned to artists we knew and whose work we admired. Then we started receiving submissions.

One recent book of ours is a biography of the German artist Martin Kippenberger, written by his sister, Susanne Kippenberger. She describes his frustration at the German art institutions' refusal to warm to his work. His impatience and desire for an audience led to self-publishing. Susanne says, "The majority of his books were, if not self-published, at least self-financed, at least in part." In the biography, she also mentions the importance of Walther König's bookstore to the community of artists in Cologne in the 1980s. König put out new books every morning on a table in the middle of the store.

"Every morning the Cologne artists crept around the table in single file," [Joachen] Siemens wrote in *Tempo*. "The 'König roundabout' is an unofficial requirement for anyone who wants to stay up to date in Cologne." Martin said, "Ten minutes in the circle and I knew whatever I needed to know in Cologne."[1]

Impatience and desire for an audience still seem to be a motivation for many artists who decide to self-publish.

ADAM BELL: Beyond the impatience and desire to have one's work seen, which is strong for many artists, what do you think accounts for this increased interest in more traditional forms like the book, especially in a time when a plethora of new options exists for presenting one's work, either online or through some new format? Why haven't we seen artists embracing the e-book or its online equivalent as a primary platform for the work? Are people retreating from the ubiquity of screens for something tactile? What is today's "König roundabout"? Is it Tumblr?

OW: I agree with Jason, but it also seems obvious that artists today are interested in traditional forms like the book because it offers an experience unlike that of a web page and that can't be found on a screen. The book seems to allow for a more controlled and considered photographic experience and within a context that the artist has created. I would presume that most photographs are seen for the first time in the context of a random Tumblr or Facebook page, one which the original artist had nothing to do with.

The overall excitement also seems somewhat related to why many younger artists have embraced the manipulated image or the photogram. They seem to be searching for something almost physical in their process. Jason, you have been making photograms lately and have also created live art-making and participatory events, do you see book publishing as being connected to these other kinds of activities?

I was at your performance in New York City at Dexter Sinister 2011 where you were behind the wall in a darkroom converting the objects people gave you into gorgeous little black-and-white photograms. I was completely surprised by what you made out of a little translucent pill box with two pills in it. Having it in my hand afterwards had a similar feeling to discovering and taking home a new book. There was also an excitement in being there, waiting among the people gathered for the event. Wasn't this just another way to connect with your audience while

also incorporating that audience into the work, much in the same way that a book does? I'm curious what other art-making practices you see happening right now that could similarly be connected to those ideas.

Regarding e-books, at least for the moment, I can't really imagine revisiting an e-book. They seem so easily disposable. That's not to say that a carefully considered website or e-book can't be powerful or effective, but until the e-book comes packaged in a homemade computer or is displayed on a screen where the inside plays off or somehow matches the exterior shell, I don't see how it will happen. Have you seen a great e-book? What about a great website that truly worked with its photographic content? A site where it was the thing and not advertising for something else to come?

JF: Sometimes the idea comes first and dictates the form. Other times the reverse happens—you're playing around in a medium and an unexpected idea happens. Both ways have potential. In either case, the end goal is for the idea and the form to support each other. You can't blame the medium though. I think there will be many great photography e-books eventually.

AB: I want to push you to elaborate a little bit more on that answer. I think your old website, which has always seemed like the "anti-portfolio" site, with its innovative design and somewhat chaotic organization, is an example of how a new experience and form for work online is possible. I may be wrong, but it seems that the design of your site also provided inspiration for your third book, *Raising Frogs for $$*. Why don't we see more examples of this kind of work online and in print? Or this kind of cross-fertilization of influence in terms of interaction and design between work online and in print? I love the current boom of photobooks but also feel dismayed that the book is too often an ill-considered and poorly designed default for many photographers' work.

JF: My old website was an attempt to apply photography to this new medium in a way that felt appropriate—endless clicking. I received a lot of frustrated feedback from people who thought it was just a poorly designed portfolio—a portfolio site with broken navigation. They actually wanted to see a portfolio, and the site was a vexation.

The old website did have an influence on the frog book, but the site itself would not have translated well into book form. And often a successful photography book will not translate well into a website or exhibition. This is what I meant about matching the content to the appropriate form. The form becomes part of the content.

One challenge to creating a nuanced website or e-book is the speed with which people naturally go through information online. There is no incentive to slow down. In fact the incentive is to speed up and multitask. Maximum action. Somehow for photography to be successful online, it has to deal with that speed.

AB: I agree. While I'm eager to see the medium reimagined through these new plat-forms, I'm also aware of how such utopic visions of the medium's future don't always align with actual artistic practice. As a technology, books are also incred-ibly stabile and tactile, whereas many of the new forms—be it a Tumblr blog or multimedia presentation online—seem ephemeral. Technological obsolescence is a real danger and potential deterrent to many artists. As John Gossage has recently commented, e-books and other forms online seem more akin to a good conversa-tion, whereas books are like writing and are "objects of fascination," something that requires sustained attention and may not reveal itself until years later.

Shifting the topic a bit, both of you either design or collaborate with designers to create your books. I'm interested in hearing about how that collaboration takes place. Jason, as someone with a design background, you've designed all your own books and work closely with artists to design their books at J&L. In your case, Ofer, you've worked closely with the designers at Common Name to create your recent series of books and have been publishing books through your imprint, Horses Think. Can you both talk about that process—be it designing your own books, working with a designer, or designing another artist's book? How do you begin a project and approach each book?

OW: Design has always been important to me, although I must admit I don't have much experience with it. I realized early on, with the creation of my first website, that I wasn't a designer and needed help. That's not to say that I don't have a design perspective, just that I don't have the background and education to make many of the decisions. I learned a lot from my web designer, Raphael Brion of Anderhalf Design, specifically about type, kerning, and laying out information.

I was lucky with the first couple of books I made, because the design was heavily influenced by the original material I was working with. It felt quite natural to use the basic design and text treatment I found that was already in place. For example, the first book I made, *Star Quality*, was inspired by a hardcover book published in the '70s with the same name, *Star Quality*. The spine of the original book had a worn-out typographic treatment of the title that felt perfect for the new cover I was making. The title page was also a direct copy, while all the images in my book derived from the original images in the hardcover book as well. So it was pretty easy to put the basic design together.

The third book I made presented a new set of problems as the images didn't come from somewhere else. While I had a very clear idea about the book format and layout, I had no clue how to design the cover. It was then that a friend referred me to Yoonjai Choi of Common Name. We met and decided to work together on that book, *Town*. I did the layout and basic concept, and she designed the cover and colophon page, essentially dealing with the font and text treatment. When she sent me the cover design, I was almost shocked at how simple and perfect it was. There was no way I would ever have arrived at that design on my own.

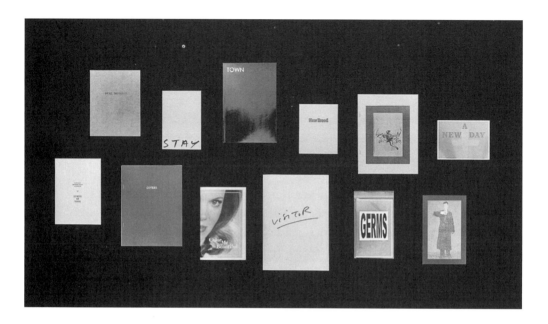

FIGURE 5.3
Ofer Wolberger, *12 Books Published by Horses Think Press*, 2012. © Ofer Wolberger; courtesy of the artist.

Moving forward, Yoonjai introduced me to her partner, Ken Meier, and we all decided to continue working together on the rest of the books. Of course the relationship has evolved quite a bit in that they are more involved from the beginning of each book project. Usually I present them with a project idea and group of images. We then play ideas off each other and work towards the book design. They have been essential in the editing process and formulation of each project. I couldn't have asked for a better partner, as I think they really support what I'm doing and are enthusiastic about it. I feel the same way about what they do.

I have learned a lot in the process, for sure, but I have also been thinking about taking some design classes and/or reading up on the history of typography and design a bit further. Like photography itself, design affords so many different choices to be made, it's essential to be as informed as possible, unless the aesthetic one is reaching for is intentionally uninformed. Even then I might argue that it helps to be informed.

JF: Each body of photographic work has its own language. I think the function of a book's design is to help the reader pick up on that work's specific language—to help the reader navigate the images. There are lots of tools: size, layout, white space, page numbers, materials, sequence, cover image, binding style, printing method, use of text, etc. Each of these can be used to direct the reader—with as much obviousness or subtlety as necessary. The packaging should work in sync with and complement the images.

When I'm working with another artist's work, we will usually start with a conversation about the design. I'll get a sense of how much they want to be involved. Then I will propose some ideas, and we keep up a dialogue all the way to press. We try to keep an open mind and leave room for last-minute inspirations or accidents. It's happened that we've changed the title for a book after all the boxes were already printed with the previous title. For Corin Hewitt's book *Weavings,* we didn't like the way the bellybands printed, so while still at the printer, Corin splattered them all with red cabbage juice.

I am a camera with its shutter open, quite passive, recording, not thinking. Recording the man shaving at the window opposite and the woman in the kimono washing her hair. Some day, all this will have to be developed, carefully printed, fixed.

Christopher Isherwood, *Goodbye to Berlin,* 1934

6

STILLNESS, DEPTH, AND MOVEMENT RECONNECTED
2012

Robert Bowen

Photography and science have been intrinsically linked since the medium's beginning. Bowen reveals how a small group of chemists, mathematicians, and physicists became pioneers of the still and moving image.

The first half of the nineteenth century witnessed the arrival of the photographic still image, the depth image, and the moving image. Their simultaneous emergence can best be described as a conceptual and theoretical convergence. This union was informed by activity in philosophy and science in search of a more empirical, yet more abstract means of collecting visual data in the form of recorded traces of natural phenomena.[1] The various discoveries leading up to the invention of photography reveal that this field did not emerge independently of other scientific research being conducted in the 1830s, when new levels of abstraction were achieved across several disciplines, including mathematics and electromagnetism. As Jean Piaget (1896–1980) describes, abstraction is the process of detecting structures that are located at levels where "forms of forms or systems"[2] may be uncovered that are not observable in an ordinary sense.

The first published account of the photographic process, though incomplete, was a milestone in the history of visual media. Its author was Thomas Wedgwood (1771–1805), whose life was tragically cut short by tuberculosis. His brother, Josiah Wedgwood, stated that Thomas had described his primary interests as "time, space, and motion,"[3] leaving us to speculate what else he might have contributed to the field.

William Henry Fox Talbot (1800–1877), who was surely aware of Wedgwood's work, came to make his great contribution to photography not only because of his knowledge of chemistry and optics but also his significant work in calculus. Calculus utilizes complex relationships between multiple variables, such as changes in velocity that precisely relate to changes in time to produce technical models of the world and solve problems

36

across scientific disciplines. An example is the use of calculus in engineering that made it possible to construct the grand architectural projects of the nineteenth century. Light recordings of depth, motion, and still imagery precisely mirrored these achievements and provided parallel technical visual models of the world, which included advances in our ability to quantify motion in specific n-dimensional space-time volumes. Talbot's desire to picture the world more abstractly and with greater precision than was possible with traditional hand-drawn techniques of that time was certainly informed by his discoveries in abstract mathematics. In fact, when he was seventeen, Talbot's mother, the scintillating Lady Elisabeth Fox Strangways, punned, "You seem so mathematically inclined that I ought *en bonne mère* to send you to Oxford to counteract it that you may not grow into a rhomboidal shape, walk elliptically, or go off in a tangent. All which evils are imminent if you go to Cambridge."[4] Talbot ultimately attended Trinity College, Cambridge.

Talbot was among an extraordinary group of British and French savants who cracked the codes of modern abstraction in the scientific culture of the 1830s. This group included Talbot's friend Antoine François Jean Claudet (1797–1867), a Frenchman who married into a family that owned a glassmaking business and ended up living in London. And so it happened that the first professional photographer working in England was a French expat. In Zelig-like fashion, Claudet's name—even his visage—reappears over and over again in the annals of early photography. He was a scientist, artist, engineer, inventor, and glass merchant, as well as a writer on photography who argued that photography should be considered a fine art instead of merely being seen as an industrial process only capable of creating machine-like copies of nature. Often writing and translating articles for both French and British publications, Claudet stands out as a link between early French and British photographic cultures. He is also important as an early champion of stereoscopic visualization, which he called "the complement of photography," and as a visionary who created some of the first stereoscopic moving pictures.

Claudet's own photographs are, for the most part, elegantly composed and exquisitely hand-tinted daguerreotype portraits set against painted backdrops—a technique he originated. A significant percentage of his portraits, which he marketed exclusively to the carriage trade, were also stereoscopic. When his subjects were posed against these painted backdrops, the images became a hybrid composed of two types of perspective: "Wheatstonian" perspective (stereoscopic) and traditional Albertian or Renaissance perspective. In an effort to add yet another layer of reality effect beyond photographic capture, stereoscopy, and painted backdrops, Claudet introduced color tinting applied by hand.

The first generation of photographic colorists was by far the best in the history of the medium because there was a large pool of jobless and highly skilled miniature painters readily available. One such individual was André Léon Larue ("Mansion"), who was employed by Claudet as a colorist. Larue authored an early book on applying color tints to photographs in which he stated, "Some very beautiful effects may be produced by the

following method, which we will call compound colouring. Use one set of tints for one picture on the slide, and a different set of tints for the other; for instance suppose you are colouring a piece of drapery, in one picture use pink madder, and in the other a tint of blue; when viewed in the stereoscope it will appear a beautiful shot purple. This plan may be adopted with great advantage for skies, draperies, fruit, flowers, shells, &c."[5] The result was a remarkable, animated, and iridescent bicolor effect.

The impulse to simulate nature is stated even more explicitly by an unidentified writer, very likely Claudet himself: "Nothing could be more curious in physics than the perfect combination of stereoscope, phenakistoscope, and photography, with which it would be possible to produce the extraordinary phenomenon of moving figures, with the illusion of natural relief. An art that would be in a position to make objects appear to be *mobile sculptures* would be the most extraordinary and marvelous result that science could have ever created."[6]

Claudet was also a talented chemist who worked to improve upon the daguerreotype, which had been invented in France by Louis Daguerre (1787–1851) and was the first photographic process to become generally available.[7] Initially, daguerreotype portraiture was impractical because of the excessively long exposure times required. Claudet's contribution speeded up the process significantly and, in honor of his work, Claudet was elected to London's exclusive Royal Society, whose members numbered among the most influential scientists of the day. Founded in 1660 and originally named The Royal Society of London for Improving Natural Knowledge, it is the world's oldest scientific society. Isaac Newton was president of the society from 1703 until his death in 1727.

Announcing Daguerre's photographic process to the public fell to the astronomer François Jean Dominique Arago (1786–1853), who was head of the observatory in Paris and secretary of the French Academy of Science, an organization similar to the Royal Society. Arago's research into wave theory and the polarization of light depended to a large extent on the technical optics of the telescope, and he later used photography for photometry: astronomical measurements of light intensity.

Early on, Arago realized that photography would prove of great use to science and, in fact, he himself would very soon begin using the daguerreotype in his experiments. However, Arago's most important contribution to photography was that he masterminded the plan that launched this first photographic process within France and, from there, into the world at large. He effectively lobbied the French government to give pensions to Daguerre and Nicéphore Niépce's son, Isadore, in exchange for patent rights and technical information, so that the citizens of France could immediately begin taking photographs. To achieve this incredible coup, Arago maneuvered to block the announcement of an alternative photographic process invented by Hippolyte Bayard (1807–1887).

On hearing of the daguerreotype, Antoine Claudet travelled from London to Paris. There, according to film historian Laurent Mannoni, Claudet learned the process from Daguerre himself and then obtained the first license to produce daguerreotypes in England.[8]

Claudet was also among the first to experiment with simulated motion using photographically recorded source imagery. His patent #711,1853, "Improvements in Stereoscopes," described "a stereo viewer with movable parts to give the illusion of moving figures when used with specially made stereo daguerreotype slides." Claudet's 1865 articles about his experiments with persistence of vision included "On Moving Photographic Figures" and the delightfully tongue-twisting "On Stereoscopic Phenakistoscopy."

According to art historian Arthur Gill, Claudet's and Jules Duboscq's inventions, about which they exchanged information, were the first devices that used photography to make simulations of motion. It should be emphasized that these were both stereoscopic. From the moment these visionary individuals realized that they could combine photographic source material with the phenomenon of apparent motion, something shifted in the chronology of visual media. What previously had been an interesting perceptual phenomenon became a technology for the analysis of motion.[9]

The singular group of scientists who endorsed Claudet's entry into the Royal Society gives us a historical window on the group of individuals whose combined efforts gave birth to the still, moving, and dimensional photographic image. In this single document, the signatures on Claudet's certificate provide a panoramic overview of associations within this elite society of visual investigators of the 1830s. They exchanged information at scientific meetings, in publications, and in personal correspondence, as well as in gentlemen's clubs, particularly the Athenaeum, at the same moment that photography was introduced. Here we find the original league of extraordinary gentlemen who encountered photography not only as the art of fixing transience but also as one step in a series of visual media technologies that included stereoscopic depth vision and the work on apparent motion that Claudet described as the "persisting action of light on the retina."

Among the signatures on Claudet's certificate, we discover that of Michael Faraday (1791–1867), who nominated Claudet to the Royal Society. Faraday's remarkable accomplishments merit mention. His father was a blacksmith, and Faraday emerged from this modest background to serve a seven-year apprenticeship with a bookbinder and bookseller. During this time, he obtained tickets to a series of scientific lectures, including one given by the noted chemist Sir Humphrey Davy (1778–1829). Faraday later sent Davy three hundred pages of notes that he had compiled during the lecture series; soon thereafter, Davy hired Faraday as his personal secretary. Because of rigid class distinctions in British society during Faraday's era, it was nearly impossible for a working-class individual to acquire the education necessary to become a scientist. Despite his extremely limited formal education, by literally entering the discipline of science through the back door, Faraday went on to become one of the most important scientists of his age, making vast and unprecedented contributions to the field of electromagnetism in the age of steam, thus constructing a bridge to the age of electricity.

Faraday's connection to photography may be traced back to his association with Davy, who had authored the first paper about photography, summarizing the work of his friend

Certificate of a Candidate for Election
to the Royal Society—Antoine
Francois Jean Claudet (elected 1853).
Signees included J. F. W. Herschel,
David Brewster, Michael Faraday, H. F.
Talbot, Charles Wheatstone, Charles
Babbage, and others. The text reads
as follows: "The author of two Papers
in the Philosophical Transactions; the
first (1841) containing the discovery
of the accelerating effect of the
Chlorides of Bromine and Iodine in
the Daguerreotype process, by which
it became possible to take portraits
in a few seconds; and the second
(1847) on different properties of Solar
Radiation producing or preventing
the deposit of mercury on the silver
plate. Also of many Papers in the
Phil. Mag. and Communications
to the British Association upon
the Theory and principles of
Photography. The inventor of the
Focimeter, an instrument for
obtaining the true chemical focus
in the camera & avoiding distortion,
& of other instruments useful for
the scientific study of Light and
practice of Photography—" Image
© The Royal Society.

Thomas Wedgwood. As Davy's personal secretary, Faraday was aware of Wedgwood's work on the "agency of light upon nitrate of silver." His prior knowledge of the photographic process made Faraday the logical choice to announce Henry Talbot's photogenic drawing process in 1839, but it was with a peripheral investigation known as Faraday's Wheel (1831) in which he made a contribution that was central to our understanding of persistence of vision. In this area, Faraday expanded on the work of fellow Royal Society member Peter Mark Roget (1779–1869), who had described the appearance of frozen spokes on a moving carriage wheel (1825), an observation that initiated the first stroboscopic research into apparent motion. The cumulative research of Roget, Faraday, and another society member, Joseph Antoine Ferdinand Plateau (1801–1883), as well as Talbot to a lesser extent, leads directly to the invention of cinema.

It should come as no surprise that Henry Talbot also signed Claudet's certificate. In addition to Talbot's work on photography and apparent motion, he was the first to create a stereo photograph (albeit not a completely successful endeavor). It was Charles Wheatstone (1802–1875) who had requested that Talbot attempt such a venture. Wheatstone invented the stereoscope; he was both a scientist and Royal Society member as well as one of the inventors of the telegraph. In a letter to Talbot, he wrote that the angle of view (camera separation) in Talbot's photos was too extreme; additionally, because of the long exposure times required, the shadows moved significantly. To correct this jarring effect of binocular rivalry, Wheatstone suggested shooting the pair of images at the same hour but on two successive days.

Charles Wheatstone's work is the single most important contribution to our understanding of stereoscopic depth perception. The stereoscope was invented to demonstrate that the brain automatically computes depth from perspective planar projections with a horizontal parallax, landing on corresponding points on the retinas of each eye. Though Wheatstone himself could fuse stereoscopic drawings without the aid of the device, the instrument allowed others to see that two flat geometrical drawings on paper could be perceived stereoscopically. Wheatstone also endorsed Claudet's nomination to the Royal Society, and he specifically references Claudet in his first paper on the stereoscope, "Contributions to the physiology of vision—Part the first. On some remarkable, and hitherto unobserved, phenomenon of binocular vision."

At Wheatstone's request, fellow Londoner Claudet made the first stereoscopic daguerreotypes,[10] which were to receive unprecedented attention in 1851 at The Great Exhibition at the Crystal Palace—a celebration of technology, and the first major international exhibition and forerunner of all world's fairs. These photographs were striking, ultrasharp, hyperstereo compositions depicting the floor of the exhibition; the two photographs that make up a single stereographic picture were captured from a greater-than-normal interaxial separation, or what was then known as "the stereoscopic angle." The result was a new form of enhanced spatial vision that went beyond normal human vision by providing the sensation of stereoscopic volume at distances closer to optical infinity. Of enhanced stereoscopic separation, the renowned German physicist Hermann von Helmholtz (1821–1894) stated, "The person who views these [hyperstereo views] in the stereoscope, believes that he sees a reduced model of the landscape, the dimensions of which are to those of the landscape as the distance between the two eyes is to the distance between the two positions of the camera from which the views were taken."[11] Before the adoption of radar in marine vessels, hyperstereo devices were used to measure distances.

Sir David Brewster (1781–1868) was another signer of Claudet's certificate of fellowship into the Royal Society. Brewster invented the kaleidoscope (1817) and the first practical hand-held refracting stereoscope (1849). Lacking in sufficient foresight, British instrument makers were unconvinced of the potential popularity of the stereoscope, so Brewster travelled to France to meet with visionary Parisian instrument maker Louis

Jules Duboscq (1817–1886) and persuade him to produce a line of inexpensive, portable stereo viewers in time for the opening of the exhibition at the Crystal Palace. Concurrently, Antoine Claudet created his extraordinary hyperstereo architectural daguerreotypes. Claudet's images in these exquisitely designed devices captivated the attention of Queen Victoria and, virtually overnight, a new cultural medium was born. The immense popularity and demand for depth media created networks for the acquisition and distribution of photographic imagery worldwide. In meaningful ways, this was equivalent to the advent of television or the Internet.

The fact that stereoscopic depiction emerged immediately before photography again underlines the convergence of these mediums in the scientific community of the 1830s.[12] There was a desire to record the world in order to abstract it and learn something about it in a scientific way. Michael Faraday referred to this procedure as "varying of the modes of perception." In other words, in terms of the scientific method, it is extremely useful to look at a given subject in a variety of ways.[13]

Another signer of Claudet's certificate was Royal Society member Sir John F. W. Herschel, the astronomer who had announced Talbot's process to the general public in 1839, the same year astronomer François Arago had announced Daguerre's process. One wonders if there wasn't intended symbolism at play here, with the empirical optic of astronomy (the telescope) being seen as similar to the photographic eye. Particularly striking is Herschel's 1869 proposal, which he said was "like a dream" that was "most certainly possible," that stereoscopic photographs could be taken in rapid succession at one-tenth of a second to reconstruct the action normally seen with drawings in a phenakistoscope. And if these photographs were hand-tinted, the illusion and the model of reality would be complete.[14] Again we have a familiar combination of mediums used to model the world in a new way. Among Herschel's most significant contributions to photography are the cyanotype, the platinum print, and photographic fixer.

Long before Herschel announced Henry Talbot's negative-to-positive photographic process, Talbot had known about photography. In 1802, thirty-seven years before Daguerre's and Talbot's work was publicly announced, a description of Thomas Wedgwood's photographic research had been published in the *Journal of the Royal Institution* and served as a basic primer for all who followed. Written by Faraday's mentor, Humphrey Davy, it described the chemistry behind the exposure and gradual appearance of a photographic image on white paper, followed by gradual, and unavoidable, annihilation of the picture into blackened silver, because Wedgwood had been unable to halt the development process: "It speedily changes colour, and, after passing through different shades of grey and brown, becomes at length nearly black."[15] Talbot's prior knowledge of the photographic process is further evidenced by the fact that his colleague Charles Wheatstone had in his possession several original photographs on metal by Nicéphore Niépce, which Wheatstone had obtained when Niépce visited London in 1825. He had travelled to Britain with the intention of making a presentation to the Royal Society;

however, because Niépce refused to reveal his chemical procedure to the scientific community, he was never invited to present his findings.[16]

It is believed that Talbot began experimenting with photography in earnest in early 1834.[17] The most important distinction between the daguerreotype and Talbot's photogenic drawing process is that the former produced a monoprint and was therefore not mechanically reproducible, whereas Talbot's process was capable of producing multiple images from a single negative.[18] He corresponded regularly with Claudet and, together, they attempted to find a way to improve Talbot's photographic process and develop it into a commercial product. In Claudet's letters, it's clear that he brought a significant knowledge of photochemical engineering, since he had had previous experience improving the exposure times of Daguerre's process. Both men were fully cognizant that Talbot's calotype process had a far greater commercial potential than the daguerreotype, but problems with contrast and exposure time had to be solved first. Beyond this, we know that Talbot and Claudet were good friends as documented by the remarkable photographs made in Claudet's studio depicting the two men engaged in a game of chess. Playing chess was an ideal subject for the early photographers because there was little movement to contend with for the technically limited slow exposure process and, allegorically, it suggested substantial intelligence on the part of the sitters depicted in the very act of thinking.

It can't be overstated that Talbot did not discover the calotype by accident.[19] The problem that he chose to tackle at this specific moment in his career had already been carefully framed. By this time, he had refined his ability to abstract information, and he was fully aware of all photography-related innovations that had been made. Together, these accomplishments allowed him to solve the extremely difficult problem of fixing the photographic image on paper, when so many before had failed miserably.[20]

Immediately before he invented the workable negative-to-positive process known as the calotype, Talbot had conducted research into the physics of motion resulting in Talbot's law (1834), which suggests a direct connection to persistence of vision. Helmholtz stated this law as follows: "If any part of the retina is excited with intermittent light, recurring periodically and regularly in the same way, and if the period is sufficiently short, a continuous impression will result."[21]

The relationship of Talbot's work to other work on apparent motion is evident. Talbot's law followed Charles Wheatstone's work on apparent motion in 1833 and the work of Plateau, Faraday, and Roget. Talbot did this work about motion immediately prior to his honeymoon excursion to Lake Como where, as the story goes, despite the aid of Dr. Wollaston's camera lucida, he was frustrated by his inability to draw and therefore resolved to invent his own method to fix the image seen in a camera obscura. Later, after publishing his initial work on photography, he returned to his research on the physics of perceived movement and his experiments with his rotating-disk photometer and studied luminous bodies in motion observed stroboscopically with the aid of a rotating mirror.[22]

These experiments combining light and time came to fruition in 1851, when Talbot, in collaboration with Michael Faraday, managed to capture the first instantaneous photographic image with the aid of one of Faraday's electric motors. The experiment is the first significant example of an object in motion being frozen by a photographic process with the aid of high-speed strobic photography.[23] This milestone was accomplished using the illumination of an electrical spark that was generated with a Leyden jar in Faraday's lab. In this experiment, Talbot photographed and was able to resolve the message written on a piece of paper, which was attached to a spinning wheel. Unfortunately that text is now a mystery. From Talbot's correspondence, we know only that it was a "paper covered with printed characters." Talbot described this experiment as "fixing transience." Conquering the problem of instantaneous photography is an undeniably important early step toward recording movement photographically, because a series of instantaneous photographs are needed in order to produce a motion picture. But it was electromagnetism itself, in the form of a spark of light, with the rotation of a motor that yielded this repeatable result.

·　　　·　　　·

At photography's inception, Wedgwood's prescient preoccupation with time, space, and movement set the stage for new forms of visual media to emerge. The certificate making official Antoine Claudet's entrance into the Royal Society offers a unique optic through which we can scrutinize a second phase, comprising specific collaborative influences and exchanges among this network of remarkable scientists and individuals who were active in the invention not only of photography but also of stereoscopic depth media and moving pictures as well.

Herschel's "multimedia" dream imagined photography as something that would be combined with the elements of color, stereoscopic depth, and motion to produce sensory models of the world out of abstracted information. In a well-known essay entitled "The Myth of Total Cinema,"[24] André Bazin argued that the concept of a total sensory cinema did not proceed from the scientific community but rather from a dedicated class of single-minded fanatics he describes as "inventors." In contrast, other experts such as Geoffrey Batchen and Virgilio Tosi identify the invention of photographic visual media with the desire to collect visual data for scientific research. But the evidence of Herschel's dream suggests that both scenarios—a vision of "total cinema" and the desire to develop new tools for collecting scientific evidence—coincided with the first generation of the founders of photographic visual media.

Of this constellation of Royal Society members in the early and mid-nineteenth century, the scientists Michael Faraday and Charles Babbage (both signers of Claudet's certificate) most profoundly connect with our own time. Faraday's work on cathode rays leads directly to quantum mechanics, and his work on electromagnetism made it possible to anticipate light fields, leading ultimately to plenoptic cameras with computational multiperspective viewpoints. Babbage, of course, is the progenitor of computer

science and his invention, the difference engine, was the first programmable computer. Between computation and the light-field model, these two scientists were instrumental in laying the foundation of the computational photographic form.

Responding to differing social and economic stimuli, the visual media that emerged from the conceptual and theoretical convergence of the 1830s resolved into the separate mediums of photography, stereoscopic imaging, and cinema. But after the historical period that we identify as analog media, the technological convergence that can be described as digital media emerged and, now, all forms of recorded information are unified.

1802 Thomas Wedgwood makes the first photographs but is unable to fix the image. And the *Journal of the Royal Institution* publishes "An Account of a Method of Copying Paintings upon Glass, and of Making Profiles, by the Agency of Light upon Nitrate of Silver. Invented by T. Wedgwood, Esq." The paper is written by the chemist Sir Humphrey Davy.

1815 David Brewster invents the kaleidoscope.

1821 Michael Faraday begins making his spectacular contributions to electromagnetism by inventing an early prototype of the electric motor.

1822 Nicéphore Niépce creates the first photographic image (not extant).

1822 Charles Babbage works on the difference engine. Later he will work on a series of designs known as the Analytical Engine, for which Ada Lovelace creates the first computer program. Babbage is a member of the Royal Society and is photographed by Talbot, Claudet, and others.

1825 Niépce visits London and shows examples of his photographic prints on metal to various members of the British scientific community.

1826–27 Niépce creates the earliest extant photograph, *View from the Window at Gras*.

1827 Charles Wheatstone introduces the kaleidophone, a device that connects sound and vision.

1828 Wheatstone invents the musical instrument called the concertina. He also invents a portable harmonium.

1829 Peter Mark Roget describes an illusion related to apparent motion.

1831 Michael Faraday publishes *On a Peculiar Class of Optical Deceptions*, a work with scientifically repeatable experiments on apparent motion (Faraday's wheel).

1832 Joseph Plateau's work on apparent motion leads him to invent the phenakistoscope.

1833 Separately, Wheatstone and Talbot research apparent motion.

1834 Talbot makes his contribution to calculus (Talbot's law) and begins his experiments in photography.

1835 Wheatstone lectures on the electric telegraph, of which he was one of the key inventors.

1838 Wheatstone describes stereopsis and invents the first stereoscope. He creates stereoscopic drawings to be seen with this instrument.

1838 Michael Faraday discovers cathode rays, a first step in the history of quantum mechanics.

1839 François Arago persuades Hippolyte Bayard to postpone announcing his direct positive process. Soon thereafter, Arago announces the daguerreotype in Paris.

1839 Sir John Herschel announces Henry Talbot's invention of negative-to-positive printing.

1839 Bayard opens the first photography exhibition, on June 24.

1839 Talbot publishes "Some Account of the Art of Photogenic Drawing, or the Process by which Natural Objects may be made to delineate themselves without the aid of the Artist's Pencil" in the *Athenaeum,* February 9.

1839–40s Herschel makes valuable contributions to photography, including photographic fixer, the platinum process, and the cyanotype. He is credited as one of the first to use the terms *negative* and *positive* and introduces the term *photography* into popular usage.

1840 Wheatstone introduces the chronoscope, a sophisticated electromagnetic, scientific time-measuring instrument that could, among other things, measure the speed of a bullet and render "evanescent portions of duration visible." Using an electric spark, Wheatstone captures the motion of dripping water.

1841 Henry Talbot and Henry Collen make the first stereoscopic photographs.

1841 Talbot patents the paper negative process called the calotype.

1846 Michael Faraday, in his lecture "Thoughts on Ray Vibrations," is the first to speculate on the existence of the light field, a concept parallel to the electromagnetic field. This idea is the basis for what we now refer to as plenoptic or light-field photography, a hot topic in computational photography.

1851 The Great Exhibition in the Crystal Palace opens with stereo daguerreotypes of the interior by Antoine Claudet. David Brewster's handheld stereopticon (1849) constructed by the Parisian instrument-maker Jules Duboscq makes viewing stereographs more practical. Queen Victoria discovers the stereograph at the exhibition, propelling the genre into the popular culture.

1851 Talbot, working with Faraday, captures the first truly instantaneous photograph using an electrical spark to illuminate writing on a piece of paper revolving on a wheel. Talbot refers to this as "fixing transience."

1853 Antoine Claudet, scientist, businessman, and the first professional photog-

rapher working in England, was elected to the Royal Society for improving the daguerreotype process using chemical engineering. He published many articles about photography and was among the first to argue that photography was a fine art. He learned the daguerreotype process directly from Daguerre and the calotype process from Henry Talbot.

1857 David Brewster publishes "The Stereoscope" in the *Athenaeum*.

1865 Antoine Claudet publishes "On Stereoscopic Phenakistoscopy," his findings from his experiments several years earlier on photographic simulations of motion based on stereographic phenomenon.

It only means that there will be a new form; and that this form will be of such a type that it admits the chaos and does not try to say that the chaos is really something else. The form and the chaos remain separate. The latter is not reduced to the former. That is why the form itself becomes a preoccupation, because it exists as a problem separate from the material it accommodates. To find a form that accommodates the mess, that is the task of the artist now.

Samuel Beckett (interviewed by Tom F. Driver), 1961

7

A LITTLE HISTORY OF PHOTOGRAPHY CRITICISM; OR, WHY DO PHOTOGRAPHY CRITICS HATE PHOTOGRAPHY?
2010

Susie Linfield

Linfield reminds us that all judgments, even those from the most astute critics, are historically grounded, and asks us to look with fresh eyes at the images that surround us.

In 1846, Charles Baudelaire wrote a short essay called "What Is the Good of Criticism?" This is something that virtually every critic asks herself at some point, and that many have had trouble answering; it has been known to evoke hopelessness, despair, even self-loathing. Baudelaire didn't think that criticism would save the world, but he didn't think it was a worthless pursuit, either. For Baudelaire, criticism was the synthesis of thought and feeling: in criticism, he wrote, "passion . . . raises reason to new heights,"[1] and he urged his fellow critics to eschew antiseptic writing that "deliberately rids itself of any trace of feeling."[2] A few years later he returned to the subject, explaining that through criticism he sought "to transform my pleasure into knowledge": a pithy, excellent description of what criticism should be.[3] Baudelaire's American contemporary, Margaret Fuller, held similar views: she urged her colleagues to reject dogma—"external consistency," she called it—in favor of "genuine emotion."[4] The critic, she wrote, should create an I-thou relationship between herself and her readers and guide them "to love wisely what we before loved well."[5]

By "pleasure" and "love" Baudelaire and Fuller didn't mean that critics should write only about things that make them happy or that they can praise. What they meant is that the critic's emotional connection to an artist, or to a work of art, or to a genre, is the sine qua non, the ground zero, of criticism. Who can doubt that Edmund Wilson loved literature and that, to him, it simply mattered more than most other things in life? Who can doubt that Pauline Kael found the world most challenging, most meaningful, most vivid when she sat in a dark movie theater, or that Kenneth Tynan felt the same way at a

play? This same sort of intuitive connection was at the heart of James Agee's approach to writing about the movies. Introducing himself to the readers of the *Nation* in 1942, he wrote that he had been lovingly immersed in movies since childhood and yet—just like his readers—was "an amateur" who knew little about them; he must, therefore, "simultaneously recognize my own ignorance and feel no apology for what my eyes tell me as I watch any given screen."[6] A similar emotional affinity led a young woman named Arlene Croce, who knew nothing about dance, to begin writing criticism after a life-changing evening at the New York City Ballet in 1957; that performance, she said, "made an addict out of me."[7] Croce, who developed an uncannily astute understanding of Balanchine's modernism, would go on to become the best dance critic of the twentieth century. "All I can tell you is, dance is the thing that hit me the hardest," she explained.[8]

For these critics and others—those I would consider at the center of the modern tradition—cultivating this sense of lived experience was at the heart of writing good criticism. Their starting point was, always, their subjective, immediate experience, which meant that they had to be honest with themselves. Randall Jarrell wrote that "criticism demands of the critic a terrible nakedness . . . All he has to go by, finally, is his own response, the self that makes and is made up of such responses."[9] Alfred Kazin agreed; the critic's skill, he argued, "begins by noticing his intuitive reactions and building up from them; he responds to the matter in hand with perception at the pitch of passion."[10] For such critics, emotional reactions and critical faculties weren't synonymous, but they weren't opposites, either. These critics sought, and achieved, a fertile dialectic between ideas and emotions: they were able to think and feel at the same time, or at least within the same essay.

The great exception to this approach is photography criticism. There, you will hear precious little talk of love, or terrible nakedness, or passion's pitch. There, critics view emotional responses—if they have any—not as something to be experienced and understood but, rather, as an enemy to be vigilantly guarded against. For these writers, criticism is a prophylactic against the virus of sentiment, and pleasure is denounced as self-indulgent. They approach photography—not particular photographs, or particular photographers, or particular genres, but photography itself with suspicion, mistrust, anger, and fear. Rather than enter into what Kazin called a "community of interest" with their chosen subject, these critics come armed to the teeth against it.[11] For them, photography is a powerful, duplicitous force to defang rather than an experience to embrace and engage. It's hard to resist the thought that a very large number of photography critics—including the most influential ones—don't really like photographs, or the act of looking at them, at all.

Susan Sontag's *On Photography* was published in 1977, though the individual essays that comprise the book began appearing, and making an impact, in 1973. The book remains astonishingly incisive, and has been immensely influential on the thinking of other photography critics—and immensely influential, too, in setting a certain tone of photography criticism. Look, for instance, at Sontag's description of photography in

the book's first chapter, which establishes a voice, an attitude, and an approach, all of which she maintains throughout. Sontag describes photography as "grandiose," "treacherous," "imperial," "voyeuristic," "predatory," "addictive," and "reductive."[12] Photographs, we learn, simultaneously embody "seductiveness" and "didacticism," "passivity" and "aggression."[13] Sontag's coolness is unfaltering, as is her unfriendliness: photographs are described as "a sublimated murder—a soft murder" and as "the most irresistible form of mental pollution."[14] A typical Sontag sentence reads, "The camera doesn't rape, or even possess, though it may presume, intrude, trespass, distort, exploit, and, at the farthest reach of metaphor, assassinate—all activities that, unlike the sexual push and shove, can be conducted from a distance, and with some detachment."[15] Metaphor indeed!

Three years later came Roland Barthes's *Camera Lucida*. This book, delicate and playful, is a love letter to the photograph (and to Barthes's dead mother). Barthes celebrates the quirky, spontaneous reactions that photographs can inspire—or at least the quirky, spontaneous reactions they inspire in him: "A photograph's *punctum* is that accident which pricks me (but also bruises me, is poignant to me)."[16] Still, *Camera Lucida* is a very odd valentine, and it shares an intellectual approach, if not a literary style, with Sontag. Barthes describes photographers as "agents of Death" and the photograph as "flat," "platitudinous," "stupid," "without culture," a "catastrophe," and—the cruelest cut—"undialectical."[17] The photograph "teaches me nothing," Barthes insists, for it "completely de-realizes the human world of conflicts and desires."[18]

Continuing this tradition of photography criticism is John Berger, the most morally cogent and emotionally perceptive critic that photography has produced. "My first interest in photography was passionate," Berger has written; and when you read his work, you know this is so.[19] (As a young man, Berger dreamed of composing a book of love poems illustrated with photographs.) Berger has frequently included photographs in his books. More important, he has argued that photographs represent an "opposition to history" by which ordinary people affirm the subjective experiences that modernity, science, and industrial capitalism have done so much to crush: "And so, hundreds of millions of photographs, fragile images, often carried next to the heart or placed by the side of the bed, are used to refer to that which historical time has no right to destroy."[20] Like Sontag, Berger is acutely aware of the central place that photography occupies in modern life; unlike Sontag, he respects the prosaic yet meaningful ways in which people throughout the world use photographs.

Yet in Berger's canonical essays he, too, took a decidedly dark view of photography, and he was especially critical of photographs that document political violence. Such images, he insisted, were at best useless and at worst narcissistic, leading the viewer to a sense of self-conscious helplessness rather than to enlightenment, outrage, or action. Thinking about photographs by Don McCullin of the then-ongoing Vietnam War, Berger observed that "McCullin's most typical photographs record sudden moments of agony—a terror, a wounding, a death, a cry of grief."[21] He continued, "These moments are in reality utterly discontinuous with normal time. . . . But the reader who has been

arrested by the photograph may tend to feel this discontinuity as his own personal moral inadequacy. *And as soon as this happens even his sense of shock is dispersed:* his own moral inadequacy may now shock him as much as the crimes being committed in the war. . . . The issue of the war which has caused that moment is effectively depoliticized."[22]

More generally, drawing on a metaphor clearly derived from the atomic bomb, Berger described the photograph—all photographs—as a "fission whereby appearances are separated by the camera from their function."[23] Yet the particular instance of the Vietnam War that Berger cited undermines rather than supports his thesis. Photographs of that conflict—such as the one taken by Eddie Adams of a street-side execution or by Nick Ut of a naked, napalmed girl—didn't foster feelings of moral inadequacy. (Neither did McCullin's.) On the contrary, they mobilized political opposition to the war.

Barthes, too, held no brief for photographs of violence. Writing about an exhibit of "Shock-Photos" in Paris, Barthes argued that "most of the photographs exhibited to shock us have no effect at all."[24] Such images are too finished, too complete—"overconstructed" is Barthes's word.[25] As such, they deprive us of our freedom of response: "We are in each case dispossessed of our judgment: someone has shuddered for us, reflected for us, judged for us; the photographer has left us nothing."[26] (Walter Benjamin, as we'll see, also feared that photography impairs independent judgment.)

Sontag's objections went further. Because photographs present us with scenes of catastrophe but can do nothing to explain their histories or causes, she was highly skeptical of the photograph's ability to be either politically or ethically potent; photographs, she argued, present archetypical abstractions, whereas "moral feelings are embedded in history, whose personae are concrete, whose situations are always specific."[27] And she insisted—an insistence that has now become the conventional wisdom—that the cumulative effect of such photographs is to create a society of moral dullards: "The shock of photographed atrocities wears off with repeated viewings. . . . In these last decades, 'concerned' photography has done at least as much to deaden conscience as to arouse it."[28]

Starting in the mid-1970s, the postmodern and poststructuralist children of Sontag, Berger, and Barthes transformed their predecessors' skepticism about the photograph into outright venom; in an influential essay written in 1981, for instance, Allan Sekula decried photography as "primitive, infantile, aggressive."[29] Indeed, for the postmoderns, a relentless hostility to modernist photography—and to any belief in the photographer's authenticity, creativity, or unique subjectivity—was an ethical stance, though I see it as more of a pathological one. At the same time, the postmoderns were attracted to photography precisely because they saw the medium—with its infinite capacity for mechanical reproduction—as the worm in the modernist apple. In assaulting photography, the postmoderns hoped to undermine modernist "claims to originality, showing those claims for the fiction they are," as Douglas Crimp wrote; the aim, he continued, was "to use the apparent veracity of photography against itself" and to expose "the supposed autonomous and unitary self" as "nothing other than a discontinuous series of representations, copies, fakes."[30]

These critics weren't really alive to photographs per se, much less to the world they reveal; what attracted them to photography—especially the postmodern photography of appropriation—was, as Rosalind Krauss wrote, "photography's travesty of the ideas of originality, or subjective expressiveness, or formal singularity," its ability to "undermine the very distinction between original and copy," and its "refusal to understand the artist as a source of originality." The assault on photography was, in short, a servant to the larger postmodern "project of deconstruction in which art is distanced and separated from itself."[31] To attack photography, especially high-modern and documentary photography, was to storm the bastions of modernism itself.[32]

In the view of the postmoderns, one of photography's original sins was its supposedly supine relationship to capitalism. In particular, photography's admittedly maddening (and obviously false) claims to objective truths—truths divorced from class and culture—made it a particularly dangerous ideological tool that could hinder critical thinking about the prevailing class system. The postmodern refusal of the fiction of objectivity—and of its close cousin, neutrality—was a genuine intellectual accomplishment.

But whereas Sontag had written that advanced industrial capitalism requires a ceaseless production of images, the critics who followed her were far more reductive. For the postmoderns, photographs were not just an integral part of capitalism but its obedient slave. Abigail Solomon-Godeau, for instance, charged that the documentary photograph commits a "double act of subjugation" in which the hapless subject is victimized first by oppressive social forces, then by the "regime of the image."[33] John Tagg went further, describing photography as "ultimately a function of the state" that is deeply implicated in the ruling class's "apparatus of ideological control" and its "reproduction of . . . submissive labour power"; he added, in a particularly inapt metaphor, that photography is a "mode of production . . . consuming the world of sight as its raw material."[34] Martha Rosler proclaimed that "imperialism breeds an imperialist sensibility in all phases of cultural life"; and photographs, it turned out, were the most imperialist of all.[35]

Photographers are usually drawn to, and excited by, the new. In contrast, a deep sense of fatigue permeated postmodern photography and the criticism that praised it. In 1986, the critic Andy Grundberg observed that postmodern photography "implies the exhaustion of the image universe: it suggests that a photographer can find more than enough images already existing in the world without the bother of making new ones."[36] Fredric Jameson described this enervated worldview: "In a world in which stylistic innovation is no longer possible, all that is left is to imitate dead styles. . . . Contemporary or postmodernist art . . . will involve the necessary failure of art and the aesthetic, the failure of the new, the imprisonment in the past."[37] Postmodern criticism and photography became notable for embodying, indeed celebrating, this sense of weary repetition; as the artist Richard Prince wrote, the way to make it new was to *make it again*."[38]

The postmoderns declared war on the formalism of high-modernist critics like John Szarkowski who, they charged, isolated photography from its social and political context.

(They reviled Szarkowski as a cold mandarin, yet failed to notice that he wrote about photographs with more empathy and insight than they.)[39] But they were equally hostile to documentary photography that rooted itself in the social and political. Sneering at liberal, socially conscious photojournalists who clung to old-fashioned ideas such as progress and truth became common, if not mandatory; Rosler, for instance, charged that the "liberal documentary assuages any stirrings of conscience in its viewers the way scratching relieves an itch. . . . Documentary is a little like horror movies, putting a face on fear and transforming threat into fantasy."[40] Similarly, Sekula assailed the photographer Paul Strand's belief in "human values," "social ideals," "decency," and "truth" as "the enemy"—a statement that, I admit, I have always found shocking.[41]

The depiction of powerless, vulnerable people is a fraught enterprise that can easily veer into condescension. But from these critics it evoked a tsunami of too-easy scorn. Carol Squiers dismissed photojournalism's depictions of suffering as the "tableaux of profound abjection."[42] Rosler, in a rising tide of fury against social documentarians, castigated images of "pathetic, helpless, dispirited victimhood," "victims-turned-freaks," "the marginal and pathetic"—enough! She went on to describe contemporary photojournalism as "the petted darling of the moneyed, a shiver-provoking, slyly decadent, lip-smacking appreciation of alien vitality."[43] There are, I suppose, some documentary photographs that fit this description; but it's odd that Rosler and her colleagues ignored the challenging work then being done by, among others, Gilles Peress and Abbas (in Iran), Susan Meiselas (in Nicaragua), David Goldblatt (in South Africa), Eugene Richards (in the United States), and Don McCullin (everywhere). One could react in various ways to their difficult, unsettling photographs, but it is doubtful that their images relieved any itches or provoked an epidemic of smacked lips.

It is no accident that many of the postmodern critics were women: the fear of sentimentality is particularly potent for female intellectuals, especially those who address a primarily leftwing audience and who write about popular rather than high culture.[44] (Pauline Kael was an invigorating exception: she could write about movies with girlish enthusiasm without losing her edge or seeming too girlish.) Along with this anxiety—this fear of frivolity—comes the mistaken idea that chronic negativity equals fearless intelligence. Mary McCarthy, looking back on her days as the theater critic for *Partisan Review,* addressed the problem: "Aesthetic puritanism . . . has, like all puritanism, a tendency to hypocrisy—based on a denial of one's own natural tastes and instincts. I remember how uneasy I felt when I found myself liking Thornton Wilder's *Our Town;* I was almost afraid to praise it in the magazine, lest the boys conclude that I was starting to sell out."[45]

Far worse than the postmoderns' rigid negativity, though, was their utter denial of freedom. They insisted that even a scintilla of autonomy, for either photographer or viewer, was impossible; insisted, that is, that the photographer could never offer, and the viewer could never find, a moment of surprise, originality, or insight when looking at a photograph. To invest a photograph with meaning is always a sad delusion: "The

wholeness, coherence, identity, which we attribute to the depicted scene is a projection, a refusal of an impoverished reality in favour of an imaginary plenitude," Victor Burgin wrote.[46] In the view of these critics, it is impossible to see the world anew, for we are all helpless, brainwashed insects caught in capitalism's ideological web—which is spun, apparently, of unbreakable iron. Indeed, Burgin condemned the activity of looking itself—an odd stance, one would think, for a photography critic: "Our conviction that we are free to choose what we make of a photograph hides the complicity to which we are recruited in the very act of *looking*."[47] Photography, he claimed, can offer only a grim Sophie's choice between "narcissistic identification" and "voyeurism."[48] In short, the postmodern critics viewed photography as a generally nasty business—the photograph is a prison, the act of looking, a crime—which may be why reading their work often feels like trudging through mud.

There are fine contemporary photography critics who have rejected the congenital animus of the postmoderns—I think particularly of Max Kozloff, who began writing regularly in the early 1960s, and of younger critics like Rebecca Solnit, David Levi Strauss, and Geoff Dyer, who have responded to the postmodern critique without succumbing to it. Indeed, it may seem as though the "corrosive, hermeneutic irony about pictures" fostered by postmodernism is no longer in fashion.[49] But if fewer essays like Sekula's and Rosler's are written now, it is in part because their ideas have been absorbed and accepted by so many in the academy, the art journals, the museums, and the galleries; as theorist W. J. T. Mitchell has written, "reflexive critical iconoclasm . . . governs intellectual discourse today."[50] Thus, in more recent publications, one bumps up against casual phrases like "the now-discredited authenticity once attributed to photography," as if the question of photography's truth-value has been tossed without regret into the dustbin of history.[51] Even worse are the ways that these ideas have seeped into the general public, encouraging a careless contempt toward documentary photographs. Since such images are cesspools of manipulation and exploitation: why look? It has become all too easy to avert one's eyes; indeed, to do so is considered a virtue.

It is interesting to compare all this—the postmoderns' obsession with victimization, their refusal of freedom, their congenital crabbiness—to the opening pages of Pauline Kael's essay "Trash, Art, and the Movies," written in 1969. Kael, too, set a certain tone, both for her readers and other critics. Here it is:

> A good movie can take you out of your dull funk and the hopelessness that so often goes with slipping into a theatre; a good movie can make you feel alive again . . . make you care, make you believe in possibilities again. . . . The movie doesn't have to be great; it can be stupid and empty and you can still have the joy of a good performance, or the joy in just a good line. An actor's scowl, a small subversive gesture, a dirty remark that someone tosses off with a mock-innocent face, and the world makes a little bit of sense.[52]

If *On Photography* was written by a brilliant skeptic, "Trash, Art, and the Movies" is the work of a smitten lover. And what Kael showed is that the lover can see just as clearly, and be just as smart, as the skeptic.

Kael had two great insights in "Trash, Art, and the Movies." One was that trash, far from contaminating judgment, can help the viewer develop an autonomous aesthetic that will lead her to art. Second, she argued that the only truly capacious, truly mature way to experience movies is to combine our deepest emotional reactions, which should never be disowned, with a probing analysis of them. She did not, as some have mistakenly thought, champion unadulterated emotion or unexamined fandom; on the contrary, she insisted that the viewer who approaches movies in such unthinking ways "does not respond more freely but less freely and less fully than the person . . . who uses all his senses in reacting, not just his emotional vulnerabilities."[53] Kael urged her readers to reclaim their emotions as a key part of their aesthetic, intellectual, and moral lives: feeling could enhance rather than undermine critical thinking.

Yet this, after all, is the same insight that Baudelaire had when he wrote of seeking "the why of his pleasure"; it was the view of Randall Jarrell when he explained that the good critic combines the "sense of fact" with the "personal truth";[54] it was what Alfred Kazin meant when he claimed that "the unity of thinking and feeling actually exists in the passionate operation of the critic's intelligence."[55] This quest for the synthesis of thought and feeling—and the essentially comradely, or at least open, approach to art that it suggests—was the central project for generations of critics, especially American critics in the twentieth century. Yet it is just this project that photography critics reject. The question is: why?

Photography is a modern invention: one that, from its inception, inspired a host of conflicts and anxieties in participants, critics, and onlookers. Indeed, when we talk about photography we are talking about modernity; the doubts that photography inspires are the doubts that modernity inspires. Photography is a proxy for modern life and its discontents, which may explain some of the high expectations, bitter disappointments, and pure vitriol it has engendered.

From the first, the essential nature of photography was puzzling. It tended to blur categories—which can be exciting, unsettling, or both. Was photography a form of art? of commerce? of journalism? of surveillance? Was it a form of science, or of magic? Was it an expression of creativity, or was its relation to reality mimetic, or even that of a parasite?

One thing was clear: photography was the great democratic medium; Ralph Waldo Emerson called it "the true republican style of painting."[56] And it was viewed, from the first, as a social medium: in 1839, the French Chamber of Deputies declared that Louis Daguerre's new invention should not be privately patented but, instead, belonged to the French people and to the world. In doing so, France "hoped to turn photography itself into a symbol of democratization," the critic Ariella Azoulay has observed. "Photography

had been presented as a gift given to the nation, a blessing bestowed on it, and a right granted to it."[57]

But such newness, and such egalitarian newness, could stir intense anxieties—even in a great modernist like Baudelaire. He hated photography for many reasons, including its general availability and its great popularity. "In these deplorable times," he warned in 1859, "a new industry has developed," one supported by the ignorant mob.[58] Like an Old Testament prophet, he railed, "Our loathsome society rushed, like Narcissus, to contemplate its trivial image on the metallic plate. A form of lunacy, an extraordinary fanaticism, took hold of these new sun-worshippers. Strange abominations manifested themselves."[59]

Baudelaire feared that photography's superior ability to capture reality would destroy painting, for "it is simple common-sense that, when industry erupts into the sphere of art, it becomes the latter's mortal enemy."[60] He continued, "Poetry and progress are two ambitious men that hate each other, with an instinctive hatred. . . . More and more, as each day goes by, art is losing in self-respect, is prostrating itself before external reality, and the painter is becoming more and more inclined to paint, not what he dreams, but what he sees."[61]

Not what he dreams, but what he sees: this is a powerful condemnation of mechanical reproduction, and might give pause to even the most ardent photographer (or critic). And though Baudelaire knew that it would be useless to call for the abolition of photography, he demanded—equally uselessly, of course—that photography confine itself strictly to factual documentation: "Let it adorn the library of the naturalist, magnify microscopic insects, even strengthen, with a few facts, the hypotheses of the astronomer."[62] Art should be left to the artists, a category that definitely did not include the camera-wielding masses.

Flaubert, too, noted the antagonism between the new form of photography and the established art of painting. In his last novel, *Bouvard and Pécuchet,* he included a "Dictionary of Accepted Ideas" in which the entry for "Photography" simply read: "Will dethrone painting."[63] George Bernard Shaw also predicted that photography would defeat art. But Shaw welcomed painting's demise as a liberation rather than feared it as the revenge of the philistines. Indeed, when it comes to photography, we might think of Shaw as the anti-Baudelaire. Writing in 1901, Shaw derided what he saw as the fussy mannerism of painting, with its "old barbarous smudging and soaking, . . . faking and forging."[64] He loved the modern, truthful clarity of the photograph, and he heralded its triumph: "The old game is up. . . . The camera has hopelessly beaten the pencil and paint-brush as an instrument of artistic representation . . . As to the painters and their fanciers, I snort defiance at them; their day of daubs is over."[65] Shaw reportedly claimed, "I would willingly exchange every painting of Christ for one snapshot!"—a statement that, not surprisingly, has endeared him to contemporary photojournalists.[66]

Almost as soon as photography was invented, it became clear that every butcher and baker—at least in the industrialized countries like England, Germany, France, and the

United States—would be able to purchase photographic reproductions; "even the poor can possess themselves of tolerable likenesses of their absent dear ones," the Scottish writer Jane Welsh Carlyle noted in 1859.[67] They could make pictures, too: "Daguerreotype calls for no manipulation which anyone cannot perform," the physicist Dominique François Arago explained to the French Chamber of Deputies. "It presumes no knowledge of the art of drawing and demands no special dexterity."[68] Photo taking, it turned out, was available not just to the butcher and baker but to the governess and schoolteacher. Indeed, photography was one of the few activities in which nineteenth-century women and men could partake on a quasi-equal basis; as Daguerre himself wrote, "The little work it entails will greatly please ladies."[69] The interest in photography spanned classes, too; photography "has become a household word and a household want," Lady Elizabeth Eastlake observed in 1857, and "is found in the most sumptuous saloon, and in the dingiest attic . . . in the pocket of the detective, in the cell of the convict."[70] There are few inventions that have been adopted for so many uses by so many kinds of people so quickly.

More startling than the fact that ordinary people could take photographs was the discovery that ordinary people could take good photographs; this is one of several things that, from the start, has set photography apart from other disciplines. Most people, after all, can't paint a wonderful painting or write a wonderful play. But lots of ordinary people—with no training, no experience, no education, no knowledge—have taken wonderful photographs: better, sometimes, than those of photography's recognized masters. (This is what Sontag meant, I think, when she wrote of the "disconcerting ease with which photographs can be taken.")[71] Yet this, too—and the leveling tendencies it implies—is troubling. For where such egalitarianism dwells, can the razing of all distinctions be far behind? Who can admire an activity, much less an art, that so many uneducated, untrained people can do so well? Photography's democratic promise has always been photography's demotic threat.

Then, too, photography evokes our ambivalence about technology. Unlike painting, writing, dancing, music making, and storytelling, photography began not thousands of years ago with innocent, primitive man but less than two hundred years ago with compromised, modern man. And unlike other forms of expression, photography depends on a machine and a chemical process. Photography, in short, is an impure, "disconcerting" art (or craft), and we have approached it with that contradictory mixture of expectation and distrust, of glorious hope and tremendous gloom, with which we have approached the machine age itself. Photography is the perfect receptor for both techno-utopianism and technophobia; perhaps inevitably, then, photography criticism has encompassed optimism, disappointment, ambivalence, and contempt.

Yet there is something else, something beyond all this, at the heart of photography criticism's peculiar hostility to its subject. Most twentieth-century photography critics—Sontag, Berger, Barthes, and the postmodernists and poststructuralists—were heavily influenced by the melancholy writers of the Frankfurt School, especially Sieg-

fried Kracauer and Walter Benjamin and, through him, Bertolt Brecht, who was Benjamin's friend and comrade. These men, who were living in the increasingly dark shadow of an increasingly dark Europe, did not write mainly about photography (though Kracauer was a film critic and, later, theorist). But what they did write has been treated by contemporary critics not just with intellectual respect, which is fitting, but with a kind of fundamentalist reverence, which is not.

Though Benjamin was in some ways highly critical of the photographic enterprise, it would be false to say that he disliked photographs. On the contrary: as a dialectician, he believed that the photograph held out liberating, indeed revolutionary, possibilities. In his essay "Little History of Photography," originally published in 1931, Benjamin argued that photography had created a "new way of seeing," one that brought masses of ordinary people closer to the world and would enable them "to achieve control over works of art."[72] Several years later, in his now enormously influential "The Work of Art in the Age of Mechanical Reproduction," he wrote of the ways in which film and photography contributed to the smashing of tradition: "Mechanical reproduction emancipates the work of art from its parasitical dependence on ritual. . . . Instead of being based on ritual, it begins to be based on another practice—politics."[73] For Benjamin, photography was part of the desacralization of the world, which is to say part of the painful but necessary task of modernity.[74]

This new way of seeing could be a kind of truth serum. The photographer Eugène Atget, who "set about removing the makeup from reality,"[75] inspired in Benjamin some of his most appreciative, and most beautiful, writing: "He was the first to disinfect the stifling atmosphere generated by conventional portrait photography in the age of decline. He cleanses this atmosphere—indeed, he dispels it altogether. . . . And thus such pictures . . . suck the aura out of reality like water from a sinking ship."[76]

Equally important, Benjamin understood the subjective power of the photograph—its spooky ability to make us want to enter the world it depicts and even, sometimes, change it. Indeed, it is this potential spur to identification and action that so distinguishes photography from painting. For Benjamin, the photograph wasn't a fixed, dead thing. On the contrary, it could embrace past, present, and future: the photograph was a document of history and possibility. Looking at a nineteenth-century daguerreotype of a man and his fiancée (she would later commit suicide), Benjamin praised the photograph's "magical value, such as a painted picture can never again have for us."[77] He mused, "The beholder feels an irresistible urge to search such a picture for the tiny spark of contingency, of the here and now, with which reality has (so to speak) seared the subject, to find the inconspicuous spot where in the immediacy of that long forgotten moment the future nests so eloquently that we, looking back, may rediscover it."[78]

But all the negatives were also true. Benjamin was highly suspicious of the passive, aestheticized society that he feared photography was helping to create: mass events—from "monster rallies" to sports competitions to war—were all "intimately connected with the development of the techniques of reproduction and photography," he wrote.[79]

He believed that photography was a form of mystification, for it "can endow any soup can"—did he foresee the age of Warhol?—"with cosmic significance but cannot grasp a single one of the human connections in which it exists."[80] He distrusted photography's ability to beautify: photography had turned "abject poverty itself . . . into an object of enjoyment" and made "human misery an object of consumption."[81] Yet he also distrusted photography's opposite attribute: its facticity. For Benjamin, photography's claim to depict an obvious, unquestionable reality was a threat to independent, dialectical thought. With the rise of photography, he wrote, "a new reality unfolds, in the face of which no one can take responsibility for personal decisions"; instead, "One appeals to the lens."[82] Benjamin feared that the presumably infallible, objective judgment of the camera would conquer the subjective, flawed judgment of mere men; the simplicity of the photographic world would obscure the complexity of the human world.

Even more than Benjamin, Kracauer regarded the photograph as a kind of diminution. Rather than presenting us with the exciting immediacy of a human character, as its advocates promised, Kracauer insisted that "the photograph is not the person but the sum of what can be subtracted from him or her. The photograph annihilates the person."[83] Kracauer could sound almost enraged—almost like Baudelaire, though for different reasons when he wrote about photography: "In order for history to present itself, the mere surface coherence offered by photography must be destroyed."[84] And far from revealing previously hidden realities, Kracauer believed that the photograph occludes: "In a photograph, a person's history is buried as if under a layer of snow."[85]

In the Weimar years, Kracauer wrote as a journalistic critic rather than a theorist, publishing almost two thousand articles and reviews in the *Frankfurter Zeitung*, a liberal daily newspaper. Yet he was alarmed by interwar Berlin's cacophonous, newly uncensored press, in which hundreds of journals, tabloids, newspapers, and magazines—often lavishly illustrated with photographs—flourished. For some of his contemporaries, this press, and especially its new and sometimes startling use of photography, was a glorious herald of modernity (and a source of employment; it was here that a teenaged Robert Capa got his start). "Photography!" the artist-photographer Johannes Molzahn exulted in an article called, "Stop Reading! Look!" published in 1928. "This greatest of the physical-chemical technical wonders of the present—this triumph of tremendous consequence! One of the more important tools for elucidating current problems, for recreating the harmony between the processes of work and life."[86]

But Kracauer was decidedly unimpressed. "The flood of photos sweeps away the dams of memory," he charged. "Never before has a period known so little about itself. In the hands of the ruling society, the invention of illustrated magazines is one of the most powerful means of organizing a strike against understanding. . . . The 'image-idea' drives away the idea. The blizzard of photographs betrays an indifference toward what the things mean."[87] Photographs, Kracauer insisted, fight contemplation; even if the new photojournalism was practiced by thoughtful people, or political radicals, or intellectuals—which it sometimes was—it did not appeal to the intellect, and was therefore

highly suspect. Still, Kracauer, like Benjamin, believed that modernity's cultural disintegration—which these new forms of media represented to him—might radicalize the masses, and he saw photography as a key instrument in this world-historic process. "A consciousness caught up in nature is unable to see its own material base," he wrote. "It is the task of photography to disclose this previously unexamined *foundation of nature*. For the first time in history, photography brings to light the entire natural cocoon; for the first time, the inert world presents itself in its independence from human beings."[88]

Kracauer wrote about popular culture—chorus girls, arcades, best-selling books, the circus—with utmost seriousness. But he was no populist; on the contrary, his disdain for the mass audience was palpable. (Especially the female audience, whose "silly little hearts" he disparaged.)[89] The products of mass culture frequently repelled him, or at the very least evoked scorn. Kracauer's essay "Film 1928," for instance, is an almost unrelievedly negative overview of that year's cinematic offerings in which every genre— fictional features, documentaries, newsreels, art films—is attacked. Yet Kracauer's antipathy grew, I think, more out of dashed expectations than contempt: he harbored the desperate hope that popular culture might help avert the catastrophe-in-the-making that he understood the Weimar Republic to be. Thus the apocalyptic tone of his writings, as when he claimed that photography, by opening up the possibility of a radically altered consciousness, "is the *go-for-broke game of history*."[90]

Not all of Kracauer's colleagues on the left shared his antipathy to the mass media. The Communist artists George Grosz and John Heartfield sought to disseminate their work in popular, accessible forms such as pamphlets, posters, book covers, and newspapers: the cheaper and more vernacular, the better. Heartfield's work was inconceivable without mass-market photographs and mass-market papers, and Grosz was a fan of American pop culture. But it was Kracauer's mandarin, often censorious tone that would flourish among successor generations of cultural critics who write about photography.

Most of all, though, it is Brecht whose shadow hangs over photography criticism and whose sensibility continues to define it. Brecht, I think it's fair to say, really did loathe photographs, or at best deeply distrust them; in 1931 he wrote, "The tremendous development of photojournalism has contributed practically nothing to the revelation of the truth about the conditions in this world. On the contrary, photography, in the hands of the bourgeoisie, has become a terrible weapon against the truth."[91] And in "Little History," Benjamin quotes Brecht: "Less than ever does the mere reflection of reality reveal anything about reality. A photograph of the Krupp works or the AEG [the massive German armaments and electric companies, respectively] tells us next to nothing about these institutions."[92]

These two sentences have been quoted, ad infinitum, with the unquestioning piety usually reserved for gospels; they were clearly influential on the indictment of photography launched by Sontag, Barthes, Berger, and the postmoderns. (Four decades after Brecht—and despite the massive body of photojournalistic work that had been created in the interim—Sekula would make an almost identical claim: documentary photogra-

phy, he charged, has "contributed much to spectacle, to retinal excitation, to voyeurism, to terror, envy and nostalgia, and only a little to the critical understanding of the social world.")[93] And on one level, there is no doubt that Brecht was right. Photographs don't explain the way the world works; they don't offer reasons or causes; they don't tell us stories with a coherent, or even discernible, beginning, middle, and end. Photographs can't burrow within to reveal the inner dynamics of historic events. And though it's true that photographs document the specific, they sometimes blur—dangerously blur—political and historic distinctions. A photograph of a bombed-out apartment building in Barcelona from 1937 looks much like a photograph of a bombed-out apartment building in Berlin in 1945, which looks much like the bombed-out buildings of Hanoi in 1972, Belgrade in 1999, or Kabul from last week. But only a vulgar reductionist—or an absolute pacifist—would say that these five cities, which is to say these five wars, represent the same circumstances, the same histories, or the same causes. Still, the photographs look the same: if you've seen one bombed-out building you've seen them all.

This kind of deceptive similarity can be found in photographs of people, too. I am looking, as I write this, at two photographs that appeared side by side in the *New York Times* on January 25, 2009. One shows a Palestinian man, hand clutching his bent head, as he grieves over four Hamas fighters who were killed by the Israeli army in Gaza. The second picture shows a group of Israeli soldiers, hugging each other and crying, as they mourn a comrade killed by Hamas. The iconography of these two images is startlingly similar, which is no doubt why the *Times* printed them together; but the men are sworn enemies who represent antithetical political projects, though one could never know this from the pictures themselves. It is precisely this anti-explanatory, anti-analytic nature of the photograph—what Barthes called its stupidity—that critics, especially those on the left, have seized on with a vengeance and that they cannot forgive.

Yet the problem with photographs is not only what they fail to do. I think that a greater problem, for Brecht and his contemporary followers, is what photographs succeed in doing. Photographs excel, more than any other form of either art or journalism, in offering an immediate, viscerally emotional connection to the world. People don't look at photographs to understand the inner contradictions of global capitalism, or the reasons for the genocide in Rwanda, or the solution to the conflicts in the Middle East. They—we—turn to photographs for other things: for a glimpse of what cruelty, or strangeness, or beauty, or agony, or love, or disease, or natural wonder, or artistic creation, or depraved violence, looks like. And we turn to photographs to discover what our intuitive reactions to such otherness—and to such others—might be. There is no doubt that we approach photographs, first and foremost, through emotions.

For Brecht, this was the worst possible approach to anything. His poetry and plays are an assault not just on sentimentality but on sentiment: for Brecht, the two were kin. He regarded most feeling—apart, perhaps, from anger—as dishonest and indulgent; he associated emotion with the chaos and irrationality of capitalism itself. Surely only Brecht could have written—without irony: "I have feelings only when I

have a headache—never when I am writing: for then I think."[94] As George Grosz once remarked, Brecht "clearly would have wanted a sensitive electric computer instead of a heart."[95] And George Grosz was a friend.

There is much that is bracing about Brecht's emotional astringency; I can only admire a man who, in one of his earliest poems, announces to the women in his life, "Here you have someone on whom you can't rely."[96] And it was Brecht who, in five beautifully spare lines, laid out the toll that violent emotions exact, even in causes that are just:

And yet we know:
Hatred, even of meanness
Contorts the features.
Anger, even against injustice
Makes the voice hoarse.[97]

What is often forgotten, however, is that Brecht and the Frankfurt critics were particular men who lived in a particular time and place and who observed particular events, not holy oracles who had discovered eternal truths. Their time and place was Weimar Germany, whose daily reality was extraordinarily turbulent and extraordinarily traumatic; as Kracauer observed in 1926, "In the streets of Berlin, one is often struck by the momentary insight that someday all this will suddenly burst apart."[98] Weimar was embracing, but also reeling from, heretofore unknown forms of mass politics and mass culture; for over a decade it lurched from one calamity to another as Social Democrats, Communists, and Nazis battled it out in the press, the Reichstag, and the streets. Weimar was the crisis of modernity, in its most exaggerated, tragic form; Brecht lived within the specter of its unfolding disaster.

Brecht's genius was to understand the role of unexamined emotion in this fatal process, and to create works of art that subverted it. Brecht saw—correctly—that his compatriots were drowning in a bath of toxic emotions: of rage over their defeat in World War I; of resentment against Jews, intellectuals, and leftists; of self-pity, bathos, fear, and loathing. Brecht saw—correctly—that this poisonous mix of increasingly exaggerated feelings, and the voodoo conspiracy theories to which it lent itself, was the perfect incubator for fascism. Against this tidal wave of irrationality, Brecht sought to entertain, reason, and shock his audience out of its delusions.

Brecht and his colleagues lived not just within a unique political moment but at a specific time in the development of photography. Photographs had become an integral part of everyday life and everyday culture, yet they were also alien and confusing; it is no exaggeration to say that Weimar Germans were bedazzled and bewildered by the rush of images. Photographs were used, and sometimes grossly manipulated and altered, by the political parties as forms of propaganda, and were a key part of an increasingly hysterical political scene. Still, there were signs that photography could be more than just another opiate (or thoughtless agitator) of the masses. Heartfield's

caustic, audacious photomontages—one contemporary critic described them as "photography plus dynamite"—undermined the presumed naturalism of the photographic image; they appeared regularly in Communist newspapers and other publications.[99] Equally important, the Arbeiter-Fotografen, or "worker-photographers" movement, was creating a leftwing body of work that documented the harshness of working-class life; its adherents regarded photography as a form of socialist activism. And soon to come were photographs, pioneered by Robert Capa and his colleagues in Spain, that would bring a mass audience close to the horrors of fascist aggression. (Benjamin's "Mechanical Reproduction" was published in 1936, the year the Spanish civil war broke out.) Brecht charged that photographs were held "in the hands of the bourgeoisie," but he was wrong.[100] All over the world, the practice of documentary photography would be dominated by liberals and leftists.

Like Brecht, we live in dark times: of exploitation, inequality, and violence. And yet there are real differences between our darkness and Brecht's. We do not live in a society that is the precursor, much less the architect, of Treblinka and Sobibor; the United States of 2010 is not the Germany of 1933, and we lose rather than gain insight by conflating the two. And we are far more adept at navigating mass culture than the Berliners of eighty years ago; photography has grown and changed, as have our understandings and our uses of it. Brecht's relentless insistence on the necessity of distancing us from emotion was politically and artistically (and, I suspect, psychologically) necessary for him, but it has been adopted in an all too uncritical way by generations of photography critics working in very different times and facing very different challenges.

Indeed, today, we are all Brechtians—or, at least, professional ironists; we excel at ridiculing passion and mocking sentiment. We are experts, too—especially in the digital age—at distancing ourselves from photographs: every teenager knows how to manipulate them, tear them apart, dismiss them as lies. What we have lost is the capacity to *respond* to photographs, especially those of political violence, as citizens who seek to learn something useful from them and connect to others through them. Antipathy to the photograph now takes us only so far; though we can be inspired by the insights of Brecht and the Frankfurt critics, we cannot simply follow their lead.

No poet, no artist of any art has his complete meaning alone. His significance, his appreciation is the appreciation of his relation to the dead poets and artists. You cannot value him alone; you must set him, for contrast and comparison, among the dead. I mean this as a principle of aesthetic, not merely historical, criticism.

T. S. Eliot, "Tradition and the Individual Talent," 1919

8

IF YOU SEE SOMETHING, SAY SOMETHING
Why We Need to Talk about and Teach Visual Literacy, Now
2014

Marvin Heiferman

The dominance and great popularity of photography in our public discourse and the art world demands an understanding of what visual literacy is and a new curriculum with which to engage it.

> Your first 10,000 photographs are your worst.
>
> HENRI CARTIER-BRESSON

I'm continually surprised by the number of people in the art and photography worlds who, confronted with the statistics that track the near-incomprehensible number of images being made—2.41 billion a day was one recent estimate for 2014—say, "So what?" They claim to be unimpressed by the traffic in mannered selfies, surveillance views, fetishized food shots, and seemingly inconsequential "I-did-this/I-did-that" pictures that beg to be "liked." These are the images, then, that some critics and curators maintain are less important than "good" pictures, which is understandable, I suppose, given the decades, dollars, and effort it took to argue for and position "good" pictures so comfortably within the arts.

But in the twenty-first century—and as the definitions, materiality of, and audiences for photography evolve—there is a cultural imperative and practical need to more generously acknowledge what photography currently is and may become. We need to get a better sense and clearer picture of what visual culture is and how photographic images work, where their power comes from, and what their consequentiality is. To accomplish that we will need not only to open up the dialogue around photography but also to rethink where that dialogue should take place. With so many pictures being made by so many people for so many reasons, we'll need to think and talk about visual literacy more often and differently.

The ever-increasing numbers of digital images reflect the fact that photographs, as

objects, as things, are seldom news-making but photographic imaging as communication and experience increasingly is. No longer an incidental but an everyday activity, photography has become essential in determining who we are, what we want, and what we will or will not say or do. Given the ways the medium now speaks to, for, and about us, we need to make more concerted efforts to address photography itself not only more democratically but also more rigorously. If we are all more than just photographers now—if we've been turned into art directors, picture editors, image manipulators, forensic detectives, and archivists, too—the public dialogue around photographic imaging needs to shift in order to reflect that. The fact that it hasn't, as yet, is noteworthy and troubling.

Anne Edgar, a clear-eyed public relations expert I know, recently suggested one possible reason for that. She recounted a story told by writer David Foster Wallace in a commencement speech he delivered at Kenyon College in Ohio in 2005: "There are these two young fish swimming along, and they happen to meet an older fish swimming the other way, who nods at them and says, 'Morning, boys, how's the water?' And the two young fish swim on for a bit, and then eventually one of them looks over at the other and goes, 'What the hell is water?'"[1] Photography, Edgar noted, is our water. Over the past decades and in various cultural corners, we have created numerous opportunities to explore the world's pedigreed pictures. But I would argue that it is the everyday imagery too often consigned to the cultural sidelines, the photographs that most actively and consequentially shape our experience in the world, that are the ones we need to be speaking and teaching about. If, and as I've written elsewhere, photography changes everything, then everyone needs to explore and be able to explain why and how that happens.

If we make photographs and are pictured all the time, if photography is no longer a special event, if the photographs not made as art are the ones that end up exerting the greatest influence over us, where is the best place to admit to and discuss that? In the past, consumers might glean their basic photographic knowledge from the film and camera companies that directly profited from their picture-taking. But where can we learn about photography now, when cameras are routinely bundled into our digital appliances and will soon become wearables. Strangely enough and with photographs everywhere, we are pretty much left to figure photography out for ourselves. And we are taking as many pictures of what we think is curious as we are of what conventional photographic wisdom once conditioned us to see as important. "Good" pictures today are not necessarily the ones we encounter in albums, frames, galleries, and museums; they are the ones that do their jobs best, the quirky ones that capture our imagination and attention, the ones that get passed along.

In late 2013, a story circulating online described a two-year-old Canadian boy who had conceived of and directed his nanny to produce series of what he thought would be funny photos. "He asked me to teach him how to take a photo," she said, and "since we use my iPhone for these, it wasn't hard to teach him."[2] But in fact, it will take more sustained efforts to talk to and teach children about what the images they see and so eas-

ily make might actually do and mean. The earlier kids start taking pictures, the sooner we need to teach them to question the motivation, production, interpretation, use, and impact of images. And that is easier said than done.

The kinds of curricula that currently promote "visual studies" and teach critical looking and thinking about photographic images are largely considered to be the province of "higher" learning. They shouldn't be. Students at all grade levels need to be taught to overcome what the art historian and cultural critic W. J. T. Mitchell calls, "the veil of familiarity and self-evidence that surrounds the experience of seeing, and," he proposes, "turn it into a problem for analysis."[3] Another hurdle we face today is that even if and when conversations about imaging do take place at lower grade levels, they tend to be relegated to art classes. They shouldn't be. While it could be argued that arts education environments might be the most obvious place to instruct students in the making and analysis of images, the reality is that in the United States, for example, where educational budgets are routinely threatened and standardized testing drives the K–12 school day, arts education barely takes place at all; it has become collateral damage.

In a world where everyone looks at and takes pictures, however, where language and images are of equal importance, reading and writing alone no longer define literacy. It is startling, when you think about it, that visual literacy skills—knowing what it means to take, read, understand, and communicate with photographs—are something we pay lip service to yet spend little energy to promote or teach.

The first use of the term "visual literacy" was in 1968 and has been credited to John Debes, a cofounder of the International Visual Literacy Association. That the concept was first bandied about as Marshall McLuhan's writings were fueling heated discussions about the spread and power of media is not surprising. What is astonishing now—nearly half a century later, when photographic imaging plays a central role in film, television, video, photography, publishing, and online environments—is how reluctant the educational community has been to address the ways photographic images actively shape perception, the flow of information, and what literacy is today.

It wasn't until the 1990s that a handful of educators began to more seriously explore the notions of multi-literacies and "intermediality" and advocate for visual literacy programming. In 2004, *The Visual Literacy White Paper*, a forward-looking document authored by Anne Bamford and sponsored by Adobe Systems, Australia, summarized current research in the field and emphasized how forcefully images impact viewers.[4] Children can, the paper explains, identify people visually within six to eight weeks of birth, read graphic images with some accuracy by the time they are one year old, and by the age of three produce images and understand that graphic forms communicate meaning. Visual literacy, Bamford explains, is based upon what is seen with the eye and what is "seen" with the mind. Central to her report is an important fact: while we pick up some visual literacy and comprehension skills automatically, they are the ones at the lower end of the visual literacy scale.

It does not, we now know, take long to see an image. Research shows that one thir-

teenth of a millisecond is all we need to extract the most basic information from and get the gist of a photograph.[5] Sometimes that may be all that is necessary. But if, as W. J. T. Mitchell has also written, it is important not just to question what images mean or do but also to understand where "the secret of their vitality" lies and what "they want,"[6] we have to define the critical strategies necessary and set aside adequate time to do that. If those young people categorized as digital natives or millennials "learn more than half of what they know from visual information," as Mary Alice White, a researcher at Columbia University's Teacher's College pointed out, the reality is that "few schools have an explicit curriculum to show students how to think critically about visual data."[7] They should. We need to teach students, from an early age, to size up what images imply in addition to what they so obviously state. We need to train viewers to discern how effectively images seduce and manipulate us as well as how they represent and inform us.

This need to understand the ways photographic language and images work is not, of course, something people have just come to recognize. "Photography," the photographer and journalist Eliot Elisofon wrote in 1944, should take "its place with the pencil and the typewriter as an instrument of our everyday language. Photography should be taught in the schools along with penmanship as part of postwar education's expansion."[8]

So what's taking so long to put this into practice? The fact that we take photography for granted? The fact that the medium is unruly and used variously across seemingly separate disciplines? The meaning of images tends to be more fluid than the meaning of words and to shift depending upon where they are encountered and who is looking at them. As a result, we need to admit and explore, rather than gloss over, the differences in how imaging operates across fields of knowledge and curricula.

Perhaps we are entering a moment where that might happen. New Common Core educational standards, calling upon students to more regularly access information from multiple sources as a necessary prerequisite to succeeding in school and the workplace, are becoming more widely adopted. Hopefully, parents and pedagogues will come to recognize photographic imaging's obvious and central place in communication today. If they do, the challenge will then be to build visual literacy into various subject areas, multiple disciplines, and across curricula. The challenge will be to resist the temptation to sideline visual literacy as an art add-on. The reality is that we no longer have the luxury to look at or talk about imagery as an enrichment exercise. We have to engage with images as text, data, and information. Another reality we will have to deal with is that school systems change slowly and that, at present, there is such scant teacher training in the field of visual literacy.

"If the goal of literacy education," Erin Riesland wrote in *Visual Literacy in the Classroom*, "is to empower students with the tools to communicate and thrive in society, shouldn't we consider the current literacy demands of the technological age?"[9] The answer is yes. And the next question we each need to ask is what will it take to make that happen?

VISION AND MOTION

We need to take the image off the screen like Moholy-Nagy envisioned more than sixty years ago. We can do it. One day you will see it everywhere.

ALEJANDRO JODOROWSKY, *BROKEN SCREENS*, 2005

I was a painter before, and it was always about the frame, of course. But within this frame, somehow, because of movement, because of things passing through the frame, it seemed to have a life bigger than the actual frame itself. That's the thing that gave me the passion to sort of want to make films. There's always the possibility of something happening within that time period that you are focusing on or that object or that person.

STEVE MCQUEEN, INTERVIEW IN *HUNGER* (CRITERION DVD), 2010

9

EXCERPT FROM *VISION IN MOTION*
1947

László Moholy-Nagy

Despite technology's union of the still and moving image, Moholy-Nagy's visionary
text reminds us to continue to explore the potentials of the lens-based image and that
nothing's new.

PHOTOGRAPHIC VISION

In rendering with the camera one may find visual sensations just as surprising as in
the direct records of light evolved by photograms. Such particular developments are the
bird-, frog-, and fish-eye views, magnifications, ultraspeed shots, reflections, penetra-
tions, superimpositions, solarizations, distortions. Their systemic coordination opens
up a new field of visual presentation, an extension of visual possibilities, in which we
may expect much further progress. Photography can render, precisely register, the speed
of objects or stop motion in a hundredth, thousandth, or millionth of a second. It can
"see" through mist, even in the dark, by using infrared emulsion. It can penetrate and
record the inside of opaque, solid objects with X-ray photography. In combination with
the electron microscope, it can make visible fantastically minute matter. Such scientific
and technological advances almost amount to a psychological transformation of our
vision,[1] since the sharpness of the lens and its unerring accuracy have now trained our
powers of observation to a higher standard of visual perception than ever before. Pho-
tography imparts a heightened and increased power of sight in terms of time and space.
Even plain matter-of-fact enumeration of specific photographic techniques enables the
student to divine the power latent in those images.

EIGHT VARIETIES OF PHOTOGRAPHIC VISION

1. *Abstract seeing* by means of direct records produced by light; the photogram
 which captures the most delicate gradations of light values, both chiaroscuro
 and colored.

2. *Exact seeing* by means of camera records; reportage.
3. *Rapid seeing* by means of the fixation of movements in the instantaneous snapshot, stroboscopic photography, an instantaneous photograph with rhythmical interruption of the motion flow.
4. *Slow seeing* by means of fixation of movements spread over a period of time, prolonged time exposures; e.g., the luminous tracks made by the headlights of motorcars passing along a road at night; virtual volume.
5. *Intensified seeing* by means of
 a. macro- and microphotography;
 b. filter photography that, by chemical variation of sensitized surface, permits photographic potentialities to be augmented in various ways, ranging from the revelation of far-distant landscapes veiled in haze or fog to exposures in complete darkness—infrared photography;
 c. bird-, frog-, or fish-eye view.
6. *Penetrative seeing* by means of X-rays; radiography.
7. *Simultaneous seeing* by means of superimpositions; a process of automatic photomontage.
8. *Distorted seeing*—optical jokes that can be automatically produced by
 a. exposure through a lens fitted with prisms, of reflecting mirrors or the distograph;
 b. mechanical and chemical manipulation of the negative during or after developing, using oil drops, suds, soaps, etc.; lighting, heating or freezing, resulting in distortion, reticulation, solarization, etc.

IMAGE SEQUENCE SERIES

There is no more surprising, yet, in its naturalness and organic sequence, simpler form than the photographic series. This is the logical culmination of photography—vision in motion. The series is no longer a "picture" and the canons of pictorial aesthetics can only be applied to its mutatis mutandis. Here the single picture loses its separate identity and becomes a part of the assembly; it becomes a structural element of the related whole which is the thing itself. In this sequence of separate but inseparable parts, a photographic series—photographic comics, pamphlets, books—can be either a potent weapon or tender poetry.

But first must come a realization that the knowledge of photography is just as important as that of the alphabet.

The illiterate of the future will be the person ignorant of the use of the camera as well as of the pen.

10

STILLNESS
2008

David Campany

The link between the still and moving image is made through the history of the chronophotographers. Campany carries forth on this linkage and meditates on the sameness and difference of the two in contemporary photography.

Photography preceded cinema, but does this imply that photography is the parent of cinema? Certainly many of the written histories tend to think so. The two share a photographic base, but beyond this the link is usually made through "chrono-photographers" of the late nineteenth century, primarily Eadweard Muybridge and Étienne-Jules Marey (although there were several). Muybridge used banks of cameras to record sequential instants of human and animal locomotion. Marey produced multiple exposures of movement on single plates. Both lived long enough to see the Lumières' invention, but as "parents" they were indifferent. It was cinema that claimed the lineage. To cinema, Muybridge's grids of consecutive photographs looked pre-animated, as if awaiting motion to come. Marey's images resembled translucent film frames layered on top of each other. Both pursued instantaneous arrest, the decomposition of movement, not its recomposition. Stopping time and examining its frozen forms was their goal. It was a noble goal, pursued diligently and achieved comprehensively. Marey even told the Lumières their Cinématographe was of no interest because it merely reproduced what they eye could see, while *he* sought the invisible. Muybridge did come up with a means of animating his images (the Zoopraxiscope of 1879), but he saw it as a novelty, far removed from the serious project of stilling things. Nevertheless, it is almost impossible not to see a connection between their instantaneous consecutive images and cinema. The problem is that chronophotography and cinematography give rise to incompatible yet intertwined ideas about the truth of images and the understanding of time and motion. In addition, they are

aesthetically distinct forms. Stillness and movement are mutually exclusive, despite their genealogy and their mutual interest.

That said, sooner or later the comparison of photography and film always comes around to questions of stillness and movement, confronting what is at stake in the common assumption that "films move and photographs are still." What *is* the movement of film and what is the stillness of photography? Is it that the film image changes over time while the photograph is fixed? Not exactly. That photographs are *about* stillness and films *about* movement? Possibly, but it still misses something. We soon come up against the limits of thinking about the question outside of subject matter. The film image certainly has duration and thus movement at a mental level. Yet, when we think of the film image moving, it is also because it has tended, conventionally, to select subject matter that moves and can be seen moving. Similarly, the stillness of photography is given to us most clearly when it arrests or fails to arrest movement, or when it confirms the immobility of inert things. Of course we can film or photograph a moving subject (say, workers leaving a factory) or a still subject (say, a building). The Lumières could have filmed motionless buildings or landscapes without people, but they didn't. We had to wait for Andy Warhol to separate cinematic duration from depicted movement. Muybridge could have photographed at high speed a sleeping horse or a human figure reading a book, but he didn't. Each chose subject matter appropriate to their ends, as do all image-makers. And since subject matter has changed so radically—think of the changes that have taken place across the histories of these media—our conceptions of photography and film remain perpetually uncertain. This is especially so in the way we understand their relation to movement and stillness.

STOPS AND FLOWS

The most significant subject for photography and film has been the human body. The second most significant has been the city. Let us begin with the city. The developments of modernity, photography and film are thoroughly intertwined and inseparable from the evolution of the modern city. When Christopher Isherwood set out to describe daily life in Berlin before the Second World War, he wrote: "I am a camera with its shutter open, quite passive, recording, not thinking. Recording the man shaving at the window opposite and the woman in the kimono washing her hair. Some day, all this will have to be developed, carefully printed, fixed."[1]

Like many writers and artists of that period, Isherwood adopted a camera-eye, or camera-I, as the ideal ego for urban living. Responding to the visual stimulation of the city, it neatly collapsed being and seeing into a single condition. But was this metaphor photographic or cinematic? Isherwood keeps it open. "Printed, fixed" suggests the still image. A "shutter open" at length might imply something more like a running film camera, or perhaps a long exposure capturing an abstract trace of movement over time. Such ambiguity was a symptom of the temporal challenges of modern life. Was the

metropolis to be experienced in fits and starts, or in its continuous unfolding? The photographer Henri Cartier-Bresson also spoke of the camera as an extension of his eye. Here he recalls developing in the 1930s what came to be known as his credo, the "decisive moment": "I prowled the street all day, feeling very strung up and ready to pounce, determined to 'trap' life, to preserve it in the act of living. Above all I craved to seize the whole essence, in the confines of one single photograph, of some situation that was in the process of unrolling itself before my eyes."[2]

"Trapping" and "seizing" belong to photography's quick snap. The "whole essence" suggests a longer situation condensed into one frame. And "unrolling before my eyes" hints at an observer not quite *in* the world but removed, as if watching it on a screen. In the opening paragraph of his book *Images à la sauvette* (translated as *The Decisive Moment,* 1952), he tells of "bursting" into photography as a boy, taking snapshots with a Box Brownie. The second begins: "Then there were the movies. From the great films I learned to look and to see."[3] In the third he describes Eugène Atget's sedate photographs of Paris, which prompted him to try a slow plate camera and tripod: "instead of a shutter a lens cap," which "confined my challenge to the static world." The most celebrated spread from his book makes a comparable switch in tempo. On the left, a man is frozen in mid-air as he jumps a puddle, his heel almost touching its reflection; on the right, an older man, solid on his feet, paused as if reflecting upon a decisive moment from his past. The first jumps quickly through his sleepy surroundings; the second is almost as still as his. The first photo looks like a decisive snapshot because we can see the arresting effect of the fast shutter. The second looks calmer because the scene is calmer. In reality, both might have been shot the same way, with the same shutter speeds, but a photograph tends to look "decisive" if there is something to arrest. This is photography of the lens and shutter actively combined, colliding and colluding with the world in motion. The frame cuts into space and the shutter cuts into time, turning the photographic act into an event in itself.[4]

Cartier-Bresson's compact Leica camera, so vital to the development of mobile reportage, took 35mm stock made standard by the film industry. Indeed, the Leica was in part designed to allow cinematographers to make exposure tests on short lengths of ciné film, without having to thread up a bulky movie camera. So while photography may have begotten cinema, cinema begat the "decisive moment." This is true in more than a technical sense. Stillness became definitive of photography only in the shadow of cinema. Specialists like Muybridge and Marey had pursued instantaneous photography since the 1870s, but the *widespread* desire for the precise freezing of action took hold in the era of "moving pictures," which had themselves taken hold in the era of modern metropolitan motion. Likewise, the term "snapshot" dates back to the 1860s, when the instantaneous photo became possible but it was not until the 1920s that the snapshot was professionalized via reportage and democratized via amateurism. It was then that it came to be understood as the very essence of photography, for a while at least. It was almost as if cinema, in colonizing the popular understanding of time, implied that life

itself was made up of distinct slices and that still photography had the potential to seize and extract them.[5]

Cartier-Bresson's most celebrated photographs are of everyday situations made eventful only by his precise framing and timing. The subject matter is often insignificant until it is photographed—the jumping of a puddle, the fleeting gesture of a face, bodies moving through space flattened suddenly and beautifully into two dimensions. He was present at a great number of historical events, but he was indirect, shooting bystanders rather than the main attraction, the diffused effects rather than the cause. Best when conjured out of next to nothing, *his* decisive moments avoided competition with history's decisive moments. The exception is the photograph titled "A Gestapo informer recognized by a woman she had denounced, deportation camp, Dessau, Germany, 1945." Here the image is a decisive event, but it is also *of* an event, a momentary depiction of something socially momentous. Suddenly we sense photography's shortcomings as historical record. We need know nothing more about that puddle-jumper because nothing more is at stake, but the violence shown here demands to be explained, demands that title to account for it. Cartier-Bresson's titles were rarely more than place names and dates. This one is long, like a newspaper caption describing the action as if it were ongoing.[6] Such a photograph does not so much narrate as *require* narration. Photojournalism *requires* journalism because facts, however "powerful," cannot speak for themselves. And, to be precise, the title here does not refer to the outburst caught by the shutter at all but to the *earlier* moment when the informer was recognized. In filling in the missing context, the title stretches the time of the image to include the moment before.

There is something theatrical in this shot of a visceral slap at the end of the war. The scene is reminiscent of a show trial taking place before the glare of the camera. The vantage point is ideal, as if the photographer had been granted it in advance. It is also a highly visible vantage point and may have influenced what was going on. To the photographer's side, an assistant was filming with a movie camera, and a more comprehensive account of the scene appears in Cartier-Bresson's documentary film *Le Retour* (1945).[7] While its individual frames show less than the photograph, the unfolding film can explain more of what is going on. The photograph may be summative, but it is in the end compelling only in its fragmentary incompleteness.

STILLNESS, MOVEMENT, MONTAGE

In 1925 the Russian artist and photographer Alexander Rodchenko visited France to witness at first hand the growing energy and speed of Paris. While there he bought a camera called the Sept. It could shoot stills, short bursts of frames (like a motor-drive) as well as moving footage, all on 35mm film.[8] In fact he bought two, the second for his friend the filmmaker Dziga Vertov. Launched well before the Leica, the Sept was a canny response to an emerging desire to close the gap between photographs put together as sequences and cinema broken down into shots or frames. That desire was

nowhere stronger than in Soviet Constructivism. Here photography and film came to share many of the same concerns. What facilitated this was not so much technical equipment but *montage,* a principle of assembly that could be applied in different but related ways to still and moving images. Jean-Luc Godard has suggested that what made possible the kinds of montage advocated by Vertov, Sergei Eisenstein, and other filmmakers was the angled shot: the look sharply up, down, or at a tilt so characteristic of Russian avant-garde cinema.[9] Renouncing the supposedly "straight" shot—frontal, rectilinear, and neutral—did not simply energize the frame with dynamic composition; it announced it as a partial image, just one choice among many. As Dziga Vertov put it in 1922: "Intervals (the transitions from one movement to another) are the material, the elements of the art of movement and by no means the movements themselves. It is they (the intervals) which draw the movement to a kinetic resolution."[10]

The following year he was more explicit: "I am kino-eye. I am a builder. I have placed you, whom I have created today, in an extraordinary room, which did not exist until just now when I also created it. In this room there are twelve walls shot by me in various parts of the world. In bringing together shots of walls and details, I have managed to arrange them in an order that is pleasing and to construct with intervals, correctly, a film-phrase which is the room."[11]

Tellingly, there is little mention here of *depicted* movement. These are virtually still shots pieced together as film, as if the world's own movements must be subordinated to the control of the editor/monteur. Vertov's words apply just as well to the montage of still images on the printed page or poster. Indeed Rodchenko extolled much the same approach in photography. He rejected what he called "belly-button shots" (the waist-level view offered by the standard use of popular box cameras), favoring unusual angles. Many images moving around a subject could overcome the fixed shot, not unlike the concatenation of views and moments in Cubism. In 1928 he declared: "Take photo after photo! Record man not with a solitary synthesized portrait but with a mass of snapshots taken at different times and in different conditions."[12] In theory at least, montage of this kind could mobilize subject and audience at once. Thus in Constructivism still photos began to look like film frames, while films were built up with almost still photographic shots.

While the Constructivists explored this intensively, the basic premise was widespread in the European avant-garde. In his book of portraits *Köpfe des Alltags* (*Everyday Heads,* 1931), Helmar Lerski offered several photographs of each of his sitters, shot from different angles under different lighting.[13] Lerski had pioneered chiaroscuro techniques in Expressionist theatre and cinema in Germany, using multiple lamps and mirrors to produce stylized and unnatural effects. In his photography he explored the belief that human identity will always elude the single, static image. In a bourgeois culture quick to embrace the definitive portrait of the citizen (the police mug shot, the passport photo, the celebrity icon), Lerski's approach was unsettling. His circling of his subjects, a literal embodiment of Vertov's call for the multiple portrait, was in stark contrast

to the work of his celebrated contemporary August Sander.[14] Where Sander aimed to make representative images of "typical" Germans, Lerski aimed for the opposite. With *Metamorphosis through Light* (1936) the idea was pushed to its limit. He photographed the head of one man 175 different ways. Looking through the project, one becomes less and less sure what the man actually looks like and quite clueless as to who or what he "is." Lerski sought a form for his ideas somewhere between photography and film, in which the factual promise of each still image could be deferred to another and another. In 1938 a slide show from the series ran for several weeks before the main feature at London's Academy Cinema. Decades ahead of the slippery filmic masquerades of Cindy Sherman, Lerski produced a cinematographic performance of a face, a mercurial façade beyond any knowable person.[15]

What Lerski sought in the face, Moï Ver sought in the city. His book *Paris* (1931) forced photography through every conceivable variant of montage—sequences, series, double printing, multiple exposure, Cubist collage, Constructivist assembly, and Surrealist juxtaposition.[16] The individual shots are unremarkable, but the assembly is ceaselessly inventive, using Paris to explore photography and photography to explore Paris. There are few fixed points of reference. Instead, Moï Ver accepts that a report on the modern city is going to be fugitive, layered, and contradictory, beyond a totalizing grasp. In 1929 the writer Siegfried Kracauer had come to the same conclusion:

> The street in the extended sense of the word is not only the arena of fleeting impressions and chance encounters but a place where the flow of life is bound to assert itself. Again one will have to think mainly of the city street with its ever-moving crowds. The kaleidoscopic sights mingle with unidentified shapes and fragmentary visual complexes and cancel each other out, thereby preventing the onlooker from following up any of the innumerable suggestions they offer. What appeals to him are not so much sharp contoured individuals engaged in this or that definable pursuit as loose throngs of sketchy, completely indeterminate figures. Each has a story yet the story is not given. Instead an incessant flow casts its spell over the flâneur or even creates him. The flâneur is intoxicated with life in the street—life eternally dissolving the patterns which it is about to form.[17]

Whether critical or celebratory, representation of the city would have to emerge less from definitive images than the marshalling of pieces. Thus modernist photography and film sought to cut out and then cut together preselected parts. The implied point of view was compound, like a fly. Ideally, the agility of the photographer or filmmaker as they shot in the street would be matched by the juggling of the pieces in the edit. The collage by Umbo for the cover of Egon Irwin Kisch's *Zurivy Reporter* (*The Frantic Reporter*, 1929) is a heightened expression if this. The reporter is a man-machine observing, recording, and interpreting all at once, just like the figure described by Isherwood. Straddling the city, he has a car and an airplane for feet, pens for arms, a typewriter for a chest, and of course a camera-eye. The time lag necessary for critical reflection on the world has

gone. Immersion and immediacy are all, anticipating the myth of instantaneous assessment typical of our twenty-four-hour news television. Despite all this, in reality life in the 1920s and '30s was not actually particularly fast for most urban dwellers. The new speed was certainly felt to some extent, but it was anticipated much more. Speed was as much a seductive and utopian promise as a fact of life, particularly for the avant-garde.

What finally broke that first bond between photographers and filmmakers was the arrival of sound in 1929. It disrupted film's photographic idea of the "shot," and for a long while it confined film production to the controlled sound studio. Vertov's silent *Man with a Movie Camera* (1929) was the pinnacle of roving film, completed just before the paralysis. Taking the familiar structure of a "day in the life of a city," it cuts together documentary footage of urban life and combines it with a highly reflexive account of the film's own making. We see the athletic cameraman at work and the sights he records intercut with images of Vertov's editor at her table seemingly putting together the very film we are watching. That level of immersion in the city was surpassed only decades later with the coming of portable video. Even so, the lure of footloose city filmmaking never went away. European Neo-realist cinema of the 1940s and '50s strived for the freedom and mobility of the documentary photographer, as did the French New Wave. In 1959 Jean-Luc Godard made much of *Breathless* on the streets of Paris. His cinematographer, Raoul Coutard, had a light enough camera but could find no ciné film stock fast enough to shoot the city on the hoof without additional lighting. The only solution was to tape together short lengths of Ilford HP5, the film manufactured for reportage and sports photographers.

CRITICALLY SLOW

The physical/mental montage of shots constitutes one version of "pure cinema." The other, advocated by the film theorist André Bazin, minimizes montage and emphasizes the "pro-filmic event," that is, the unfolding of action in front of the rolling movie camera. For Bazin, the synthetic nature of montage should be subordinate to the organic nature of the individual shot. When the experimental filmmaker Hollis Frampton imagined the "infinite film," it included both versions: "The infinite film contains an infinity of endless passages wherein no frame resembles any other in the slightest degree, and a further infinity of passages wherein successive frames are as nearly identical as intelligence can make them."[18]

Popular narrative film stays away from endless difference and endless sameness. It occupies a small mid-ground of "sentence-length" shots, neither too short to be comprehensible nor too long to be tolerable.[19] By contrast, the history of avant-garde cinema is a history of gravitation to those two extremes. At one end there is the film built up from rapid cuts, and at the other the long, single take. Significantly, at both ends we find versions of photographic stillness. Montage sees the photograph as a partial fragment, as we have seen. The long take sees the photograph as a unified whole. The shorter a

film's shot, the more like a photograph it gets, until one ends up with a single frame. The longer the shot, the more like a photograph it gets too, the continuous "stare" of the lens giving us a "moving picture."[20]

The advanced art and film of the inter-war avant-gardes was characterized by their engagement with speed and montage. But by the 1950s speed had lost much of its artistic appeal and almost all its critical potential, particularly in Europe. Beyond the sobering effects of the war, modernity had developed a terrifying autonomy, not least at the level of the image. The "society of the spectacle," diagnosed by Guy Debord in 1967 but intimated much earlier, relied upon the breathless turnover of popular culture with is ephemeral advertising, commodified news, and droning television. Speed and montage were degenerating from the promise of mass mobilization into mass distraction. The accelerated image world began to feel dehumanizing, repetitive, and monotonous. In this context *slowness,* the deliberate refusal of speed, became central in vanguard art and culture, and we can see this change of pace both in photography and film.

Influential filmmakers such as Ingmar Bergman, Roberto Rossellini, Robert Bresson, Yasujiro Ozu, Michelangelo Antonioni, Pier Paolo Pasolini, Andrei Tarkovsky, Danièle Huillet and Jean-Marie Straub, Stanley Kubrick, Chantal Akerman, Wim Wenders, and latterly Terence Davies, Hou Hsiao-Hsien, Tsai Ming-Liang, and Béla Tarr have exploited the long take, the locked-off camera, and the extended tracking shot. The often glacial tempo of their films seeks a distance from the spectacle of Hollywood and the cut and thrust of television. The fleeting is considered irredeemably frivolous and artistically beyond the pale. Instead, cinema's gaze would be extended to become so long and penetrating as to estrange what at first looked and felt familiar—a roadside, a face, a building, a landscape, the sea. The embrace of the slow was also a sign of increasing uncertainty about the recorded image in general. The long look would describe the surface of the world but doubt would creep into the equation between seeing and knowing. As Wenders put it in 1971: "When people think they've seen enough of something, but there's more, and no change of shot, then they react in a curiously livid way."[21] The existential entropy of postwar modern life was diagnosed by Antonioni's films of the early 1960s, in which he developed an aesthetics of decelerated alienation. Here the almost-nothing of the image drained of narrative urgency and quick cuts flirts with the audience's everyday experience of doubt about the world and its future.[22] At the same time the slowness of the image on-screen opens up a space for philosophical and aesthetic reflection *within* the film.

Art film and experimental film of the 1960s and '70s took a similar approach, typified by Andy Warhol's movies and the inquiries of Structuralist and Materialist filmmakers. Structuralist film tended to take a single organizing idea from the grammar of cinema and interrogate it (e.g., shot/counter shot, the zoom, the tracking shot, the dissolve, split-screen, dialogue patterns, gestures, sounds, narrative elements). Materialist film tended to foreground the mechanics of the apparatus and the act of viewing (camera, celluloid, projector, screen, the physiology of perception). Michael Snow's

Wavelength (1967), a landmark in experimental film, is as Structuralist as it is Materialist. The film appears to be an imperceptibly slow forty-five-minute zoom across a bare apartment space, ending on a still photograph of ocean waves pinned on the opposite wall. In the course of the zoom, the image flickers through different color filtrations and switches day to night and positive to negative, highlighting the physical substance of the projected image. Fragments of narrative are introduced when a man enters the room and collapses on the floor, but the unwavering zoom continues on its way to the photograph. *Wavelength* builds up a tension between human and mechanical vision, which is never resolved but dramatized as its central idea. The film is not fast enough to feel like movement nor slow enough to register as stillness, not eventful enough to feel like a story nor uneventful enough to set the viewer free of narrative.

Forty years on, subsequent generations are still unpacking the ramifications of the intensive experimentation of the 1960s and '70s, just as many gallery artists continue to look to the equally productive Conceptualism of that period. A significant change is that experimental cinema has been taken up substantially by contemporary art. It has left behind the film co-ops and alternative cinemas in which it developed to move into the gallery and museum. Despite the variety, a certain slowness predominates in these new practices. We see it in the work of Bill Viola, Douglas Gordon, Gillian Wearing, Fiona Tan, Eija-Liisa Ahtila, David Claerbout, Sharon Lockhart, Stan Douglas, Mark Lewis, and Victor Burgin, among others. Art's preference for the slow is motivated by more than the desire to separate itself from mainstream cinema and spectacle at large. Slowness allows film to approach the traditional sense of "presence" typical of art's materially fixed media such as painting, sculpture, and photography, all of which have valued the depiction rather than the re-creation of movement. The fact that things happen only incrementally and are often screened as loops means that one has the opportunity to contemplate and interrogate *while looking*, an experience that continues to remain central to the depictive arts, regardless of media.

In 1993 Douglas Gordon transferred Hitchcock's *Psycho* (1960) to video, silenced it and slowed it down twelvefold so that it lasted a whole day. Running at two frames per second, *24 Hour Psycho* invites a microscopic dissection of the original, holding each scene long enough to yield more meaning than was ever required by the narrative. Three years later Gillian Wearing assembled police officers as if for a photograph but had them attempt to hold still for an hour in front of her video camera.[23] A snapshot is replaced by sixty minutes of stiff posing, except for the inevitable sniffing, coughing, shuffling, and yelps of relief when the hour is up. But the extreme had already come in 1978 when James Coleman had made half a second of James Whale's film version of *The Invisible Man* (1933) last over eight hours.[24] Transferring twelve frames to mounted slides for projection he produced a sequence of twenty-minute long dissolves from one to the next in which the invisible man is shot and becomes visible as he dies. To the eye transformation is neither visible nor invisible, hovering somewhere in between.

Pursuing what he terms "part cinema" artist Mark Lewis makes single-take short

films that extend the principles of Structuralist film. Each of his works last roughly as long as the shortest reel of commercially available film stock. Lewis respects the notion that historically the art gallery has been the space of the silent pictorial tradition. His uninterrupted shots without sound produce what can be described literally as moving photographs. In this his films connect as much to painting and photography as to the single-reel films of the Lumières or Warhol's long takes. They are often set in the in-between parts of the city, the "no man's land" that has neither the dynamism of the center nor the stillness of the neglected periphery. Shot on Super 35mm film and transferred to DVD, *Queensway: Pan and Zoom* (2005) presents three different framings of the same almost still scene within one take. The first, held for about a minute, appears to be an establishing shot of a nondescript roadside building. A woman in the middle distance stands rummaging in her bag. A sharp pan to the left reframes on a second figure seated outside the building's entrance. A minute later the camera pans and zooms swiftly to frame a curtained window. A minute later the shot ends, only to start again on a loop. Nothing seems to connect the three framings or the people besides their coexistence in space and time, but Lewis plays on our compulsion to look for meaningful coherence and narrative momentum.

Victor Burgin's recent video works have established a new ground between stillness and movement. *Nietzsche's Paris* (1999) draws on the written correspondence between Friedrich Nietzsche, Paul Rée, and Lou Salomé in which the three envisioned living together in Paris. The ménage à trois never happened. Burgin's video combines three deceptively simple elements. The first appears to be a series of circular pans, shot from the promenade of the new Bibliothèque Nationale in Paris. In fact, the images are long panoramas made by digitally stitching together twenty-four separately shot stills. The feeling of movement comes from their slow and steady scroll across the screen. Intercut with these are short allusive phrases appearing on-screen that could be quotations from a written text, or captions, or intertitles for a silent film. We also see a second image, of a typically "nineteenth-century woman" seated on a park bench. While the leaves around her tremble in the wind, she seems even more still than her stiffened posture suggests. She is in fact a freeze frame keyholed digitally within a real-time shot of her surroundings. The overall effect gives *Nietzsche's Paris* a temporality all its own, one that is uncannily well suited to its subject matter: a past moment of future hope, reimagined in the present.

STILL PHOTOGRAPHY, STILL

In photography something of this loss of faith in speed can be measured against the steady waning of interest in the instantaneous snapshot. As we have seen, it was only from the 1920s, in the shadow of cinema and with the growing dominance of print journalism, that photography became the modulator of the concept of the event. Good photo-reporters followed the action, aiming to be in the right place at the right time.

This lasted until the late 1960s, with the standardized introduction of portable video cameras to news coverage. Over the last few decades the representation of events fell increasingly to video and was then dispersed across a variety of platforms. As television overshadowed print media, photography lost its position as a medium of primary information. It even lost its monopoly over stillness to video and then digital video, which provide frame grabs for newspapers as easily as they provide moving footage for television and the Internet. Today, photographers often prefer to wait until an event is over. They are as likely to attend to the aftermath because photography is, in relative terms, at the aftermath of culture. What we see first "live" or at least in real time on television might be revisited by photographers depicting the stillness of traces.

Thus immersion in subject matter has given way to distance. Sharp reflexes have given way to careful strategy. The small format has given way to the large. Nimbleness and a "quick eye" are passed over as photographers attune to the longer wave rhythms of the social world. As a consequence, the photographic image becomes less about the "hot" decisiveness of the shutter and more about the "cold" stoicism of the lens. Where the boundaries between the still and moving image are breaking down, the photographic image circulates promiscuously, dissolving into the hybrid mass of mainstream visual culture. But where photography attempts to separate itself out and locate a particular role for itself, it is decelerating, pursuing a self-consciously sedate, unhurried pace. Slower working procedures are producing images more akin to monuments than moments. Many of the defining photographic projects of the last decade or so have been depictions of aftermaths and traces in the most literal sense. They include projects as diverse as Joel Meyerowitz's documentation of Ground Zero in New York; Paul Seawright's and Simon Norfolk's images of the traces of war in Afghanistan; Robert Polidori's records of the damage wrought by Hurricane Katrina on New Orleans; and Sophie Ristelhueber's images of the sabotaged Kuwaiti oil fields in 1991. In all of these examples photography has reengaged its forensic function, although none of these photographers make images resembling police pictures. Instead, forensic attention to traces is spliced with an almost classical sense of place typical of traditional landscape photography. Just as the medium has been sidelined from events, these image-makers find their outlet away from the popular press, in the expanded field of fine-art photography. In parallel to this, others have focused on the time *before* the event. At first glance, An-My Lê's series *29 Palms* looks like battlefield photographs from a contemporary war zone. In fact they document the military preparations of U.S. Marines on American soil for conflict in the Middle East. This is not the "theatre of war" but its rehearsal studio. Similarly, Adam Broomberg's and Oliver Chanarin's *Chicago* (2005) documents a mock Palestinian settlement built deep in the Israeli desert for the training of troops.

That many photographers now work in these "late" or preemptive ways is not just a consequence of their coming to terms with the marginal status of the medium. It is also a question of coming to terms with the idea that documentary and photojournalism are now thoroughly allegorical. These photographers know full well their restrained

images are read through the barrage of mass media coverage of the events they so studiously avoid.[25]

BODY, GESTURE, ACTION

How does the dialectic of stillness impact upon the representation of the human body? Let us consider "posing" and "acting" as two distinct modes of bodily performance. We might associate acting with unfolding or "time-based" media like cinema or theatre. Posing may suggest the stillness of photography or painting. Of course plenty of examples complicate this. Think of scenes of arrest such as the *tableau vivant* in theatre, cinema's close-ups of faces in stilled contemplation, blurred gestures caught but escaping a long exposure, or narrative scenes acted out for the still photograph. Such things are too common to be exceptions.

In Alfred Hitchcock's *North by Northwest* (1959) Cary Grant's entire performance is a series of balletic swoops and pirouettes strung between archly frozen poses. He is on-screen almost the whole time and his intermittent halts provide the suspense in the hurtling story of mistaken identity. Early in the film, he stoops to aid a man who has been knifed in the back. Stunned, Grant puts his hand on the weapon and becomes easy prey for the incriminating flash of a press photographer. We see the resulting image on the cover of a newspaper: his indecision has framed him decisively. He flees in a panic, setting the plot in motion.

Grant's performance is a slick and knowing commentary on the very nature of screen presence. Each pose is a wink to the audience that he is toying with his own identity and celebrity. Fans knew Grant began life as plain Archibald Leach, a circus tumbler from Bristol. In the film he plays Roger Thornhill, an advertising executive mistaken for the nonexistent spy George Caplan. Grant holds his poses for longer than is strictly necessary, long enough for the story to fall away momentarily and allow the audience to stare at a man with four identities.[26] At one point Grant breaks in through a hospital window. A woman in bed yells "Stop!" first in shock, then with a comic swoon. What if your movie heartthrob really did spring to life from a frame on your bedroom wall? Grant's technique, much like Hitchcock's, is extravagant but it differs from convention only by degree. Hollywood performances, especially in thrillers and dramas, crisscross between filmic character and the excesses of star persona, between acting and posing.[27]

We see the opposite in the films of the French director Robert Bresson, whose pared-down style avoids all excess. Bresson disliked the very idea of stars and cast nonprofessionals, avoiding even the term *actor* and its theatrical implications. He preferred the term *model*, which recalls the still photograph or the painter's studio. He had his models drain their actions of as much theatre as possible, insisting they perform over and over in rehearsal until they could do it without thought or self-consciousness. Bresson writes in his only book, "No actors (no directing of actors). No parts (no playing of parts). No staging. But the use of working models taken from life. BEING (models)

instead of SEEMING (actors)." Later he notes "Nine-tenths of our movements obey habit and automatism. It is anti-nature to subordinate them to will and thought."[28] *Pickpocket* (1959) may be Bresson's most complete exploration of the approach, since what happens on-screen mirrors his own method. The film follows the career of a pickpocket as he trains himself relentlessly, perfecting his technique. The result is a performance in which everything and nothing looks controlled as the pickpocket "goes through the motions" possessed of an inner stillness, even when moving.

The grammar of cinema distinguished itself from filmed theatre through montage and the close-up. The close-up is a pause in the narrative flow, a stable image close to the halting stare of the photograph. In early cinema, close-ups were lit by the conventions of studio portrait photography. But other photographic references soon emerged. Buster Keaton modeled his stone-faced persona on Matthew Brady's portraits of soldiers from the American Civil War, mimicking them directly in *The General* (Buster Keaton, 1927). Keaton had a huge popular following but he was equally admired by the European avant-garde, who saw in his performances something of the tension between the organic and the inorganic life that comes with modernity. While his body was capable of breathtakingly agile movement (he was a supreme athlete), his expression remained immobile, showing no strain or emotion. At times the disconnection was stark. In *The Cameraman* (Edward Sedgwick, 1928), Keaton dashes across town to meet his girlfriend. The camera tracks alongside at he races down a busy sidewalk, his limbs a machinic blur while his face is perfectly still.

Similarly, in the final moments of *Queen Christina* (Rouben Mamoulian, 1933), Greta Garbo stares out impassively from the prow of a ship, an "untamable," restless woman. She holds herself as still as a photo, looking to the horizon as the camera nears. The shot is held, letting us know she is at the eye of her own emotional storm, "sailing onward." It is one of popular cinema's most celebrated scenes, but its effect is not purely cinematic. The image clearly echoes the countless publicity pictures that had already made Garbo's face famous.[29] The impeccable stillness of her face is offset by the wind that ruffles her hair. The little movements let us know time is passing, while signaling the unpredictability of her future. Both photography and cinema find this kind of chaotic movement highly photogenic. Consider the well-known publicity still from Victor Sjöström's *The Wind* (1928): A young Lillian Gish digs the dry earth as a dust storm engulfs her. For publicity stills, hair is usually groomed to perfection, but hers is a mess, obscuring her face. The film's real star was the wind itself and it looks magnificent in this technically impressive vision of semicontrolled chaos. Gish's apparent loneliness belies the reality of the shoot. She recalled, "It is, without any doubt, the most unpleasant picture [film] I've ever made, the most uncomfortable to do. I don't mind the heat so much, but working before the wind-machines all the time is nerve-racking. You see, it blows the sand, and we've put sawdust down, too, because that is light and sails along in the air, and then there are smoke-pots to make it all look even dustier. I've been fortunate. The flying cinders haven't gotten into my eyes, although a few have burned my hands."[30]

In 1993 the photographic artist Jeff Wall paid homage to wind with an equally complex production. His *A Sudden Gust of Wind (after Hokusai)* is a "decisive moment" assembled digitally from dozens of separately shot elements. Wall made the picture with the help of actors, assistants, and a wind machine. The result does not look like a composite since it obeys the rules of the coherent, singular photograph. But once we sense or know it may be a composite, many things change, not least our relation to the wind blowing through it. It becomes a curiously airless image, certainly compared to the still of Gish. Wind animates Wall's picture at a level more conceptual than actual. It captures an idea, not a sudden gust. Moreover, there is an improbable perfection in Wall's picture. The bleak setting on the dirt ground cannot quite anchor its realism. It is as if photographic arrestedness, so in thrall to the decisive moment as a "slice of life," demands imperfection somewhere. Perhaps Wall's perfectionism is its own deliberate undoing, allowing the viewer an entry point. Indeed, formal perfection in art often seems to have this effect. In other contexts, however, the stakes are quite different. Compare Wall's image to Don McCullin's reportage shot of a Turkish gunman in Cyprus. The light, gestures, setting, and composition are all so "right" here that an aesthetic distance threatens to intrude, undermining the intended urgency. McCullin was reluctant to use it in a news story, since for him it seemed too much like a film still from a war movie.[31]

FREEZE FRAME

No image seems more immobile than the freeze frame. Dramatized by movement, it is a species of still image that exists only in film. Most often the freeze frame is a sign of a director or editor exercising control over the film, and indeed the audience. Its sudden arrival always comes as a surprise to the viewer. So it is no surprise at all that it is most common in "auteur" cinema and particularly popular with self-consciously cinephile filmmakers. Its effect is never less than powerful, but because it is such a tempting trick, it has given rise to as many blunt clichés as thoughtful insights about stillness and movement. For all their variety, what is most striking about freeze frames is that we cannot help but read them as photographs. Technically speaking, they are of course single photographic frames repeated to give the illusion of time at a standstill, but we tend to read them *culturally* as photographs too. The moment we register that the image is a freeze, we have in place a number of possible ways to read it photographically: as a poignant snapshot, a telling news image, a family album photo, or a mythic emblem. Indeed it is difficult to imagine a freeze frame resistant to a photographic reading.

As early as the 1920s filmmakers made a virtue of this. In *People on Sunday* (Robert Siodmak and Edward G. Ulmer, 1930), we see a photographer shooting informal portraits in a park with his camera and tripod. As his sitters gaze into his lens, we see their faces in direct address. Shuffling and smiling awkwardly, they either strike poses or let themselves be snapped by the photographer (to pose is to turn oneself into a photograph

and preempt its unpredictable arrest). As the frame freezes each face in turn, we read the halts as clicks of the photographer's shutter, the stilled frames doubling as his still photographs. The sequence then switches to a series of frozen faces with no movement, then to moving shots that leave the viewer to imagine the freeze, and finally to a series of typical nineteenth-century salon portraits, as if it were not clear enough already that the itinerant photographer was replacing the formal studio.[32]

Stanley Donen's fashion satire *Funny Face* (1957) exploits relentlessly the freeze-as-photograph. Fred Astaire plays the glamorous photographer Dick Avery (based on Richard Avedon, who was the film's visual advisor). Audrey Hepburn plays an intellectual bookseller bribed into being a model. The entire film is geared around a sequence of location fashion shoots, each culminating in a freeze frame that corresponds to the snap of the photographer's shutter. In the first, Hepburn is gauche, the photographer grabbing the moment he needs from her uncertainty. By the last, she can anticipate him, freezing herself in prepackaged "spontaneity."

The year the film was released, the cultural critic Roland Barthes contrasted the faces of Garbo and Hepburn. Emerging from silent cinema as the embodiment of a collective wish for timeless and platonic beauty, Garbo's immobile visage was "an idea"; Hepburn's, with its endless expressions, was "an event."[33] Each was filmed in ways that confirmed this. The staring lens of Garbo's lingering close-ups contrasts with the eventful poses and freezes of Hepburn. Ten years on from *Funny Face,* in the other well-known fashion film *Blow-Up* (Michelangelo Antonioni, 1966), the face was neither idea nor event but had become a non-event. The film dwells on the sourness of commercialized glamour and the defining image is of the model Veruschka, who haunts the film with the vacant demeanor of a somnambulist, barely able rise above her lack of interest in the world. (Among other things *Blow-Up* signals the beginning of fashion's cultivated boredom.) At one point someone says to her, "I thought you were in Paris." She replies indifferently, "I am in Paris." Antonioni's long takes highlight Veruschka's apparent indifference to time itself.

Cinema tends to freeze the idealized instant—the pinnacle of the action, the clearest facial expression, or the perfect composition. In other words, it is drawn to the moments action photographers tend to prefer. Think of the car in the concluding freeze frame of *Thelma and Louise* (Ridley Scott, 1991), held at the peak of its arc so we are saved from seeing the heroines plunge into the ravine, or the runner/soldier in Peter Weir's *Gallipoli* frozen at the moment he is shot. Chest out and head thrown back, he recalls Robert Capa's famous Spanish Civil War photo of a shot soldier, combined with an athletic photo finish. Or *Butch Cassidy and the Sundance Kid* (George Roy Hill, 1969), in which the outlaws are memorialized as they run into a hail of gunfire, the freeze fading hastily to sepia to convert their violent demise into mythic destiny. Others directors adapt the freeze to expository ends. Martin Scorsese frequently turns his players into momentary portraits. In *Goodfellas* (1990), Ray Liotta's face is held as he witnesses a murder and in voice-over he confides, "As far back as I can remember, I always wanted to be a gang-

ster." It is stylish and it feels sharply modern, but it is a classical and thoroughly literary device, updating what is really the nineteenth-century novelist's way of suspending the narrative for a paragraph or so in order to flesh out a character.

The inevitable jolt of the freeze frame stems from more than the sudden switch from movement to stillness. Sound is always disrupted. Sound does not come in frames and cannot be suspended in the same way. The freeze frame must either be left silent (very rare, either in mainstream or avant-garde film) or it is domesticated by nonsynchronous sound such as music or voice-over. But most often, the synch-sound continues after the freeze, emphasizing its silence as much as its stillness. When François Truffaut ended *The 400 Blows* (1959) on a freeze, the silence is almost as striking the stillness. Antoine, the film's restless adolescent hero is running away from the world. In the final act, he finds himself on a beach with nowhere left to go. He slows at the water's edge. The music surges while the sound of breaking waves marks time. As Antoine turns from the sea, his eyes look to the camera as if by accident. The freeze frame catches the glance and zooms tighter into his face, which shows no clear expression. The sounds continue but we sense their disconnection from the image, cutting Antoine off from his surroundings. In that freeze an abyss opens up between the simplicity of what is seen and the complexity of what it may mean. Antoine's face resembles a family snap but also a state identity photo. It could mean a future of frustration in schools and prisons or possible escape. It could suggest robust youth leading to a long life or the imminence of an early death. We cannot tell if this is Truffaut's certainty about how to bring things to a conclusion or his apprehension. Through the still, he manages to end without concluding, opting for what is in effect the essential openness of the photographic image. Rather than taming it, Truffaut lets it loose in all its wild multiplicity, creating what is cinema's most definite and indefinite ending.[34]

While the freeze frame may show the world at a standstill, it cannot articulate the *experience* of such a state. Faced with a freeze, the viewer is thrown out of identification with the image and left to gaze upon its sudden impenetrability. But there are a number of image forms that allude to something between movement and stillness. Since around 1980 the British filmmaker Tim Macmillan has been developing a technique known as time-slice. Multiple cameras arranged around a moving subject are all triggered at once. The resulting images are then sequenced and screened as moving footage. The result resembles a mobile gaze moving through a frozen world. The science-fiction film *The Matrix* (Andy and Lana Wachowski, 1999) made the technique famous, although the directors refer to it more dramatically as Bullet-Time. Although it feels strikingly contemporary, the technology for doing this is as old as cinema, if not older. If Muybridge had fired all his cameras at once and animated the images via his Zoopraxiscope, we might have had a century of time-slice. That it only came into being recently is less an anomaly than a sign of the fact that for any image form to come into existence, it must first be imagined or desired, and imagination and desire are historically grounded. The basic structures of photography and cinema have existed for a long time, but they

have proved flexible enough to accommodate ever-newer conceptions of time, space, movement, and stillness. That is why they are still with us rather than belonging to the nineteenth century. Macmillan's *Dead Horse* (1998), a time-slice film of a horse at the moment it is killed at a slaughterhouse, alludes to this historical delay with its clear reference to the work of Muybridge.

THE ANNIHILATION OF TIME AND SPACE
2004

Rebecca Solnit

Solnit excavates the legacy of Eadweard Muybridge in her signature lyrical prose, taking us to the heart of an understanding of time and space.

In the spring of 1872 a man photographed a horse. The resulting photograph does not survive, but from this first encounter of a camera-bearing man with a fast-moving horse sprang a series of increasingly successful experiments that produced thousands of extant images. The photographs are well known, but they are most significant as the bridge to a new art that would transform the world. By the end of the 1870s, these experiments had led to the photographer's invention of the essentials of motion-picture technology. He had captured aspects of motion whose speed had made them as invisible as the moons of Jupiter before the telescope, and he had found a way to set them back in motion. It was as though he had grasped time itself, made it stand still, and then made it run again, over and over. Time was at his command as it had never been at anyone's before. A new world had opened up for science, for art, for entertainment, for consciousness, and an old world had retreated further.

The man was Edward James Muybridge of San Francisco, already renowned for his photographs of the West.[1] In the eight years of his motion-study experiments in California, he also became a father, a murderer, and a widower, invented a clock, patented two photographic innovations, achieved international renown as an artist and a scientist, and completed four other major photographic projects. These other projects are also about time: about the seasonal and geological time of landscape, about the difference between the time that the camera sees and the eye sees, about a war between two societies with radically different beliefs about time and space, about the passage of a midsummer day's sunlight across a city in turmoil. The experience of time was itself changing

dramatically during Muybridge's seventy-four years, hardly ever more dramatically than in the 1870s. In that decade the newly invented telephone and phonograph were added to photography, telegraphy, and the railroad as instruments for "annihilating time and space." The big corporations were spreading their grasp across wider spaces and into more subtle interstices of everyday life. The Indian wars were reaching their climax and their turning point. The modern world, the world we live in, began then, and Muybridge helped launch it.

Muybridge produced more successful high-speed photographs than anyone had before. His 1878 camera shutters were a triumph of engineering that made reliable exposures of a fraction of a second for the first time, a speed at which extremely rapid motion could be captured in focus rather than recorded as blurs. The photographs were also a triumph of chemistry, which made the film "fast" enough to record so brief an instant. They froze motion so that the legs of a trotting or galloping horse, then a leaping man, and eventually the movements of lions, doves, dancing women, water spilling, artists drawing, could be depicted as a sequence of still images. At the same time, Muybridge improved upon the zoetrope, a small device invented in 1834 that makes a series of spinning images seen through a slot appear to be a single image in motion. His zoopraxiscope, as he called it, projected versions of his motion studies on a screen: moving pictures, pictures of motion. It was the first time photographs had dissected and reanimated actual motion, and it was the foundation of cinema, which emerged tentatively in 1889, in full force in France and the United States by 1895. Motion pictures proper were invented by others, but no matter which way the medium's genealogy is traced, it comes straight back to Muybridge. And motion pictures changed the relationship to time further; they made it possible to step in the same river twice, to see not just images but events that had happened in other times and other places, almost to stop living where you were and start living in other places or other times. Movies became a huge industry, became how people envisioned themselves and the world, defined what they desired and what was desirable. The Russian film director Andrei Tarkovsky thought that time itself, "time lost or spent or not yet had," was what people desired and fed upon in the films that became a collective dreamworld inhabited by multitudes.[2] It all began with photographs of a horse in California.

Occident, the horse that Muybridge photographed in 1872, was one of the fastest trotting horses in the country. At that time trotting races were a national passion, and the great trotters were more celebrated than horses that ran their races. Occident belonged to Leland Stanford, who had brought speed to the country in a far more dramatic way, as one of the four masterminds of the transcontinental railroad completed three years earlier. Once, the North American continent had taken months to cross, and the passage was arduous and perilous. In the decade before the railroad the time had been whittled down to six or seven grueling weeks, barring accidents. With the completion of the railroad those three thousand miles of desert, mountain, prairie, and forest could be comfortably crossed in under a week. No space so vast had ever been shrunk so dramatically.

The transcontinental railroad changed the scale of the earth itself, diminishing the time it took to circumnavigate the globe. Walt Whitman hailed it as the long-dreamed-of "Passage to India."

The railroad had utterly transformed its builders too, into multimillionaires, buyers of estates, commissioners of paintings and photographs, corrupters of politicians, controllers of much of California, managers of one of the most powerful monopolies this country has ever seen. Stanford was the president of their company, the Central Pacific Railroad, and its most visible figure. Governor, senator, thief on a grand scale, he also became a philanthropist on a grand scale with the establishment of Stanford University on the grounds of his vast country estate forty miles south of San Francisco, the site where Muybridge perfected his motion-study technology in the late 1870s. His sponsorship of Muybridge was his first venture into scientific research for its own sake. Stanford University carried and carries on this venture with a hybrid of commercial and pure research that continues to change the world. Like other immensely powerful men, Stanford affected the world indirectly. In person he seems to have been ponderous and a little dull, a respectable effect he may have cultivated, but his impact was, to use a term of the time, electrifying. Spatial changes on a continental scale, technological innovations, influences on national policy and the national economy, the thousands of men who worked for him, the vast edifices and institutions that arose under his direction, and the countless lives he affected are his real expression. His support and encouragement of Muybridge is not the least of these impersonal effects.

In the spring of 1872, a man photographed a horse. Stanford commissioned the photographs in the hope that they would solve a debate about whether a trotting horse ever has all four feet off the ground at a time. Muybridge's first photographs gave an affirmative answer to that minor scientific question, but by later in the decade he realized that the project had broader possibilities and got Stanford to underwrite his development of them. He told an associate he was going to "revolutionize photography" with the technique he developed, and he did. The story of what Muybridge accomplished with Stanford's support is a peculiarly California story. Much has been written about the artistic and literary modernism that was born in Paris, but only high culture was born there, though that high culture was a response to the pervasive alienations and liberations brought by industrialization. Another part of the modern world came from California, and this part was and is an amalgamation of technology, entertainment, and what gets called lifestyle that became part of everyday life for more and more people around the world and a form of industrialization itself. Perhaps because California has no past—no past, at least, that it is willing to remember—it has always been peculiarly adept at trailblazing the future. We live in the future launched there.

If one wanted to find an absolute beginning point, a creation story, for California's two greatest transformations of the world, these experiments with horse and camera would be it. Out of these first lost snapshots eventually came a world-changing industry, and out of the many places where movies are made, one particular place: Hollywood.

The man who owned the horse and sponsored the project believed in the union of science and business and founded the university that much later generated another industry identified, like Hollywood, by its central place: Silicon Valley. Hollywood and Silicon Valley became, long after these men died, the two industries California is most identified with, the two that changed the world. They changed it, are changing it, from a world of places and materials to a world of representations and information, a world of vastly greater reach and less solid grounding. Muybridge's life before those eight years of the California motion studies was a preparation for that phenomenal productivity; his life afterward only polished, promoted, and enlarged upon what he had accomplished in those years. This book [*River of Shadows*, 2003] is about those years that followed upon that encounter between photographer and racehorse and about that man who seems in retrospect like a bullet shot through a book.[3] His trajectory ripped through all the central stories of his time—the relationship to the natural world and the industrialization of the human world, the Indian wars, the new technologies and their impact on perception and consciousness. He is the man who split the second, as dramatic and far-reaching an action as the splitting of the atom.

Muybridge was forty-two when he began the motion studies, and he had been traveling toward this achievement down a circuitous path. He had been born Edward James Muggeridge on a street in Kingston-upon-Thames paralleling the banks of the Thames, not far upriver from London, on April 9, 1830. An ancient market town, Kingston had a millennium earlier been the place where seven Saxon kings of England were crowned.[4] The lump of sandstone said to be their coronation stone was, with great ceremony, rescued from its long role as a mounting block and raised on a pedestal in the center of town in 1850. On the pedestal below this molar-shaped stone were carved the names of those kings, including two Eadweards. Though Muybridge wouldn't change his first name to Eadweard until his visit to England in 1882, he likely derived it from this monument (he changed his surname twice, to Muygridge in the 1850s and to Muybridge in the 1860s).

His own birthplace and childhood home was a row house only a few dozen feet away from the coronation stone, on the other side of one of the oldest surviving road bridges in Britain, a twelfth-century bridge across a small tributary of the Thames on which locals liked to idle and gossip. At the time, the town's buildings and pace of life seemed hardly changed over centuries: the mayor walked to church amid a procession every Sunday, the market square bustled, a night watchman patrolled the streets, locals got their water from the town pump and their beer from the many public houses. Muybridge's father, John Muggeridge, was a merchant dealing in grain and coal, and the ground floor of the family home had a wide entrance for horses and wagons to come through with their loads.[5] John and Susan Muggeridge and their four sons lived above, in compact rooms whose back windows looked out onto the broad Thames itself, and some of the family business must have been conducted by barge. Like Stanford, Muybridge was born into a quiet commercial family in a provincial town, and like Stanford had he stayed where he was he might have lived and died having made hardly a ripple

in history. It was California that set them free to become more influential than they could have imagined. Or California and the changing world around them, for their fame was achieved by taking hold of those changes and pushing them further. The year of Muybridge's birth and the years of his childhood saw a set of inventions and discoveries that set the stage for his own.

John Muggeridge died in 1843, and like her mother before her Susan Muggeridge took over her husband's business and seems to have run it successfully, for in 1845 the corn and coal business was listed in her name. Muybridge's grandfather Edward Smith had died when his wife, Susannah Norman Smith, was pregnant with her ninth child. She assumed command of his flourishing barge business and ran it successfully until she passed it on to her older sons, and she presided regally over her large family and larger workforce for decades afterward. When Susannah Smith died at a great age in 1870, she owned more than a dozen houses and considerable other property, though the barge business with its stables of powerful horses seems to have unraveled. Barges had transformed the transport of goods in England before railroads arrived, and the man-made canals built in the late eighteenth and early nineteenth century to accommodate them had transformed the English landscape. Before, most communities had relied largely on local materials for building supplies, provisions, and other materials. Roads were bad and sometimes dangerous, horses were expensive, and each village and town lived in a kind of isolation hard to imagine now. Most people who wanted to get somewhere walked, and many lived and died having never gone farther than a day's walk from home. By the early nineteenth century a carefully coordinated stagecoach system with horses changed every dozen miles or so brought traveling speeds up to ten miles an hour for those who could afford its exorbitant charges, and the coaches seemed reckless and godlike in their swiftness.

Goods moved on barges along canals dug into the landscape, and the barges themselves were a slow-moving business. Muybridge's cousin Maybanke Susannah Anderson recalled that when their grandfather Edward Smith "drove in his gig to London, to buy wheat or coal, he took under the seat of his gig, a carrier pigeon, and in his pocket a quill or two, and when he bought a cargo, he wrote on a small piece of paper the number of barges he needed, put the paper in the quill, tied it under the wing of the pigeon and set it free. Someone watching for the bird's arrival unfastened the quill, took the message to the barges, and they started."[6] Pigeons were the fastest communications technology; horses were the fastest transportation technology; the barges moved at the speed of the river or the pace of the horses that pulled them along the canals. Nature itself was the limit of speed: humans could only harness water, wind, birds, beasts. Born into this almost medievally slow world, the impatient, ambitious, inventive Muybridge would leave it and link himself instead to the fastest and newest technologies of the day. But that world was already being transformed profoundly.

On September 15, 1830, less than six months after Muybridge's birth, the first passenger railroad opened. The celebrated young actress Fanny Kemble had been given a

preview of the Manchester and Liverpool Railroad that August. In a letter to a friend she exclaimed, "The engine . . . set off at its utmost speed, thirty-five miles an hour, swifter than a bird flies (for they tried the experiment with a snipe). You cannot conceive what that sensation of cutting the air was; the motion is as smooth as possible too. I could have either read or written; and as it was, I stood up, and with my bonnet off 'drank the air before me.' . . . When I closed my eyes this sensation of flying was quite delightful, and strange beyond description."[7] Thirty-five miles an hour was nearly as fast as the fastest horse, and unlike a gallop, it could be sustained almost indefinitely. It was a dizzying speed. Passengers found the landscape out the train windows was blurred, impossible to contemplate, erased by speeds that would now seem a slow crawl to us.[8] Those who watched the trains approach sometimes thought they were physically getting larger, because the perceptual change in a large object approaching at that speed was an unprecedented phenomenon. Ulysses S. Grant remembered riding on one of the early railroads in Pennsylvania in 1839 with the same amazement that most early travelers recorded: "We traveled at least eighteen miles an hour when at full speed, and made the whole distance averaging as much as twelve miles an hour. This seemed like annihilating space."[9] If distance was measured in time, then the world had suddenly begun to shrink; places connected by railroads were, for all practical purposes, several times closer to each other than they ever had been.

At the railroad's official opening, Kemble returned to ride with her mother, who was "frightened to death" of "a situation which appeared to her to threaten with instant annihilation herself and all her traveling companions."[10] That celebration of a thousand passengers and almost a million onlookers along the route was interrupted by an actual annihilation, the death of the progressive Tory politician William Huskisson. At a stop to take on water for the steam engines, Huskisson got out to stretch and was hit by an oncoming train. It is hard to imagine today the reflexes and responses that made it impossible to step away from a noisy locomotive going perhaps thirty miles an hour, but Huskisson could not. His leg was run over and crushed. Though the duke of Wellington applied a tourniquet to prevent him from bleeding to death on the spot, he died that evening. In Manchester the duke, who had been the hero of the battle of Waterloo and was now the prime minister preventing the democratization of voting, was greeted with angry cries of "Remember Peterloo." The railroad cars had to retreat hastily. It was no coincidence that the first railroad linked two of the Industrial Revolution's primary sites or that the Manchester workers linked the duke and the new technology to the 1819 Peterloo massacre of workers demanding reform. Industrial workers saw the new market economy as bleak and brutal, and they launched a powerful reform movement in the 1830s to gain a voice in it. The agricultural economy was as grim: the Captain Swing riots in the south of England that season of the first passenger railroad's opening protested starvation wages and wrecked reaping machines. An old order had vanished, to be replaced not by a new one but by turbulence and continual change.

Long afterward, Kemble called this railroad "the first mesh of that amazing iron

net which now covers the whole surface of England and all the civilized portions of the earth."[11] The Industrial Revolution preceded railroads, but railroads magnified its effects and possibilities unfathomably, and these roaring, puffing machines came to seem that revolution incarnate. Often compared to dragons, they devoured coal and iron in unprecedented quantities, spreading mines and mills wherever they went. In the United States, they ran on wood, and whole forests were fed into their boilers, as though the landscape itself were being devoured by speed. Railroads made possible the consolidation of industries and the industrialization of traditional activities. The fast, cheap transport of goods meant that a town could be given over to shoe-making or beer-making, a whole region to cattle raising or wheat growing, and people grew used to depending upon commodities that seemed to come from nowhere. The New England philosopher Ralph Waldo Emerson opined in 1844, "Not only is distance annihilated, but when, as now, the locomotive and the steamboat, like enormous shuttles, shoot every day across the thousand various threads of national descent and employment, and bind them fast in one web, an hourly assimilation goes forward and there is no danger that local peculiarities and hostilities should be preserved."[12] He saw the network of railroads undoing the local character of every place and approved of the erasure. People were being drawn out of their small familiar worlds into one more free, less personal, in which the associations that once attached to each person, place, and object came undone. It was a leap forward of extraordinary liberation and equal alienation.

Grant and Emerson were sounding variations on one of the stock phrases of the day, "the annihilation of time and space," which was applied over and over to railroads and other new technologies.[13] "Annihilating time and space" is what most new technologies aspire to do: technology regards the very terms of our bodily existence as burdensome. Annihilating time and space most directly means accelerating communications and transportation. The domestication of the horse and the invention of the wheel sped up the rate and volume of transit; the invention of writing made it possible for stories to reach farther across time and space than their tellers and stay more stable than memory; and new communications, reproduction, and transportation technologies only continue the process. What distinguishes a technological world is that the terms of nature are obscured; one need not live quite in the present or the local.

Between the time of the Roman Empire and the dawn of the industrial age, wheel-drawn transportation, roads, and ships were improved, but only the printing press made a major alteration in means. Afterward, the devices for such annihilation poured forth faster and faster, as though inventiveness and impatience had sped and multiplied too. Nothing annihilated more dramatically than railroads. As people and goods traveled more frequently and farther, experience was standardized. Distance had always been roughly measurable in time, the stable time of human or equine locomotion, but the railroad transformed those equations, shortening the time and thereby seeming to decrease the distance. The world began to shrink, and local differences to dissipate. People could go much farther because places were not, in terms of time, so far apart,

nor was travel so expensive. Distance was relative; a technological infrastructure could shrink it spectacularly. Early in the twentieth century, when Albert Einstein reached for metaphors to explain his theory of relativity, he repeatedly seized upon the image of a train running across the landscape, a train whose passengers were experiencing time differently than those on the ground.

Railroads transformed the experience of nature, and they transformed the landscape itself. Kemble had been amazed by the cuttings, tunnels, and viaducts that leveled the route of the Manchester and Liverpool Railroad, raising the train far above and dropping it below the surface of the earth. "I felt as if no fairy tale was ever half so wonderful as what I saw," she said.[14] Amateur geologists found a rich resource in the railroad cuttings that laid bare Britain's rock and fossils. Geology was the key science of the Victorian era, as physics was of the modern era and perhaps genetics is today, and in that era geology texts sometimes outsold popular novels. One such book was Charles Lyell's *Principles of Geology*, whose first volume was published the year of Muybridge's birth and Kemble's ride. Geologists had begun to debate the age of the earth. Bible scholars asserted that the earth was only about six thousand years old. Its rocks suggested a far greater age to those who studied them, but they did not agree among themselves how old. Catastrophists argued for a comparatively young earth in which forces far more violent than those presently at work had wrenched and welded its topography, and some still claimed Noah's flood had placed aquatic fossils in the heights. The uniformitarians believed that earthquakes, volcanoes, erosion, and other forces still at work must have gradually shaped the earth, and it must be far more ancient than had ever been imagined. Lyell had gone to Sicily to study Mount Etna and concluded that its massive cone was the result of aeons of small eruptions, and that cone sat atop relatively young rocks. His uniformitarian *Principles* portrayed an earth whose age was in the millions of years.

The railroad shrank space through the speed of its motion. Geology expanded time through the slowness of its processes and the profundity of its changes. When they subscribed to the old biblical scale of time, human beings seem to have marched as confidently as elephants, sure they were center stage in a drama whose beginning and end were near at hand and whose set changes were slight. In the new industrial and scientific sense of time, they swarmed and darted like insects, quick but uncertain of their place in a cavalcade of unimaginable length. Expelled from the cozy millennia of biblical time, Lyell's wide audience found itself on a vast plateau of millions of years of geological time. As his colleague George Poulett Scrope put it in 1829, "The periods which to our narrow apprehension . . . appear of incalculable duration, are in all probability but trifles in the calendar of Nature. It is Geology that, above all other sciences, makes us acquainted with this important though humiliating fact. . . . The leading idea which is present in all our researches, and which accompanies every fresh observation, the sound to which the student of Nature seems continually echoed from every part of her works, is—Time! Time! Time!"[15] It was geology, specifically Lyell's book that he took with him on the *Beagle*'s sail around the world from 1831 to 1836, that would lead Charles

Darwin to his theory of evolution, and that theory would further transform the place of human beings on the stage of life, more distant from God and closer to the other species. Muybridge, by photographing human beings as "animals in motion" among other animals, took a Darwinian stance.

At the far end of the decade of the railroad's arrival came a third great transformer of time: photography. The Industrial Revolution is most often represented by the bleak textile mills of the British Midlands. But the same steam engines that drove the factories drove the railroads, and though railroads required mines and manufactories, they themselves produced exhilarating effects. Photography is equally a technology of its time, but it generated few such impositions on the landscape or on workers; it was an artisan's technology (though photographic factories came into existence by the late nineteenth century, and every version of the medium has involved toxic chemicals, starting with mercury and cyanide). It did not impose itself on the world but interpreted it, transporting appearance as the railroad transported matter. As a technology, it requires a very different argument about effects and merits than the heavy-duty icons of the Industrial Revolution. For if railroads and photography had one thing in common, it is that they brought the world closer for those who rode or looked. While the dull, repetitive toil of the factories seemed like slavery, these technologies often seemed liberatory.

The brothers Nicéphore and Claude Niépce had begun working on the chemistry of photography in the teens, as had Louis-Jacques-Mandé Daguerre in the 1820s, while the Englishman William Henry Fox Talbot took up the challenge in 1833. Just as the date that counts for the railroad is not that of the invention of the steam engine or the railroad track or the locomotives hauling coal in remote mines, but the date that railroads began to transform public experience, so photography was nothing but a desire, a few premature announcements, and a few faint images before January 7, 1839. That day, Daguerre publicly announced his invention of the photographic method he called daguerreotypy, prompting Talbot to rush to announce his own breakthrough later that January. (In much the same way, the American painter Samuel F. B. Morse and the Englishmen William Fothergill Cooke and Charles Wheatstone invented electric telegraphy at virtually the same time in the early 1840s, and Darwin overcame his long reluctance to announce his conclusions about evolution when Alfred Russel Wallace announced similar conclusions in 1858.)

Photography was in the air. The hope of making images mechanically rather than manually was widespread, and so was the knowledge of the light-sensitive chemicals and the basic principles of the camera obscura, or dark chamber, whose small aperture casts an image of the outside view within its walls. Photography arose out of the desire to fix the two-dimensional image that the camera obscura created from the visible world, to hold on to light and shadow. That desire was compounded of many elements. There was the enormous value placed on realistic images and accurate representations as part of the European embrace of the empirical and the expansion of knowledge and power (a society whose art was abstract or symbolic and whose goal was stasis might never

crave this verisimilitude). There was the tendency to replace the activities of the hand by machines, just as the railroad replaced the actions of the traveling foot. And there was the restlessness that characterized modern European and then American society, always willing to overturn what is for what might be, that restlessness of exploration, colonialism, science, and invention, of originality and individualism, the restlessness that regarded the unknown as a challenge rather than a danger, time as something to speed up or speed through. Photography may have been its most paradoxical invention: a technological breakthrough for holding on to the past, a technology always rushing forward, always looking backward.

Photography did not appear all at once as we know it now. Talbot's process, the almost universal method of photography since the 1850s, produced a negative image and the possibility of printing multiple positives from that negative. But it was Daguerre's process that dominated the first decade of photography. Daguerre had found a way to make direct positive images on polished plates. Each daguerreotype was unique, since there was no negative and no printing, and the images were small and elusive. The mirrored surface that at one angle showed the image at another showed the viewer looking at the image; it seemed phantasmagorical in a way paper prints would not. Compared to painting, early photography was astonishingly fast, but it required exposures from dozens of seconds to several minutes. Morse, who was in Paris the spring of Daguerre's announcement, wrote back to New York of the new invention, "Objects moving are not impressed. The Boulevard, so constantly filled with a moving throng of pedestrians and carriages, was perfectly solitary, except for an individual who was having his boots brushed. His feet were compelled, of course, to be stationary for some time, one being on the box of the bootblack and the other on the ground. Consequently his boots and legs were well defined, but he is without body or head, because these were in motion."[16] This man having his shoes polished and the blurry bootblack were the first human beings photographed, and it is eerie to look at them apparently alone, but really surrounded by scores who vanished into speed. Photography was faster than painting, but it could only portray the slow world or the still world. People sat for their portraits with braces to hold their heads steady, and in those old portraits fidgeting children are often a blur. Landscapes were photographed on windless days when the leaves wouldn't move and the water was smooth. The bustling nineteenth century had to come to a halt for the camera, until Muybridge and his motion studies.

Even so, photography was a profound transformation of the world it entered. Before, every face, every place, every event, had been unique, seen only once and then lost forever among the changes of age, light, time. The past existed only in memory and interpretation, and the world beyond one's own experience was mostly stories. The rich could commission paintings, the less rich could buy prints, but a photograph reproduced its subject with an immediacy and accuracy art made by hand lacked, and by the 1850s it offered the possibility of mass reproductions, images for everyone. Every photograph was a moment snatched from the river of time. Every photograph was a piece of evidence

from the event itself, a material witness. The youthful face of a beloved could be looked at decades after age or death or separation had removed that face, could be possessed like an object. Daguerreotypes, which were soon sold in elaborately molded cases with cut-velvet linings facing the image that sat within, were alluring objects. Soon countless thousands were lining up to possess images of themselves, their families, their dead children, to own the past. Most daguerreotypes reached out in time to make familiar faces permanent possessions; it was only when the later photographic processes arrived on the scene that photography extended its grasp in space as it had in time. The images piled up, and photography became an industry too. The world was growing larger and more complicated, and photography was both an agent of this enlargement and a device for trying to sort it all out, to own it, to make it manageable. Photography had frozen the river of time, but a torrent of photographs began to pour from the photography studios into homes, pockets, albums, photographs of pyramids, empresses, streets, poets, cathedrals, trees, actors.

Five years after photography, one more technology, telegraphy, arrived to transform time. Telegraph messages traveled almost instantly as electrical impulses over the wires, a technology that telephones and the Internet would only elaborate. "This is indeed the annihilation of space," the *Philadelphia Ledger* exclaimed over the first long-distance telegram in the United States. Many of the early telegraphic lines followed the railroad tracks, and they replaced the railroad as the fastest communications technology. News, words, data were dematerialized and almost instantaneous wherever the telegraph wires were strung. The distance between places that had once been measured at ten miles an hour or less was wavering, drawing closer, almost dissolving. Karl Marx took up that catchphrase of the day when he wrote, "Capital must on the one side strive to tear down every spatial barrier to intercourse, i.e., to exchange, and conquer the whole earth for its market. It strives on the other hand to annihilate this space with time, i.e., to reduce to a minimum the time spent in motion from one place to another."[17] In other words, the more capitalism shrinks space and speeds up time, the more it can profit. In Marx's view, capitalism itself was the engine of the annihilation of time and space, the locomotive its tangible form, and time and space were being annihilated to increase profits. This led to the formation of ever-vaster fortunes and the first modern corporations, even the stock markets whose first major stocks were railroad shares. Capitalism, stocks, corporations, transformed the labor of workers and the materials of the world into that abstraction profit. Labor and materials were themselves abstracted as the one went into the factory to become a series of simple repetitive gestures rather than an authorship of objects, and the objects themselves came to be bought and used by people more and more remote from the process of their making. But these changes also transformed the way everyone touched by the technologies perceived time and space. To use railroad terms, the engine of this cultural and perceptual change was economic.

Before the new technologies and ideas, time was a river in which human beings were immersed, moving steadily on the current, never faster than the speeds of nature—of currents, of wind, of muscles. Trains liberated them from the flow of the river, or isolated

them from it. Photography appears on this scene as though someone had found a way to freeze the water of passing time; appearances that were once as fluid as water running through one's fingers became solid objects. Through the nineteenth century, as Darwin worked out his theories about literal evolution, it is as though consciousness evolved from something utterly immersed in this river to something that clambered onto land. There the atmosphere was thinner, the view was farther, and no current forced these mutating Victorians to move at a set pace—but no water bore them up and carried them along either. And there was no going back. The art of the hand had been replaced by the machinery of the camera; the travel of the foot, human or equine, had been replaced by the pistons of the locomotive; bodies themselves were becoming insulated from nature by machinery and manufactured goods; and memory had been augmented and partly replaced by photography, that freezing eye whose gaze soon reached the corners of the world. Appearances were permanent, information was instantaneous, travel exceeded the fastest speed of bird, beast, and man. It was no longer a natural world in the sense it always had been, and human beings were no longer contained within nature.

Time itself had been of a different texture, a different pace, in the world Muybridge was born into. It had not yet become a scarce commodity to be measured out in ever smaller increments as clocks acquired second hands, as watches became more afford-able mass-market commodities, as exacting schedules began to intrude into more and more activities. Only prayer had been precisely scheduled in the old society, and church bells had been the primary source of time measurement. In the preindustrial world, most work was agricultural, and the time of the year mattered more, the time of day less. Work was done according to task and available light, and tasks varied from season to sea-son. People worked for themselves or worked with masters who were, for better or worse, more than employers. The new age, with its factories and mobilities, its industrial scale, was to be impersonal as nothing had been before. Tightly enforced schedules came in with the factories whose owners sought to calibrate human labor to machine labor, the machine labor that was speeding up the production of goods, thereby speeding up the raking in of profits, the consumption of raw materials, and on and on—a runaway train of consumption driving production driving consumption. It was these factories and rail-roads that made knowing the exact time important, that launched the modern world of schedules and bustle. Goods increased in abundance as, for example, Manchester mills generated cheap cotton fabric, but time was becoming scarcer—literally so for workers putting in fourteen-hour days at the mills and slaves growing cotton on the other side of the Atlantic, apparently so for those in the rush of the growing cities, the greater variety of experiences, publications, images, the hectic greed of that era.

The railroad, the photograph, the telegraph were technologies for being elsewhere in time and space, for pushing away the here and now. They made the vast expanses not so vast, the passage of time not quite so unrelenting. They were celebrated for the very real powers and pleasures they supplied, the real isolations and inconveniences they undid. But there were doubts too about what Thomas Carlyle in 1829 called the Mechanical

Age, and the literature of the time is full of it. Hans Christian Andersen's 1844 tale "The Nightingale" compared the drab, independent-minded real nightingale with its bejeweled mechanical imitation, which sang the same waltz over and over. The court music master approved of the machine's predictability: "For you must perceive, my chief lord and emperor, that with a real nightingale we can never tell what is going to be sung, but with this bird everything is settled. It can be opened and explained, so that people may understand how the waltzes are formed, and why one note follows upon another."[18] But it is the mechanical nightingale that grinds to a halt and finally fails the dying emperor because there is no one to wind it up. The live nightingale returns to sing the emperor back to life, out of an affection beyond the abilities of a machine. In a similar vein, Nathaniel Hawthorne's grimly comic short story of 1846, "The Celestial Railroad," sent a group of pilgrims by railroad across the landscape of the great spiritual allegory *The Pilgrim's Progress*.[19] The harsh terrain John Bunyan's Pilgrim had trod on foot sped by pleasantly, but the train ended up in hell rather than paradise. The old world, Hawthorne seemed to argue, was arduous, but it knew where it was going, and it went the slow, sure way. Machines made life easier, faster, more predictable, but they led away from an integrity that people missed from the beginning. It is said that on the first day of fighting in Paris's July Revolution of 1830, the clocks in the towers were fired on simultaneously and independently from several points.[20] The destruction of machinery would be a hallmark of resistance to industrial regimentation and industrial time up through the nationwide railroad riots of 1877, which involved Stanford and, less directly, Muybridge.

Each event and thought itself must have been experienced at a radically different pace—what was slow then was slower than we could now tolerate, slower than we could pay attention to; while the speed of our own lives would have gone by them like the blur of speed before Muybridge's images or been as invisible as the passersby in that first photograph of the Parisian boulevard Morse described. Distance had a profundity that cannot be imagined now: a relative who had moved a hundred or a thousand miles away often seemed to have dropped over the horizon, never to be seen again, and travel for its own sake was rare. In some psychological and spiritual way, we became a different species operating at a different pace, as though tortoises became mayflies. We see much they did not, and can never see as they did. In 1860, George Eliot mourned the transformation of time with an aside in a novel: "Ingenious philosophers tell you, perhaps, that the great work of the steam-engine is to create leisure for mankind. Do not believe them; it only creates a vacuum for eager thought to rush in. Even idleness is eager now—eager for amusement, prone to excursion-trains, art-museums, periodical literature, and exciting novels; prone even to scientific theorizing and cursory peeps through microscopes."[21]

Out the train window, the landscape disappeared into a blur; traveling was no longer an encounter, however awkward and dangerous, but a transport. It was as though the world itself was growing less substantial, and though some doubted the value of the change, many celebrated it. The year before Eliot mourned leisure, the essayist and judge Oliver Wendell Holmes exulted over the way photographs of the material world

seemed to eclipse their subjects: "Form is henceforth divorced from matter. In fact, matter as a visible object is of no great use any longer, except as the mould on which form is shaped. Give us a few negatives of a thing worth seeing, taken from different points of view, and that is all we want of it. Pull it down or burn it up, if you please. . . . Matter in large masses must always be fixed and dear; form is cheap and transportable. We have got the fruit of creation now, and need not trouble ourselves with the core."[22] In Holmes's account, this dematerialization was liberatory. "Everything that is solid dissolves into air," said Marx of that uncertain era, and Holmes thought that dissolving into air was wonderful, that his generation would rise up like birds into that thinner medium, with a new freedom to see the whole glorious nineteenth-century world as a bird in flight might see it, as small pictures of things far away.

Photographic reproduction would make the world's images and experiences as available as the Manchester mills made cotton fabric. It's not hard to see ahead from Holmes's vision of the photographic revolution to cable television with its torrents of nature documentaries and news reports, comedies and advertisements, but behind it lay the hunger and ignorance of a world where images and information were scarce. One way to describe this transformation of the world whose great accelerations came in the 1830s, the 1870s, and the age of the computer is as increasing abstraction. Those carried along on technology's currents were less connected to local places, to the earth itself, to the limitations of the body and biology, to the malleability of memory and imagination. They were moving into a world where places were being homogenized, where a network of machines and the corporations behind them were dispelling the independence of wilderness, of remoteness, of local culture, a world that was experienced more and more as information and images. It was as though they sacrificed the near to gain the far.

There was no simple dichotomy, however, between nature's pace and the railroad, between images and the natural realm of the senses. It was not long before railroad lines were being built to take people into the landscape for scenic excursions and cameras were being used to make landscape photographs. It is as though the Victorians were striving to recover the sense of place they had lost when their lives accelerated, when they became disembodied. They craved landscape and nature with an anxious intensity no one has had before or since, though they pursued it in new ways: with microscopes and rock hammers, with guidebooks and cameras, with railroad excursions and collections of specimens. They filled their houses with pictures of places, but even the close-ups were often as not of places far away. The ideal landscape seemed formed of a wholeness that was no longer theirs. They looked for this wholeness as a place, and so mostly do we. These histories suggest nature was equally a kind of time or a pace, the pace of a person walking, of water flowing in a river, of seasons, of time told from the sky rather than electrical signals. Natural meant not where you were but how you moved through it, and a woman drifting across London on foot could attain certain harmonies not available to those speeding across the prairie on the express train. But the Victorian age had launched a juggernaut, and slowing down was the single thing hardest to do.

This is the paradox of Muybridge's work. He was using his state-of-the-art equipment to feed that ravenous appetite for place, for time, for bodies. He had turned his back on the slow world of his grandfather's barges and pigeons to embrace the new railroad and photographic technology, and with electricity and chemistry he made the latter faster than ever before. But his work is largely a collection of striking still images of the settlements and wilderness of the West through the mid-1870s, then an avalanche of images of bodies, the bodies of horses, then men, then women, children, camels, lions, vultures, reenacting their most familiar gestures. His inventive technology was depicting the place and the bodies that seemed ever more alienated by technological change, as though what had been lost as direct experience could be, just as Holmes dreamed, recovered as imagery. The speed of Muybridge's invention allowed real motions to be recovered at their own pace, though watching them meant stepping out of one's own time. If the experience that was vanishing can be summed up as a person standing alone in a landscape, then photography and, subsequently, film would offer images of that experience. The very essence of that solitary experience in the landscape, however, was its immediacy, its situation in a resonant here and now, while representations are always about there and then, a substitute, a reminder. Yet Muybridge spent much of his adulthood in some version of that experience, photographing the landscape for the market.

In the spring of 1872 a man photographed a horse. With the motion studies that resulted it was as though he were returning bodies themselves to those who craved them—not bodies as they might daily be experienced, bodies as sensations of gravity, fatigue, strength, pleasure, but bodies become weightless images, bodies dissected and reconstructed by light and machine and fantasy. The movements of horses dismayed artists and amused members of the public when Muybridge's instantaneous photographs revealed them as much more complex and ungainly than the rocking-horse gallopers in paintings. Then he offered his audience of scientists, artists, dignitaries, and connoisseurs the whole world of everyday gesture back. Those gestures—a gymnast turning a somersault in midair, a nude pouring water—were unfamiliar and eerie stopped because they showed what had always been present but never seen. Set into motion, they were uncanny another way when they undid the familiar distinction between representations, which did not move, and life that did. Through the new technologies—the train to the landscape, the camera to the spectacle—the Victorians were trying to find their way back, but where they had lost the old familiar things they recovered exotic new ones. What they had lost was solid; what they gained was made out of air. That exotic new world of images speeding by would become the true home of those who spent their Saturdays watching images beamed across the darkness of the movie theater, then their evenings watching images beamed through the atmosphere and brought home into a box like a camera obscura or a crystal ball, then their waking hours surfing the Internet wired like the old telegraph system. Muybridge was a doorway, a pivot between that old world and ours, and to follow him is to follow the choices that got us here.

12

ON EDITING AND STRUCTURE
2002

Wolf Koenig

Henri Cartier-Bresson, the twentieth-century master of photography, is given homage
by the venerated Canadian documentary filmmaker in his discussion of editing and the
importance of structure.

The editing of a documentary is like creating something out of thin air. The shots
are often unrelated in time and space and yet, by bringing them together correctly,
they begin to attract each other and cohere, like molecules forming a new substance.
In editing—like playing an instrument—one has to know the rules as almost second
nature. Then one has to let go and allow the material to lead you. The shots often tell one
where they should go; one has to be alert and listen. The process of editing, especially
documentaries, is probably the most demanding part of filmmaking and it's also the
most rewarding. In the editing process, the film begins to live. Even ordinary material,
well put together, can really shine. Conversely, good material badly edited can ruin the
project. . . . Film is an ensemble art. This way of working was probably unique to our
gang. Many great films have been made by individuals working solo. [My colleagues and
I were] just more comfortable as a chamber orchestra.

Any of Cartier-Bresson's photographs shows us the truth. He was our inspiration
because he did it so consistently. Clearly, it was no accident for him. He knew exactly
when to trip the shutter. With film, it's a little different. It exists in time, and so the
element of time becomes important. In both cases, though, there's a shared commonal-
ity—and that's structure. Roman [Kroitor]—the great structuralist—used to clutch his
forehead after a rushes screening and ask despairingly, "What's the structure? What's
the structure?" And he was right to ask it, because that's what a film is really about. I've
come to the conclusion in my dotage that "structure" is what all the arts are really about:
music, dance, the graphic arts, the theatre, the literary arts, architecture, poetry, etc.

They show us by inference something that we otherwise can't see. This "something" is invisible to us, like a fir tree in the dark, but come Christmas time, people hang lights all over the boughs. At first one only sees the lights, but if you step back a bit and squint, you see the shape of the tree, even though the tree itself is still invisible. The lights define it, so we're able to see it by inference. In this labored analogy, the lights represent the "arts" and the tree the "structure." And the structure is what permeates the universe from the subatomic particle to the whole cosmos; in effect, we are all little lights hung on the invisible tree. And the arts are about the only way we have of talking about this thing: structure or truth. So you are quite right to raise the question. Truth is what it's all about, isn't it?

13

FLICKERING SCREENS
Posted on February 5, 2008

Ai Weiwei

The screen and its moving images are a palimpsest revealing everyday life, past and present, in this entry from the artist and activist Ai's influential blog.

When I was young, movies were shown in the village square. As soon as a movie would come on, the entire village would light up. There was no electricity in the village, only oil lamps, and even though the light was only from the film, we would unconsciously cover our eyes with our hands, it seemed that bright.

Each time a film finished screening in our village, it was passed on to the neighboring village to be screened again. We would travel with it, carefully placing one foot after another in the irregular soil of the fields and on the dark roads. The scene was something like pious devotees on a religious pilgrimage.

In truth, those were tedious and boring times, and the films weren't even that interesting. Perhaps it was precisely for this reason that we liked the villains in the films: they always seemed different from the rest.

Generally speaking, I enjoy Hollywood films and never paid much attention to Chinese-language films or to Asian cinema. But now, I don't limit myself to Hollywood, because my affections for Asia and China are gradually increasing, an affection inspired by the latest generation, their lifestyle, the way they express emotions, and their ability to endure pain.

The greatest difference between Asian and European or American films is faith. Some people have faith, and some films are an expression of faith, but in China the latter is a rarity.

When we say films from any certain culture are "good," I don't believe we are merely talking about the film itself. We can see the state of the entire culture from the film:

Are there bravery and passion? Is the culture rich in illusion? What kind of hardships do they endure? Chinese film is lacking the ability to express what kind of an era we live in and what the characteristics of that era are.

The overall aesthetic and philosophy of Chinese films can be rather frenetic, even deranged. But if you wonder whether or not Chinese film will surge forth, I think that it will. After all, China is a nation that likes to express itself—just look at karaoke. I think it's psychotic how many people love singing karaoke.

If only Chinese film could be like the karaoke industry, and everyone were able to make his or her own films. Film industry people surround me, and it seems as if the system gives them absolutely no support, so they search elsewhere for encouragement; overseas film festivals are just one example. At the same time, people only rarely have the power to make films, to work with more powerful entities, or to angle for their own benefits.

When working with unfair standards, all one can do is create deformities. Ultimately, these circumstances produce two kinds of people: victims of the larger environment and opportunists. There is no self-respecting, enlightened cultural class here; instead people are all looking for their piece of the pie. But such is the state of culture in China; everyone has become this way, not a single person is an exception. Young directors are often too eager to reap benefits fast, and they just embarrass themselves: The present state of culture is already such a mess, and you hope to earn some glory from it? The vegetable market has been trashed, and you're really hoping to steal a few edible fruits off the floor? It's embarrassing to be too immature to know better.

If I were making a film about life, I would pay more attention to reality. Reality is extremely harsh, but the subject must be broached. I've said before that all the defects of my era are reflected in my person, and if I were filming, I would be unscrupulous. Are you ashamed by your lifestyle? Or do you want to live by someone else's standards? We shouldn't pay attention to social taboos; we should pay attention to what we ought to be doing. The heavens will rain, but what will you do?

I watch films just as arbitrarily as I eat at a banquet or order take-out; it's all the same to me. Generally, I won't go to see a film alone, but always with friends. In New York, cinema is a public ritual, where everyone stands in line together chatting while waiting in line. But watching DVDs in your home is a different mode of viewing: you can watch ten films in one night, you can fast forward, or you can start watching from the middle. You can integrate the films into your actual life. This mode of viewing has changed film narrative and how we interpret movies.

Films don't necessarily need ticket sales, nor must they be entertaining. If that were the case, the world would be awfully boring. Is popular taste influencing culture, or are films influencing the public's interest? The answer can't be only one possibility. I like films that are easy to watch, but I take greater pleasure in "difficult" films. Of the films I've seen lately, *The Sun Also Rises* by Jiang Wen has left the greatest impression on me. Everyone is saying, "Ticket sales are low; director Jiang Wen is finished." But using such

inferior logic, simply the fact that such an "old" director as Jiang Wen would make such a film earns him my respect. As an artist in the spotlight, the audience is paying a few RMB for the right to damage him.

Our films are becoming increasingly oriented toward pure entertainment. The moment the crowds pile into the cinema, directors' tongues begin to tingle with joy. Recently I watched Kurosawa's *Dodesukaden*. I think that most people would also enjoy it. Fifteen years ago I saw Hou Hsiao-Hsien's *A Time to Live, a Time to Die* in a New York cinema. His narrative style, personal memories, and control are quite realistic, and they pulled me into the film. When I'm watching current films, I often can't even remember what happened.

Tarkovsky. Everyone talks about Tarkovsky so often, but I still think that he is the best. All of his films are good—*Nostalghia,* or *Zerkalo;* he is able to unify individual faith, literature, poetry, and the cinematic language into one integral whole. Many people have mastered one of these qualities, but it is difficult to achieve so many simultaneously; he has mastered them all.

The ultimate filmgoer would be a captive of sloth. Sitting constantly in a movie house, among the flickering shadows, his perceptions would take on a kind of sluggishness. He would be the hermit dwelling among the elsewhere, foregoing the salvation of reality. Films would follow films, until the action of each one would drown in a vast reservoir of pure perception.

Robert Smithson, "A Cinematic Atopia," 1971

14

A LECTURE
1968

Hollis Frampton

Frampton, a seminal thinker on the role of images and technology, demonstrates in the script for his famous performance piece that there is an experiential and performative aspect of any viewing experience.

Please turn out the lights.

As long as we're going to talk about films, we might as well do it in the dark.

We have all been here before. By the time we are eighteen years old, say the statisticians, we have been here five hundred times.

No, not in this very room, but in this generic darkness, the only place left in our culture intended entirely for concentrated exercise of one, or at most two, of our senses.

We are, shall we say, comfortably seated. We may remove our shoes, if that will help us to remove our bodies. Failing that, the management permits us small oral distractions. The oral distractions concession is in the lobby.

So we are suspended in a null space, bringing with us a certain habit of the affections. We have come to do work that we enjoy. We have come to watch *this*.

The projector is turned on.

So and so many kilowatts of energy, spread over a few square yards of featureless white screen in the shape of a carefully standardized rectangle, three units high by four units wide.

The performance is flawless. The performer is a precision machine. It sits behind us, out of sight usually. Its range of action may be limited, but within that range it is, like an animal, infallible.

It reads, so to speak, from a score that is both the notation and the substance of the piece.

It can and does repeat the performance, endlessly, with utter exactitude.

Our rectangle of white light is eternal. Only *we* come and go; we say: This is where I came in. The rectangle was here before we came, and it will be here after we have gone.

So it seems that a film is, first, a confined space, at which you and I, we, a great many people, are staring.

It is only a rectangle of white light. But it is all films. We can never see *more* within our rectangle, only *less*.

A red filter is placed before the lens at the word "red."

If we were seeing a film that is *red*, if it were only a film of the color red, would we not be seeing more?

No.

A red film would *subtract* green and blue from the white light of our rectangle.

So if we do not like this particular film, we should not say: There is not enough here, I want to see more. We should say: There is too much here, I want to see less.

The red filter is withdrawn.

Our white rectangle is not "nothing at all." In fact, it is, in the end, all we have. That is one of the limits of the art of film.

So if we want to see what we call *more*, which is actually *less*, we must devise ways of subtracting, of removing, one thing and another, more or less, from our white rectangle.

The rectangle is generated by our performer, the projector, so whatever we devise must fit into it.

Then the art of making films consists in devising things to put into our projector.

The simplest thing to devise, although perhaps not the easiest, is nothing at all, which fits conveniently into the machine.

Such is the film we are now watching. It was devised several years ago by the Japanese filmmaker Takehisa Kosugi.

Such films offer certain economic advantages to the filmmaker.

But aside from that, we must agree that this one is, from an aesthetic point of view, incomparably superior to a large proportion of all films that have ever been made.

But we have decided that we want to see *less* than this.

Very well.

A hand blocks all light from the screen.

We can hold a hand before the lens. This warms the hand while we deliberate on *how much less* we want to see.

Not so much less, we decide, that we are deprived of our rectangle, a shape as familiar and nourishing to us as that of a spoon.

The hand is withdrawn.

Let us say that we desire to *modulate* the general information with which the projector bombards our screen. Perhaps this will do.

A pipe cleaner is inserted into the projector's gate.

That's better.

It may not absorb our whole attention for long, but we still have our rectangle, and we can always leave where we came in.

The pipe cleaner is withdrawn.

Already we have devised four things to put into our projector.

We have made four films.

It seems that a film is anything that may be put in a projector that will modulate the emerging beam of light.

For the sake of variety in our modulations, for the sake of more precise control of what and how much we remove from our rectangle, however, we most often use a specifically devised material called: *film.*

Film is a narrow transparent ribbon of any length you please, uniformly perforated with small holes along its edges so that it may be handily transported by sprocket wheels. At one time, it was sensitive to light.

Now, preserving a faithful record of where that light was, and was not, it modulates our light beam, subtracts from it, makes a vacancy, a hole, that looks to us like, say, Lana Turner.

Furthermore, that vacancy is doing something: it seems to be moving.

But if we take our ribbon of film and examine it, we find that it consists of a long row of small pictures, which do not move at all.

We are told that the explanation is simple: *all* explanations are.

The projector accelerates the small still pictures into movement. The single pictures, or frames, are invisible to our failing sense of sight, and nothing that happens on any *one* of them will strike our eye.

And this is true, so long as all the frames are essentially similar. But if we punch a hole in only one frame of our film, we will surely see it.

And if we put together many dissimilar frames, we will just as surely see all of them separately. Or at least we can *learn* to see them.

We *learned* long ago to see our rectangle, to hold all of it in focus simultaneously. If films consist of consecutive frames, we can learn to see *them* also.

Sight itself is learned. A newborn baby not only sees poorly—it sees upside down.

At any rate, in some of our frames we found, as we thought, Lana Turner. Of course, she was but a fleeting shadow—but we had hold of something. She was what the film was *about.*

Perhaps we can agree that the film was about *her* because she appeared oftener than anything else.

Certainly a film must be about whatever appears most often in it.

Suppose Lana Turner is not always on the screen.

Suppose further that we take an instrument and scratch the ribbon of film along its whole length.

Then the scratch is more often visible than Miss Turner, and the film is about the scratch.

Now suppose that we project all films. What are they about, in their great numbers?

At one time and another, we shall have seen, as we think, very many things.

But only one thing has *always* been in the projector.

Film.

That is what we have seen.

Then that is what all films are about.

If we find that hard to accept, we should recall what we once believed about mathematics.

We believed it was about the apples or peaches owned by George and Harry.

But having accepted that much, we find it easier to understand what a filmmaker does. He makes films.

Now, we remember that a film is a ribbon of physical material, wound up in a roll: a row of small unmoving pictures.

He makes the ribbon by joining large and small bits of film together.

It may seem like pitiless and dull work to us, but he enjoys it, this splicing of small bits of anonymous stuff.

Where is the romance of moviemaking? The exotic locations? The stars?

The film artist is an absolute imperialist over his ribbon of pictures. But films are made out of footage, not out of the world at large.

Again: Film, we say, is supposed to be a powerful means of communication. We use it to influence the minds and hearts of men.

But the artist in film goes on building his ribbon of pictures, which is at least something he understands a little about.

The pioneer brain surgeon Harvey Cushing asked his apprentices: Why had they taken up medicine?

To help the sick.

But don't you enjoy cutting flesh and bone? he asked them. I cannot teach men who don't enjoy their work.

But if films are made of footage, we must use the camera. What about the romance of the camera?

And the film artist replies: A camera is a machine for making footage. It provides me with a third eye, of sorts, an acutely penetrating extension of my vision.

But it is also operated with my hands, with my body, and keeps them busy, so that I amputate one faculty in heightening another.

Anyway, I needn't really make my own footage. One of the chief virtues in so doing is that it keeps me out of my own films.

We wonder whether this interferes with his search for self-expression.

If we dared ask, he would probably reply that self-expression interests him very little.

He is more interested in reconstructing the fundamental conditions and limits of his art.

After all, he would say, self-expression was only an issue for a very brief time in history, in the arts or anywhere else. And that time is about over.

Now, finally, we must realize that the man who wrote the text we are hearing read has more than a passing acquaintance and sympathy with the filmmaker we have been questioning.

For the sake of precision and repeatability, he has substituted a tape recorder for his personal presence—a mechanical performer as infallible as the projector behind us.

And to exemplify his conviction that nothing in art is as expendable as the artist, he has arranged to have his text recorded by another filmmaker, a different filmmaker, whose voice we are hearing now.

Since the speaker is also a filmmaker, he is fully equipped to talk about the only activity the writer is willing to discuss at present.

There is still time for us to watch our rectangle awhile.

Perhaps its sheer presence has as much to tell us as any particular thing we might find inside it.

We can invent ways of our own to change it.

But this is where we came in.

Please turn on the lights.

15

FLATNESS/DEPTH. STILL/MOVING. PHOTOGRAPHY/CINEMA.
2012

Grahame Weinbren

Weinbren, filmmaker, writer, and editor, parses the perceptual subtleties
of the still and moving image's pictorial space.

On the cliffs above Ocean Beach in San Francisco stands a cottagelike structure that
resembles a giant camera. It is neither elegant nor ugly, as much a "Decorated Shed" as
a "Long Island Duck," in the terms of *Learning from Las Vegas,* the celebrated book by
Robert Venturi, Steven Izenour, and Denise Scott Brown, which is often cited as herald-
ing the emergence of postmodernism in architecture. The shed-decorated-to-resemble-
a-camera, like the burrito and hot dog stands in Los Angeles built to look like the food
they specialize in ("ducks," certainly), appears cheap, arbitrarily constructed, and tem-
porary. However the structure has been in place since 1946 and houses the famous San
Francisco Camera Obscura. I classify it as a Decorated Shed rather than a Long Island
Duck on the grounds that the exterior does not reflect its function: a camera obscura is
by no means a camera, since though it produces an image, it does not retain it. A camera
is a device for storing images, not displaying them.

 In stark contrast to the exterior, upon entering the "camera" a visitor is immediately
confronted with a dim image projected on a horizontal concave disc about ten feet in
diameter at approximately thigh height. The image is produced by an optical system
that focuses the light trapped by a series of mirrors and lenses, poking out of the roof
of the structure like a submarine periscope. The system rotates, so that over the course
of six minutes it produces a panoramic view moving from beach to unmitigated ocean
to the Seal Rocks to cliffs and highway. The image is composed of the very same light
that would enter the eye if one looked out at the scene directly— light not compressed
or encoded, not converted to grain, pixels, or brushstrokes by a medium such as film,

FIGURE 15.1

Grahame Weinbren, *The San Francisco Camera Obscura*, February 2014. © Grahame Weinbren; courtesy of the artist.

video, or paint, but simply refracted and reflected. But there are crucial differences between the visual experience of the image on the disc and the view of the actual landscape.

The containment of the 360° field of view within a delimited area, every element of the scene tiny and precise, elicits a specific emotional response. It evokes the delicate quality of a miniature infused with the poignancy of the chimerical, as prized, for example, by nineteenth-century Romantics. For one, it is the perfection of detail that contributes to the feeling the image encapsulates—that the vista is an ideal, beyond any world we can hope to reach, at least in this life. This sense of unfulfillable longing is intensified, paradoxically perhaps, by the tenebrosity of the image: we have to strain just a little to see it, a result of absorption of luminance by the multiple mirrors, lenses, and prisms the light must negotiate in order to reach the viewing surface. In addition to the perfection of detail, the sense of remoteness integral to the image communicates simultaneously both presence and the unattainable. It is as if the actual landscape itself has been captured and miniaturized, suspended on a curvilinear surface, as an ideal space that one can never hope to reach.

I suggest that this effect is provoked by two distinct qualities. The first is being able to see it only as an *image* (and not, for example, as a view through a moving porthole); the second is the curvature of the projection surface. That we cannot mistake the image for reality is due to certain properties of the visual experience well established in perceptual psychology, especially in the work of James J. Gibson, to which I will turn presently. The

theoretical basis for the second point can be found in the writing of early-twentieth-century art historian Erwin Panofsky.

PERSPECTIVE AS SYMBOLIC FORM: ERWIN PANOFSKY

In his magisterial essay originally published in 1927, Panofsky proposes that the visible world curves around us as if we are at the center of a sphere, and any attempt to depict our visual experience in two dimensions is necessarily a distortion. To comprehend this idea, one need only consider the experience of moving through space, objects retreating into the periphery of vision and then into oblivion as we pass beyond them. Though we have come to accept perspectival images, which include photographs, as providing an accurate reflection of our perceptual experience, Panofsky argues that this involves ignoring their severe limitations:

> Exact perspectival construction is a systematic abstraction from the structure of [this] psychophysiological space. . . . It negates the differences between front and back, between right and left, between bodies and intervening space ("empty" space), so that the sum of all the parts of space and all its contents are absorbed into a single "quantum continuum." It forgets that we see not with a single fixed eye but with two constantly moving eyes, resulting in a spheroidal field of vision. It takes no account of the enormous difference between the psychologically conditioned "visual image," through which the visible world is brought to our consciousness, and the mechanically conditioned "retinal image" which paints itself upon our physical eye.[1]

Panofsky's crucial point is that the eyes and the body housing them are in constant motion, seeking visual information rather than passively attending to input. This insight is at the center of the theory of perception developed by J. J. Gibson, which I will address in some detail later in this essay.

Panofsky goes on to argue, in a close analysis of several Baroque paintings, that a perspective-based picture incorporates the sense that the represented space is understood to continue into the actual environment of the viewer. He sees the discovery of linear perspective in the early Renaissance as "liberating three-dimensional space from its ties with the front plane of the picture" and uses a work by Jan van Eyck as a primary example. "The picture has become a mere 'slice' of reality, to the extent and in the sense that *imagined* space now reached out in all directions beyond *represented* space, that precisely the finiteness of the picture makes perceptible the infiniteness and continuity of the space."[2] That a two-dimensional perspectival image conveys the sense of the infinite continuity of space "in all directions" is one of the factors responsible for the distancing quality of the image referred to at the beginning of this essay. The sense of separation and containment the camera obscura image evokes depends, at least partly, on the curvature of the surface on which is it projected. The circular image stops definitively at the

edges, while a landscape image contained within a rectangular frame on a flat surface has a different effect, which is evident, for example, in recent photographic images by Abelardo Morell and Vera Lutter, whose work I will examine in more detail shortly. (Both photographers, incidentally, rely on techniques that either refer to or actually utilize the technology of the camera obscura.) A viewer effortlessly imagines the space shown in their pictures as extending beyond the borders of the images and eventually right into the viewer's environment, as if the picture's surface abruptly terminates the depicted world.

The observations I will make in the rest of this essay concern the *experience* of images and can be understood best, possibly *only*, in reference to actual images. To this end I will examine in some detail three recent photographs and one short film, and indicate specific web locations where the images, still and moving, can be found.

PHOTOGRAPHS BY ABELARDO MORELL AND VERA LUTTER

Abelardo Morrell's photograph *Manhattan View Looking South in Large Room*, 1996, is of a simple room, one wall parallel to the camera plane with a short section of a side wall visible, and a few items of furniture in silhouette casually aligned against the back wall.[3] In contrast to the simplicity of the room, a huge image of New York City, from rooftops and street to characteristic skyscrapers including the Empire State Building and the Chrysler Building, is projected on the walls and ceiling, the image upside down, with reduced contrast and a lighter tone than the furniture. The chairs, table, and sidepiece appear more solid and material than the cityscape, which has an imagistic, almost ethereal quality, though both elements of the picture are equally photographic.

The unsettled, irreconcilable relationship between the two spaces depicted in Morell's photograph endows it with an eerie and powerful aesthetic sense. One does not feel that the image projected on the wall and ceiling is either separate from the space of the room, like a picture on the wall, or a part of the same world, like a view out the window. The city image obtrudes into the space of the rather plain room, almost overwhelming it; pulled in from outside, the image is perfectly extensible into the room, and it is clear that its edge is a crop, not a limit, very much a part of a continuous, infinite world-space. Not only does the projection on the wall of the room suggest a continuation of the city skyline farther into the room, beyond the edge of the projected image, but the image of the underfurnished room is easily imagined to continue across the picture plane and into the environment of the viewer. The collision of the two depicted spaces, each with its own illusion of breaking through the picture plane, is a definitive aspect of the photograph's appeal.

Vera Lutter's negative image of San Marco, Venice, *San Marco, Venice, III: November 9, 2005*, produced with her pinhole camera obscura apparatus, for which she adapted a commercial shipping container, elicits a similar reaction.[4] The viewer recognizes immediately that the photograph depicts an extract of a visual world that continues in all

directions, especially into the space in front of and beyond the picture plane. Panofsky's point, that this is a result of the geometries of linear perspective, is reinforced by the experience of Lutter's photograph. Because the perspective lines demarcating the edges of windows, roofs, pavements, and porticos are strikingly dominant, one cannot but see their potential continuation into the viewer's (extended) environment, if they were not terminated by the picture plane and the edges of the paper support. This sense of continuity is not challenged by the fact that the image is negative. The space stops at surfaces and edges where it might have continued, but not arbitrarily, needless to say, since the photograph is carefully and satisfyingly composed for balance and tension within its frame.

"SEEING AS" AND "TWO-FOLDEDNESS": LUDWIG WITTGENSTEIN AND RICHARD WOLLHEIM

Based on Panofsky's insight regarding perspective, we can say that one component of the aesthetic satisfaction offered by the photograph stems from the sense that its world eventually extends into ours. But this is patently not the whole story. In fact the argument in Panofsky's essay that we have highlighted is an ancillary aspect of perspective. The crux of perspectival representation, of course, is the veracity it lends to the depiction of recession on a flat surface: above all, perspective gives a picture an inescapable sense of depth. However, even when we see into the scene depicted in a photograph or painting, we do not lose our awareness of the two-dimensional support on which it is grounded. Philosopher Richard Wollheim describes this feature of viewing art as "two-foldedness," advancing the concept as a basic building block of his extensive aesthetic theory. Its roots can be traced to the work of Ludwig Wittgenstein.

Wittgenstein devoted many pages of his slender published output to the concept of "seeing as" or "aspect seeing." His favorite example was the drawing that has come to be known as the duck-rabbit.[5] Seen as a rabbit, the duck's bill becomes ears, and the creature appears to be looking in the opposite direction, while an insignificant indentation on the head of the cheerful duck becomes the mouth of the bewildered rabbit. "What changes?" Wittgenstein asks.[6]

Even though the object of vision remains the same, how we characterize what we see is different. This difference is captured in language as "seeing the drawing *as* a rabbit" or "*as* a duck." Wollheim advanced the concept of "seeing as" as a cornerstone of his philosophy of aesthetics. In *Painting as an Art* he argues that one of the main pleasures of painting—and this can apply equally to photography—is that we can see both surface and depiction: we *see* the surface of the canvas or the photographic support *as* receding.[7] Thus the experience of many paintings is "two-fold:" they can be seen in two distinct ways. In a photograph the characteristics that determine depth are apparent: the tapering of parallel lines as the path or wall they outline recedes into the distance, or the cobblestones of a street reducing in size the farther they are from the camera. But it

takes a kind of mental agility to see these qualities when we look up a highway or down a city street: we have to make a conscious effort to notice the perspectival effect when looking at the world rather than at a picture. It is noteworthy that Gibson, a psychologist whose work was grounded in empirical laboratory practice, describes these qualities in the same terms as the philosophers who were (more or less) his contemporaries. In his final book, *The Ecological Approach to Visual Perception,* he writes: "A picture requires two kinds of apprehension, a direct perceiving of the picture surface along with an indirect awareness of what it depicts. This dual apprehension is inescapable under normal conditions of observation."[8]

A PHOTOGRAPH BY PAUL WOLFF AND ARTHUR TRITSCHLER

The concept of "two-foldedness" or "seeing as" introduces an immediate question: what qualities of an arrangement of shapes and shades (or colors) inscribed on a surface bring about our seeing depth in that arrangement? Perspective, clearly exemplified in the photograph shown, is one of many such depth indicators. Like of many of Paul Wolff's and Arthur Tritschler's photographs, this picture is grounded in graphic qualities, that is, the arrangement of shapes on the picture plane, and provides an excellent example of the contribution of two-foldedness to the aesthetic experience. In the autobahn photograph, we are struck by the convergence of lines toward the perspectival center of the picture, lines that form strong diagonals cleanly dividing the picture into seven wedges in a range of shades and textures. In the same instant, one also sees the triangular wedges as defining the recessive space of a newly built German autobahn. The ruler-straight edges of the highway, their convergence pronounced in the photograph but likely unnoticed by those traveling the highway, imply the cliché of the supposed precision of German engineering. This positive assessment is balanced against the knowledge that many of these roads, though conceived in the Weimar years, were completed during the Nazi era, possibly with forced labor. The simultaneous experience of both the graphic space of the picture plane and the recession of the depicted landscape is crucial for this aesthetic understanding, with its mix of pleasure and discomfort, to play on the viewer. We *see* the segments into which the flat picture plane divides *as* defining the separations between tarmac road surface, center divider, highway shoulders, thick forests, and the obtuse triangle of pale sky; many three-cornered figures that both share a common apex and, unequivocally but incompatibly, disappear into the deep distance, never to meet. Like the duck-rabbit, the picture provides two separate ways of seeing one set of visual data.

DEPTH CUES

To summarize: though arguing from different methodologies and intellectual practices, Gibson, Wittgenstein, and Wollheim all point out that pictures, at least those that portray recessive space, are available to two distinct modes of attention. We can see a

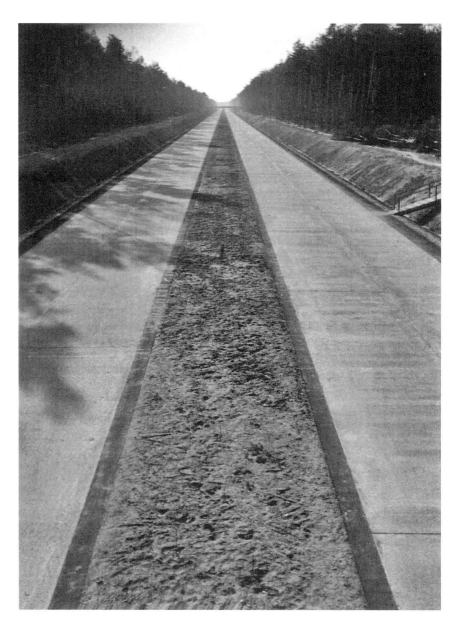

FIGURE 15.2
Paul Wolff and Alfred Tritschler, *Autobahn Frankfurt-Darmstadt*, 1934. © Dr. Paul Wolff and
Tritschler; reprinted courtesy Historisches Bildarchiv, Offenburg.

picture as a planar object, or we can pay attention to information conveyed about the
recession of the scene depicted. The factors in a picture that provide this information
are traditionally known as "depth cues." Gibson's view is that depth cues were developed
by artists and picked up by psychologists; they are *not* an aspect of our visual experience
of reality.[9]

Simon Norfolk's 2004 photograph *Tibetan Refugees in the Dhauladhar Range, Himalayas, Northern India* provides an excellent example of the interactions of multiple depth cues in a single image.[10] The camera looks into a valley with makeshift buildings clustered and crammed between trees, down hillsides, and onto the valley floor. The higgledy-piggledy arrangement of houses and buildings on the slopes is comprehensible partly (1) because of the way closer structures obtrude on and obscure those farther away. This is reinforced by (2) shading and shadows. Shading defines the shape of an object in space by graduated darkening of the area away from the light, while shadows are the unlit areas separate from the object caused by the blocking of light. The subtle shifts in brightness of the walls of buildings, based on their direction in relation to the ambient light, provides further information about their layout in relation to one another. This information is amplified and verified by (3) perspective distortion, the enlargement of closer and reduction of farther parts of an image due to distances from the camera, also known as foreshortening. In this case it is in the decreasing scale of the buildings with distance, an effect that leads the eye into the scene and emphasizes the way the houses are built almost on top of each other. And lastly, the sense of recession is brought to a conclusion by (4) atmospheric distortion or haze. The hillside disappears into mist, limiting the extent of the scene and creating an effective backdrop, which gives the landscape a fairy-tale, theatrical quality. This in turn endows the photograph with a satisfying sense of containment and completeness, furthered by the Tibetan flags in the upper foreground, which mark the frontmost point of the scene, colored shapes almost on the picture plane of the photographic object (the forward limit of any depiction), so that it seems like a proscenium within which reality is laid out. In the foreground of the stagelike area, we see the only living creatures visible in the photograph, a family of baboons, gamboling like a troupe of dancers.

A principal aesthetic pleasure of photography is in its presentation of these cues on the same phenomenological level as the reality depicted—we can always pay attention to the flat surface of the photographic object and hence to how space is presented in that surface. We see depth in a picture's flatness, or, in the Wittgenstein/Wollheim terminology, we see the surface *as* recessive. The simultaneous experience of the two visual aspects, combined with the knowledge that the picture is causally connected to an actual place at an earlier time: these are the delights of photography. In Norfolk's picture, as in many great photographs, the visual experience is enhanced by pictorial composition—the elements constantly draw the eye back into the scene, as if what is outside the frame is irrelevant. The photograph contains an entire world, laid out before our eyes like a presentation to a deity.

I referred earlier to Gibson's assertion that depth cues are properties of *pictures*, developed by artists specifically for the creation of images, and not pertinent to our daily interactions with our surroundings. The implication is that the aspects of the photograph that enable a viewer to understand the spatial layout of the scene depicted

would not be available to a viewer of the actual hillside shown in Norfolk's photograph. For this reason, we rarely mistake a picture for the scene it depicts. There is, however, a well-known anecdote from the early days of the Renaissance that offers a counterexample.

THE FIXED VIEWPOINT: FILIPPO BRUNELLESCHI'S MIRROR

According to an account first published in 1480 by Antonio di Tuccio Manetti (and inordinately familiar to students of art history), the artist and architect Filippo Brunelleschi painted a small wooden panel depicting the Florence Baptistry from the portal of the great Florence Cathedral, at that period still under construction. Brunelleschi drilled a conical hole in the painting, and a viewer was instructed to stand at the very position from which the panel was painted and look through the hole at a mirror held at arm's length so that it reflected the painting. The illusion was so convincing, the story goes, that it was a perfect trompe l'oeil. The viewer was unable to tell whether he was seeing the Baptistry itself or a picture of the elegant building.

Brunelleschi's demonstration required the painted scene to be reversed so that it would read correctly when reflected in the mirror. This has led some art historians to argue that the work was drafted using a pinhole camera obscura, which both reverses and flips the image.[11] More significant for the present discussion is that, as Friedrich Kittler emphasizes in his recent *Optical Media*, in order for the illusion to succeed as trompe l'oeil, the viewer's position must be determinate and unchanging.[12] Brunelleschi guaranteed this by marring his own work with the bored cavity, which fixes the view to a specific point in space, since he realized that any shift in position would reveal the planarity of the object before the eyes and ruin the illusion. This is an essential point about linear perspective: the subject is always depicted from a single position. The slightest head or body movement when viewing an image immediately reveals its flatness. The hole, like a peephole in an apartment's front door, prevents such movement: you either look through the hole or you don't see the picture.

PERCEPTION AS ACTIVITY: J. J. GIBSON'S AFFORDANCES

Linear perspective lays out a scene from the position of a static single eye, which implies a passive spectator. However, we are active participants in the visual world. Vision is a springboard to interaction with the environment, and our senses are, first and foremost, functional.

This point is one of the foundations of J. J. Gibson's theory of "ecological" perception, though he states it in quite different terms. One of the ways he summarizes his highly detailed and sophisticated ideas is that our visual experience is structured by what he calls "affordances." One's vision is largely determined by an immediate grasp of the usability, function, or practicality of a visual object—what the object can "afford"

us. What we know about the world and the potential use-value of the things we see are essential components of how it looks to us.

Gibson adopted this position after many years of research isolating visual factors and testing their efficacy with empirical methods. As his career progressed, he developed the position that it is misleading to consider visual perception as anything less than a *system* integrated with other perceptual systems. To propose that a specific "sense" (a term Gibson found misleading) is reducible to atomic sensation-elements that are eventually—mysteriously—brought together by mental activity leads only to conceptual confusion. He was particularly scornful of the standard psych-lab technique of grounding the study of visual perception in tests involving subjects looking at *pictures*. He rejected the idea that everyday vision is made up of static impressions of two-dimensional variegated color fields (the technical term is "fixations," and the eye movements between fixations, "saccades") stitched together over time by the brain.

Gibson insists on two fundamental ideas in reference to perceptual systems: first, as already mentioned, that a perceptual system is active, seeking out information rather than constructing a visual world from data received by passive receptors, and second, that perceptual systems are sensitive primarily to change. This pair of ideas, he claims, represents a radical departure in perceptual psychology. Here is how he states his divergence from traditional psychological practice in the first major statement of his theory, published in 1966 as *The Senses Considered as Perceptual Systems:*

> The classical concept of a sense organ is of a passive receiver, and it is called a receptor. But the eyes, ears, nose, mouth, and skin are in fact mobile, exploratory, orienting. Their input to the nervous system will normally have a component produced by their own activity. The photographic camera is an analogue to a passive receptor. But the eye is not a camera; it is a self-focusing, self-setting, and self-orienting camera whose image becomes optimal because the system compensates for blur, for extremes of illumination, and for being aimed at something uninteresting. This fact might seem to complicate hopelessly an understanding of how the senses work, but the intermixture of externally produced and activity-produced stimulation promises to be the clue to an understanding of how the perceptual systems work. . . .
>
> The traditional theory of visual perception based on a retinal picture or image of each object is profoundly misleading. I will treat the eyes . . . not as a pair of cameras at the ends of a pair of nerves but as an apparatus for detecting the variables of contour, texture, spectral composition, and transformation in light.[13]

Gibson goes on to argue that the visual system is best suited to acquiring information about the environment based on three types of parameter: spatial, chemical, and optical. We acquire spatial information through the effects of ambient light on the surfaces, corners, curvatures, and edges of objects (note that the last three are liminal points, moments of change); through the chemical characteristics of objects that determine their pigmentation and absorption of light (color and luminance); and from the shadows

and the occlusion of one object over another. Based on the premise that animal perceptual systems are most sensitive to change, Gibson developed his theory of ecological perception starting from the idea that motion, not stillness, is the foundation of the information we gather from the world through the sense of vision. We are active observers of our environment, he insists, and our knowledge of it is based on transformations in visual information resulting from shifting spatial relationships between objects as they move and as we move among them. These motions affect the ambient light that objects absorb and reflect, and these changes provide the information our perceptual systems rely on to comprehend the visual environment.

MOTION PERSPECTIVE

Picture-makers have been experimenting on us for centuries with artificial displays of information in a special form. They enrich or impoverish it, mask or clarify it, ambiguate or disambiguate it. They often try to produce a discrepancy of information, an equivocation or contradiction, in the same display. Painters invented the cues for depth in the first place, and psychologists looked at their paintings and began to talk about cues.

J. J. GIBSON, *THE ECOLOGICAL APPROACH TO VISUAL PERCEPTION*

Throughout his later work, Gibson repeats, sometimes with bitter irony, that depth cues are relevant only in reference to pictures.[14] For reality directly perceived, occlusion is the basis of our understanding of the spatial relationships of objects. Gibson's definition of *occlusion* is "the hiding, covering, superposition, or screening of one thing by another."[15] Material objects block one another—we get only a limited view of most things in our visual world, because closer objects mask parts of the farther. While depth cues provide information about a depicted scene, directly perceived information about the layout of the world around us comes primarily from the shifting concealment and exposure of parts of objects as we move in relation to them and they move in relation to us.

Gibson uses the expression *motion perspective* to describe the changing relationships of objects determined by motion. For example, as we move, closer objects shift more rapidly in the visual field than those farther away from us. A familiar example is traveling past an orchard at dusk: the closer trees whip by, while those farther away move more slowly and stay in the visual field longer, and the moon, millions of miles distant, seems to remain at a fixed spot in the sky. Gibson's hypotheses about the significance of motion perspective in visual perception provides an excellent way to begin to understand the radical difference between the way cinema and photography convey depth.

In most cases, movies move. Their motion brings recession along with it, whether it is an abstract work like one of Stan Brakhage's late-career projected paintings on film stock, Pat O'Neill's *Screen* of 1969, Jennifer Reeves's recent hand-painted and optically

printed films, or, at the other extreme, the latest inane Hollywood "rom-com." It is impossible to shut out the sense of recession even if one focuses on the screen plane, given the insistence and apparent reality of cinematic motion.

Gibson's description of motion perspective can be solicited to account for the emphatic sense of recession in the *moving* image of cinema. The camera trucks through space, recording changing forms as one object apparently shifts to cover or reveal sections of other objects and providing unequivocal information about spatial relationships. Since motion in the movie is indistinguishable from "real" motion, the information imparted by the relative motion of objects in the field of vision is equally valid on the screen.

But an essential element is missing.

PROPRIOCEPTION AND THE MOVING IMAGE

One of Gibson's central contentions is that "self-awareness accompanies perceptual awareness."[16] He points out that awareness of one's own body is deprecated, if acknowledged at all, in traditional perceptual psychology, and sees this as one of the primary flaws of the field. He insists that we utilize inner sensations of body motion and position, including the rotation of the eyes, the orientation and movement of the head, and the gross changes of body position, in making sense of visual information. For Gibson, body awareness is an essential feature of the ecology of the perceptual system.

The connection between body awareness and visual experience has particular significance in relation to the all-important concept of motion perspective. We are almost always aware of our movements through the sixth sense, commonly known as kinesthesia, though Gibson's preferred term is *proprioception*. One of the cornerstones of his "ecological approach" is that proprioception and visual perception are inextricably linked. As we move, with even only slight head turns or tilts, the arrangement of the field of objects before our eyes shuffles and shifts *in concert with our movements*. In fact, shifting visual perspectives are often entirely the result of our own body adjustments. The information we gather about the visual world depends on the interplay between inner knowledge of the movement and position of our joints and muscles and the apparently changing relationships of the objects in the visual field. The two systems working together provide information that tells us both where we are in relation to the things around us and how those things are placed in relation to each other—from that which is looming to that which is out of reach.

However, proprioception is absent from the experience of the cinematic image. While we sometimes shift position in a movie theatre to see around the heads of other viewers, our movements have absolutely no effect on the cinematic image. How could they? But once proprioception is removed from the conglomerate, the sense of reality dissolves as well. Since our own body movements in relation to the screen do *not* affect the image in any way, we are hardly ever prompted by a movie into believing that we are in the presence of reality (contrary to the much-repeated stories of the initial reception

of Lumière films). That our movement affects what we see is the primary indication that we are seeing the Real.

With these points in mind, let us return to the San Francisco Camera Obscura and the quality of remoteness evoked by the image projected on the concave disc. On the one hand, the fact that the image is unmediated, composed of exactly the same light as the actual scene, endows it with an intense degree of detail and an infinite color palette. No picture, however fine the grain or miniscule the pixels, can match the degree of detail of reality. On the other hand, that the elements of the scene do not shift in relation to one another as the viewer moves around it—that there is no motion perspective initiated by the viewer's movement—fixes it as an *image* rather than a view through a window or other opening. This pair of factors must be what finally invests the San Francisco Camera Obscura disc image with its special poignancy. It is a step removed from the world, yet a step closer than a mediated image.

A SIDE NOTE: COMPOSITION IN STILL AND MOVING IMAGES

Another crucial difference between the sense of depth of a motion picture and of a still image has far-reaching implications for practitioners. While the still image depends on the epistemology of *seeing . . . as* (i.e., *seeing* the picture plane *as* recessive), in a movie the picture plane is not available to the visual system. It is incomprehensible to say of a movie that we see two-dimensional shapes *as* moving—it even seems grammatically incorrect. No, we see moving elements on-screen, one behind another, while remaining perfectly aware that it all takes place on a planar screen on which the images are either projected or generated. The shorthand consequence of this is that while the photographer composes in two dimensions, the cinematographer composes in three—but further discussion of this point would need another essay.

A FILM BY GARY BEYDLER

During the 1970s many filmmakers (as well as artists in other media) produced works that foregrounded, or at least referred to, the material or semiological bases of their medium. Though not always included in the canon of experimental cinema, *Pasadena Freeway Stills* (1974) is a paradigmatic work in this tradition, an elegant balance of analytic concerns with a pleasurable, purely cinematic aesthetic.[17] The film consists of a series of photographic prints presented one at a time, replicating the operation of the movie projector—which retains one frame after another in its gate, enabling light to be shone through and its image momentarily focused on-screen. The subject of the photographs is the Pasadena Freeway, the oldest highway in the Los Angeles system. Traveling the Pasadena Freeway is an uncharacteristically picturesque experience for Los Angeles highway drivers: following a complex topology of alternating spectacular and markedly unspectacular office buildings, they encounter a series of short tunnels

resembling gopher holes burrowed through grassy mounds. As they emerge from the northmost tunnel on a clear day, the San Gabriel Valley appears, spread out before them, the distant mountains visible but softened by a rose-pink haze.

Beydler mounted a 16mm camera on his dashboard to record the driver's viewpoint as he navigated the freeway, then reprinted each film frame as a small black-and-white photograph. The film opens with an image of an empty white rectangular outline, behind which the artist appears, stationing himself in the center of the frame. After a short period, he reaches down for one of the highway stills and presses it against the white rectangle, which we now identify as masking tape on the back side of a sheet of glass between the artist and the camera. The tightly composed shot (chest, fingers, photo) is the single image of the movie—the artist's white T-shirted torso centered, his fingers holding each print in place, its position defined by the tape.

Initially each photograph is on-screen for a few seconds, but the hold period is decreased incrementally, until, about three minutes in, one photograph remains for exactly one film frame. At this point the temporality of the original movie is reconstituted and its forward motion restored: we are driving along the lightly trafficked freeway, entering and exiting the tunnels, passing turnoffs on the left and right, all within the rectangle demarcated by masking tape. Vehicles appear in the frame, obscure and reveal other vehicles, then disappear from the camera's field of view as they veer off onto spurs for Glendale and Ventura. The image undergoes continuous change as we progress along the highway, the invariants of pavement and landscaped road shoulder unfolding in the lower and side portions of the image. The print sequence has been transformed into an embedded movie composed of an interplay of relative motions, dense and complicated but immediately comprehensible without effort—a tribute to the processing power of the viewer's information-gathering visual system.

At the moment the critical frame rate is reached, when the sequence of stills becomes a movie, we see not only motion but also an illusion of depth. The recession of the embedded movie now defines the entire frame, the tunnels through the foothills of the San Gabriel Mountains emphatically boring into Beydler's white T-shirt, while the artist's upper body has flattened into a background for the movie frame, his fingers darting planar shadows at the edges of the now-substantial film image.

Gibson's poetic description of the formation of the depth illusion in the motion picture (his preferred expression was *progressive picture*) is a substantive generalization of what happens when Beydler's series of stills becomes a movie: "The progressive picture displays transformation and magnifications and nullifications and substitutions of structure along with deletions and accretions and slippage of texture. These are the 'motions' of the motion picture."[18]

In other words, *Pasadena Freeway Stills* is a tailor-made demonstration of perhaps the most fundamental of Gibson's observations: it is primarily *motion*, not perspective or other depth cues, that establishes the sense of three-dimensional space in visual experience. When the sequence of stills attains the frame rate of a movie, the dimensionality

of the inner image is inescapable. However, despite the incontrovertible fact of motion on the movie screen, not for a single moment do we forget that we are confronted with an *image* of reality, not reality itself, when watching a movie. Though the elaborate shifts and sallies of the many shapes on-screen are effortlessly comprehensible as the ordinary passage of ordinary traffic from an ordinary moving vehicle, the additional information provided by the viewer's awareness of his or her own body's position and movement is lacking. Without the alterations provided by proprioceptive awareness and its effect on the arrangement of objects before our eyes, we never mistake the image for reality. Like the dim circular scene projected on the disc of the San Francisco Camera Obscura, a movie will always retain its epistemological status as an image.

We show part of our twenty-five-hour movie and we speak to the kids. We tell them we don't believe in goals. We don't believe in art. Everything is art.

Viva, "La Dolce Viva," 1968

16

HD VISION
2012

Bob Giraldi, Ethan David Kent, Christopher Walters,
Charles Traub, and Adam Bell

As part of a graduate seminar at the School of Visual Arts, the editors of this volume interviewed a legendary filmmaker and two of his colleagues, a cinematographer and an art director, about the impact of technology not only on their craft but also on their seeing.

ADAM BELL: What are the major technical developments that have occurred within your craft, and how has that affected your production from the conception of a project to its actual creation?

CHRISTOPHER WALTERS: From an ad agency's perspective and a cameraman's perspective, the first thing that comes into my mind is the increased level of collaboration that is possible with digital media as opposed to film. All of a sudden the director, the cinematographer, and the creative director can look at an image on a monitor that really approximates what we are going to have to work with during color correction, right down to the way the lighting affects the wardrobe, makeup, and production design. The three of us can have a dialogue on set that wasn't really possible ten years ago, because you had to wait to see dailies the next day.

ETHAN DAVID KENT: I would also add the client to the mix. If the three of us are looking at the monitor, then the client is right there too. And they usually don't hold back. When you are on set, it is really important for the Director of Photography (DP) to have the lighting right, the angle right, and so on because the client is looking at exactly what is going to come out of the camera. They are paying for it, whatever it might cost—$20,000 or $2 million—and they will definitely let you know what their thoughts are because it's their investment. You have to have confidence and you need to make them feel comfortable. Don't let them get nervous.

BOB GIRALDI: For me, there are two things that happen differently today. One is financial. While this often doesn't concern students, it impacts production companies

that need to raise money for a project. The other is collaboration. In the old days, I would stand next to the camera and my cameraman. We would talk about what we were going to shoot and how to light it. Collaboration is entirely different than what it was before. Cameramen used to be the "mystics." They had an aura, especially the older cameramen, and would say, "What I've just sculpted here—trust me, it will come out when I develop the film. Wait three days. You're going to see the film and love it." Today, he can't say that to me. We're both going to look at the monitor, the agency is going to look at the monitor, and everyone will know exactly what we're going to get. That in and of itself is a mind-blowing change, because the amount of people I now have to deal with as a director is fifty times what it used to be. Before, all I had to say was "Wait three days and you'll love it." There is no more of that bullshit today. There is no imagination. It is what we see. So being there is the name of the game.

CW: It can also really impact the nice insular vibe that exists sometimes on set among the principal creatives who all understand the vocabulary that you're using to make this film. When you're shooting film, only people with an in-depth understanding of the technical and aesthetic knowledge really comprehend what you are up to on set. Now that the floor is open for discussion, your job goes from being 80 percent creative and 20 percent politics to maybe 30 percent creative and 70 percent politics. You can't offend anyone. You have to listen to everyone.

EDK: If you have a good team, that becomes easier. In the cases when we've worked together, I've taken control of the politics and let Chris do his thing with the camera. As a conduit, I need to know enough about the image-making world so I can talk to him intelligently about what I need.

BG: In some ways, art has always been about the marriage of vision and technology. The high-gloss technology is what often leads and excites us, but in many ways the tools we use have always been "new" technology. If anything, in our business, the manufacturers have tripled and there are always new cameras.

If you want to know the truth, it is the lenses that matter more often than not. It is rarely the body; it is always the lens. When you look at all the commercials, TV shows, and movies, look at the lensing. That is what really distinguishes the artistry and makes work stand out. It is not the body.

CW: I think that camera bodies are going to become less and less relevant. It is going to be a box that houses a CMOS sensor. It won't really matter that much in terms of image quality what that box is or what brand it is. It will be, and always has been, about the lenses. You can shoot with a Canon 5D and a $2,000 zoom lens or you can shoot with a lens that costs $100,000, and it will look different.

CHARLES TRAUB: How does it change the aesthetics that anybody and everybody can have these cameras and make a film? What changes in the way you look as a DP or a director or the advertising agent? Walter Murch, the famous editor, once said

the last thing he wanted to do was to be on set when the film was being shot. He wanted to see it in his own environment afterwards with no preconceived notions.

CW: Versatility.

CT: What does that mean to what you make? To the end product?

CW: You also have with these modern tools, which are very small and light and cheap, options to create improvised techniques that allow you to realize shots that until then you have only imagined—shots that maybe with an expensive lens and/or camera body would have taken a whole day of rigging and safety precautions. I shot a recent student film where we wanted a perspective of someone flying off a rooftop. I just tied a rope to a 5D and threw it off the roof. It looked great. It was amazing. The camera was fine. It could have been destroyed. Could we have done that with a $250,000 camera system? No way. It would have been a $50,000 shot because of the amount of time and manpower in realizing it. The shot wasn't perfect and it did take us a lot of time, but it made a shot that with more expensive equipment would have been impossible.

EDK: In advertising it's possible to get two end products with the same equipment, photo and video, and there are negative and positive aspects to both. In photography, for example, the negative is the affordability of volume. You're not shooting roll after roll of film; you're capturing tens of thousands of images a day. To edit 100,000 shots is absolutely insane. On the flipside, when you are talking with a client, you have lots of options because you have lots of coverage. They are paying you to make your best assessment, and you give them what you think is right. (You just have to be prepared if they don't like it.) As for video, it still takes a lot of time to set up. No matter how equipment evolves, you can't diminish the variables—lighting, wardrobe, weather, sound, and so on. For two videos we shot, we had less than six hours, because we were working with a celebrity. That's all the time she could give us. The first video was going to be edited to a minute long, and it took about four hours to shoot. We were left with an hour and a half to shoot the second video, which was going to be about three minutes long. We were able to do it though. That was possible for us.

BG: Speed is critical, which also brings us to another point that is the number-one issue for Hollywood, which is financial. It is really a financial consideration. That determines a lot of where we are going. In the past, manufacturers would compete based on lenses, compatibility with other equipment, and whatever new technology they'd developed. Today it is really based on how cheap they can be.

CT: Has this impacted the business of production? Do you have to make more stuff to please the client? Less stuff? Is the client pushing and rushing you for more and more?

EDK: You just have to deliver. So as far as clients go, I set them up to see something specific. I have sold them a project with pictures and words, and I need to instruct

and engage a team of creatives to help make that project come to life on film. I have the vision for the project, I know what the clients' thoughts are and what they are going to expect. I can either get it right then and there or after the shooting is over with help from editing and postproduction. It just has to be right.

BG: That's never changed. I've been in the business for forty-plus years and that's never changed. On the first day, the client was always on set with me. The difference was that they couldn't see. Now, the big difference is that they are on set with me and they can see, so they have an opinion. And, boy, do they have an opinion. There is nothing wrong with the client having an opinion; it's the fact that we have a lot of silly opinions. Every creative person has had to learn how to navigate. If you know Hollywood, and you know the pecking order of directors, you know that some are very smart and good politically, and some are atrocious. But being good politically is good for anyone looking to make a film. Selling yourself and your work is very important to the discipline.

EDK: If you can master the equipment and tell a really good story, that is how you get work. The client doesn't know the difference between any cameras you are talking about, or any lenses. Regardless of the cost, you need to sell the story.

BG: There is a difference when you look at something large in the cinema, not small like a handheld device. When you look at something large, the film version is better to look at than the digital version. Something large up there with that organic style and sensibility, that little bit of soft and sharp mixing is like a village of beautifully talented people versus a very crisp image.

CW: I think the distinction between digital and film defies verbal description. A comparison I read recently that I thought was a really great one was between mediums a sculptor might use. When sculptors started working in brass, it did not mean they needed to stop working in marble. Brass might be better for some things, but it doesn't mean that marble is not good because it is difficult and more expensive to work with. The exciting thing about the advent of digital for me as a filmmaker and DP is that we have one more medium to work in. I am hoping that the proliferation and relative cheapness of digital won't compel the extinction of film. I definitely think that both mediums have their place.

CT: I began incorporating digital in SVA's MFA Photography program in 1988. Everyone said, "It will never replace film. It's ridiculous. Don't to this." Yes, it was always different, and always a little less, and all of a sudden it is getting equal. There is really a parity between the two now. My opinion is that we have to preserve the history, but whether we need to preserve the production at the expense of moving technology forward for all that it is liberating us for and making available to us is another issue.

BG: *Sharper* is the dirty word for me. Why does it have to be sharper?

BG: Does anyone really want it to be sharper? It has to be better. The story doesn't need to be crisper, it just has to be better. Don't ask me to predict what's next, because that is an unanswerable question. The older I get, the less I know how to predict what is going to happen next, but it will be cheaper. Whatever it is will be cheaper.

AUDIENCE MEMBER: Do you think we are possibly getting to a singularity when the technology doesn't need to get better and in some cases is detrimentally affecting the art?

BG: Hear, hear! I agree with that.

CW: I think it has to do with what the audience is conditioned to appreciate. It is about our visual palettes. If you think about what kids are growing up watching now, they are watching moving images on their iPhones and iPads. That will help determine what is palatable to them versus what is palatable to an older audience. If there is a way to gradually introduce sharper images like that to an audience, then over a generation, they will appreciate them.

AB: Given that the default is no longer the movie screen, how the growing diversity of screens—from smartphones to tablets—changed the way you shoot and conceive projects?

BG: The final destination is important. You need to know what that is before you go out and shoot. You can't tell me filmmakers and creators can create the same visual impact for a cinema screen as large as this room and have it also work for a small screen.

We're involved in an industry where they want us to shoot the commercial or film while at the same time shooting some footage for the interactive aspects online. They may want them, but they generally don't work together. They need to be separate. That means that the filmmaker has got to think two different ways.

CT: What does that mean for the education of camerapeople? How do they adapt to the need to be more versatile than ever before? Their roles are changing. For photographers, you often have to make both videos and stills.

BG: In my mind, they need to understand what separates all of the good work from the bad stuff. It is not the technology. It is the story. I insist when my DP shoots that he wears headphones so he or she can listen to what is being said by the actors. DPs need to understand what they are shooting. Technology is secondary. I guarantee you it will separate you from everyone else if you can understand and embrace good ideas.

CW: If the basic tenets of your shooting are how these shoots can serve the story being told, then adapting your shoot to the various media is secondary.

BG: As a director, I don't let the technology lead me. I come from a time where the idea of a thing is the most important. László Moholy-Nagy was a key influence for me

as a student. Form follows function. It's an old idea, but it is what drove me and has driven me all my life as a creator. Some go to a movie not to see a story but to see how a technology unfolds itself as a story. While I can appreciate that, that is not where I came from. Give me *On the Waterfront,* give me *Twelve Angry Men,* or the stories that make you laugh or cry, and get incredible performances. You get them still today.

CT: Since you mentioned Moholy and the Bauhaus, I should add that he understood the camera sees differently than the human eye. We then need to learn to see as the camera sees, rather than make it see as we see now that the cameras have more versatility than we have ever had before in all forms of camera arts. That's the magic for me. The fact that you can use a digital camera to shoot in almost virtual darkness has got to change the aesthetics of what you make and the content of your story.

BG: It does. Versatility is the number-one advantage.

CW: I think there are extreme examples of the ways in which new technology might spawn ideas for different stories if you think about the accessibility of something like the new Phantom camera, which is fairly cheap and shoots at 1,000 frames per second. If the camera can then see better than the human eye and can photograph the individual droplet of water as it strikes a surface—if you can actually see that play out in a way that the human eye couldn't, can you then start to tell stories that take place in microseconds? That type of technology has been around for a long time, but the difference today is that it is accessible.

BG: It still has to come down to story. It must come down to concept.

AUDIENCE MEMBER: I think an important issue might be the value of the director knowing what is going to come out of the camera, not looking at the monitor, and being present in the scene with the talent. The whole idea is that you are working with a DP that you trust and you've talked about it all.

CW: I think that there is a comparison to be made between composers working on the same piece of music on a piece of paper and a band jamming on a piece of music in a rehearsal space. Both are valid means of collaboration, but they are different. You'll get a different energy out of a bunch of people playing together. There is a theoretical aspect to the director who never looks at the monitor or through the lens and trusts his cinematographer. It's great to be able to talk about these things theoretically. It's rare.

CT: Given that we're all becoming more sophisticated about the moving image, what are the consequences and altered expectations that arise out of this shift—both for audiences and creators?

BG: There is a good and bad side to the proliferation of imaging. The good news is anybody can make a film. The bad news is that everyone can make a film, which can bring the overall quality down. It doesn't negate the positive. It is just the tool

in the hands of an artist who can make it cheaper and quick. You just have to sort through the crap, but younger people are used to that. They do it every day.

cw: The pursuit of entertainment has become entertainment itself. That is an interesting by-product of this proliferation.

bg: If you think about your favorite films, did the technology really matter? Did you even notice or think about it?

cw: There are certain buttons you need to push as a storyteller that people have been pushing since Greek tragedies. If you don't push those buttons, you ain't going to sell any popcorn.

bg: And all the HD in the world is not going to save you.

cw: The floodgates are open. The field is being demystified as painting was demystified when most people could suddenly afford to buy watercolor paints. Because the camera technology is available to make technically great images, those who do possess talent in that field shouldn't be encumbered by the lack of access to adequate technology to realize their talents.

bg: If you are talented, make sure that you understand the camera you're going to use. Make sure you understand how to get the best images. For film, make sure you have good sound. You can ruin an entire week of shooting with bad sound. You put that up on a screen and people will immediately tune it out.

ct: My biggest gripe about graduate student films is the sound. Great visuals, but the sound is often an afterthought.

bg: You can have stuff out of focus, not lined up, or badly lit, but you cannot have inaudible or bad sound. There is nothing artistic about bad sound.

AUDIENCE MEMBER: If our technology is constantly changing, are we really getting into what we can do?

bg: I think they do move too fast. Our job as creatives is to keep up with it or else be buried. I need to keep reinventing myself and dealing with all that is thrown at me, or else I'm out of business and irrelevant. So much is being thrown at students that it is difficult to grasp and master. You can take any one of these different cameras. Just pick one and be good at it.

ct: That maxim has to be part and parcel of photography education from day one. Take one camera. Shoot everything with that camera and learn everything about that camera. Additionally, you have to understand the lens is a stupid thing. It has no brain. Whether you are shooting still or moving images, it doesn't know what is going to come into the frame. Only you know that. Therefore, the lens arts are about ideas. That is the thing that is hardest to teach. We can teach you lighting, technique, theory, and history, but we can't teach you how to come up with an idea.

17

MOVING AWAY FROM THE INDEX
Cinema and the Impression of Reality
2007

Tom Gunning

The thorny issue of cinematic realism and its indexical image is
turned on its head in Gunning's timely essay.

INDEXICAL REALISM AND FILM THEORY

While cinema has often been described as the most realistic of the arts, cinematic realism has been understood in a variety of ways: from an aspect of a sinister ideological process of psychological regression to infantile states of primal delusion, to providing a basis for evidentiary status for films as historical and even legal documents. Cinematic realism has been praised as a cornerstone of film aesthetics, denounced as a major ploy in ideological indoctrination, and envied as a standard for new media. I believe the time has come to return to this issue without some of the polemics that have previously marked it but with a careful and historically informed discussion of cinema's uses and definitions of the impression of reality. In film theory over the last decades, realist claims for cinema have often depended on cinema's status as an index, one of the triad of signs in the semiotics of Charles Sanders Peirce. Film's indexical nature has almost always (and usually exclusively) been derived from its photographic aspects. In this essay I want to explore alternative approaches that might ultimately provide new ways of thinking about the realistic aspects of cinema.

Peirce defined the index as a sign that functions through an actual existential connection to its referent "by being really and in its individual existence connected with the individual object."[1] Thus, frequently cited examples of indices are the footprint, the bullet hole, the sundial, the weathervane, and photographs—all signs based on direct physical connection between the sign and its referent—the action of the foot, impact

of the bullet, the movement of the sun, the direction of the wind, or the light bouncing from an object.[2] A number of these examples (such as the weathervane and the sun-dial) perform their references simultaneously to the action of their referents. This fact reveals that the identification of the photographic index with the pastness of the trace (made by several theorists) is not a characteristic of all indices (and one could point out that it only holds true for a fixed photograph, but not of the image that appears within a camera obscura).

For Peirce the index functions as part of a complex system of interlocking concepts that comprise not only a philosophy of signs but a theory of the mind and its relation to the world. Peirce's triad of signs (icon, index, and symbol), rather than being absolutely opposed to each other, are conceived to interact in the process of signification, with all three operating in varying degrees in specific signs. However (with the exception of Gilles Deleuze, for whom Peirce's system, rather than the index, is primary), within theories of cinema, photography, and new media, the index has been largely abstracted from this system, given a rather simple definition as the existential trace or impression left by an object, and used to describe (and solve) a number of problems dealing with the way what we might call the light-based image media refer to the world. In fact, Peirce's discussion of the index includes a large range of signs and indications, including "any-thing which focuses attention" and the general hailing and deixic functions of language and gesture.[3] Peirce therefore by no means restricts the index to the impression or trace. I do not claim to have a command of the range of Peirce's complex semiotics, but it is perhaps important to point out that the use of the index in film theory has tended to rely on a small range of the possible meanings of the term.

I have no doubt that Peirce's concept has relevance for film and that (although more complex than generally described) the index also provides a useful way of thinking through some of these problems; indeed, even the restricted sense of the index as a trace has supplied insights into the nature of film and photography. However, I also think that what we might call a diminished concept of the index may have reached the limits of its usefulness in the theory of photography, film, and new media.[4] The nonsense that has been generated specifically about the indexicality of digital media (which, due to its digital nature, has been claimed to be nonindexical—as if the indexical and the analog were somehow identical) reveals something of the poverty of this approach. But I also feel the index may not be the best way, and certainly should not be the only way, to approach the issue of cinematic realism. Confronting questions of realism anew means that contemporary media theory must still wrestle with its fundamental nature and possibilities. I must confess that this essay attempts less to lay a logical foundation for these discussions than to launch a polemic calling for such a serious undertaking and to reconnoiter a few of its possibilities.

It is worth reviewing here the history of the theoretical discourse by which a rela-tion was forged between cinematic realism and the index. Without undertaking a thor-ough historiographic review of the concept of the index in film and media theory, the

first influential introduction of the concept of the index into film theory came in Peter Wollen's groundbreaking comparison of Peirce to the film theory of André Bazin.[5] But to understand this identification, a review of certain aspects of Bazin's theory of film is needed. Bazin introduced in his essays and critical practice an argument for the realism of cinema that was, as he termed it in his most quoted theoretical essay, "ontological." The complexity and indeed the dialectical nature of Bazin's critical description of a realist style have become increasingly recognized.[6] For Bazin, realism formed the aesthetic basis for the cinema, and most of his discussion of cinematic realism dealt with visual, aural, and narrative style. Although Bazin never argued the exact relation between his theories of ontology and of style systematically (and indeed, one could claim that Bazin's discussion of realism across his many essays contains both contradictions and also a possible pattern of evolution and change in his work taken as a whole—not to mention multiple interpretations), at least in the traditional reception of Bazin's theory, cinematic realism depended on the medium's photographic nature.

A number of frequently quoted statements containing the essence of Bazin's claim for the ontology of the photographic image and presumably for motion picture photography warrant consideration. Bazin's account of the realism of photography rests less on a correspondence theory (that the photograph resembles the world, a relation Peirce would describe as iconic) than on what he describes as "a transference of reality from the thing to its reproduction," referring to the photograph as "a decal or approximate tracing."[7] Bazin extends these comments saying: "The photographic image is the object itself, the object freed from temporal contingencies. No matter how fuzzy, distorted, or discolored, no matter how lacking in documentary value the image may be, it proceeds, by virtue of its genesis, from the ontology of the model; it is the model."[8] He adds shortly after this: "The photograph as such and the object in itself share a common being, after the fashion of a fingerprint. Wherefore, photography actually contributes something to the order of natural creation instead of providing a substitute for it."[9] To cite one more famous description from another essay, Bazin claimed, "The photograph proceeds by means of the lens to the taking of a veritable luminous impression in light—to a mold. As such it carries with it more than a mere resemblance, namely a kind of identity."[10]

Bazin's descriptions are both evocative and elusive, and Wollen was, I think, the first to draw a relation between Bazin's ideas and Peirce's concept of the index. In his pioneering essay "The Semiology of the Cinema," Wollen said of Bazin: "His conclusions are remarkably close to those of Peirce. Time and again Bazin speaks of photography in terms of a mold, a death mask, a veronica, the Holy Shroud of Turin, a relic, an imprint. . . . Thus Bazin repeatedly stresses the existential bond between sign and object, which, for Peirce, was the determining characteristic of the indexical sign."[11] The traditional reception of Bazin's film theory takes his account of the ontology of the photographic image as the foundation of his arguments about the relation between film and the world. Wollen's identification of Bazin's photographic ontology with Peirce's index has been widely accepted (although critics have rarely noted Wollen's important

caveat: "But whereas Peirce made his observation in order to found a logic, Bazin wished to found an aesthetic").[12]

I must state that I think one can make a coherent argument for reading Bazin's ontology in terms of the Peircean index, as Wollen did. However, I have also claimed elsewhere that this reading of Bazin in terms of Peirce does some disservice to the full complexity of Bazin's aesthetic theory of realism.[13] Likewise, in a recent essay Daniel Morgan makes a convincing and fully argued case (different from mine) that Bazin's theory of cinematic realism should not be approached through the theory of the index at all.[14] I would still maintain, however, that parallels between aspects of Bazin's theory of cinematic realism and the index do exist, even if they cannot explain the totality of his theory of cinematic realism (or, as Morgan would argue, its most important aspects).

I do not intend to rehearse here either my own or others' arguments about why the index might not supply a complete understanding of Bazin's theory of cinematic realism, but some summary remarks are in order. The chief limitation to the indexical approach to Bazin comes from the difference between a semiotics that approaches the photograph (and therefore film) as a sign and a theory like Bazin's that deals instead with the way a film creates an aesthetic world. When Bazin claims that "photography actually contributes something to the order of natural creation instead of providing a substitute for it," he denies the photograph the chief characteristic of a sign, that of supplying a substitute for a referent. While it would be foolish to claim that a photograph cannot be a sign of something (it frequently does perform this function), I would claim that signification does not form the basis of Bazin's understanding of the ontology of the photographic image and that his theory of cinematic realism depends on a more complex (and less logical) process of spectator involvement. Bazin describes the realism of the photograph as an "irrational power to bear away our faith."[15] This "magical" understanding of photographic ontology is clearly very different from a logic of signs. In Peirce's semiotics, the indexical relation falls entirely into the rational realm.

BEYOND THE INDEX: CINEMATIC REALISM
AND MEDIUM PROMISCUITY

The indexical argument no longer supplies the only way to approach Bazin's theory. Rather than assuming that the invocation of Peirce's concept of the index solves the question of film's relation to reality, I think we must now raise again the question that Bazin asked so passionately and subtly (even if he never answered definitively): What is cinema? What are cinema's effects and what range of aspects relates to its oft-cited (and just as variously defined) realistic nature? Given the historically specific nature of Bazin's arguments for cinematic realism as an aesthetic value (responding as he did to technical innovations such as deep focus cinematography and to new visual and narrative styles such as Italian Neo-realism), it makes sense for a contemporary theory of cinematic realism to push beyond those aspects of cinematic realism highlighted by

Bazin. Specifically, we need to ask in a contemporary technical and stylistic context: What are the bounds that cinema forges with the world it portrays? Are these limited to film's relation to photography? Is the photographic process the only aspect of cinema that can be thought of as indexical, especially if we think about the term more broadly than as just a trace or impression? If the claim that digital processing by its nature eliminates the indexical seems rather simplistic, one must nonetheless admit that computer-generated images (CGI) do not correspond directly to Bazin's description of the "luminous mold" that the still photograph supposedly depends on. But can these CGI images still be thought of as in some way indexical? In what ways has the impression of reality been attenuated by new technology, and in what ways is it actually still functioning (or even intensified)? But setting aside the somewhat complex case of computer-generated special effects, is it not somewhat strange that photographic theories of the cinema have had such a hold on film theory that much of film theory must immediately add the caveat that they do not apply to animated film? Given that as a technical innovation cinema was first understood as "animated pictures" and that computer-generated animation techniques are now omnipresent in most feature films, shouldn't this lacuna disturb us? Rather than being absorbed in the larger categories of cultural studies or cognitive theory, shouldn't the classical issues of film theory be reopened? I will not attempt to answer all these questions in this essay, but I think they are relevant to the issues I will raise.

Within the academy, the study of film theory has often been bifurcated between "classical film theory" and "contemporary film theory." Insofar as this division refers to something more than an arbitrary sense of the past and present, "classical" film theories have been usefully defined as theories that seek to isolate and define the "essence" of cinema, while "contemporary" theories rely on discourses of semiotics and psychoanalysis to describe the relation between film and spectator.[16] While the classical approach has been widely critiqued as essentialist, it seems to me that a pragmatic investigation of the characteristics of film as developed and commented on through time hardly needs to involve a proscriptive quest for the one pure cinema. Therefore, if I call for new descriptions of the nature(s) of the film medium, I am not at all calling for a return to classical film theory (and even less to a neo-classicism!). But I do think the time has come to take stock of the historical and transforming nature of cinema as a medium and of its dependence and differentiation from other media.

Considering historically the definitions of film as a medium helps us avoid the dilemma of either proscriptively (and timelessly) defining film's essence or the alternative of avoiding any investigation into the diverse nature of media for fear of being accused of promoting an idealist project. As a new technology at the end of the nineteenth century, cinema did not immediately appear with a defined essence as a medium, but rather, displayed an amazing promiscuity (if not polymorphic perversity) in both its models and uses. Cinema emerged within a welter of new inventions for the recording or conveying of aspects of human life previously felt to be ephemeral, inaudible, or

invisible: the telephone, the phonograph, or the X-ray are only a few examples. Before these devices found widespread acceptance as practical instruments, they existed as theatrical attractions, demonstrated onstage before paying audiences. Indeed, the X-ray, which appeared almost simultaneously with the projection of films on the screen, seemed at one point to be displacing moving pictures as a popular attraction, and a number of showmen exchanged their motion picture projectors for the new apparatus that showed audiences the insides of their bodies (and unknowingly gave themselves and their collaborators dangerous doses of radiation). It is in this competitive context of novel devices that Antoine Lumière, the father of Louis and Auguste Lumière, who managed the theatrical exhibition of his sons' invention, warned a patron desirous of purchasing a Cinématographe that it was an "invention without a future."[17]

Rather than myths of essential origins, historical research uncovers a genealogy of cinema, a process of emergence and competition yielding the complex formation of an identity. But cinema has always (and not only at its origin) taken place within a competitive media environment, in which the survival of the fittest was in contention and the outcome not always clear. As a historian I frequently feel that one of my roles must be to combat the pervasive amnesia that a culture based in novelty encourages, even within the academy. History always responds to the present, and changes in our present environment allow us to recognize aspects of our history that have been previously obscured or even repressed. At the present moment, cinema finds itself immersed in another voraciously competitive media environment. Is cinema about to disappear into the maw of undefined and undifferentiated image media, dissolved into a pervasive visual culture? To be useful in such an investigation where theory and history intertwine, the discussion of cinematic realism cannot be allowed to ossify into a dogmatic assertion about the photographic nature of cinema or an assumption about the indexical nature of all photography.

My history lesson resists either celebration or paranoia at the prospect of a new media environment, seeing in our current situation not only a return to aspects of cinema's origins but a dynamic process that has persisted in varying degrees throughout the extent of film's history—an interaction with other competing media, with mutual borrowings, absorptions, and transformation among them. Cinema has never been one thing. It has always been a point of intersection, a braiding together of diverse strands: aspects of the telephone and the phonograph circulated around the cinema for almost three decades before being absorbed by sound cinema around 1928, while simultaneously spawning a new sister medium, radio; a variety of approaches to color, ranging from tinting to stencil coloring, existed in cinema as either common or minority practices until color photography became pervasive in the 1970s; the film frame has changed its proportions since 1950 and is now available in small, medium, and supersized rectangles (television, CinemaScope, IMAX, for example); cinema's symbiotic relation to television, video, and other digital practices has been ongoing for nearly half a century without any of these interactions and transformations—in spite of numerous predictions—yet spelling the

end of the movies. Thus anyone who sees the demise of the cinema as inevitable must be aware they are speaking only of one form of cinema (or more likely several successive forms whose differences they choose to overlook).

Film history provides a challenge to rethinking film theory, arguing for the importance of using the recent visibility of film's multiple media environment as a moment for reflection and perhaps redefinition. In contemporary film theory, a priori proscriptions as well as a posteriori definitions that privilege only certain aspects of film have given way to approaches (like semiotics, psychoanalysis, or cognitivism) that seem to ignore or minimize differences between media in favor of broader cultural or biological conditions. My view of cinema as a braid made of various aspects rather than a unified essence with firm boundaries would seem to offer a further argument against the essentialist approach of classical film theory.

But we also increasingly need to offer thick descriptions of how media work, that is, phenomenological approaches that avoid defining media logically before examining the experience of their power. And while I maintain the various media work in concert and in contest rather than isolation, I also maintain that the formal properties of a specific medium convey vital aesthetic values and do not function as neutral channels for functional equivalents. An attempt to isolate a single essence of cinema remains not only an elusive task but possibly a reactionary project, yet most earlier attempts by theorists to define the essence of cinema can also be seen as attempts to elucidate the specific possibilities of cinema within a media environment that threatens to obscure or dismiss the particular powers that film holds. In other words, while the naming of a specific aspect of cinema as its essence must always risk being partial, it once had the polemical value of drawing attention to those aspects, allowing theorists to describe their power. This was true of the emphasis given to editing by the Soviet theorists in the twenties, who established that film could function not simply as a mode of mechanical reproduction but that it could create a poetics and a rhetoric that resembled a language. Partly as a corrective to this earlier claim that editing formed the essence of film as a creative form, the emphasis on film's relation to photography found after World War II in the work of Bazin, Siegfried Kracauer, and Stanley Cavell also performed this sort of vital function of attracting attention to a neglected aspect of cinema. In the current environment, probing the power of cinema, its affinities with and differentiations from other media, must again take a place on our agenda.

WHAT REALLY MOVES ME...

Photography's relation to cinema comprises one of the central concepts in classical film theory's attempt to characterize the nature of cinema, and it remains a rich area for investigation. However, to offer alternative paradigms, I want to return to the generation of film theorists of the twenties, primarily the work of filmmaker theorists such as Sergei Eisenstein, Jean Epstein, and Germaine Dulac, who wrote before the dominance

of photography that marks the work of Bazin and Kracauer (and arguably Walter Benjamin).[18] Although photography played a key role in film theories of the twenties as well (especially in the concept of Photogénie—the claim that film produced a unique image of the world more revelatory than other forms of imagery—championed by Epstein, Dulac, and Louis Delluc), I want to focus on the centrality of cinematic motion in the discussions of cinema's nature that marked this foundational period of classical film theory. Dulac declared in 1925, "Le cinéma est l'art du mouvement et de la lumière" (Cinema is the art of movement and light). In her writings and her innovative abstract films, she envisioned a pure cinema uncontaminated by the other arts (although aspiring to the condition of music), which she described as "a visual symphony, a rhythm of arranged movements in which the shifting of a line or of a volume in a changing cadence creates emotion without any crystallization of ideas."[19] The concerns that preoccupied both the French Impressionist filmmakers and the Soviet montage theorists of the 1920s—cinematic rhythm as a product of editing, camera movement, and composition; the physical and emotional reactions of film spectators as shaped by visual rhythms; even the visual portrayal of mental states and emotions—were all linked to cinema's ability both to record and create motion.[20]

The role of motion in motion pictures initially appears to be something of a tautology. Rather than simply recycling this seemingly obvious assumption—that the movies move—theories of cinematic motion can help us reformulate a number of theoretical and aesthetic issues, including film spectatorship, film style, and the confluence of a variety of new media. Further, a renewed focus on cinematic motion directly addresses what I feel is one of the great scandals of film theory, which I previously mentioned as an aporia resulting from the dominance of a photographic understanding of cinema: the marginalization of animation.[21] Again and again, film theorists have made broad proclamations about the nature of cinema, and then quickly added, "excluding, of course, animation." Perhaps the boldest of new media theorists, Lev Manovich, has recently inverted this cinematic prejudice, claiming that the arrival of new digital media reveals cinema as simply an event within the history of animation. While I appreciate the polemic value of this proclamation, I would point out (as Manovich's archeology of the cinema also indicates) that far from being a product of new media, animation has always been part of cinema and that only the overemphasis given to the photographic basis of cinema in recent decades can explain the neglect this historical and technological fact has encountered.

Stressing, as Manovich does, the nonreferential nature of animation implies that only photography can be referential—a major error that comes from a diminished view of the index. But if cinema should be approached as a form of animation, then cinematic motion rather than photographic imagery becomes primary. Spectatorship of cinematic motion raises new issues, such as the physical reactions that accompany the watching of motion. Considering this sensation of kinesthesia avoids the exclusive visual and ideological emphasis of most theories of spectatorship and acknowledges instead

that film spectators are embodied beings rather than simply eyes and minds somehow suspended before the screen. The physiological basis of kinesthesia exceeds (or supplements) recent attempts to reintroduce emotional affect into spectator studies. We do not just see motion and we are not simply affected emotionally by its role within a plot; we feel it in our guts or throughout our bodies.

Theories of cinema's difference from the other arts that appeared in the twenties derived from the excitement that filmmakers of the teens and twenties experienced in their newfound ability to affect viewers physiologically as well as emotionally through such motion-based sequences as chase scenes involving galloping horses or racing locomotives, rapid camera movement, or accelerated rhythmic editing. While kinesthetic effects still play a vital role in contemporary action cinema, nowadays these devices of motion rarely generate theoretical speculation or close analysis. Nonetheless, critical attention to cinematic motion need not be limited to action films, however rich this mainstay of film practice may be. Motion, as Eisenstein's analysis of the methods of montage makes clear, can shape and trigger the process of both emotional involvement and intellectual engagement.[22] Analysis of motion in cinema should address a complete gamut of cinema, from the popular action film to the avant-garde work of filmmakers such as Stan Brakhage, Maya Deren, or Abigail Child.

In many ways these avant-garde filmmakers took up the legacy of Dulac's pure cinema and explored the possibilities of filmic motion outside of narrative development. Although Deren in particular stressed the importance of the photographic basis of film in her theoretical writings, she made the analysis and transformation of motion essential to all her films, especially her later films inspired by dance and ritualized bodily movement such as *Ritual in Transfigured Time* (1946), *A Study in Choreography for the Camera* (1945), *Meditation on Violence* (1948), and *The Very Eye of Night* (1958).[23] Brakhage's use of handheld camera movement and complex editing patterns, as well as frenetic kinetic patterns created by painting directly on celluloid, produced patterns of motion that evoked a crisis of perception and lyrical absorption in the processes of vision.[24] Filmmaker Abigail Child's recent volume of writings on film and poetry is actually titled *This Is Called Moving*, testifying to her commitment to cinema as a means of deconstructing the dominant cultural forms of media through an intensification of cinematic perception that relies in part on new patterns of motion, often created through editing. As cinematic experience, motion can play an intense role both in sensations of intense diegetic absorption fostering involvement with dramatic, suspenseful plots à la Hitchcock and in kinetic abstraction, thrusting viewers into unfamiliar explorations of flexible coordinates of space and time.

Theoretical exploration of cinematic motion need not contradict, but can actually supplement, photographic theories of cinema such as those of Kracauer and Bazin. Kracauer in particular deals extensively with cinema's affinities with motion (discussing especially the cinematic possibilities of the chase, dancing, and the transformation from stillness to motion) as a part of cinema's mission to capture and redeem physical

reality.[25] Even if movement never receives a detailed discussion as a theoretical issue within Bazin's work, he clearly sees camera movement as an essential tool within a realist style, as in his analysis of the extended track and pan in Jean Renoir's *The Crime of M. Lange,*[26] or his description of the shot in Friedrich Murnau's *Tabu* in which "the entrance of a ship from left screen gives an immediate sense of destiny at work, so that Murnau has no need to cheat in any way on the uncompromising realism of a film whose settings are completely natural."[27]

METZ AND CINEMATIC MOVEMENT

While Bazin and Kracauer saw motion as contributing to (or at least not contradicting) the inherent realism of the film medium, another film theorist went further and made movement the cornerstone of cinema's impression of reality. I want to turn now to a neglected essay by a theorist usually associated with postclassical film theory, Christian Metz. "On the Impression of Reality in the Cinema," a short essay that directly superimposes the issues of motion and cinematic realism, opens the first volume of Metz's writings and is among Metz's presemiotic essays that the section heading characterizes as "phenomenological" (and that most theorists have zoomed past, treating as juvenilia).

Metz attempts in this essay to account for the "impression of reality" that the movies offer ("Films release a mechanism of affective and perceptual participation in the spectator [. . .] films have the appeal of a presence and of a proximity.")[28] While later apparatus theorists (including Metz himself in later writings) would see realism as a dangerous ideological illusion (while Bazin, on the contrary, would deepen cinematic realism into the possibility of grasping the mysteries of Being), in this early essay Metz simply attempts to give this psychological effect a phenomenological basis. Metz begins by contrasting media, claiming this degree of spectator participation and investment does not occur in still photography. Following Roland Barthes, Metz claims that still photography is condemned to a perceptual past tense ("This has been there"), while the movie spectator becomes absorbed by "a sense of 'There it is.'"[29]

Metz locates the realistic effect of cinematic motion in its "participatory" effect. "Participation" seems to be a magic word in theories of realism that seek to overcome the dead ends encountered by correspondence theories of cinema. For Bazin, participation describes the relation between the photographic image and its object. Likewise, his description of the spectator's active role in the cinematic style that makes use of depth-of-field composition ("it is from [the spectator's] attention and his will that the meaning of the image in part derives") indicates an active participation by the viewer.[30] For Metz, similarly, participation in the cinematic image is both "affective and perceptual," engendering "a very direct hold on perception," "an appeal of a presence and proximity."[31]

Metz points out that "participation, however, must be engendered."[32] What subtends this sense of immediacy and presence in the cinema? "An answer immediately suggests itself: It is movement . . . that produces the strong impression of reality."[33] While Metz

admits other factors in film's effect on spectators, he ascribes a particular effect to the perception of motion, "a general law of psychology that movement is always perceived as real—unlike many other visual structures, such as volume, which is often very readily perceived as unreal."[34] In terms that seem to recall Bazin's claim that a photograph "is the object," Metz adds, "The strict distinction between object and copy, however, dissolves on the threshold of motion. Because movement is never material but is always visual, to reproduce its appearance is to duplicate its reality. In truth, one cannot even 'reproduce' a movement; one can only re-produce it in a second production belonging to the same order of reality for the spectator as the first. . . . In the cinema the impression of reality is also the reality of the impression, the real presence of motion."[35] Metz gives here a very compressed account of a complex issue, and his assumptions would take some time to isolate and explicate (such as exactly what the "reality of an impression" might be and the begging of the question through the assertion that cinema delivers "the real presence of motion"). But the relation he draws between motion and the impression of reality provides us with a radical course of thought. We experience motion on the screen in a different way than we look at still images, and this difference explains our participation in the film image, a sense of perceptual richness or immediate involvement in the image. Spectator participation in the moving image depends, Metz claims, on perceiving motion and the perceptual, cognitive, and physiological effects this triggers. The nature of cinematic motion, its continuous progress, its unfolding nature, would seem to demand the participation of a perceiver.

Although Metz does not refer directly to Henri Bergson's famous discussion of motion, I believe Bergson developed the most detailed description of the need to participate in motion in order to grasp it. Bergson claims, "In order to advance with the moving reality, you must replace yourself within it."[36] For Bergson, discontinuous signs, such as language or ideas, cannot grasp the continuous flow of movement, but must conceive of it as a series of successive static instants, or positions. Only motion, one can assume, is able to convey motion. Therefore, to perceive motion, rather than represent it statically in a manner that destroys its essence, one must participate in the motion itself. Of course, analysis provides a means of conceptual understanding, and Bergson actually refers to our tendency to conceive of motion through a series of static images—a distortion he claims our habits of mind and language demand of us—as "cinematographic." Great confusion (which I feel Deleuze increases rather than dispels) comes if we do not realize that the analytical aspect of the cinematograph that Bergson took as his model for this tendency to conceive of motion in terms of static instants derives from the film strip in which motion is analyzed into a succession of frames, not the projected image on the screen in which synthetic motion is re-created.

Cinema, the projected moving image, demands that we participate in the movement we perceive. Analysis of perceiving motion can only offer some insights into the way the moving image exceeds our contemplation of a static image. Motion always has a projective aspect, a progressive movement in a direction, and therefore invokes

possibility and a future. Of course, we can project these states into a static image, but with an actually moving image we are swept along with the motion itself. Rather than imagining previous or anterior states, we could say that through a moving image, the progress of motion is projected onto us. Undergirded by the kinesthetic effects of cinematic motion, I believe "participation" properly describes the increased sense of involvement with the cinematic image, a sense of presence that could be described as an impression of reality.

Metz claims that the motion we see in a film is real, not a representation, a claim I take to be close to Bergson's discussion of the way movement cannot be derived simply from a static presentation of successive points. According to Metz, what we see when we see a moving image on the screen should not be described as a "picture" of motion, but instead as an experience of seeing something truly moving. In terms of a visual experience of motion, therefore, no difference exists between watching a film of a ball rolling down a hill, say, and seeing an actual ball rolling down a hill. One might object to this identification of motion and its visual sensation by pointing out that our sensation of motion (kinesthesia) does not depend entirely on vision but on a range of bodily sensations. But I believe Metz could respond to this in two ways. First, the most extreme sort of kinesthesia primarily refers to the sensation of ourselves moving bodily, traversing space, not simply watching a moving object. Insofar as we do experience kinesthesia when we observe a moving object other than ourselves, the same sensations seem to occur when we watch a moving object in a film. Thus, perceiving motion in the cinema, while triggered by visual perception, need not be restricted to visual effects. Clearly, cinema cannot move us, as viewers, physically (we don't, for instance, leave our seats or get transported to another place, even if we have a sensation of ourselves moving as we watch films in which the camera moves through space). However, while acknowledging that Metz can only claim that cinema possesses visual motion, not literal movement through space—a change of place—the fact remains that even visual motion, such as camera movement, doesn't only affect us visually but does produce the physiological effect of kinesthesia.

Metz questions whether there could be a "portrayal of motion" that did not actually involve motion, a representation parallel, say, to the use of perspective drawing to render volumes. In a way, it is not hard to conceive of such a portrayal. A diagram conveying the trajectory of a moving object, such as a graph of the parabola described by a baseball hit by David Ortiz, could be said to portray motion. The speed lines used by comic book artists to indicate a running figure also portray the idea of motion visually but in static form. Indeed, the chronophotographs of Étienne-Jules Marey, with their composite and successive figures tracing the path of human movement, or the blurred image of simple actions like turning a head found in the photo-dynamist photographs of Futurist Anton Giulio Bragaglia, all portray motion without actually moving. But that is the point, precisely. These diagrammatic portrayals of motion strike us very differently from actual motion pictures. Such portrayals of motion recall Bergson's descriptions of attempts to

generate a sense of motion from tracing a pattern of static points or positions, which miss the continuous sweep of motion. In contrast to these diagrams of the successive phases of motion or indications of its pathways, we could say, perhaps now with even more clarity, that cinema shows us motion, not its portrayal.

Ultimately, I think there is little question that phenomenologically we see movement on the screen, not a "portrayal" of movement. But what does it mean to say the movement is "real"? As I understand Metz's claim, it does not at all commit us to the nonsensical position that we take the cinema image for reality, that we are involved in a hallucination or "illusion" of reality that could cause us to contemplate walking into the screen, or interacting physically with the fictional events we see portrayed. In the cinema, we are dealing with realism, not "reality." As Metz makes clear, "on the one hand, there is the impression of reality; on the other, the perception of reality."[37] Theater, for instance, makes use of real materials, actual people and things, to create a fictional world. Cinema works with images that possess an impression of reality, not its materiality. This distinction is crucial.

THE REALISTIC MOTION OF FANTASY

Metz's description of cinematic motion supplies at least part of (and probably a central part of) an alternative theory of the realistic effect of the cinema (one I find much more compelling and flexible than the ideological explanation of psychological regression offered by Jean- Louis Baudry and, in a sense, the later Metz of *The Imaginary Signifier*). But we should keep in mind that this is a theory of the impression of reality (based, as he says, on the reality of the impression), rather than an argument for a realist aesthetic such as that offered by Bazin or Kracauer. Part of the flexibility of Metz's theory of the reality of cinematic motion lies in its adaptability to a range of cinematic styles. As Metz indicates, the "feeling of credibility" film offers "operates on us in films of the unusual and of the marvelous, as well as in those that are 'realistic.'"[38] But his description also shows that movement can be an important factor in describing a realist style (one need only think of the role of camera movement in Welles and Rossellini, undertheorized by Bazin, or in Renoir, which Bazin describes beautifully). But the fantastic possibilities of motion, or rather its role in rendering the fantastic believable, and I would say visceral, shows the mercurial role motion can play in film spectatorship and film style.

It is this mercurial, protean, indeed mobile nature of cinematic motion that endows it with power as a concept for film theory and analysis. Not only does the concept of cinematic movement unite photographic-based films and traditional animated films (not to mention the hybrid synthesis of photographic and animation techniques that computer-generated images represent), movement displays a flexibility that avoids the proscriptive nature of much of classical film theory.[39] While the formal aspects of cinematic movement (and the range of ways it can be used, or even the number of aspects of cinematic motion possible) make it an important tool for aesthetic analysis (and even

useful in a polemical argument like Dulac's or Bazin's for a particular style of film), nothing restricts movement to a single style.

The impression of reality that cinematic movement carries can underwrite a realist film style (think of the use of handheld camera movement in the films of the Dogma 95 movement), a highly artificial fantasy dependent on special effects (the importance of kinesis in the *Star Wars* films), or an abstract visual symphony (animator Oskar Fischinger). Metz describes the role of the impression of reality enabled by cinematic motion as "to inject the reality of motion into the unreality of the image and thus to render the world of imagination more real than it had ever been."[40] Like Mercury, winged messenger of the gods, cinematic motion crosses the boundaries between heaven and earth, between the embodied senses and flights of fancy, not simply playing the whole gamut of film style but contaminating one with the other, endowing the fantastic with the realistic impression of visual motion.

The extraordinary writings Sergei Eisenstein produced in the 1930s on the animated films of Walt Disney accent this double valence of movement, tending not only toward realism but also, as the animated film and new digital processes demonstrate, toward fantasy. Movement in the cinema not only generates the visual sense of realism that Metz describes, but bodily sensations of movement can engage spectator fantasy through perceptual and physical participation. Thus, movement created by animation, freed from photographic reference, can endow otherwise "impossible" motion and transformations with the immediacy of perception that Metz claims movement entails. In some ways this returns us to Dulac's concept of a pure cinema based entirely on the motion of forms (and the forms of motion). In his writings on Disney, Eisenstein focuses on the possibility of the animated line to invoke precisely this aspect of motion, which he calls "plasmaticness" and defines as "a rejection of once-and-forever allotted form, freedom from ossification, the ability to dynamically assume any form."[41] Rather than simply endowing familiar forms with the solidity and credibility that Metz describes, movement can extend beyond familiarity to fantasy and imagination, creating the impossible bodies that throng the works of animation, from the early cartoons of Émile Cohl to the digital manipulation of Gollum in *The Lord of the Rings*.[42] While flaunting the rules of physical resemblance, such animation need not remain totally divorced from any reference to our lived world. As I once heard philosopher Arthur Danto explain, the cartoon body can reveal primal phenomenological relations we have to our physical existence, our sense of grasping, stretching, exulting.[43] For Eisenstein, this plasmatic quality invokes "[a] lost changeability, fluidity, suddenness of formations—that's the 'subtext' brought to the viewer who lacks all this by these seemingly strange traits which permeate folktales, cartoons, the spineless circus performer, and the seemingly groundless scattering of extremities in Disney's drawings."[44]

Motion therefore need not be realistic to have a "realistic" effect, that is, to invite the empathic participation, both imaginative and physiological, of viewers. Eisenstein's discussion of motion as a force that does not simply propel forms but actually creates

them not only refers back to the theories of Bergson but makes clear the multiple nature of the participation that motion invokes, from the perceptual identity described by Metz to the realm of anticipation, speculation, and imagination of the possibly transforming aspects of line described by Eisenstein. Unlike the literalness of pointing to an actual individual that a narrow adherence to the diminished indexical theory of film and photography forces on us, as Metz emphasizes, the cinematic impression of reality affects the diegesis, the fictional world created by the film, and thus escapes the straitjacket of exclusive correspondence or reference to any preexisting reality. Metz's concept of cinematic movement's "novel power to convince . . . was all to the advantage of the imagination."[45]

The realist claim offered for cinema's indexical quality, based in still photography, actually operates in a diametrically different direction than the role Metz outlines for cinematic movement in the medium's impression of reality. An indexical argument, as it has been developed, based in the photographic trace, points the image back into the past, to a preexisting object or event whose traces could only testify to its having already been. Metz's concept of the impression of reality moves in the opposite direction, toward a sensation of the present and of presence. The indexical argument can be invoked most clearly (and usefully) for films used as historical evidence. It remains unclear, however, how the index functions within a fiction film, where we are dealing with a diegesis, a fictional world, rather than a reference to a reality. Laura Mulvey, in her extremely important discussion of indexicality in film, has pointed out how it relates to the phenomenon of the Star, clearly an existing person beyond the fictional character he or she plays and therefore a reference outside the film's diegesis.[46] The effect of an index in guaranteeing the actual existence of its reference depends on the one who makes this connection invoking a technical knowledge of photography, understanding the effect of light on the sensitive film. Metz's cinematic impression of reality depends on "forgetting" (that is, on distracting the viewer's attention away from—not literally repressing the knowledge of) the technical process of filming in favor of an experience of the fictional world as present. As he claims, "The movie spectator is absorbed, not by a 'has been there' but by a sense of 'There it is.'"[47]

Even if the indexical claim for cinema is granted, I am not sure it really supplies the basis for a realist aesthetic. Although Bazin invokes something that sounds like an index in his description of the ontology of the photographic image, maintaining the exact congruence of his claims with a strictly indexical claim seems fraught with difficulty. Rather than an argument about signs, Bazin's ontology of the photographic and filmic image seems to assert a nearly magical sense of the presence delivered by the photographic image. In any case, at best, the index would only function as one aspect of Bazin's realist aesthetic.[48] Once again, I am not claiming no use exists for the index in theories of film and photography, but simply that it has been entrusted with tasks it cannot fulfill and that reading it back into classical realist theories of the cinema probably obscures as much as it explains.

But I would also have to admit that "motion," even when specified as "cinematic motion," probably includes multiple aspects, not just one perceptible factor. The extreme spectator involvement that movement can generate needs further study, both in terms of perceptual and cognitive processes (which I think call for both experimental and phenomenological analysis) and in relation to broader aesthetic styles. Metz's description is based on the classical fiction film: what role does motion play in nonclassical films? (I have, of course, argued for its vital role in avant-garde film.) I am offering only a prolegomena to a larger investigation; my comments here aspire to be provocative rather than definitive. Motion, I am arguing, needs to be taken more seriously in our exploration of the nature of film and our account of how film style functions. At the same time, giving new importance to movement (or restoring it) builds a strong bridge between cinema and the new media that some view as cinema's successors. Like the animated line Germaine Dulac described, whose movement directly creates an emotion, motion involves both transformation and continuity (film history involves both the transformation of its central medium and a recognition of an ever-shifting continuity, a trajectory, to this transformation). As an art of motion, cinema has affinities to other media: dance, action painting, instantaneous photography, kinetic sculpture. But it also possess its own trajectory, one in which I suspect the new media of motion arts will also find a place, or at least an affinity.

The point of view [the work] is conveying has to be completely entwined with a sense of life as it is, and has to be got across through subtle injection into the audience's consciousness . . . The ideas have to be discovered by the audience, and their thrill in making the discovery makes those ideas all the more powerful.

Stanley Kubrick, "Words and Movies," 1961

18

SEEING AROUND THE EDGE OF THE FRAME
2001

Walter Murch

One of film's greatest editors, Murch insists that part of the mystery of giving birth
to a film is an understanding of the subtleties of the frame.

The film editor is one of the few people working on the production of a film who does
not know the exact conditions under which it was shot (or has the ability not to know)
and who can at the same time have a tremendous influence on the film.

If you have been on and around the set most of the time, as the actors, the producer,
director, cameraman, art director, and so on have been, you can get caught up in the
sometimes bloody practicalities of gestation and delivery. And then when you see the
dailies, you can't help, in your mind's eye, seeing around the edge of the frame—you
can imagine everything that was there, physically and emotionally, just beyond what
was actually photographed.

"We worked like hell to get that shot; it has to be in the film." You (the director, in
this case) are convinced that what you got was what you wanted, but there's a possibility
that you may be forcing yourself to see it that way because it cost so much—in money,
time, angst—to get it.

By the same token, there are occasions when you shoot something that you dislike,
when everyone is in a bad mood, and you say under protest: "All right, I'll do this; we'll
get this one close-up, and then it's a wrap." Later on, when you look at that take, all you
can remember was the hateful moment it was shot, and so you may be blind to the
potentials it might have in a different context.

The editor, on the other hand, should try to see only what's on the screen, as the audi-
ence will. Only in this way can the images be freed from the context of their creation.
By focusing on the screen, the editor will, hopefully, use the moments that should be

used, even if they may have been shot under duress, and reject moments that should be rejected, even though they cost a terrible amount of money and pain.

I guess I'm urging the preservation of a certain kind of virginity. Don't unnecessarily allow yourself to be impregnated by the conditions of shooting. Try to keep up with what's going on but try to have as little specific knowledge of it as possible because, ultimately, the audience knows nothing about any of this—and you are the ombudsman for the audience.

The director, of course, is the person most familiar with all of the things that went on during the shoot, so he is the most burdened with this surplus, beyond the frame information. Between the end of shooting and before the first cut is finished, the very best thing that can happen to the director (and the film) is that he say goodbye to everyone and disappear for two weeks up to the mountains or down to the sea or out to Mars or somewhere—and try to discharge this surplus.

Wherever he goes, he should try to think, as much as possible, about things that have absolutely nothing to do with the film. It is difficult, but it is necessary to create a barrier, a cellular wall between shooting and editing. Fred Zinnemann would go climbing in the Alps after the end of shooting, just to put himself in a potentially life-threatening situation where he had to be there, not daydreaming about the film's problems.

Then, after a few weeks, he would come down from the Alps, back to earth; he would sit down in a dark room, alone, the arc light would ignite, and he would watch his film. He would still be, inherently, brimming with those images from beyond the edge of the frame (a director will never be fully able to forget them), but if he had gone straight from shooting to editing, the confusion would be worse and he would have gotten the two different thought processes of shooting and editing irrevocably mixed up.

Do everything you can to help the director erect this barrier for himself so that when he first sees the film, he can say, "All right, I'm going to pretend that I had nothing to do with this film. It needs some work. What needs to be done?"

And so you try as hard as you can to separate out what you wish from what is actually there, never abandoning your ultimate dreams for the film, but trying as hard as you can to see what is actually on the screen.

19

SENSORIAL CINEMA
Conjectures/Conversations
2014

Scott MacDonald

Film historian MacDonald explores the provocative sensorial achievements of two landmark films to emerge from Harvard's influential Sensory Ethnography Lab—*Leviathan* and *Manakamana*.

In this age of hysterical consumption and endless distraction, it has become commonplace for people, especially young people, to escape from the sensory awareness of their daily surround by reducing their focus to the miniature screens of their smartphones. These screens offer the panoply of data that seems necessitated by the demands of their social interchange and the pressures of education and work within an economically precarious society. Implicitly the phones reduce the world, or at least those aspects of the world necessary for practical life, to what seems a manageable size. The auditory surround is often controlled as well, with the use of earbuds and other devices.

In fact, the larger sensory surround is increasingly understood as a distraction from the electronic environment within which smartphones (and all our other digital devices for accessing information and communicating with others) function. As a result, it is hardly surprising that a new generation of motion-picture artists would become interested in confronting this tendency toward the miniaturization of sensory experience, that a Sensory Ethnography Lab (SEL) would be instituted at Harvard University (its goal: "to support innovative combinations of aesthetics and ethnography . . . that explore the bodily praxis and affective fabric of human existence"), or that Lucien Castaing-Taylor, who established the SEL, and his filmmaker colleagues would dedicate themselves to the production of motion-picture experiences that evoke the power and fascinations of the sensory world and the various kinds of awareness that experiencing it can make available to us.

The SEL has become the instigation for a series of remarkable films that in approach

and impact seem midway between documentary and avant-garde film. Notable SEL "avant-docs" include *Sweetgrass* (2009) by Ilisa Barbash and Castaing-Taylor; *Songhua* (2007) and *Chaiqian (Demolition)* (2008) by John Paul Sniadecki; *Monsoon-Reflections* (2008) and *As Long as There's Breath* (2009) by Stephanie Spray; *Foreign Parts* (2010) by Sniadecki and Véréna Paravel; *People's Park* (2013) by Sniadecki and Libbie D. Cohn; and, most recently, the subjects here: *Leviathan* (2013) by Castaing-Taylor and Paravel and *Manakamana* (2013) by Spray and Pacho Velez. *Leviathan* and *Manakamana* represent two distinct cinematic approaches and offer film experiences that could hardly be more different from one another. However, each film, in its own way, is devoted to the expansion of a younger (and older) generation's willingness to engage with the sensory world, both within the movie theater and outside, in the world-at-large.

The conversation with Castaing-Taylor and Paravel, excerpted here, was developed online during the fall of 2012; the conversation with Spray and Velez, in the early months of 2013.

LEVIATHAN

As its title suggests, Castaing-Taylor's and Paravel's approach in *Leviathan* is immersion. They immersed themselves for a time in the daily life of fishing boats shipping out of New Bedford, Massachusetts, in order to record the image and sound they would use in creating a remarkably immersive film experience. Indeed, while the film's title seems to be a reference to the Biblical leviathan, a large sea monster or whale (the film's opening quotations from Job confirm this Biblical reference), or perhaps to the ocean, the leviathan in *Leviathan* is the film itself. Made to be shown on the big screen with surround sound, *Leviathan* swallows *us*—regurgitating us out of the theater at the end of 87 minutes, exhausted and happy to have "lived through" a visual phantasmagoria embedded within a powerful auditory surround.

The experience created by *Leviathan* is, to some extent, a function of the new recording technologies available to Castaing-Taylor and Paravel. To record life on the fishing boats, they depended on tiny DSLR and GoPro video cameras that they could handhold but also mount in a variety of ways: on the bodies of the fishermen working on the boats and sometimes on a long pole so they could film from above the boat and below the surface of the ocean. Though they usually recorded in long continuous shots, these shots often have the impact of dense montage. Abrupt camera movements can cause two elements of the same shot to seem like separate shots, especially when the filming takes place at night under the erratic lights on the fishing boat, and since digital recording tends to flatten perspective, distant and nearby elements of particular scenes often pile up, creating complex compositions that have the impact of superimposition. Even when the tiny cameras are held relatively still, they seem always in motion—in large measure because the boat itself is always moving. Periodically, the film does provide momentary relief (most obviously, perhaps, during a four-minute shot, near the end,

of one of the fishermen falling asleep watching *The Deadliest Catch* on a television in the galley!), but the overall impact of *Leviathan* is of the continuous motion of ocean, boat, cameras, fishermen, fish and shellfish, seabirds, and of the always changing auditory surround.

Castaing-Taylor's and Paravel's approach in *Leviathan* is unusual for documentary cinema—though there are various precedents. In painting there are the maritime paintings of J. M. W. Turner and Winslow Homer, for example, and on a different register, the action paintings of Jackson Pollock; in cinema there is Georges Franju's *Le Sang des bêtes* (*The Blood of the Beasts*, 1949) and Michael Glawogger's *Workingman's Death* (2005)—but more to the point here: *Forest of Bliss* (1986), Robert Gardner's depiction of life at the Manikarnika Ghat in Benares/Varanasi, India, where the dead are cremated in a ritualized fashion along the banks of the Ganges. As fully as any film, *Forest of Bliss* was the premonition for the approach to filmmaking championed by the SEL. Indeed, Gardner was Castaing-Taylor's colleague at Harvard during the formative moment of the SEL (it was established in 2006), as well as the subject of *The Cinema of Robert Gardner* (Oxford/New York: Berg, 2007), co-edited by Ilisa Barbash and Castaing-Taylor. Like *Leviathan*, *Forest of Bliss* is an immersive film, though it proceeds by gradual accretion, adding elements to our visual and auditory awareness until, by the latter part of its feature length, we are aware of a plethora of visual and auditory elements near and far. Gardner's spirit has continued to hover near the SEL: to shoot *Manakamana*, Spray and Velez used the camera with which Gardner shot *Forest of Bliss*.

The immersive approach in *Leviathan* also looks back to the history of what has usually been called "avant-garde film," and particularly to an approach identified with Stan Brakhage, many of whose films were achieved by freeing the motion picture camera from the tripod and relying on handheld gestural camerawork as a way of exploring the filmmaker's sensory surround. Brakhage was ocular-centric: most of his films were made for silent exhibition, on the grounds that the process of acculturation in modern societies is, to a considerable extent, a process of individuals learning *not* to see: that is, to become increasingly unaware of the physical world around them and of the particulars of their own sight. Brakhage refused sound in order to create expanded awareness of sight, though his understanding of how sight is controlled could apply equally to hearing, touching, feeling, and our sense of smell.

The films of the SEL certainly don't ignore sound—indeed, it is a characteristic of SEL films that sound is heard for some moments before imagery appears—but the free-form camerawork in *Leviathan* often evokes the camerawork in canonical Brakhage films like *Anticipation of the Night* (1958) and *Window Water Baby Moving* (1959), not surprising perhaps, since Castaing-Taylor spent several years in Boulder, Colorado, where Brakhage was teaching and was a regular attendee of Brakhage's cine-salon (Brakhage is thanked in Barbash and Castaing-Taylor's *Sweetgrass*). And Brakhage's films are frequently shown at the SEL. Of course, both Brakhage's commitment to the silent 16mm camera (sometimes to even lighter and therefore more mobile 8mm and

FIGURES 19.1 AND 19.2

Stills from Lucien Castaing-Taylor and Véréna Paravel's *Leviathan*, 2013. Copyright Arrête Ton Cinéma.

Super-8mm cameras) and Castaing-Taylor/Paravel's decision to work with tiny digital cameras allowed for forms of visual experiment that, in the end, provide an alternative to industrially produced media and the conventional kind of viewing marketed by so much of the commercial cinema.

CASTAING-TAYLOR AND PARAVEL: Filming in New Bedford, in and around the harbor, started, occasionally and intermittently, during the summer and fall of 2011, and in earnest during the winter. The initial idea was to make a film about fishing, and the ocean more broadly, without ever seeing, or at least recognizing, a fishing boat or the sea. We first went out to George's Bank on a dragger in March 2012. After that first trip, we quickly lost interest in the land.

Most captains we met in port were very welcoming, intrigued by our interest, and they invited us to go out with them.

MACDONALD: It must have been obvious to both of you, almost from the beginning, that you weren't going to make a conventional informational documentary about industrial ocean fishing or a TV melodrama about the men who work on fishing boats.

CASTAING-TAYLOR AND PARAVEL: Fishing is perhaps the most photographed endeavor in the history of photography and cinema—from Octavius Hill and Robert Adamson, Robert Flaherty and John Grierson, all the way up to Allan Sekula, Discovery Channel's *The Deadliest Catch,* and *The Cove* [2009]. The vast majority of this tradition indulges in the kinds of sentimentality and romanticism that one knows all too well, or else fits snugly into the agitprop liberal public-television victimhood tradition, both of which we knew from the get-go we had to avoid.

MACDONALD: I know from talking with the two of you over the past couple of years that the labors of recording the material for *Leviathan* were considerable—if not as grueling as the work the fishermen do, difficult in other ways. Could you each talk about what you physically and psychologically went through while shooting the film?

PARAVEL: The boat contained many of my deepest fears, if not phobias: being trapped in a highly claustrophobic space, with no possible way to escape either from the men or the unrelenting engine noise or the menacing, dark sea, constantly sensing the deep and unknown below me. Despite all that, I felt pretty much at ease to move about on the boat. Unfortunately after several days of rough seas, my body could no longer handle the pressure and on each trip I ended up covered with bruises and immobilized, having put my back out.

CASTAING-TAYLOR: I had never been seasick before and didn't anticipate having any problem with it, though Véréna had an intuition that I would. I basically puked my guts out for the first 24–48 hours of each trip. I tried various antiemetics, which induced different degrees of stupor, and even made me see double, which didn't particularly help matters.

The boat was all-imposing, oddly claustrophobic, with no relief anywhere—very loud, not especially seaworthy, no real privacy.

MACDONALD: How much did you shoot, and how did the shooting process evolve?

CASTAING-TAYLOR AND PARAVEL: Between land and sea we probably shot around 250 hours of footage. Once we lost interest in land, we jettisoned maybe one hundred hours of that material. We took six trips out to sea of between nine days and three weeks. We never knew how long they would last, any more than the captain did—it would depend on the weather, their catch, whether the gear broke, and fluctuating fish prices. Maybe 2 or 2½ months out at sea, altogether.

It wasn't until the last trip that our curiosity and sense of wonder about what we were witnessing began to wane, that we felt that our accumulated footage had begun to do justice to everything we'd experienced on the boat.

MACDONALD: Like so many of the SEL films, *Leviathan* is as much a sound work as an image work. I assume this was partly inevitable, given the realities of ocean fishing.

CASTAING-TAYLOR: The sensorial intensity of life on the boat is as acoustic as it is visual—the engine is relentless and renders dialogue all but unintelligible—and it never occurred to us not to afford equal billing to sound and picture.

PARAVEL: Except at one point early in the editing when Lucien had the ridiculous notion to make the whole film silent!

CASTAING-TAYLOR: Initially, both in New Bedford and out on the Atlantic, we were shooting with a Sony EX3 and an EX1, each with a stereo Sanken microphone mounted on it. We were also recording wild sound onto a Sound Devices T788 recorder, both from a superstereo microphone (another Sanken model) and various Lectrosonics wireless lavaliers. Though we lost the EX3 and EX1 (one was stolen and another washed overboard) and ended up discarding all the images except one that we'd shot with them, we kept the sound—as well as all the wild sound we recorded on the recorder: the nets, the winches, the cutting tables, the scallop shucking basins, inside the bridge. . . . Then we started recording on DSLRs, with smaller stereo mikes mounted on them, and with the tiny automated GoPro cameras with their inbuilt mono microphones, which were no great shakes, and even more compromised when enclosed in waterproof housing.

MACDONALD: You also went for surround sound and worked both with Ernst Karel and, later on, Jacob Ribicoff.

CASTAING-TAYLOR AND PARAVEL: Ernst Karel is first and foremost a remarkably subtle musician, phonographer, sound artist, and audio engineer. His ears are the most delicate and discerning we know. While we were editing the film, the soundtrack was unremitting, often overmodulating, an overbearing monotony. We were interested in continuing something of this aesthetic over into the final mix, but we also knew it would have to be rendered much more variegated and multidimensional. Ernst came up with a wonderful 5:1 mix that had subtleties and modulations

we could barely imagine, and Jacob Ribicoff reworked this into something more cinematic.

In many ways, sound is less coded and reducible to putative meaning than picture, more evocative, imaginative, and abstract. As choreographed as the film may seem, we are both drawn to the uncoded and the uncontrolled.

MACDONALD: In *Leviathan* the focus seems to have been double: first, you focus on a modern version of a centuries-old industrial process; and second, you seem to be focusing on a new kind of documentary experience. Did your assumption that you were going to be working in a new way develop quickly once you were out at sea?

CASTAING-TAYLOR AND PARAVEL: We weren't hell-bent on creating a "new kind of documentary experience" any more than we were interested in slavishly following or subverting what are often considered the rules and regulations of filmmaking. We were trying to grapple with the magnitude of what we were confronted with, both outside and inside ourselves.

One's style is borne out of one's encounter with one's subject. Yet many films, especially nonfiction films, seem to go to great pains to render that encounter invisible. Neither of us is interested in cinema as sheer spectacle, distraction, as a form of enter- or info-tainment. We're interested in the world, and how to render the world's aesthetic due, whether or not that ends up conforming to the norms and forms of cinematic or other artistic conventions as they congeal at any one point in time.

If *Leviathan* represents for some people a new kind of cinematic experience, this is perhaps simply because the film returns us to some of the imperatives of cinema at its inception, allowing us to apprehend the world anew, to shake us out of both our dogmatic and perceptual slumbers, to rid us momentarily of the habitual blinkers and moralistic alibis which burden our socially sanctioned everyday lives.

MANAKAMANA

While the approach in *Leviathan* is immersion within the visual phantasmagoria of life on the fishing boats and within the film's relentless surround sound, the approach in *Manakamana* is the inverse. It offers a comparatively quiet meditation appropriate to the experiences it documents. Spray and Velez filmed pilgrims (and tourists) on their way to visit Manakamana, the sacred place of the Hindu goddess Bhagwati, who grants wishes to those who come to pay their respects (and sacrifice an animal). All the filming took place on the Manakamana cable car that, during a bit less than ten minutes, takes visitors from the valley town of Cheres to the top of the mountain, where the Manakamana Temple stands, 2.8 kilometers away. Each set of cable car passengers is recorded from inside the cable car by a camera mounted on a tripod, in a continuous single shot that lasts as long as the ride itself. Each ride ends with the cable car arriving in the darkened

space of the dock, and this darkness forms the transition to the following ride. Within the film's extended shots, there are two visual foci: the various visitors in the cable car, seen in medium shot, who interact with each other and in subtle ways with the camera—as well as with the other focus: the landscape outside the windows of the cable car, seen six times on the way up, five on the way down.

Like *Leviathan*, *Manakamana* is indebted to American avant-garde film, though to a very different strand of that historical weave: to filmmakers who have been committed to a meditative or contemplative approach to Place: Peter Hutton, Sharon Lockhart, and especially James Benning—filmmakers whose work is often shown at the SEL. These filmmakers, like Spray and Velez, confront the contemporary tendency to avoid engaging our sensory surround, by slowing down perception, by providing time within the movie theater when viewer-listeners can process the subtleties of sight and sound and contemplate the implications of what they're seeing and hearing.

As in *Leviathan*, in *Manakamana* there is no attempt to provide data—the goal of many forms of documentary cinema and one of the most marketed dimensions of contemporary digital culture. We don't "learn about" the pilgrims in the cable car any more than we learn about the fishermen in *Leviathan*. Rather, through the film's visuals and sounds, we take a trip with the pilgrims and experience a cine-version of the sensory environment they are experiencing. Most of these people may seem quite different (ethnically, at least) from those in most audiences who will see *Manakamana*, but our experience of seeing and hearing the pilgrims' responses to riding in the cable car (and being filmed) allows us to see them not as Other, but simply as fellow voyagers—to the goddess and within the ongoing transformation of modern life.

SPRAY: The initial idea for *Manakamana* evolved from my filming in a Nepalese village just outside of Pokhara, where over the years I'd made *Monsoon-Reflections* and *As Long as There's Breath*. I was looking for new film contexts for my subjects, where I'd have some control over the shoot. I'd heard about the Manakamana cable car and the Manakamana Temple and invited Bindu Gayek (the woman in the second shot of *Manakamana*) and her son Kamal to ride with me on the cable car in September 2010, thinking that the confines of the small space might allow for a productive, albeit forced, intimacy between the film subjects and the camera—I'd never been on a cable car and wasn't quite sure what to expect. Later, viewing the footage, I realized that the duration of the trip would allow for intimate exchanges to unfold.

VELEZ: Stephanie and I had met in Lucien Castaing-Taylor's first Sensory Ethnography class, back in 2006: I was Lucien's teaching assistant and Stephanie was a graduate student.

SPRAY: There had already been examples of productive collaboration in the SEL, namely *Foreign Parts*, co-made by Véréna Paravel and J. P. Sniadecki, which was doing well at that point. I'd never collaborated on a film before but knew that Pacho had, and

FIGURES 19.3 AND 19.4
Stills from Stephanie Spray and
Pacho Velez's *Manakamana*, 2014.
Courtesy of Stephanie Spray and
Pacho Velez.

I felt confident he'd be a good partner. He had already been thinking about a film about public transportation, and it was his brilliant idea to shoot on 16mm, knowing that a 400-foot roll of 16mm film at twenty-four frames per second would be roughly equivalent in cinematic time to the duration of the cable-car trip.

VELEZ: We were drawn in by the conceptual logic that the string of cable cars pulled along on a wire "rhymes" with the frames of 16mm film pulled along through a motion picture camera.

MACDONALD: Filming in a cable car suggests an idea that seems fundamental to the Sensory Ethnography Lab: that culture is always in a process of transformation.

VELEZ: *Manakamana* presents the audience with a collection of time-and-space-limited encounters. During the long continuous shots, the characters' attention is shifting around: absorbing the landscape, reflecting on inner thoughts, and contemplating the goddess. Since the film is so much about these flows, "movement" begins to

take on an ideological and maybe a metaphoric aspect as well. These people *are* on the move, and so is their way of life. But while the camera is constantly moving, it also never moves at all. Both movement and stasis are important to the film. As we built *Manakamana,* we thought in terms of binary propositions: portraiture/landscape, nature/culture, man/animal, East/West, speech/ambient noise. Maybe the film makes an experiential claim that culture is in motion, but it's also a moving target locked inside an enclosed box.

SPRAY: I began filmmaking in 2006 as an art practice that might allow me to explore the world in ways that were not merely discursive. In 2007, I began training in anthropology; I was attracted to its traditional emphasis on long-term, deep engagements with people and place and, especially, learning the local languages. For me, humanistic aims trump any interest in illustrating concepts such as culture or culture-in-flux. I hope *Manakamana* conveys how artificial distinctions (call them cultural, religious, political, or whatever) between ourselves and presumed Others fall short of what James Agee calls "the cruel radiance of what is" or what Buber refers to as "I and Thou."

Manakamana also provides commentary on the cinematic frame: the window behind the passengers is reminiscent of the ways in which the film-image's frame both reveals and misconstrues our vision. The cinematic frame is therefore a metaphor for any conceptual frame that we bring to viewing Others.

MACDONALD: How much time did you spend filming?

VELEZ: *Manakamana* was shot over two summers, 2011 and 2012. The bulk of the work was done that first trip.

SPRAY: Pacho selected the stock, loaded and unloaded the magazines, and shot the film. I recorded sound on a two-channel sound recorder, the Sound Devices 702, using a shotgun stereo microphone encased in a zeppelin on a boom pole.

VELEZ: There were a number of practical reasons why 16mm film was right for us. It has a great exposure latitude and we wanted to capture both our characters and the bright backgrounds behind them. Also, 16mm has very deep focus, and we wanted to be sure that our characters as well as the distant backgrounds were crisp. The look we wanted runs counter to the standard look today, when everything is shot on DSLRs with big chips and little depth-of-field.

We shot in 16mm and ended up with a 2k DCP [Digital Cinema Package]. We had dreams of going to 35mm, but just couldn't afford it.

SPRAY: We were aware of the nostalgia indexed by the grain of 16mm film and the 16mm film camera—especially the camera we were using: Robert Gardner's. We thought about how within the state-of-the-art digital technology of the "developed" world, our use of 16mm might reflect the "developing" country of Nepal, where, en route to a temple, the majority of cable-car riders go to worship a goddess requiring blood sacrifice.

VELEZ: The nicest, easiest part of the shoot was dealing with the people. I think we said the same things to our subjects that many observational documentarians say to theirs: "Please ignore the camera; just do what you would normally do." Of course, fly-on-the-wall observation is impossible to achieve. In fact, the ways in which we most clearly failed to be flies-on-the-wall add an interesting texture to the film.

MACDONALD: Ernst Karel had done *Swiss Mountain Transport Systems* [2011], sound pieces of a variety of forms of mountain transport, including cable cars. At what point did he become involved in *Manakamana*?

VELEZ: Ernst consulted with us from the beginning about strategies for documenting sound in the cars. And he received reports about our progress while we were in the field. During postproduction, Ernst mixed and sweetened and spatialized our sound.

MACDONALD: What factors led to your choice of a 6:5 organization?

VELEZ: We spent a long time figuring out the film's shape. Early cuts featured eighteen rides: nine up, nine down, and for each ride the camera would switch positions in the cable car: facing forward, backward, forward, backward. . . . It was a very precise and clean edit, without loose ends or mysteries. We ended up with a more playful structure, one that borrowed ideas from structuralism but also from classical Hollywood cinema, like the shift at twenty-five minutes from "Act 1" to "Act 2." In *His Girl Friday* [1940], that's the moment when Walter Burns (Cary Grant) convinces Hildy Johnson (Rosalind Russell) to stay in town and write the newspaper article; in *Psycho* [1960], it's the moment when Marion Crane meets Norman Bates; in *Manakamana,* it's the moment when characters begin to talk, which totally shifts the audience's expectation. The glib explanation for six shots up but only five down is that the goats that you see going up in shot 6 are sacrificed and don't make the return trip. But we gave a lot of thought to the film's conclusion. For a while, it finished with the two musicians (now shot 10) riding into the station. But then we realized that we had a character arc with the older couple who ascend with a live chicken, then descend at the very end. When I watch their descent, I find myself drawn to the woman's face. I see her fear at the shaking car, her interest in the beautiful landscape, but also what I would call her spiritual satisfaction. She looks fulfilled to me. And it's something I don't think I've ever really felt, living my comfortable, rational, agnostic existence; I envy her for it. That's why it should be the last shot.

There are certain ironies in the ways that technology has played into *Leviathan* and *Manakamana*. In *Leviathan* Castaing-Taylor and Paravel used the newest filmmaking technologies to do justice to one of the oldest forms of labor, and in *Manakamana* Spray and Velez used an older technology (and a particular camera familiar to them from its

use in a classic film) to document people experiencing the new technology of the cable car on their way to and from an age-old ritual. However, these distinctions in technology—and the considerable distinctions between both the form and content of the two films—should not obscure the fact that the fundamental mission of both pairs of filmmakers (and of the SEL in general) is to play a role in reviving awareness of our shared sensory surround—in filmgoers attracted to independent forms of cinema, of course, but in the long run, in others as well.

Modern cinema and the many new image and sound technologies available to professional and amateur filmmakers have, for the most part, functioned as means of distracting us from the demands of the environmental conditions that ultimately control the lives of everyone on our planet. The films coming out of the Sensory Ethnography Lab are made to be seen in theatrical venues (public theaters, first-rate screening rooms in colleges and universities) that can do justice to the filmmakers' commitment to complex visuals and sound, in the hope that modern cinema might play a more productive and energizing role in drawing our consciousness to the physical and spiritual environments within which we live and work and to the diverse humanity with whom we share the world. Given the environmental challenges we are already facing and which we seem sure to face in the coming decades, this expanded awareness is of the essence.

I have a real personal relationship with machines. It's true that even though I've been very, very critical of technology in terms of what I say, I find that I make those criticisms through 15,000 watts of power and lots of electronics. And that says a couple of things at least, that I hate and love it.

Laurie Anderson, "Interview with Charles Amirkhanian," 1984

20

RECONQUERING SPACE AND THE SCREEN
2005

Pipilotti Rist and Doug Aitken

Two celebrated artists discuss the complexities of their art in an age when screens, projectors, and technology itself are an integral part of the architecture of the event.

PIPILOTTI: Hello, colleague.

DOUG: Hello, secret agent.

PIPILOTTI: City of Zurich reporting to colleague in Venice, California. Hey, is everyone using flat screen televisions over there these days?

DOUG: Quite a bit. . . . How are people in Zurich getting along in the television world?

PIPILOTTI: People haven't switched to flat screen TVs and home projectors yet like Americans have. They're still using those boxlike things from the 1950s and '60s.

DOUG: It seems you've always resisted making work within the restrictions of a "box." I like how you approach the moving image in a very restless way. You can see this in how you sometimes fight or provoke the frame. I'm thinking of *Open My Glade (Flatten)* from 2000, where you press your face against the video screen. Are you intentionally trying to break out of the frame in defiance of formalism?

PIPILOTTI: It's part of trying to keep the moving image from being reduced to the flat square of the screen. Whether the viewer reads the screen as a two- or three-dimensional object is only a question of his or her awareness. Both CRT and LCD television screens have a third dimension: the CRT's glass screen and LCD's liquid crystals. It's easy to ignore their physicality because we're so fascinated by watching the images move across the screen.

DOUG: I often get the feeling when I watch your videos that the images are metaphorically exploding the screen and that the picture plane is disintegrating.

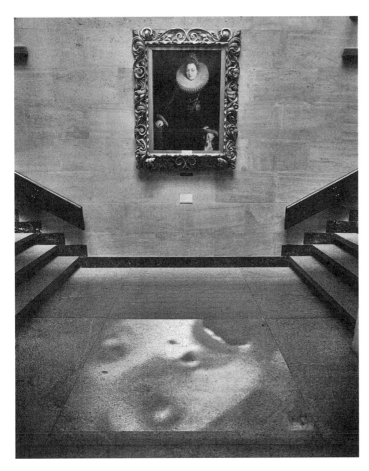

FIGURE 20.1
Pipilotti Rist, *Mutaflor,* 1996
video installation; installation
view at National Museum for
Foreign Art, Sofia/BG; photo
by Angel Tzvetanov. © Pipilotti
Rist; courtesy of the artist,
Luhring Augustine, New York,
and Hauser & Wirth.

PIPILOTTI: I try to explore the screen by using a lot of little screens in conjunction with sound boxes, or I sometimes just project images with sound. I want to reconquer the space in and around the viewer that we forget about when we're watching a two-dimensional computer, television, or cinema screen.

DOUG: It's as if you're bringing moving images into physical space, making them come to life. How much do you consider the way the content will interact with the space in which it will be shown?

PIPILOTTI: I conceive of my installations like architectural miniatures. I like the idea of being able to walk around plans and models. I try to configure the viewing rooms in a way so people can decide when they want to go into the installation and when they want to come out again. I like that you have to think about how you want the viewers to approach each work. But at the moment, I'm actually trying to take a step away from architecture in my work.

DOUG: How are you stepping away?

PIPILOTTI: I'm concentrating mainly on the video's content. The first things that come to me when I make a work are the image and the sound. Only then do I think about how I want to be seen.

DOUG: The video's distorted pixels and color lines are visible in your work. The images seem to inhabit a world of electricity where colors switch and shift and video feedback cuts across the screen, like in *Firework Television Lipsticky* (1994/2000). These distortions pull the viewer in, while at the same time the image seems to push itself outward, disrupting the way we typically experience a moving image. It's reminiscent of the work of experimental filmmakers like Stan Brakhage and others. But your medium is video rather than film. Can you talk about your preference for video over film?

PIPILOTTI: These qualities that you describe are what make video different from film, but they are also video's limitations and I try to work with these. I use video because I'm not interested in creating images that are more pictorial and sharper than reality, something that film often does. Video has its own beauty, even if it suffers from problems like super-poor resolution, which is its major disadvantage. But its problems bring with them other unique qualities, like the way light shifts or the way colors build up. I try to bring these qualities together in what I want to show about movement. I actually think the nervous quality of video is very beautiful. It lets me feel very calm in contrast.

DOUG: Your work has a three-dimensional quality to me.

PIPILOTTI: I try to work like an applied artist—applying video to three dimensions.

DOUG: It seems like you try to challenge the flatness of the screen not only by manipulating video's pixels and colors, but also by introducing unpredictable moments. This creates an interesting progression from passivity to sudden agitation where the image lurches toward the viewer. It's as if the moving image gains an electrical physicality.

PIPILOTTI: For me, video is less a tool for recording external reality than a way to show psychological and physiological inner worlds—like finding symbolic colors and speeds for different states of mind, or creating images that look like those graphic formations called afterimages that you see when you close your eyes. The technology has been invented by human beings and it mirrors us back to ourselves.

DOUG: It's as if you're taking the camera inside the electricity of the moving image in order to hunt for stories and worlds, like in *Pimple Porno* (1992), where bursts of electricity seem to leach out of the screen. What is the relationship for you between real experience and the kind of electrical experiences you create in your work?

PIPILOTTI: I think pure electrical experience happens only when you lie down, close your eyes, and come to terms with the billions of electrical impulses that our feelings and thoughts are made of. This is when, in your imagination, you experience the melting together of images you extract from reality and the electrical pictures

FIGURE 20.2

Pipilotti Rist, *Ever Is Over All*, 1997 audio/video installation; installation view computer simulation. © Pipilotti Rist; courtesy of the artist, Luhring Augustine, New York, and Hauser & Wirth.

you see in your mind's eye. Electrical experience on a monitor is something quite different. You will always have the unelectrified space around you.

DOUG: There's a mental editing too that goes on in the process—the way the mind edits the inner and outer experiences of daily life. After you started editing video, did you begin to see the world differently?

PIPILOTTI: Yeah, it has sharpened my perception. I'm able to talk to someone now, or watch something, and simultaneously concentrate on the sounds coming from behind me. Another thing is that in editing you become very clear about what you want, whether it's three seconds of this or twenty seconds of that. But editing takes months. The challenge is that you have to keep watching and listening to your work as if it were the first time you've ever encountered it. You always have to be conscious of how the viewer will experience your work for the first time. And it's this moment that you manipulate.

DOUG: Can you describe this process of manipulation?

PIPILOTTI: I don't mean manipulation in a negative way, although it is something that can always be abused. I only want to be as precise as possible in my work, not pushy.

FIGURE 20.3
Pipilotti Rist, *Tyngdkraft, var min vän* (Gravity, be my friend), 2007; installation view Magasin 3, Stockholm Konsthall, 2007. © Pipilotti Rist; courtesy of the artist, Luhring Augustine, New York, and Hauser & Wirth.

DOUG: Do you conceive of the exhibition space as a way of editing the viewer's experience, or do you concentrate primarily on the moving image?

PIPILOTTI: There are many different ways to edit the moving image. First of all, designing the installation itself gives you many options to work with. And in the final design, I like giving the viewer a few possibilities to choose from. When I go to see other art, I want to experience the rhythm of the artist. I want to feel how long they want you to be in front of their work. I want to be sucked in. I want to be guided by them. But in the end, each viewer decides how long he or she wants to be there. That's why I like museums. People choose to go there. They go there because they want to be manipulated.

DOUG: Does the museum offer an adequate platform to show experimental work with the moving image?

PIPILOTTI: If you want to do something that has a beginning and an end, it needs a good room.

It doesn't matter if it is in a museum, in a cinema, or a studio. Recent art history could have developed very differently in this way. What would have happened if in the 1960s video art had become part of cinema rather than fine art? Imagine going to the cinema today and seeing little screening rooms for video installations where you could watch videos before or after the movies. What if in every cinema, there were rotating video installations?

DOUG: That would be amazing. Sometimes I have the feeling that I have rotating installations going on in my head! When I dream, I feel like I'm continuously editing and reediting.

PIPILOTTI: Yes, when I dream, I feel like I see much better than I actually do in real life. I'm very shortsighted normally, but in my dreams—even though I'm usually flying in them—I always see in sharp focus, like in film.

DOUG: It's always hard for me to gauge how long I've been sleeping when I wake up from a dream. The dream always seems to have compressed or expanded itself to be just the right length. With film, though, we instinctively know when it's too long. Making concentrated short pieces, do you find yourself restless when you see a two-hour movie?

PIPILOTTI: I always think films are too short. They should be longer!

DOUG: When you're watching a movie, do you ever think about the physical experience of being part of the audience? Do you ever feel too safe?

PIPILOTTI: I think there's a ritual that takes place between the audience members. Everyone's looking and concentrating in one direction and it creates this energy in the room. That said, in my own work I try to get away from the ritual that evolves out of watching moving images. I do, though, like the feeling of this collective concentration on a single screen in a movie theater. It creates a miraculous energy in the room.

DOUG: An energy from the collective act of watching?

PIPILOTTI: Yes. It's really like a dance in silence, you know. People watching the screen all together is like a communal dance.

21

LOOKING AND BEING LOOKED AT
2014

Shelly Silver and Claire Barliant

Experimental filmmaker and photographer Shelly Silver and writer and curator Claire Barliant discuss the role of narrative, genre, and "watching" in the formation of Silver's films, and posit for the future the idea of a machine to teach someone to see.

CLAIRE BARLIANT: I thought it would be good if we started by talking about one of your most recent films, *TOUCH* (2013). The protagonist is an older Chinese man, who is gay. Also, he is straddling two different worlds: his memory of China and New York City. But he's not really at home in either place. The idea of using a fictional character and real-life images to illustrate his world was very interesting. And he is so fleshed out, it really feels like you're listening to this person. But it's all manufactured.

SHELLY SILVER: I like the word *manufactured* in this context. It rubs up against many things the film talks about. It's from the Latin for "made by hand," which is what it meant in the sixteenth century. A hundred years later it came to mean producing on a large scale with machinery as well as "to invent or fabricate."

I did manufacture, in all senses of the word, the character and story and film. Although he is based on research, this man does not exist, and I decided what the character did for a living, how he spoke, what and whom he desired, why he left Chinatown and then came back.

I also in a sense constructed what is seen of the neighborhood, shot by shot, deciding where I pointed the camera and at what time of day.

TOUCH grew out of my experience making the short film *5 lessons and 9 questions about Chinatown* (2011), which was commissioned by the Museum of Chinese in America, as part of the Chinatown Film Project. *5 lessons* anarchically moves among the past, present, and futures of Chinatown—from the draining of

Collect Pond to the implementation of the Chinese Exclusion Act to impending gentrification. A chorus of different voices—in English, Cantonese, and Mandarin—asks who belongs, owns, and controls a neighborhood. The chorus ends with the question, "Who are we?"

For *TOUCH* I wanted to slow down and address the neighborhood from a solitary vantage point. The idea for the main protagonist originated with the actor Lu Yu, who had done the Mandarin voice-over for *5 lessons*. I was struck by his voice and wanted to make a character based not on him but on who "this voice" might be. A good deal of research went into *5 lessons,* and with all that in the back of my mind I started writing this character who was both insider and outsider. I chose this position for him partly because I too am an insider/outsider. I'm not Chinese but have lived in Chinatown for the last twenty-eight years. Outsiders make good observers, especially those who are looking for a way in. As I was doing the initial interviews for *5 lessons,* I was struck by how many people said that they too felt like outsiders in Chinatown, for any number of reasons. Some said it was because they spoke the "wrong" dialect; others because of where they came from or when they came; for others, the reasons were economic. This feeling of not belonging was a surprisingly common one.

TOUCH was shot largely on the block where I live, the juicy sound of the butcher shop being scrubbed, the purveyor of pork products lugging a large, wide-eyed pig. In the act of filming you see things you never noticed before, and this is part of the experience I wanted to give to the viewer.

CB: Can you talk more about your process?

SS: The process of making *TOUCH* was different from making traditional narrative or documentary films, which often relies on prescripting and a fairly rigid structure of preproduction, production, and postproduction. I was constantly moving between shooting, editing, and writing. This is a very live way of working.

There are three films I've made this way: *suicide* (2003), *What I'm Looking For* (2004), and *TOUCH* (2013). Together they make up a loose trilogy of fictional essay films that are each filmed from the point of view of a solitary fictional protagonist. This first-person essay structure allows me flexibility both in process and subject matter—voice-over can be endlessly rewritten, reflecting whatever the character is thinking that day; scenes can be cannibalized or shifted elsewhere. The process is closest to puzzle making, collage, or bricolage.

Each film has what I think of as three main characters. There's the central fictional character who comments on or fights against the documentary-based images. We see the world through his or her eyes. The second "character" is the place or places where the films are shot. For *TOUCH* it's Chinatown; *What I'm Looking For,* Lower Manhattan post–September 11; and *suicide,* the traveler's world—as Emerson says, "anywhere but here." And, because these characters have a playful and at times passive-aggressive relation with the viewer, who is

often addressed directly, the audience can be seen as the third character, a character that is both desired and implicated.

CB: *TOUCH* is in fact devoted to the topic of watching. Why have you decided to focus on this theme, and how is this phenomenon important for your artistic work generally?

SS: Most films are devoted to watching; that is the process they activate. *TOUCH* brings that watching to the surface, as something to hold up to the light and examine. The act of watching forms the film.

Watching is a form of taking care. At its best, it's a form of reaching out, or as the character in *TOUCH* says, a kind of touching. It's through looking and showing that my invisible character begins to be present—to us and to this community that he fled as an adolescent. *TOUCH* is a paean to a certain kind of watching.

Watching in public, this collective act of looking and being looked at, has gotten a bad rap in the last few decades. This parallels our giving up of our proprietary ownership of public space, this place where we gather to see and be seen, to check each other out. In *The Death and Life of Great American Cities,* Jane Jacobs, the great examiner of American cities, writes passionately about watching, describing it as the fabric that holds us together as feeling, empathic creatures. She singles out the crucial importance of "eyes upon the street, eyes belonging to those we might call the natural proprietors of the street." Now we have "eyes" on the street, in the form of disembodied surveillance cameras, faux streetlamps with black bulbs, rectangular boxes hanging off metal wires, where we can't see the people on the other end of the cameras. Surveillance is one-sided. It's destructive, rending the social fabric. These cameras are especially prevalent in Chinatown, which is close to several prisons and a main police precinct.

This co-optation of public space, this not seeing who is watching but knowing that they are, causes a floating anger and anxiety, which does not get aimed at the police or so-called Homeland Security. It instead gets transferred to those we do see, the people we share the streets with, whether they have cameras or not. The general unlocalized paranoia gets localized onto each other.

CB: Much of your work is shot in public space. What is it about public space—why do you choose to work in that arena?

SS: Growing up in NYC, much of my childhood was spent on the streets. I feel comfortable there, and I feel most comfortable on streets where I don't know everyone or anyone.

Our society is increasingly focused on the individual, whereas I am searching out the "we," or the bridge between "I" and "us." And the streets are where you find "us." My films *Former East/Former West* and *in complete world* are both based on street interviews with scores of people I didn't know and would never see again. *Former East/Former West,* filmed in Berlin between 1992 and '93, raises the question of a shared country, language, and ideology after the fall of the Wall.

in complete world, shot in the early days of the 2008 presidential primary leading to Obama's first election, is about civic responsibility in the face of individual desire, and the interviews with these strangers who I share a city with made me proud to be a New Yorker. I couldn't imagine either of these projects being filmed anywhere other than the public space of the street.

CB: This reminds me of another quote from *TOUCH*: "What I own of this place, I own through the images I take." If you're able to view it, it's public, it's available somehow. It's open space that is available to everyone.

SS: Here, the character is positing a different idea of personal and shared ownership. He is well aware that he doesn't legally own the buildings he's filming—he's being evicted from his mother's apartment. But as keeper, steward, examiner, and fabricator of histories, he knows that images and memories are a crucial form of owning. They also create an uncanny fluidity in time: "I will own this place even after it ceases to exist."

This question of control, ownership, and the right to stay is also central to *5 lessons* and NYC in general, this city where I've lived for most of my life. When people talk about neighborhoods changing, they often attach the words *progress, natural,* or *inevitable,* when there's typically nothing natural or inevitable about it. Neighborhoods are changed based on decisions made largely by politicians, judges, and developers. New York City laws favor the landlord over the tenant, the developer over the community, especially during the Giuliani-Bloomberg years. Neighborhoods are also engineered, manufactured.

CB: Chris Marker, the great film essayist of the late twentieth century, seems like an interesting reference to talk about in relationship to your films. In *La Jetée* (1962), he uses still photographs to compose a fictionalized essay while yours at times feel to me like moving photographs. There is a stillness to the way they are composed.

SS: The film of Marker's that's had the greatest effect on me is *Sans Soleil* (1983), where the voice of an unknown woman reads letters sent by a fictional camera-man—friend or lover—who is travelling across continents. In this film Marker builds a web of desire (there must always be desire!) that holds together fragments of ideas, places, people, histories, and lush images, many of which were shot by others. We, the viewers, thrive in the space between this low-voiced woman and this absent, hyperarticulate man who seems just out of reach.

suicide (2003), which was also shot around the globe, was made in dialogue and argument with Marker. It's a faux personal video diary of a crazed, suicidal filmmaker who endlessly circulates through the world of transitional spaces, airports, train stations, malls—what Marc Augé refers to as nonplaces—in the hopes of finding a desire to continue living. Unlike Marker's protagonist, she, in an extreme take on tourism, projects her desires, fears, and history onto everyone and everything around her, pushing the limit (my limit) of what's acceptable in

terms of filming in public space. I don't think I would have made this film without the love and at times frustration I felt towards Marker's work.

CB: Like Marker, language seems a very important component of your work, but unlike him, you seem to play more with the question of language and translation. *TOUCH* is largely in Chinese, *Former East/Former West* is in German, and *37 Stories about Leaving Home* (1996) is in Japanese. Were you thinking about translation?

SS: Making films in languages far from my mother tongue is a subspecialty of mine. It's a somewhat masochistic pleasure.

The character in *TOUCH* is someone who suffered growing up a linguistic outsider. As he says in the film he was "made fun of in two languages." He then grows up to become a librarian, a keeper of language. In the film he largely speaks Mandarin, then for a word here, a phrase there switches to Cantonese or English. At times he decides not to speak at all, leaving the subtitles to represent his inner voice or inability to speak certain words out loud.

The theorist Gayatri Spivak spoke at a conference on translation last year about *TOUCH* and how the film uses subtitling as a commentary on the place of translation, from the point of view of this man from the diaspora. She proposed that the character in the film stages the three phases of learning a second or third language: the withholding of translation, the having the ability to translate, and then forgetting to translate, or as Marx puts it "forgetting the language that was planted in you." She then puts forward that the subtitles in *TOUCH,* rather than performing the typical role of being there for "the English speaker's convenience," function as "a site to actively problematize translation."

I feel a different sense of responsibility when making interview-based films where people are speaking particular words to give voice to their ideas or experiences. It's ethically important to honor this voice as best as possible, at the same time acknowledging that translation can never be one to one. Meaning always escapes. When I work in a foreign language it's impossible to take language for granted, and this influences my approach when I return to my native tongue, English. Language is never transparent.

CB: Looking at the range of your work, would you say that rather than being connected to a specific style or genre, it's instead reconfiguring or exploring the spaces between genres?

SS: Yes. I'm always happiest between the cracks.

CB: And it seems that the crack you're interested in most is that connected to some kind of storytelling, hovering somewhere between fiction and nonfiction?

SS: My work has always played between these two artificial poles of fiction and nonfiction that have more to do with genre, language, and audience expectation than anything else. This preoccupation with genre, in part, comes out of my decade-

plus working as a video editor on everything from music videos to feature films to advertising to documentary. Now it's quite commonplace to mix genres, but I was at the forefront of mixing documentary with fiction. An example is my film *Meet the People* (1986), where, after a screening, audience members would be angry when they found out, in the credits, that the people who were talking, singing, and confessing directly to the camera (directly to them) weren't "real" but actors. PBS refused to show *Meet the People* on the grounds that it might "alienate" their audience. Amazing how things change.

My ongoing interest in fiction and the fabrication of a character and story is tied to the question of imagining change. How can we imagine a different future world, if all we see are carefully constructed status quo stories and images of the past and present? So many commercial films made by men—which is to say, most films—deal in some way with wish fulfillment. And the wishes they're fulfilling are most often . . . men's. A typical example of this genre is *Whatever Works*, the Woody Allen film that we see being filmed in Chinatown towards the end of *TOUCH*, where the skanky man pushing seventy, played by Larry David, is married to a woman who looks to be about seventeen. This is a story we see over and over—evidently it must be constantly reinforced. Women have rarely taken advantage of this genre of wish-fulfillment stories, and I think we should. I'm not saying we should make bad films with what amounts to a claustrophobic "happily ever after," but I do think it's time we start finding a way to use and abuse this form of storytelling. To make it our own. A great example of a film that does this is Lizzie Borden's astonishing *Born in Flames* (1983), a futuristic fantasy of radical female rebellion set in a post–socialist revolution America.

Fiction has the magic (and at times dangerous) ability to allow us to imagine and therefore make a future that doesn't yet exist. The man in *TOUCH*, as he reconceives his past, present, and future, is constantly fabricating the improbable, which he wisely mixes with the actual. At one point he says, "Words make the impossible imaginable, therefore possible. Improbability is the domain of all outsiders."

I'm interested in a different way of thinking about the future, starting with what should exist, rather than what does or has. You can't make a documentary that shows something that should exist but doesn't. Fiction is good at that.

CB: I wanted to get back to this idea of manufacture and machine. I was intrigued by the quote in *TOUCH* when he says he's building "a machine for looking . . . a machine to teach myself how to see." It seems that the machine is not necessarily the camera but what comes out of the camera. I assume that would include photographs and moving images. There is a lesson in how to see or look.

SS: This idea of a machine to teach someone to see—I didn't mean the camera—a camera doesn't teach anyone to see. It's a tool, a cog in a much larger machine, starting with the eye behind the camera, which draws a line through the camera

to whatever is within the view of the lens: the person, object, or place. I'd expand this machine to include the fabrication of the film itself: the thinking, writing, and juxtaposition of images and sounds that make up the editing. This is the machine the protagonist of *TOUCH* is thinking of, a machine in action, in process. He would also include the audience who will watch the film. The "you" and "us" that is ever-present in his thinking and speaking. This expands into the past, to the image-makers and viewers who have shaped our way of seeing. The future audience—that will continue the discussion long after he is gone—is also part of this machine.

I have used the camera according to perceptual or cognitive models based on sound rather than light. I think of all of the senses as being unified. I do not consider sounds as separate from image. We usually think of the camera as an "eye" and the microphone as an "ear," but all the senses exist simultaneously in our bodies, interwoven into one system that includes sensory data, neural processing, memory, imagination, and all the mental events of the moment. . . . I happen to use video because I live in the last part of the twentieth century, and the medium of video (or television) is clearly the most relevant visual artform in contemporary life.

Bill Viola, "Statements for *Summer 1985*," 1985

22

IT'S ABOUT TIME
2013

Christian Marclay with Amy Taubin

A life in art and music is the background for an insightful discussion between an acclaimed artist and a celebrated critic. *The Clock*, a contemporary video masterpiece, takes center stage.

AMY TAUBIN: When I first encountered your work, I had no idea you were a visual artist. I saw you scratching records in a music series at The Kitchen in NYC around 1980. You were a pioneer. How did you start making art?

CHRISTIAN MARCLAY: I went to art school in 1975, first in Geneva, Switzerland, where I grew up, and after a year I enrolled at the Massachusetts College of Art in Boston. Then I heard they had this exchange program with Cooper Union, so after a year in Boston I went to New York. That is where I ultimately wanted to go, but coming from quiet Geneva, I thought New York was kind of scary, especially in the 1970s. This exchange program allowed me to go to Cooper Union for a semester. I studied with Hans Haacke, and because I found a cheap apartment in the East Village, I stayed a whole year. As my parents wanted me to finish my BA, I went back to Boston. It ended up being a really important year for me. MassArt had this yearly festival called Eventworks—a sort of performance festival that was curated by a student each year. I took it on. I wanted to share all the exposure I had with the punk and No Wave music scene in New York. I invited to Boston people who I felt had a connection not only to performance, but to music. I was very interested in that crossover. I remember Eric Bogosian, who was then the dance curator at The Kitchen, advised me with the dance. He also participated with one of his aggressive rants. I presented dance, film, music, performance that I felt had a relation to or was influenced by the punk energy—from Karole Armitage to DNA to Zev.

I hadn't really started making music yet, but when I went back to Boston, I brought with me the kind of DIY attitude of punk music found in New York. The fact that most people involved in punk had not learned how to play an instrument gave me freedom. I too could make music. First I wanted to make a film, a musical—all dancing and singing—but with the tools of the time like Super 8. I wrote some lyrics for songs and asked a fellow student if he would write music for them. The film was never made, but we rehearsed a set of songs and performed in Boston underground clubs. That was in 1979 and I graduated in 1980. In retrospect, it's interesting that what I first wanted to do was a film. I always thought that the format of the musical was such an odd thing. It is so surreal. Seeing all these actors all of a sudden burst out singing and dancing. [*Laughs*] Of course, I would not have done a traditional musical, like Fred Astaire—the kind of stuff my mother liked to watch. But the form was attractive to me.

AT: Fred Astaire was an extraordinary dancer. He inspired so many artists, not just performers.

CM: I always liked tap dancing. Much later, in 1989, I did an installation called *Footsteps*. I covered a gallery floor with records that contained the sounds of footsteps—of myself walking in my studio mixed with fragments of tap dancing. After the 12-inch record was pressed, I covered the floor with 2,000 copies of it. People were invited to walk on the records. Later they were packaged and sold. When played back, the damaged recordings were a random mix of scratches, pops, and clicks, blending beautifully with the recorded footsteps. The surface damages and the recording sounded similar. Each LP was a different composition because it was damaged differently.

But back in Boston in 1979, I started using records in a band called The Bachelors, Even—a duo band, me singing and Kurt Henry on guitar. We used prerecorded cassettes with loops, strange props, small percussion, and film projections. We used Super 8 footage and we made loops—both visual and sonic. We had these cartoon films—like a cat crashing into a garbage can. It was as much about the sound as the image. The films and cassette loops were our rhythmic tracks. The cassettes were made from skipping records, so I eventually eliminated the cassettes and began to use the records live, bringing them onstage. The skipping records would give us the rhythm. So mixing records grew out of that first band. We did a few shows in Boston and then came to NYC. Kurt didn't like NYC and went back to Boston, and by then I had moved on to different things. I didn't have a studio or space to make art, and I was getting more involved in music, so I ended up throwing away a lot of my visual work because I didn't have room to store it.

AT: What were the different things that began to interest you?

CM: I got involved with the improvising scene and met John Zorn. He introduced me to a lot of interesting musicians. I was also very involved in the dance world. I did

a lot of music for Yoshiko Chuma. I got connected to dance because I needed to do some physical exercise. I was taking classes with Simone Forti and doing "contact improvisation." For me it was more as a fitness activity and a social connection. I saw a lot of dance performances. I even performed in a piece by Simone at the Cunningham Studios—something called *Estuary*. She always had these nature-inspired metaphors. Much, much later, in the 1990s, I was invited to do some music for Merce Cunningham.

AT: That period in the late 1970s was so crucial for so many artists. So when did you do what you might consider your first visual collage piece?

CM: Records were really the transitional medium because I was collaging records together, literally "cutting" the records—the actual objects. I would slice and re-glue them together, and play them on my turntables. These were sound objects, but they had a strong visual element. I would often use colored vinyl to cut and paste. People wanted to exhibit them, but I was thinking of them more as one-of-a-kind sound compositions—instead of multiples. The needle would jump around differently every time you played them. This was in the early 1980s, around the time of hip-hop.

AT: When you started using turntables in performance, had you heard any hip-hop?

CM: No, I was totally unaware of it. Bob George, from One Ten Records (who released Laurie Anderson's first hit record, "O Superman"), said "You should check out what is going on in the Bronx." So I went to see Grandmaster Flash. It was just before the people downtown became aware of this music. Tim Carr, then the music curator of The Kitchen, invited a few hip-hop DJs from uptown and some downtown people like me and Stuart Sherman to be part of an evening about records, *His Master's Voice*. That was in 1982.

AT: Were you interested in movies, other than musicals?

CM: I'm really a dilettante when it comes to films. I could say the same about music. I wasn't exposed to live music until I came to the U.S. Growing up in Switzerland, I was watching a lot of American films dubbed in French. I saw a lot of art videos in the '80s. At Mass Art, I took a film class and I took video—but it was reel-to-reel video, so the edits were very haphazard. You could not be as precise as with film editing, and it was black-and-white. I did a few experiments with Super 8. It wasn't until video became really affordable that I made a few documentations of live performances. The first video I made was called *Record Players*. It was based on a piece I did live at The Kitchen in 1982. I had an ensemble of a dozen people using records as acoustic sound objects. People wobbling the records, scratching them with their nails, breaking them . . . things like that. A year later I restaged it for the camera. The video was then shown on "Alive from Off Center," which showed some of the first video art on TV on Channel 13. It still had a documentary quality. The first video for which I collaged found footage was *Telephones* in 1995, so it was

FIGURE 22.1

Christian Marclay, video still from *Telephones,* 1995 (video run time 7:30 minutes). Courtesy of the artist and Paula Cooper Gallery, New York.

much later. The Wexner Art Center gave me a grant to edit it on their Avid for five days. I didn't know how digital editing worked, so there was an editor and I had to tell him where to cut. I had sampled and prepped all the footage before at The Kitchen. All these telephone conversations were lifted from bad VHS rentals. It wasn't very hands-on, because this was before digital editing.

AT: From the start, you looked for this material on existing VHS tapes?

CM: Whatever was available at the video store. That process came out of my practice of sampling music from records. I've always worked with collage. I felt there was so much stuff already there for me to use. Thrift stores were really important in that development, because I would buy these 10-cent records. A dollar was expensive. [*Laughs*] You'd get all this music for almost nothing. I also started seeing VHS cassettes in the thrift stores. When I got my own digital video-editing system to work on *Video Quartet,* everything changed. I could have a computer at home and do everything by myself.

AT: For that piece, what was the system?

CM: I started using Final Cut Pro for *Video Quartet*. I bought a computer and software. That piece took me a year to make.

AT: It was obviously more complicated than the telephone piece just in terms of screens and simultaneity . . .

CM: Yes, editing for four screens, and with Final Cut you can't see four images at the same time, but you can hear the four tracks of sound. So I constantly had to shift back and forth between viewing and listening. At the time, the rendering would take hours because the computer was so slow. I had to be very organized. I got used to the system and eventually enjoyed the process very much.

AT: It is not unrelated to collaging records or scratching records.

CM: Especially with that piece, because it was like mixing records on four turntables. It's a sound piece with the added elements of visuals. It was just one more element to worry about in the mixing. I used images where the source of the sound or the cause was visible—diegetic sounds. In video the sound and image become one, and I was editing it as one. That's what I like about video. Of course there is always postproduction tweaking, where you have to balance the sound and improve the quality.

In *The Clock* there is a lot of postproduction sound work. The sound is the binding element. The disconnected scenes are glued with the soundtrack overlapping from fragment to fragment. The sound helps smooth the visual edits.

AT: When you edited *The Clock,* did you first break the source material into separate image and sound elements?

CM: No, I work with both together. When the samples are entered into the computer, image and sound are one. Final Cut allows me to do basic sound mixing. I do as much as I can and then work with a sound designer. *The Clock* needed a lot of work because there was such a variety of material and so many different qualities of sound recording, from bad, old optical sound to slick Dolby sound. To give the sense of continuity, I had to rework some of the sound. Sometimes I had to change the music. In some films, you might have a voice-over, which implies reminiscence—or a different time. Because I wanted everything to be in the present, I had to remove any voice-over and replace it with sound effects. Sometimes I had to recreate the Foley in a scene or throw some music on top of it. I remember we needed the sound of shaving cream coming out of a can. I had to go buy a can of shaving cream, because we could not find the right sound effect. I worked with a great sound designer, Quentin Chiappetta, who is as much a perfectionist as I am. We've worked on many projects together. I did a lot of recordings in his studio in Brooklyn. He has an amazing library of sounds effects, and we spent several months working on the sound.

The Clock was very time consuming. After finishing a piece like that, I got so drained that I thought I would never work with video again. *Video Quartet* took

a lot of energy for a year. It is an unhealthy process because you are sitting at a computer all day long. After that I wasn't ready to start something else on such a scale. I don't think of myself as a video artist—I like to do a lot of different things. I might work on some music for a while or on purely visual things.

AT: What do you mean by purely visual?

CM: Well, when I say purely visual, there is always an implication of sound, but the sound is not heard, only imagined. Like in some of my photographs.

AT: Is the source material for the image always existing images or stuff that relates to the process of making or recording photographs? Do you go and take your own photographs?

CM: I do a lot of that actually. I always keep a camera in my pocket.

AT: Do you keep an audio recorder too?

CM: No. Though my phone is supposed to do everything. For me, my snapshot camera acts as a notebook—a way to remember things that trigger my interest, or to document something visually stimulating. I take a lot of pictures of the traces of sound—or more, what kind of visual traces our sound culture leaves behind, any kind of visual representation of sound. Most of my photographs show the presence of sound, but photography is a silent medium. I like the paradox of photographing something that makes sound and being left with a completely silent image. But I also work with found images. In a project I used snapshots found in flea markets of people playing music. They were then reproduced on large scrims and hung in a church in Venice as part of the 1995 Biennale. The original snapshots were also part of the installation. The piece was called *Amplification*. I was interested in what happens to an image when it changes scale. In another project, I pinned found snapshots to a wall so that you couldn't see the images—but you knew they were photographs because of original annotations on the back or the scalloped edges. There was enough information there to make you realize they were photographs even though you could not see the front.

AT: Are the photographs you take ever intended as art photography, something you'd show in a gallery simply as your photographs?

CM: Yes, sometimes. I take more photographs when I'm traveling. I am more aware of my surroundings when I am in a foreign place. I used to take a lot of these snapshots, but it is only recently that I've begun printing and showing them. I always title them by the name of the city or place in which they were taken and the date. Often the same title reappears. It is not about identifying an image. To me they are more about recording my movements. I don't like to title photographs in a way that suggests a reading. I want the viewer to read whatever they want into the image.

AT: *The Clock* has reached a larger audience than any of your previous work. And many of the people who view it think and talk about it quite obsessively.

CM: Everyone is obsessed with time, but I think people were surprised that they could stay interested in something that didn't have a traditional narrative. The narrative thread is time. It is your time—the time you are living in—that connects you to the piece and to the other viewers. It is not a traditional film that takes you out of time. It makes you aware that you are completely in synch with this collage. Your life becomes part of it. You know exactly how long you've spent watching it. You know how much more time you have until you have to go off to your next scheduled meeting. It implicates you in a way that no other film does. That is part of the appeal.

AT: When you started working on it, was the concept already in place?

CM: It was, but I wasn't sure if it was possible. It took me a year of research before I felt confident that I could finish it. I first had the idea while working on my "video score," *Screen Play* (2005), and looking for footage of clocks. Because it is a score to be interpreted by musicians, I needed to mark time, and give musician durational instruction, like the hands of the conductor or the hands of a clock. That's when the idea of *The Clock* clicked, and I asked myself, "Would it be possible to find every minute of a day in the history of cinema?" It was more a question. Then I thought, "Oh no, I don't want to get involved in that." I knew it was going to be a chore. I postponed it for a while—almost three years. But when I moved to London, I needed to do something that did not require a studio. All I needed was a desk and a computer. When a project is so big and you can not see the end of it, it is kind of frightening.

AT: Did you have researchers helping you?

Christian Marclay, video still from *The Clock*, 2010 (single-channel video with stereo sound 24 hours, looped). Courtesy of the artist and Paula Cooper Gallery, New York.

CM: Yes, I couldn't do everything myself. I stuck to the editing. And I told my research assistants what I was after. They would rent movies, watch them, and then bring me the parts. I would go through the material and organize it.

AT: How long did it take to make *The Clock*?

CM: It took three years of actual work, or five years from the idea to completion.

AT: How did you make the decisions about what clips to use? It must have been overwhelming.

CM: Let's say it is exactly 3 P.M. and there is no indication of the seconds [between 3:00 and 3:01]. I have a minute in which to place the scenes together, but I also have to build a kind of narrative flow. I have to find connections between them. Some just didn't fit in the narrative, so I didn't use them.

AT: When you say "narrative," what do you mean? It isn't a narrative in the traditional sense.

CM: It's more like attempting to create a logical sequence, out of disconnected fragments, but there are links, like a thread: it can be a movement, an energy, a line in the dialogue, or simply a mood. There are so many different ways to connect the scenes: the quality of light, if people are outdoors or indoors. Some things just don't work as well as others. The footage really dictates what I can do with it. I can't have preset ideas. I have to be open to the footage. But the time structure is extremely limiting. I have to stick to this clock. I also think of it as a structural film really, because there is a set of limitations. But the nature of the material is not at all what you'd expect from a structural film.

AT: The clock is a grid.

CM: Yeah. You can't move away from it for drama or something else. But a minute can be a long time in a film. I can add something that is not time specific to create a bridge. I can borrow a scene from another film—as long as it adds to the flow and "narrative" that I am focusing on in that minute. If it's a garden scene, I might cut to a close-up of a flower from a different film to help with continuity. To be consistent with the quality of light was really hard: 5 P.M. in the summer and 5 P.M. in the winter are really different worlds. I could shift from dark to light, but it had to be progressive. I couldn't be disjointed, though sometimes it is surprising what you can get away with: you can jump from color to black-and-white if the connecting elements are strong enough. That tension between seeing the edit and being "fooled" by it is a strange thing. You know that the shots are from different films. You just saw the sequence go from color to black-and-white, yet you want to believe it is all one film.

AT: Hollywood has spent enormous amounts of time and money to create what seems like real time when it almost never is. I remember the first time I ever looked at Hitchcock movies in a class. Everyone was talking about the cuts, but I couldn't see them. I was so carried away, mostly by the music, but also the narrative. I missed them all the time. I had to train myself to see them.

CM: Films are so manipulative. So constructed. Yet we are so used to this construction that we accept it and don't think about it much. With *The Clock* you are constantly reminded that you've been fooled. I show you the edits, yet there is enough going on that you just accept them. It is an interesting kind of balance between that knowledge and ignorant bliss. In *Telephones,* I used the most traditional kind of edit to jump-cut from one space to another. It's really a crazy idea, but it works and we are totally familiar with it. We accept it as normal. The camera is in this space in New York and then suddenly it's in LA with the other person talking on the phone. That jump cut is a big jump in space. I thought what if I could take that convention and jump-cut in time as well—let's say, from a 1940s film to a 1990s one.

AT: Nabokov wrote about how movies transformed narrative time for the novel, because now no one has a problem on the page with being in LA in one minute and New York the next because the telephone exists and you've seen it in movies. When you were putting *The Clock* together, did you ever force yourself to watch it for twenty-four hours straight?

CM: No, I never did. Though I've seen it all in the editing process. But in a very dis-jointed way. I would jump around all the time. I could work on any part independently. But I was dependent on the material I would receive. Someone would bring me a clip for 3:35 A.M. So what do I have for 3:00 A.M.? What is missing? I may have to redo a section because of a great clip that was discovered later. The process was one of constantly constructing and unravelling. I would eventually finish an

hour. Then I had to connect all the hours. I worked with twenty-four one-hour timelines. It was so big that I had two computers. One for the A.M. and the other for the P.M.

AT: What did you mean when you said before that people are now obsessed with time?

CM: We are very conscious of time in ways that we weren't before. We used to have to wait for a letter to arrive by post, and now if your computer server is slow, you get very impatient. We all have so little time to do things. We are talking about seconds when it comes to your computer slowing down, but time can also be a bigger metaphor for life. I often refer to *The Clock* as a gigantic memento mori. When I couldn't find an image specific to a minute or needed some filler, I used someone lighting or blowing out a candle. Cigarettes are also very contemporary memento mori. People smoke so much in films—or they used to. Now they are not allowed anymore. We tend to think of memento mori as seventeenth-century painting subject matter. But today it is not just candles and skulls anymore. It was harder to find contemporary symbols of mortality.

AT: Photographs in general?

CM: Yeah, they are, much more than the moving image, strangely.

AT: Really? They are all ghosts up there.

CM: They are all ghosts, but they come back to life through the magic of film. The most moving part for me was seeing actors at different times of their lives, seeing them age, but out of the normal sequence. It was great to see these actors with their amazing craft and how their aging affected their performance and the kind of roles they were asked to play. In *The Clock* I have footage of Michael Caine as an old man and then young again a few minutes later, the same thing with Maggie Smith or Jack Nicholson.

AT: Most of the installation pieces I see in galleries don't deserve much time, but some do, and even with those, gallery and museum viewers usually just take a peek and leave. I remember seeing a great Warhol double-screen film—*Paul Swan*—projected on the wall of an uptown gallery. People just stood in the doorway for a few seconds and walked away. But people stayed for hours when they came to *The Clock*. They didn't want to leave. I certainly didn't.

 When you were making the piece, did you think of those very long 1960s movies like Warhol's *Empire*? I think of *The Clock* as a counter-experience to *Empire*.

CM: When you do something that is about time and duration you can't help but think about Warhol. Somewhere it is a fantasy that many filmmakers have: making a film that lasts forever—where real life and life in the film get confused. Once I had the idea for *The Clock,* that was the driving force, not Warhol, but of course I thought about *Empire* or *Sleep.* But those are shorter.

AT: Much shorter. [*Laughs*] That is baby stuff.

CM: And easier to edit.

AT: Callie Angell, who wrote so brilliantly on Warhol, often mentioned that he thought of all the films he made as one big film that always would be on, the way television is always on.

CM: That's a nice idea—as an ambient thing. That's the way I think of *The Clock*. It is not a film to necessarily see in its entirety. It has no beginning nor end. It doesn't matter when you come in or when you leave. Ideally, it should always be there and you get to see parts of it when you have time.

OLD MEDIUM/NEW FORMS

The only thing that is different from one time to another is what is seen and what is seen depends upon how everybody is doing everything. This makes the thing we are looking at very different and this makes what those who describe it make of it, it makes a composition, it confuses, it shows, it is, it looks, it likes it as it is, and this makes what is seen as it is seen. Nothing changes from generation to generation except the thing seen and that makes a composition.

GERTRUDE STEIN, "COMPOSITION AS EXPLANATION," 1925

Without culture there is no photographer. Without understanding of man there is no photographer. There is just a clicker shutter snapper.

LÁSZLÓ MOHOLY-NAGY, "THE COMING WORLD OF PHOTOGRAPHY," 1944

23

PHOTOGRAPHY AND THE FUTURE
2010

Tom Huhn

Philosopher Tom Huhn stuns us in his disavowal of the contemporary photographic image and asks us to question our understanding of seeing and imaging the world.

Of course this will sound curmudgeonly, but here goes anyway: photography is now the largest impediment to human advancement. I say this without having in mind any particular goal toward which human development ought to be headed, but rather with the conviction that photography is currently just the biggest, dumbest block in the road impeding our motion toward wherever else we might instead wander. I hold no particular brief against the snapshot, fine art photography, fashion, or product shot alone. Rather, it is the photographic image *tout court* that bears the distinct look of devolution.

The pervasive appearance of the photographic image—in print and on screens, monitors, LEDs, jumbotrons, cellphones, and thus all the while more firmly entrenched in our visual imaginations—continuously incapacitates us. Indeed, the plain old photograph seems pretty quaint these days, as if photography itself, pixilated or not, has the look, increasingly, of a rustic technology. This sheer, flat deadness of the photographic image is nearly enough to make one wish nostalgically for a return to the days when we purportedly were still in thrall to some image or another. The problem is that photographic imagery, though we are surrounded by it, no longer captures us. Still, the photographic image does have some kind of hold on us, and it is the nature of that hold that is most distressing. That there is something amiss about photography's hold, or perhaps only that it doesn't hold us enough, is betrayed by its proliferation, as if by multiplying and simultaneously becoming more "high-definition" and "Blu-rayed," ultra-glossy and leaking color, it might justify the stakes it has in us. These are the marks of the contemporary overdetermination—that is, desperation—of the photographic image.

Another way to approach this current impasse of ours is to consider the primacy the image has thus far enjoyed in the visual constitution and organization of our lives. The image has been, for a very long time now, the structured, dynamic unity by means of which visual experience takes place in us. (And, further, there are of course many people now suggesting that what stamps our era most deeply is the displacement of the centrality of the word by the image.) The hallmark of the historical image has been its composition into bounded, cohesive totalities—that is, things that we see. The image has been the unit, par excellence, of visual life and thought. The advent of photography, however, introduced a novel wrinkle into the history of image-making: the hand and eye of the machine. This most thrilling advance in image-making, transforming the photograph's quasi-alien origin into the source at once for both its exoticism and seeming hyper-realism, tempted those like Walter Benjamin to imagine some revolutionary potential lay precisely in the photographic image's divorce from the hand and eye (and mind) of human history. Even the impulse underlying William Eggleston's *Democracy of Images* is a weak version of this belief that the value of photography is rooted in its distinct distance and differentiation from human making. Perhaps, in the end, there is something to be said for technological developments that liberate us from ourselves. Still, at what cost do we abandon our continuities with the long history of image-making that precedes the recent appearance of the photographic mechanisms and all that follow in their train?

The question of the status of the photographic image needs to be placed in the larger inquiry that asks which developments of our capacities, whether technological or aesthetic, enhance whatever we might next become. My fear is that the photographic image has helped to disinherit us from images that could have had their beginnings only with us anyway. The sheer mechanicalism of the photographic image seems to absolve us of all responsibility toward, and kinship with, imagery, thus slowly marking all imagery as no longer recognizable or as once having been our own. Indeed, the history of the photographic image is the history of our diminishing share in the imagery that produces and reproduces the world we attempt to inhabit. An old-fashioned word for this event is *alienation.* And the most profound sort of alienation is not merely having the things we make become unrecognizable to us but rather to have the very capacities by which we engage the world become the capacities of someone, or rather something, else. The photographic image has served as the means by which we've been losing our affinity for, and kinship with, ourselves. I imagine this is about as estranged as anything might become. And yet, we still make and see these photographic things, repeatedly and endlessly, and thereby continue to remake ourselves ever more removed from what we previously produced as that which resembled, or might come to resemble, us.

Our fascination with the photographic image and thus the reason why it holds us— however fleetingly and in the end fruitlessly—lies in our continuing to hope for some relief from ourselves, which is to say, some respite from the self-alienating dynamic that the photographic apparatus has become the vehicle of. We therefore have a somewhat

ambivalent relation to just that power of the photographic apparatus that has taken up residence within us. The photographic image's estrangement from us makes it seem just the right place to look for deliverance, as a site where we might be located just far enough from ourselves in order to have a look back into what we've become. We look into the photograph to find what is strange about us and to try thereby to feel at home within it, which is to say, with ourselves. And yet, we also seem to know that each photographic image will distract us only long enough to allow us to forget what it is we nevertheless seek to find in it. Despite our vigilant scrutiny, accompanied by the longing for some knowledge that might transform us, the photograph continues to stupefy us.

24

MACHINE-SEEING
2012

Trevor Paglen and Aaron Schuman

The roles of machines, science, technology, and geography are
intertwined in this discussion of Paglen's work.

AARON SCHUMAN: In your studies and your career, you've engaged with both geogra-
phy and fine art, and to begin with, I'm curious to know what first inspired you
to pursue these two particular fields. What was the relationship that you saw
between them?

TREVOR PAGLEN: I've been an artist of one sort or another my whole life, and I studied
art long before I studied geography. I first came to geography because I'd become
frustrated with the boundaries of art theory. More specifically, I'd become frus-
trated with some of art theory's underlying premises, beginning with the idea that
there's something like an art object that can be more or less disassociated from
the social, economic, spatial, and political relations that it's embedded within. I
was reading widely in other fields, looking for a theoretical language that could
incorporate culture, space, and political economy in some kind of dialectical way.
Eventually I found geography, which I think can do that very well. So I started
studying geography, and ultimately got a PhD in it. There is of course a little more
to it, but the point is that, for me, geography was a way to help me think about
art. Since then, most of my artwork has drawn on the work that I've done as a
geographer, but that wasn't so much the case at first.

AS: So how has geography's theoretical language manifested itself within your art
since then, and how has the study of geography influenced or changed your idea
of the "art object" in terms of its relationships with these other contexts that
you mention?

TP: One of the major ways that I've come to understand art through geography has to do with thinking about the things that I'm making as process, as praxis, and/ or as performance. I think about art not just as something that we go look at in a museum, gallery, or what-have-you, but as a moment of congealed production: the politics through which a given work is produced is a huge part of how I understand what I'm doing. In other words, if I go out, find some kind of secret military base, and then develop tools to photograph it, I'm suggesting a particular way of acting in the world, and I'm engaging in a kind of political performance or action. In this sense, the act of photographing something is, for me, a crucial political moment in the overall work. What the image actually looks like or how it's displayed is almost unrelated to that process of production.

In a more general sense, I think that a geographic understanding of the relationships between culture, space, and politics helps us to move beyond a conception of art that's limited to an understanding of it as allegory, metaphor, or questions of representation and instead towards a conception of art as processes, events, and ways of being (or more precisely, becoming). I've written more extensively about these issues in some of my experimental geography literature, but to be honest with you, my visual work is situated pretty squarely in the "art world," with a few important exceptions.

AS: So if your work is primarily intended for an art context, how would you describe the relationship between its aesthetic qualities (and those of photography in general) and its informational content?

TP: I tend to insist that the photographs have pretty much no information content whatsoever. They can "point" to various stories and political phenomena, but I think of them as more of an opportunity to tell those stories, or at least talk about them. With regard to the aesthetic, I think a lot about the various formal and art historical references that I'm making with different images. By riffing off various historical tropes, I try to think about how the present rhymes with the past and perhaps even the future. The same is true of the aesthetic tropes in my work; it's a way to think about whatever it is I'm looking at in relation to ideas associated with different aesthetic forms.

AS: But although you argue that photographs have no information content, your work often employs the photograph as a form of evidence—so much so that it has been used to substantiate and support vital legal arguments—albeit they represent quite subdued and somewhat obscured forms of evidence: hints, traces, and whispers rather than blatant statements of "fact." For nearly a century, particularly within the realms of art, cultural, and social criticism, the medium of photography has been continuously critiqued in terms of its reliability and trustworthiness and has often been discredited due to its ambiguous, subjective, malleable, and therefore potentially deceptive nature. Yet paradoxically, in the twenty-first century it seems

as though within the general cultural, social, and political spheres photography (and video) is increasingly becoming very prominent as a form of reliable witnessing—whether it be the handheld images and footage made on cameraphones or the images made by the mechanisms that are often your subjects, such as satellites, drones, and so on. So if you believe that photographs contain no information, then what is your understanding of photography in terms of its validity and evidential value?

TP: You're certainly right about both of those trajectories in photography—photographs are both evidence and fiction; they're myopic and still potentially useful. I'm not someone who comes down on either side of this. I think that artists and photographers should put this conversation to rest and just recognize that we work with an extremely contradictory apparatus. Actually, that's what I like about it. I'm attracted to photography not because it's truth or fiction, but because it can be both at the same time. Let's be excited about that rather than worry about it, because that's what makes photography interesting.

AS: With that in mind, how do you imagine that photographic images will evolve, be used, and be interpreted in the future, in regard to art as well as science and politics?

TP: I don't really worry about how photographic images might evolve in the future. For me, the real issues have to do with how "cameras" in the broadest sense—spy satellites, drones, facial recognition surveillance cameras, police automated license plate readers, etc.—sculpt society. We're living in a world that is increasingly characterized by forms of machine-seeing—that is, a world of photography in the broad sense—and those machine-seeing apparatuses have political structures built into them, quite literally. For example, if you are going to have secret satellites, then you have to have secret-satellite factories, launch vehicles, operations centers, image interpreters, and so on. The spy satellite, or "camera" in the broadest sense, creates a political geography. For me, this is increasingly the future of what photography means. A lot of more traditional photographers really lament the state of photography and think that it's over. It might be over as they knew it, but in terms of our overall society, it's just getting going.

AS: Do you define yourself a "photographer," a "geographer," an "artist," an amalgamation of these roles, or something else entirely?

TP: I suppose that how I represent myself largely depends on whom I'm talking to. The slope between my work as an artist and as a geographer is pretty slippery to say the least. I've written a number of academic journal articles about state secrecy and geography, where I'm trying to develop some theoretical models to think about secrecy. I've also written more academic articles about spy satellites, the politics of orbits, and other texts that are really about geography theory. And then there are my more "popular" books—like *Blank Spots on the Map: The Dark Geography of the Pentagon's Secret World,* and *Torture Taxi: On the Trail of the CIA's Rendition*

FIGURE 24.1

Trevor Paglen, *Dead Satellite with Nuclear Reactor, Eastern Arizona (Cosmos 469)*, 2011. C-print.
Courtesy of the artist, Metro Pictures, Altman Siegel Gallery, and Galerie Thomas Zander.

Flights—which blend into my more "art" books, like *I Could Tell You But Then You Would Have to Be Destroyed by Me: Emblems from the Pentagon's Black World* and *Invisible: Covert Operations and Classified Landscapes*. It's a continuum, for sure.

But ultimately, words like *artist* or *geographer* mean much more to me than *photographer*, precisely because they're less defined. To me, *photographer* sounds an awful lot like *painter*—it implies a commitment to the medium that I just don't have.

AS: The reason I ask is that you've specifically chosen to use photography, and like you, the medium of photography has always both straddled and struggled with the boundaries of art and art theory. Furthermore, like the work you strive to make and engage with, it is nearly impossible to disassociate photography from the social, economic, spatial, and political relations that are embedded within it. So to me, it seems slightly contradictory that you prefer to be regarded as an artist and refer to your photographic work as something that sits "pretty squarely in the art world," considering that unlike other more traditional art mediums,

photography implicitly enables you to address theoretical languages both within the boundaries of art and those that lie outside it and also allows you to engage with much broader contexts.

TP: Of course, I use photography a lot in my work, and I'm interested in it for precisely the reasons you mention—on one hand, it's completely bound up with pervasive forms of state and corporate power, and on the other hand it's incredibly ambiguous. I don't care at all about a notion of photography that's distinct from histories and traditions of cultural seeing, fine art, military and intelligence imaging, advertising, psychology, or anything else. I don't think that the history of painting is interesting, but I do think that the history of representation and its limits is interesting. Similarly, I don't think that a history of photography is interesting, but I'm very interested in a history of humans-seeing-with-machines.

But I think that most people who see my visual work probably encounter it in an art context—whether that's an art book, a magazine, or a museum or gallery—and it seems to me that art is about as big a context as exists. It certainly is much bigger than geography or human rights activism or journalism, which are all other places where I've done a lot of work. Yet, I don't think of those contexts as distinct from that of the art world. Perhaps it's more like a Venn diagram—there are places where art intersects and overlaps with geography, ditto for human rights, social science, and even hard science. I think that a lot of my work lies at these intersections, or hopefully even helps to create them. Having said that, working as an artist—in relation to other artists and people who think about art—gives me much more flexibility than I'd have in any other discipline. And at the same time, it allows me to ask questions and generate conversations that just don't happen in other fields.

AS: So do you feel that the meaning of your visual work has more efficacy and potential when it's placed and experienced specifically within an art context, which is as you describe it, broader and more expansive than others?

TP: I'm not sure that the work has any meaning whatsoever outside the specific context that it's seen in. In other words, the work doesn't have any kind of inherent metaphysical Meaning with a capital M. Meaning is always incredibly overdetermined, isn't it? That's actually one of the most interesting things about art to me. I think that a lot of people worry that ambiguity or shifting meanings in artworks map onto a cultural logic of late capitalism or neoliberalism (or whatever you want to call it) and are therefore suspicious of its critical potential. I understand that argument and agree with it to a certain extent, but we also know that a desire for some kind of transcendental Meaning quickly becomes a nostalgia for authoritarianism. Just look at the radical right in both the United States and elsewhere in the world—their whole cultural agenda is about fixed meanings (i.e., "traditional marriage," etc.). My work in experimental geography, incidentally, is about trying

to navigate this cultural terrain by using geography and space, instead of culture, as way to productively reframe these questions.

AS: Yes, I entirely agree that, in regard to visual work, meanings and context are intertwined and integral to one another, that meanings shift, are malleable, and are dependent upon context. But this also leads me to wonder if, without Meaning, the work becomes just as vulnerable to authoritarianism as that made with the intention of determining Meaning, or fixed meanings. It seems to me that in geography, one is "mapping a terrain" and therefore constructing and establishing a determined context that brings meaning to whatever resides within it, whereas in creating art objects that have fluctuating meanings, one is in a sense freeing the work from being tied to Meaning but is also relinquishing it to contexts determined by others. Therefore, it becomes vulnerable to manipulation if not abuse on the part of whoever is creating or determining the various contexts in which it might sit, whether they be authoritarian or not. Furthermore, if they have no intended Meaning, why make art objects—why not simply make contexts?

TP: Of course, we all know that no one has ever produced an image or representation whose meaning is totally fixed. We all know that an image is worth not only a thousand words but is also worth a thousand lies. Given this situation, as a critical artist you can go in any number of directions, from the abstract and formal to the realist. There's no right answer here; we are all familiar with the possibilities and shortcomings of any approach and recognize that any image can be co-opted or used to authoritarian purposes. It's a game that no one can win. So instead of picking a spot on a line between abstraction and realism and saying, "This is the critically correct point on the line," I propose adding a second axis, one having to do with the politics of production going into the work. Instead of asking, "Does this image as a thing in itself help create a more just world?" we can ask, "Do the means through which this particular work is produced help contribute to a more just world?" Incidentally, there's nothing new about this idea—Walter Benjamin makes the same point in his essays "The Author as Producer" and "The Work of Art in the Age of Mechanical Reproduction." In sum, perhaps that's another way of my saying that I agree with you: creating "contexts" is perhaps much more politically useful than creating images.

AS: I find it fascinating that within your art practice and your photographic work, you continually collaborate with scholars and institutions that sit outside of the conventional art sphere: astronomers, computer scientists, engineers, journalists, lawyers, activists, and so on. In the early nineteenth century, when photography was invented, the "Arts" and the "Sciences" (as well as Politics) were much more closely aligned—and of course this is no coincidence; as we discussed earlier, the medium itself embodies the overlaps between such fields. Henry Fox Talbot was not only a photographer and inventor of photographic processes but was also chemist, a classicist, an etymologist, an archeologist, and a member of Parlia-

Trevor Paglen, *Detachment 3, Air Force Flight Test Center, Groom Lake, NV; Distance approx. 26 miles,* 2008. C-print. Courtesy of the artist, Metro Pictures, Altman Siegel Gallery, and Galerie Thomas Zander.

ment; Charles Dodgson (Lewis Carroll) was a photographer, an author, an inventor, a philosopher, a logician, an Anglican deacon, and a lecturer in mathematics at Oxford; Timothy O'Sullivan was a war correspondent and served as the official photographer for both the U.S. Geological Survey and the U.S. Treasury Department; Jacob Riis was a journalist, a writer, a social reformer, and a public lecturer; and so on. Yet throughout the twentieth century, Art and Science—and their uses of photography—seem to have grown further and further apart, and for many people, the two now sit at opposite ends of an ill-defined spectrum. For whatever reasons, it seems that sometimes artists can be quite dismissive of science, and vice versa. So I'm very curious about the relationships and discussions that you have with your scientific colleagues; how do such collaborations work?

TP: It's always very strange for me to hear artists be dismissive of science—it's something I absolutely do not understand. At its best, science is about trying to ask the biggest questions about the nature and fate of the universe and our place in relation to it. For me, those are very much the same questions that great artists ask.

Yes, the overwhelming majority of science is conducted either for the benefit of the military or for capital and is usually based on ethically dubious assumptions, but the vast majority of art is also compromised. There's plenty of bad science and plenty of bad art, but whenever I spend time with great scientists, I often find people who think in ways that can be surprisingly close to the ways great artists think. Of course, there are vast differences in the way people are trained, but I think there are often a lot of similarities between artists and scientists.

For example, I'm reminded of a fantastic earth scientist named Kurt Cuffey, who teaches at University of California, Berkeley. We used to talk a lot about deep time and the long-term evolution of everything from global warming to glaciation and plate tectonics. Kurt primarily studies glaciers, and I learned that at one point he had dug a hole in an Alaskan glacier and then sat there for a week. He'd done that because he thought he'd learn something about glaciers just by sitting there and experiencing them. One day I was making fun of him about this, and he pointed out that I'd often spend a week or more sitting on the top of a mountain, looking off at a secret military base, trying to understand what it looks like. Point taken.

A very suitable definition of contemporary man might be that he is under observation—observed by the state, for one, with more and more sophisticated methods, while man makes more and more desperate attempts to escape being observed, which in term renders man increasingly suspect in the eyes of the state and the state even more suspect in the eyes of man; similarly each state observes and is observed by all other states, and man, on another plane, is busy observing nature as never before, inventing more and more subtle instruments for this purpose, cameras, telescopes, stereoscopes, radio telescopes, X-ray telescopes, microscopes, synchrotrons, satellites, space probes, computers, all designed to coax more and more new observations out of nature, from quasars trillions of light-years away to particles a billionth of a millimeter in diameter to the discovery that electromagnetic rays are nothing but radiant mass and mass is frozen electromagnetic radiation; never before had man observed nature so closely. . . .

Friedrich Dürrenmatt, *The Assignment*, 1986

25

THERE IS ONLY SOFTWARE
2011

Lev Manovich

Manovich, an artist and theorist, as well as a prescient seer, delves beyond our
understanding of the digital devices that surround us to explore their foundational philology.

Academics, media artists, and journalists have been writing extensively about "new
media" since the early 1990s. In many of these discussions, a single term came to stand
for the whole set of new technologies, new expressive and communicative possibilities,
and new forms of community and sociality that were developing around computers and
the Internet. The term was *digital*. It received its official seal of approval, so to speak, in
1996 when the director of the MIT Media Lab Nicholas Negroponte collected his *Wired*
columns into the book *Being Digital*. Fifteen years later, this term still dominates both
popular and academic understanding of what new media is about.

When I did Google searches for *digital, interactive,* and *multimedia* on March 2, 2011,
the first search returned 1,390,000,000 results; the other two returned only between
276,000,000 and 456,000,000 each. Doing searches on Google Scholar produced sim-
ilar results: 3,830,000 for *digital*, 2,270,000 for *interactive*, 1,900,000 for *multimedia*.
Based on these numbers, Negroponte appears to be right.

I don't need to convince anybody today about the transformative effects Internet,
participatory media, mobile computing have already had on human culture and society,
including creation, sharing, and access to media artifacts. What I do want to point out
is the centrality of another element of IT, which until recently received less theoretical
attention in defining what "media" is. This element is software.

None of the new media authoring and editing techniques we associate with comput-
ers is simply a result of media "being digital." The new ways of media access, distri-
bution, analysis, generation, and manipulation are all due to software—which means

that are they the result of the particular choices made by individuals, companies, and consortiums who develop software. Some of these choices concern basic principles and protocols that govern the modern computing environment: for instance, "cut and paste" commands built into all software running under GUI (or newer media user interfaces such as iOS), or one-way hyperlinks as implemented in web technology. Other choices are specific to particular types of software (for instance, illustration applications) or individual software packages.

If particular software techniques or interface metaphors that appear in one particular application become popular with its users, often we soon see them in other applications. For example, after Flickr added "tag clouds" to its interface, they soon became a standard feature of numerous websites. The appearance of particular techniques in applications can also be traced to the economics of the software industry—for instance, when one software company buys another company, it may merge its existing package with the software from the company it bought.

All these software mutations and "new species" of software techniques are social in a sense that they don't simply come from individual minds or from some "essential" properties of a digital computer or a computer network. They come from software developed by groups of people and marketed to large numbers of users.

In short, the techniques and the conventions of the computer metamedium and all the tools available in software applications are not the result of a technological change from "analog" to "digital" media. They are the result of software that is constantly evolving and that is subject to market forces and constraints.

This means that the terms *digital media* and *new media* do not capture very well the uniqueness of the digital revolution. Why? Because all the new qualities of digital media are not situated inside the media objects. Rather, they all exist "outside"—as commands and techniques of media viewers; e-mail clients; animation, compositing, and editing applications; game engines; and all other software species. Thus, while digital representation makes it possible for computers to work with images, text, forms, sounds, and other media types in principle, it is the software that determines what we can do with them. So although we are indeed "being digital," the actual forms of this "being" come from software.

Accepting the centrality of software puts in question a fundamental concept of modern aesthetic and media theory—that of properties of a medium. What does it mean to refer to a digital medium as having properties? For example, is it meaningful to talk about unique properties of digital photographs, or electronic texts, or websites, or computer games?

Or what about the most basic media types: text, images, video, sound, maps? Obviously, these media types have different representational and expressive capabilities; they can produce different emotional effects; they are processed by different networks of neurons; and they also likely correspond to different types of mental processes and mental representations. These differences have been discussed for thousand of years—from

ancient philosophy to classical aesthetic theory to modern art theory and contemporary neuroscience. For example, sound, video, and animation can represent temporal processes; language can be used to specify logical relations; and so on. Software did not change much here.

What it did fundamentally change, however, is how concrete instances of such media types (and their various combinations) function in practice. The result is that any such instance lost much of its unique identity. What as users we experience as particular properties of a piece of media come from software used to create, edit, present, and access this content.

On the one hand, interactive software adds a new set of capabilities shared by all these media types: editing by selecting discrete parts, separation between data structure and its display, hyperlinking, visualization, searchability, findability, and so on. On the other hand, when we are dealing with a particular digital cultural object, its properties can vary dramatically depending on the software application that we use to interact with this object.

Let's look at one example—a photograph. In the analog era, once a photograph was printed, whatever this photograph represented or expressed was contained in this print. Looking at this photograph at home or in an exhibition did not make any difference. Certainly, a photographer could produce a different print with a higher contrast and in this way change the content of the original image—but this required creating a whole new physical object (i.e., a new photographic print).

Now, let's consider a digital photograph. We can capture a photo with a dedicated digital camera or a mobile phone; we can scan it from an old magazine; we can download it from an online archive, and so on—this part does not matter. In all cases we will end up with a digital file that contains an array of pixel color values and a file header that may typically specify image dimensions, information about the camera and shot conditions (such as exposure), and other metadata. In other words, we end up with what is normally called "digital media"—a file containing numbers that mean something to us. (The actual file formats may be much more complex, but the description I provided captures the essential concepts.)

However, unless you are a programmer, you never directly deal with these numbers; instead, you interact with digital media files through some application software. And here comes the crucial part. Depending on which software you use to access it, what you can do with the same digital file can change dramatically. E-mail software on your phone may simply display this photo—and nothing else. Free media viewers and players that run on desktops or over the web usually give you more functions. For instance, a desktop version of Google's Picasa includes crop, auto color, red eye reduction, a variety of filters (soft focus, glow, etc.), and a number of other functions. It can also display the same photo as color or black-and-white without any changes to the file itself. It also allows you to zoom into the photo many times, examining its details in way which my mobile phone software can't. Finally, if I open the same photo in a professional

application such as Photoshop, I can do much, much more. For instance, I can instruct Photoshop to combine the photo with many others, to replace certain colors, to make its linear structure visible by running an edge detection filter, to blur it in a dozen of different ways, and so on.

As this example illustrates, depending on the software I am using, the properties of a media object can change dramatically. Exactly the same file with the same contents can take on a variety of identities depending on the software used by a user.

What does this finding mean in relation to the persisting primacy of the term *digital* in understanding new media? Let me answer this as clearly and directly as I can. There is no such thing as "digital media." There is only software—as applied to media data (or "content").

To rephrase: for users who can interact with media content only through application software, "digital media" does not have any unique properties by itself. What used to be "properties of a medium" are now operations and affordances defined by software.

If you want to escape our prison of software—or at least better understand what media is today—stop downloading apps created by others. Instead, learn to program—and teach it to your students.

Digital technology is programmed. This makes it biased towards those with the capacity to write the code. In a digital age, we must learn how to make the software, or risk becoming the software. It is not too difficult or too late to learn the code behind these things we use—or at least to understand that there is a code behind their interfaces. Otherwise, we are at the mercy of those who do the programming, the people paying them, or even the technology itself.

Douglas Rushkoff, *Program or Be Programmed*, 2010

26

GOOGLE STREET VIEW
The World Is Our Studio
2011

Lisa Kereszi

A straight photographer ponders the creative possibilities latent in the cameras that travel our streets.

. . . All of consciousness is shifted from the imagined, to the revisive, to the effort to perceive simply the cruel radiance of what is. . . . This is why the camera seems to me, next to unassisted and weaponless consciousness, the central instrument of our time.

JAMES AGEE, *LET US NOW PRAISE FAMOUS MEN*

What photographers do, ultimately, is take the real stuff of the world and *edit* it down, noticing, choosing, standing in the right spot, pointing, framing, removing something from one context and placing it in another, and in the best-case scenario, transforming it in one way or another. What if there is a second camera directly involved, or nine? Google Street View (GSV) has added another layer to the way we, as viewers and voyeurs and critics, can interact with our environment, all from the relative physical comfort and domestic safety of our home computers or our iPhones. We feel we can fly, zip, and zoom around the world in an instant, witnessing the activity along roadsides and curbsides from Kalamazoo to Kishiniev. If photography itself is really mostly a form of visual editing, does it matter that the initial camera operator is not the artist himself, but a spooky, indiscriminate, black Google car thousands of miles away, connected not by synapses and nerves but by satellite and signal? Is it valid to make a 2-D image from a 2-D world, rather than from 3-D reality, and call it one's own? Who is the author of such imagery? Does authorship even matter anymore, or is the anonymous, motor-driven nature of this image collection an interesting and valid conceptual layer? Anonymous people shot by an anonymous camera.

In a recent critique in the MFA Department at the Yale School of Art, Collier Schorr

made the following comment about a student's work made from appropriations of Internet pornography. She said, "Is it *your* picture, or is it your *choice?*" Although the statement was rhetorical, it was tinged with a hint of judgment. Is that enough? Does the artist's choice itself make it automatically the artist's image? Is choice a form of authorship? Isn't that what I am doing anyway when I take a photograph of a sign or a vernacular mural that was painted by the hand of another?

Appropriation is nothing new in the art world, from Richard Prince to Carrie Mae Weems. Having a cinematographer shoot your film (or your still photographs) is nothing new, either, like legions of film directors and Gregory Crewdson have done. Having a robot shoot your raw material, however, feels a little newer though and makes for an uneasy feeling for some viewers and critics. Taking images from an automated database, a computer brain, is much more cut-and-dry than one artist using pictures made by another artist (whether the source is fine art or commercial), for there is no conscious, sentient initial author here. And what does this traveling, automated eye see? Remember that photography itself was once seen as an automatonesque medium, so it wasn't taken seriously, leading to overcompensating fads like Pictorialism, the Impressionism of photography.

Although those days are (mostly) behind us, the problem still nags at photographers like Stan Douglas, who brings it up in talking about a news photographer like Weegee in the introduction to his 2011 catalogue for the conceptual *Midcentury Studio*. In the work, Douglas poses as a sort of mysterious 1950s-era commercial Joe-the-photographer, making purposely anonymous-looking images that are not at all anonymous in the end, but instead very specific and strange. He explains that the power in some of Weegee's work was "the uncanny events at the periphery of the images that were beyond his control and automatically recorded by the apparatus. This kind of automatism was one of the primary arguments against photography being regarded as legitimate art form."[1] As a photographer, it is those things outside of my control that excite me so much about the medium—those happy accidents, those things I couldn't possibly make up, whether fantastical or supremely banal. These are the things that have the potential to excite me as a viewer of some of the work that has been sourced from Google Street View.

Just like the real world, most of life along the roads of GSV is repetitive and mundane, like handheld real estate shots and WPA-era tax photos over and over again, but when it isn't bland, it can be shocking and wonderful. It's true, most of what gets highlighted from Google's database online on personal blogs and websites is merely silly, scary, and plain old strange; fortunate findings of unfortunate occurrences appear on websites with names like StreetViewFun and StreetViewGallery. Photographer Benjamin Donaldson has been using serendipitous images from Urlesque's "Top 10 Moments Caught on Google Maps Street View" in his undergraduate Introductory Photography lectures, first at Hunter College and then at Yale, since they appeared in 2009. What does one find out there? Fires, accidents, a Viking quest battle royale, flashers, those who have

fallen and can't get up, dead deer, Horse Boy, firemen coaxing down a cat in a tree, fence jumpers, and crimes in progress.

Photographer Michael Wolf won an honorable mention in the 2010 World Press Photo Contest for his series of pictures captured via GSV, entitled "A Series of Unfortunate Events," a prize that was hotly debated and stirred up controversy. Purists saw the award as unfair. After all, Wolf didn't "take" the photos in person with his own camera. He did, however, "make" them, in a way, by the mere act of consciously editing Google's world (and our world) in the same way that he would otherwise edit the real world: with a camera in hand. How different is this from Garry Winogrand's precarious steer crossing the road, or Walker Evans shooting from an immutable, unstoppable train window in the *Fortune* magazine portfolio "Along the Right of Way"? In those cases, the photographer was trapped inside a vehicle of one sort or another, and couldn't move his body and frame to just the "right" place. No, of course, it's not the same, exactly, but it's not utterly, one-hundred-percent different. It is, however, conceptually different with this added layer of distance and meaning attached to the project, since the pictures are captured not by a human who chooses where to stand and how to frame, but by a robotic car, clicking pictures every few meters, without cognitive reasoning, and involuntarily, like a heartbeat. Like blinking.

As with any photography project, some image-makers are more interesting than others, and some are artists while others are entertainers—comedians. After all, the real stuff of the world is already available; whether it's in person or on-screen might not matter so much in the end. The photographer Jon Rafman has posted a series on 9-eyes. com that includes pictures you can hardly believe exist, full of prostitutes, Segways, one unicycle, accidents, the Rod Stewart Fan Club, a whale and birds, and a human suspended in air (all separately, of course.) The improbability of real-life events and the wonder of the wide world seem to be a subject of this collection of images. I felt as if I had visited places I never even knew existed, and that I had a better idea of what life might actually be like in a far-flung place shown to us previously only in professional, commercial photographs. Street View, and Rafman, shows us, with a heightened sense of reality, what the glossy travel mags leave out, like an otherwise boring-looking corner that hosts a kid fallen off a bike or a routine traffic stop gone awry. How great and wild and weird the world is. Making pictures makes me feel that way; seeing great pictures makes me feel that way; and this work torn from the virtual pages of GSV makes me feel that way.

Another photographic artist making what appears to be carefully edited work in the same way is Doug Rickard, whose project *A New American Picture (ANAP)* debuted late in 2010 at Le Bal during Paris Photo and was published both as a limited edition by Schaden and in an expanded version later by Aperture. In the United States, the work was shown in the 2011 *New Photography* show at the Museum of Modern Art, then bounced back to France at the Centre Pompidou the following spring. Rickard chooses to be much more narrow in focus and is not interested in the sensationalist and silly.

He is no comedian; what he shows is tragedy. But not blatant tragedies like accidents and fires. His tragic piece is about poverty in America. The Google car goes down every street and in so doing, traverses the streets in those "bad neighborhoods" that many middle-class people actively avoid, but also those same street corners and curbsides that many other people cannot escape. Wide-angle scenes from Detroit, Memphis, Oakland, Camden, New Jersey, and more picture mostly African Americans and mostly run-down, neglected neighborhoods: graffiti, abandoned cars, a man pushing a shopping cart full of cans, another supporting himself on crutches, the projects, a cowboy in a wheelchair. Lone figures, slightly blurred, look like the movers in the zombie flicks that were popular a few years ago, all wandering, seemingly drawn to the onlooker. They have a forced anonymity, as facial-recognition software has been used to blur the faces even more.

Citizens are frozen in time, forever disobeying the "No Loitering" signs pictured nearby. There's a sense of suspension, of waiting. Walker Evans's Depression-era photos come to mind, as do Paul Graham's from *A Shimmer of Possibility,* a project that touched on some of the same social concerns. This looks like a twenty-first-century response to Robert Frank's *The Americans.* I see Frank's New Orleans Canal Street trolley car reiterated over and over again, in a way, but in reverse. These scenes are what that beautiful black man leaning out of the rear of that streetcar was seeing, over and over again, block to block, but it's as if he were seeing into the future to the twenty-first century. The photos are unflinching and damning, even though the initial camera operator was incapable of flinching anyway. (I ask myself, of the best images, could I have done any better, or worse, with film behind my eyes or a chip imbedded in my brain?) The pictures visually also remind one of Paul Fusco's *RFK Funeral Train,* in that there are regular American people seen alongside a route, often looking at the Google car, caught in mid-wave or shout, barely making contact with the lens in that split second as time, and the car, rolls on. There is no coffin of a much-loved American icon on board, however, and no one has a hand on heart or in salute. Instead, people sometimes stop to see and be seen by the Google cameras, as if to say, "Take my photo. I am here. I exist." (They sometimes stop to flip the world the bird, in the *9 Eyes* series at least—a defiance, or perhaps a judgment.) There is nothing funny about Rickard's series. Instead, it shows a deadly serious devastation. He is telling us to look around, to pay attention, and not to lie to ourselves and pretend that this America does not exist. Understandably, though, there has been a bit of a critical backlash for his not really *being there.* The question is, how much does it matter anymore?

Since Rafman, Wolf, and Rickard began using GSV, other artists have explored its possibilities, like Viktoria Binschtok, whose *World of Details* combines GSV images with her own street photographs. As GSV continues to update and expands its reach, more and more imagery is being made available not only to the general public but to artists. GSV is an exciting new tool, but the question still remains: Is it your choice or your picture?

In Tod Papageorge's book of essays, *Core Curriculum,* he quotes Brassaï on switching to photography from painting: "It is not enough for the artist of today to express the meaning of our age; he must express it in the modern medium, . . . in the new language of our century." Upon reading this, I froze in self-protective terror. I have been a photographer using film; am I actually the dinosaur I was starting to feel like I am? I decided internally that digital video was the "new" medium, and that YouTube was the "new" conduit. I realized then, from the words of a dead Hungarian, that everything had changed. That is, until I saw *ANAP* and the like. I realized that things just changed again, and that now this is what is "new." But for how long? What is coming next, and after that? Pixels to pixels, ashes to ashes, and dust to dust. The camera (now digital, here unmanned) is still, as Agee called it, "the central instrument of our time." It will always record our world, one way or another, whether we are physically there or not.

Every perfect traveler always creates the country where he travels.

Nikos Kazantzakis, *Japan, China,* 1963

27

EXPLORING OPTIONS
2011

Alec Soth and Charles Traub

Embracing and implementing new tools and opportunities foregrounds, in Soth's mind, the centrality of risk, the possibility of boredom and failure.

CHARLES TRAUB: In many ways, you've become an incredibly influential figure for a new generation of photographers and lens-based artists not only through your books, your old blog, and Little Brown Mushroom but also by embracing many different avenues for your work. How do you feel about that role? Do you agree with it? And what does it represent to others?

ALEC SOTH: Honest to God, I feel old. [*Laughs*] Things are moving so quickly, and there was a little moment where I got into blogging and what not and was in the flow of the moment. Then, boom. Blogs are so 2007. It got faster and faster, then moved to Facebook and Twitter. I'm really not so interested in keeping up. Very quickly, I feel out of the flow of things. It is not my ambition to be with the flow of things either. However, I'm not afraid to dabble in these other arenas. The way to keep things fresh for me is to experiment in these different areas. Some things are going to fail, and I have failed with a number of different ventures—video being one of them.

CT: Why do you think you failed in video?

AS: I hate to use the word *failure*. I experimented with it in a frighteningly high-profile way on the *New York Times* website. It was something I could not sustain for a variety of reasons. It is also something I'm no longer interested in pursuing anytime soon. Maybe sometime in the future. So in that sense, I don't think I'm out there on the cutting edge at all.

CT: I think you may be more on the cutting edge than you think, though there are many different people who pick up these roles easily—especially young technologists. We find that students are quite conservative in a funny way—until the generation that preceded them tells them, "Look you can do this! It is OK to be a videographer and photographer and to blog, or whatever." I think this is one reason why you are important to this young generation of photographers.

AS: Well, I do find students to be very conservative. I'm fascinated when I do visiting-artist gigs, and students immediately pin up ten photos on the wall. It is this very standard presentation. Does it have to be this one way, over and over again? It is amazing to me. It is amazing how little people use the computer as the tool for communication. Truth be told, I don't like looking at work online, but come on. It is an incredible tool, and young people should be interested in engaging with it as an actual medium.

CT: I've been teaching and making pictures for many years, and I think I know the reason. They see the success of any given person just a little older themselves. They see that as a model. They say, "Maybe I'll get a show at this gallery and I can do that." The new generation always tries to follow the old generation. The old generation tries to circumvent the new in some ways. If you were giving a lecture to emerging photographers or lens-based artists, what would you tell them to do? How would you tell them to engage this technology? Or would you?

AS: No one has made *The Americans* online. No one has made an incredible body of work that can be experienced only online, that is of its time and will change the medium. It is just sitting out there for someone to do a great project in that arena. If I was younger, I would be chasing after it like crazy. There is a way to break new ground, rather than just doing the same thing over and over. I think it is an incredibly exciting time to be a young lens-based artist. In a way, working towards the book, which is my number-one motivation, feels of another time.

CT: What might you encourage them to look at or experience in terms of technology? How would you change their education or experience? To frame it another way: We are four blocks from Chelsea, and that hangs over most students like Damocles's sword. They are still enamored with that model.

AS: I'm in Minnesota right now, so I don't have Chelsea next door, and I think that is a good thing. In terms of my education, I would get images mostly through books and magazines, so that becomes the ultimate medium for me. I think if I were living in Minnesota and getting all that info online, then that would be the ultimate medium as well. I think that exciting work often comes from unexpected places.

CT: That's why I think practitioners need to be encouraged to take those leaps and jumps. When you look outside photography, what inspires you? Literature? Films? The general and specific?

AS: I look less towards photography for inspiration because it becomes dangerous at a certain point. The danger of imitation is powerful. I look to film, but I have this battle with filmmaking and cinema. It does all these things that I wish photography could do. So I get inspired by filmmaking, but it also frustrates me by exposing the limitations of photography. The same can be said to a lesser extent for literature. I kind of hate poetry, but it is the thing that is most similar to photography. I force myself to read poetry. I wish I liked poetry more.

CT: I feel exactly as you do.

AS: In terms of education, photography couldn't be any easier. It has been simple for a very long time, but now with digital photography, anyone can do it. You have to be looking at all sorts of things. For me, the Internet, as research tool, is incredible. I'll get interested in one thing, say, carnivorous plants, and that leads you to this and that, and soon you are off to some exotic locations. In the past, it would have been so much work, I just could not have done that. Everyone is using the Internet in this way.

CT: Video has always been daunting in terms of handling sound to editing to position and movement. Despite the fact that Canon's 5Ds are amazing instruments, I find myself very distracted from my natural sense of composition. Is it possible for a person to master all that? Or should we be encouraging more collaborative-based work? Would you be more comfortable as the director or cameraman? Or soundman?

AS: Initially, like so many people, I was attracted to photography because I was a loner and wanted to work alone. Your first experience out photographing is usually wandering around, perhaps at night, and it is incredibly magical. So you want to keep creating that experience. With a few exceptions like Ross McElwee, filmmaking is a much more collaborative process. It is hard to work alone.

CT: Now it is much easier than before. A technically savvy person can do it.

AS: What I found for myself is that I just don't think like a filmmaker. I think like a photographer with a moving image. It is just a different language. I'm trying to translate the still image into this other language, and it's clumsy. The two things just don't fit that well.

CT: Can you say how they are different?

AS: I think there is an interesting place in between filmmaking and photography. That said, what I like about filmmaking is the narrative drive. That is what I struggle with. I'm not schooled in narrative. I crave it, but it is not what photography does best.

 As a student, I did take filmmaking classes at Sarah Lawrence. The faculty there were experimental filmmakers in the mold of Ernie Gehr or Stan Brakhage, which is now very hard for me to watch—although nowadays I'm coming back

around to it in some ways and finding it interesting. Nonetheless, I still crave narrative.

CT: I teach a class with Grahame Weinbren on the still and moving image, and we've found that many students are surprised that those films exist. I think the purpose of it is to understand that a film or moving image doesn't have to have a narrative, nor does it have to be structured in conventional ways. For lack of a better word, it can be an object too. I think these new cameras are allowing for these new short-form pieces that are really moving photographs as much as anything else. I think that is the interspace that you are talking about. We have something that is a photographic moving image or a moving photograph.

AS: I think all that stuff is totally valid. But I'm sort of weirdly traditional in my tastes. In the end, I do like conventional narrative cinema and photography that operates according to a specific language. This language and vocabulary have been built up over time. You can then use that vocabulary to say something. Trying to invent a new language is interesting, but I guess not what I'm engaged with.

CT: Irrespective of your own tastes and needs, would you encourage young artists to engage this new language? And how?

AS: This is an interesting question. When I was a student, I wanted to change the world. I wanted to invent a new language. I did whacked-out work with slide projectors, fake backdrops, and the like. I thought, "No one has ever done this before," but the work was so shallow and sophomoric. It was only when I left school that I accepted my influences. I'm obviously influenced by the straight-photographic tradition, and I accepted that my work was going to look like it, but hopefully I could work through that language and try to find my own little voice within it. Generally, I think it is naïve to try and create a new language, but that goes against what I've said about using these new forms. In this moment in time, there is a new medium out there that wasn't there before. That medium is going to generate good work—someone should do it, but I'm not the one.

CT: Are there any people touching on that new medium that you admire? Or that you would point to as an example?

AS: This is where I have to confess that I don't follow it that closely. There was a time when I was really excited about it. I got the first CD-ROM photo project by Pedro Meyer—*I Photograph to Remember*. It is a simple slideshow with a voice-over, and I thought, "That is really cool." There were a number of CD-ROMs and the DVDs, but those things haven't quite survived. I don't totally know what is happening out there. I know it is going to take the form of some social media that I can't even imagine.

CT: I think your experience parallels my own. Maybe what has happened is that while these things are exciting, we now get them in a fraction of a second over the

Internet every day ten times a day, so we don't really see them. Maybe it isn't about the individual expression anymore but about the collective.

AS: In some ways, the exciting thing that is going on could be what's happening in YouTube mash-ups and that kind of stuff. Maybe all these great things only last for a day.

CT: Or our attention span is shorter.

AS: All I know is that I've given up a little. My ambition is still the book. Whether or not that is old-fashioned, I don't really care. That's all I care about.

CT: I kind of once again agree. The book is never going to go out. It might become more of a high-end collector's item and done in lesser numbers. But I think when you talk about the moving image, something changes.

In one of your recent interviews, you talked about "dismantling your career." It is refreshing to see someone who's become successful and known for a particular kind of work throw that out the window in a certain respect. Was that driven by your own desire to experiment or the new tools that were available?

AS: I just don't want to get boxed in—that's all. I thought I set up my career nicely with *Sleeping by the Mississippi,* because it had portraits, landscapes, and still lifes, so I wasn't attached to one particular image or kind of image. At the same time, I got attached to a specific technology—the 8×10 camera—and there was still this expectation that really frustrated me. I reached a point where I knew how to make those pictures and I just wanted to break out. There is no real reason not to—other than the commercial concerns. I think those moves are bad commercially.

CT: They are the right artistic moves, but not the best commercial decisions. A real artist does them, nevertheless.

AS: I've tried to set up the situation where I can make those moves. I don't have a huge SoHo studio. So I don't have to keep doing that, and I just refuse to. So I just want to shake it up. If the goal is to make a great body of work, there is no formula. You have to keep changing and trying things out. Hopefully, you get lucky and you fall into it. This is the big problem in education. Students think there is a formula. You do this and that. First you get your undergrad degree, then you get your master's degree, then you get a show. It just never works that way.

After some experimenting, I'm coming back to photography. Trying to make interesting pictures and making them work together with fresh eyes after doing all these little experiments.

CT: It sounds like you are interested in the bigger narrative and how that can be enclosed within a book—in a sense, a movement from point A to point B. There is a connection there to filmmaker. Students don't always see that until they have the completed body of work. Making a linear, time-based sequence can help students see that in their work when they move back to the still image.

AS: For one of my recent books, *Broken Manual,* these two European filmmakers were following me around making this documentary. It was really interesting watching them and thinking about what they had to do. They were envious of me and my freedom. The beauty of photographic storytelling is that you have points A and F, and you do not need to put them in order. I was envious of them because they get to project this final thing they have created, and it immerses an audience for an hour or more. We both learned from each other. I absolutely think that for the education of a student experimenting with both the still and moving image is essential. Just as I think photographers should try doing editorial or assignment work so they are responding to an assignment as a magazine photographer would. Then very commercial work. Try all these different things and see what they are drawn to. I'm convinced that there are "assignment photographers." They are great at responding to other people's ideas and creating technical solutions. That is a valid thing to do. Not everyone can create from within.

CT: Is there any question you have for us?

AS: I think it is important to emphasize that early moment of excitement we all felt as young artists. Part of the reason I did a lot of experimenting was to get back to that excitement. I want to feel that total newness, and I'm trying to figure it out. Do you get that sense that your students are so excited? And what is that thing that's driving them?

CT: I think they are. They are in a place where they've been given permission and are encouraged to pursue that thing they love—which is exciting and new for many of them. It is a great privilege to live this life. You might not get rich, but you can live a life that you direct. Everyone is paying attention to you and your muse. You will not get that opportunity again in your life. You don't get that in an MBA program. Most of us are not rich, but we get to look at and explore the world. There are new constraints in terms of the cost of education that prior generations did not have that make a difference. But it is still academia, and academia has formulas, and the formulas are not good. Very rarely do you find someone who is a natural-born talent who has evolved without it. How do you get someone who breaks all the rules after you've taught them all the rules? Tell us we are full of shit? And not be afraid to fail.

28

ON
2014

Charlie White

White considers the origins and deeper implications of online image use, from the assimilation of popular culture to the crude and often offensive images that circulate in the dark corners of the web.

Through a close examination of the histories that led to the presence of images online, and an in-depth look at the locations and patterns of online image-exchange, this essay will suggest that an image-based vernacular is being established within the space of the Internet and that its various forms are radically new. Using the lens of linguistics, I will present and analyze two primary forms of image: the authorless (or self-less) image born from appropriation and aggregation and the authored (or self) image made directly by and of the user. It is important to note that I am neither a linguist nor a philologist; rather, I am an artist whose scholarship and practice are based in photography and whose observations and participation in the exchange of images online have led me to seek out a more articulate understanding of the patterns and behaviors to be found there.

It is equally important to note up front that, as has been the case with other vanguard movements in history, the image culture this essay is attempting to map operates without a moral or ethical compass, is often politically incorrect, and is at times deeply problematic in its interests and cultural incursions. This essay does not aim to excuse the behavior or attitudes occurring within the examples shown; instead, my intent is to offer a clear picture of an early phase of online visual culture in order to posit how these new forms of communication might transform linguistic processes and visual meaning in the future. Much like rudimentary life crawling up from the primordial ooze, an embryonic brilliance of visual language lies within the unformed emotions, obsessive behaviors, anger, humor, fandom, sexual fetish, hate, fear, and vulgarity of online culture. This essay attempts to locate and reveal such potential.

Before considering the online image as a new form unto itself as well as a linguistic plat-form capable of countercultural and progressive expression, it is useful to quickly review how the online image, and the networks it travels within, came into existence. The first benchmark occurred in 1957, at the National Institute of Standards and Technology, where researcher Russell Kirsch used a drum scanner connected to the Standards East-ern Automatic Computer (SEAC) to translate a traditional black-and-white print photo-graph of his three-month-old son into a 30,976-pixel digital image. Although Kirsch may not have been completely aware of the impact of his experiment, his translation of an image born from light and chemistry into a binary sequence of ones and zeros that could be infinitely reproduced and transmitted would shift the course of photography and its distribution forever. A little over a decade later, in the fall of 1969, the U.S. Department of Defense's Advanced Research Projects Agency Network (ARPANET) went live, string-ing a small number of computers across the United States together to form the first Internet. However, it would be another two decades before these seemingly disparate breakthroughs would work in concert. In 1989, researcher Tim Berners-Lee working on ARPANET at the European Council for Nuclear Research (CERN) proposed the concept for a "Hypertext project" called the "World Wide Web" capable of trafficking graphic, textual, and pictorial data using what would be called a "web browser."

Three years later the World Wide Web went live, implementing a standardized code called HyperText Markup Language, or HTML, which allowed images (identified by the tag) and other media to be posted, shared, and transferred across this new network using hypertext transfer protocol (HTTP) servers. Almost immediately, HTTP servers began to multiply around the world, supporting and inspiring the unrestricted transmission and exchange of textual, graphical, and pictorial data. As the 1990s pro-gressed, the convergence of the increasingly popular "WWW" and exceedingly more affordable digital cameras and scanners rapidly began to transform the notion of popu-lar photography from a film-based process to a file-format capable of being distributed across the Internet.[1] By the close of the decade, message boards, Internet forums, and e-mail traffic were providing critical hubs for the exchange, experimentation, and recir-culation of a new form of collective visual communication that was being authored by a vast and varied international community known simply as *users*.

As could have been expected, many of these earliest users were also programmers, and as code begat code, the very start of the twenty-first century saw the emergence of new websites introducing new possibilities for data exchange. These sites opened the door to new intersocial behaviors involving the display, exchange, and manipulation of media across the network. This expansion can be mapped through a succession of foun-dational sites that capitalized on new forms of distribution and revealed the challenges of free and open exchange within a market economy that had yet to frame the moral, ethical, and commercial impact of such liberties. For example, Napster, which launched

in the summer of 1999, pioneered peer-to-peer sites and foreshadowed the challenges of controlling copyrighted data in online exchange. That same year, the humor-based site Something Awful Forums launched, providing one of the first platforms for the formation and popularization of Internet memes. Then Craigslist, which went national in 2000, introduced the Internet's most popular and problematic personals site, rife with a new form of intimate exchange.[2] Evolving from peer-to-peer technologies, Bit-Torrent protocol, established in 2001, opened the Internet to the trafficking of large caches of content between users. As the user base broadened, community became more relevant, and Friendster, which launched in 2002, introduced the first modern online social network, hosting more than 3 million user profiles within its first three months.[3] The following year, MySpace, a social networking site inspired by Friendster, launched and quickly became the most trafficked social network. However, as an online social order emerged, antisocial societies also sprung up. That same year, 4chan, created by then-fifteen-year-old Christopher Poole (and born out of Japan's hugely popular 2chan), quickly evolved into the Internet's most trafficked and controversial anonymous image-board, hosting heterodox threads that functioned as vital platforms for the evolution of image exchange and anonymous activity.[4] Moving forward, this essay will take an in-depth look at imageboards, or chans.

Fundamental to the evolution of the online image was the imageboard, a bulletin board system (or BBS) that allowed images to be posted alongside text. The most important and influential of these was Poole's rogue outlier 4chan, which made the simple claim that it was the world's largest English language imageboard, with approximately 575 million page impressions to over 25 million unique visitors per month (around 12 million in the United States). As an anonymous and noncommercial site, 4chan quickly became an incubator for the creation and evolution of entirely new forms of image, hosting boards that catered to a variety of topics that thrive within Internet culture such as anime, cosplay, ecchi, games, and torrents. However, it was within the channel's "miscellaneous" sections that more complex images began to circulate and new operational trends gained footing. Most notorious of these miscellaneous threads is 4chan's random board, popularly known by its link /b/, and best described as a no-limits community where millions of illegal, offensive, and nefarious images traffic between anonymous users who pride themselves on maintaining a culture without moral or ethical parameters. As a result of 4chan's adamant support of anonymity and commitment to freedom of expression, its /b/ threads have become the ur-location of image exchange—dynamic platforms where archly heterodox images rapidly establish new operations of communication through continual recirculation.

One of the more important forms resulting from 4chan's culture of exchange was the establishment of the *image macro*.[5] The term *macro* refers to a single computer instruction that triggers a sequence of other operations. Similarly, the image macro stands in for a series of linguistic operations, merging produced or appropriated images of select meaning with Internet slang—a variety of sublanguages, expressions, and idioms that

date back as far as ARPANET and have evolved their meaning from traditional code-writers' abbreviations and shorthand to the general public's online lexicon.[6] The image macro represented an entirely new form: a category of image born from the Internet's message boards and forums, the legibility of which depends on its receivers' working knowledge of its culture and references.

THE AUTHORLESS

Analog photography—as practiced by nonprofessionals—had generated static visual objects that were collected and archived as a form of recorded memory for personal viewing by limited numbers of people. Meanwhile, analog commercial photography worked in tandem with this personal model, distributing highly refined and idealistic representations for a mass audience as a means of soliciting desire and motivating consumption. The image macro represented an entirely different dynamic, presenting a fluid, image-based vernacular that was individually distributed, yet absent of author and shared by thousands, or even millions, of individuals literate in its language. Unlike the personal image's role as memory or the commercial image's role as authority, the image macro operated as a simple visual cue amounting to little more than a gesture or a shrug. Thus, it is no surprise that the first macros were as random as the discourse that generated them, evolving directly from the Internet slang used on forums. The most recognized of these early image macros is known as *O RLY?* (fig. 28.1), the merging of the slang phrase for "oh, really" (first used on Something Awful Forums) and an image of a highly expressive snowy owl. First posted on 4chan in 2005, the *O RLY?* macro rapidly evolved into the first meme of its kind through heavy circulation and reapplication, establishing both the pattern and style for this new image form.[7] As a result, *O RLY?* became a sort of template for an entire class of images that began to traffic sites where Internet slang and image appropriation were facilitating culturally specific forms of communication.[8]

Similar to other forms evolving across the hypergenerative network of the web, the image macro quickly transformed into multiple subsets that varied in tone and content. However, these separate iterations still followed the same basic function of a macro, providing a condensed and culturally specific set of terms within a singular form. The majority of early image macros operated in a uniquely sardonic manner, reflecting the cultural tone of the platforms where they were formed, understood, and distributed. What was critically important about these early macros was that they offered a visual (pictorial/glyph) extension to a developing language form and established a dimension of complexity in the potential application of images within online culture.[9] As the form of image macros developed, their applications ranged from comedic advisories and subcultural in-jokes, such as *Advice Dog* and *lolcat,* to aggressive responses and consequential challenges, such as *DO IT FAGGOT* (fig. 28.1). Within one year of heavy circulation and ongoing evolution, image macros had saturated the Internet, establishing a new mode of communication whose linguistic form followed a basic set of design and logic.

FIGURE 28.1

Examples of image macros. *From left: O RLY?* image macro, 2005, modified and created from a copyrighted photograph taken by the nature photographer John White and originally posted to the newsgroup alt.binaries.pictures.animals in 2001. *Advice Dog* image macro, 2006; background is a primary color graphic (a "rainbow") with an imposed (via Photoshop) dog face cut out (via Photoshop) of an image originally used on 4chan as a ruse for newcomers ("noobs"), with a two-line text, a nefarious, ironic, or humorous advisory authored by the user. *I IS TEN NINJAS,* a lolcat image macro subset, originally formed on 4chan in 2005 on Saturdays, nicknamed "Caturdays" in 4chan's subculture. *DO IT FAGGOT* image macro, 2007; background is a variable face (photo or cartoon—in this case, an unattributed photograph of Christopher Poole, founder of 4chan) with an extreme smile, which originated on 4chan, where the culture's slang phrase challenging a claim or strongly urging an action by another user evolved into an image macro of variable content. Notably, the use of *faggot* is generic within 4chan culture, often applied indiscriminately.

Evolving out of the image macro was the formation of the more specifically dialogical reaction face, which first appeared around 2008 on 4chan.[10] The reaction face consists of a "borrowed" photographic facial expression culled from popular or Internet culture; it is removed from its original context and repurposed to convey a user's response or "reaction" to subject matter or image content within a thread. The first recognized reaction face was that of the very shocked Italian politician, Massimo D'Alema, who served as prime minister (1998–2000) and minister of foreign affairs (2006–2008) (fig. 28.2, top left). The fact that the identity of D'Alema, commonly referred to as "reaction guy," remains unknown to the majority of users who apply his image illustrates the degree to which images are removed from their original source and reassigned meaning within the exchange. Following the explosion of the D'Alema reaction face on 4chan, a wave of other reaction faces began to circulate, rapidly filtering into other forums, walls, and boards, where its form quickly became part of the common dialogic vernacular of state and response.

In its most basic form, the reaction image does what its name suggests: it represents, by proxy and in a single visual gestalt, the user's response to written or visual information within a conversation thread with other users. What makes the reaction image more complicated than an emoticon is that it is an endlessly varied means of expression that is both shared and applied freely within the culture of appropriated exchange. Further, the constant recirculation of these variations has made the reaction face a pervasive and intuitive substitute for written response and has established it as a common visual

FIGURE 28.2

Examples of the reaction image. *Top row, from left* (without text): "Do not want," conveying shock, disgust. Laughing at or with. "Too much" or surprise. Support or encouragement. *Bottom row, from left* (with text): *O Face* (the face during orgasm), conveying excitement or exuberance. *Sort of want*, meaning "maybe" or vague interest in what is being offered in a thread. *DERP*, meaning dumb, stupid, or idiotic. *The Fuck?* conveying shock, confusion, or disgust.

cue based on a highly malleable set of legible, shared reactions. Rarely created by the user, selected "reactions" are instead taken from the vast trove of images in media or the network in order to function as a widely agreed-upon expression within the culture of online exchange.

In use, the reaction face is an expressive gesture, mostly acting as an exclamation within the context of a larger exchange of ideas and therefore functioning much like a syntactic unit within discourse. As such, the reaction face has quickly evolved into two forms, either operating alone as a selected facial response within the exchange (like the original D'Alema face) or hosting superimposed Internet slang, similar in form to the image macro (fig. 28.2, bottom row). However, the text applied to the reaction face is most often limited to cultural idioms and performative utterances in order to both operate within the context of the thread and enhance the reaction face with which it is paired.[11]

Like the image macro, the reaction face is commonly appropriated from the multitude of images online, offering a shared (even if factually limited) awareness of the image's popular origin. In this way, both the image macro and the reaction face function as authorless, impersonal systems operating as a pure form of online visual language. However, because both forms were born out of exchange, they can truly function only *within* an exchange, where they have both formed and evolved their specific meanings

through collective understanding and constant circulation. Because of these limitations, both forms lack the plasticity necessary to function as languages unto themselves. However, each has established a set of abstract operations that could allow shared contents to function as shared meaning, interchangeable contents to function as varied expressions, and varied expressions to function as variations of meaning—and although these current forms rely on a visual hybridization of borrowed syntax and captured body language, each offers potential operations that could provide a tool for the further formation and expansion of an image-based discourse that is less limited in its forms or contents. In short, these forms constitute an aggregate vocabulary constructed from neologisms and appropriated visual cues—an evolving pidgin of utterances, code, idioms, and other accessible units of meaning capable of functioning as dynamic components within a new visual language.

Since the formation of the image macro in 2003, multiple variants of the authorless image have evolved on 4chan's platform. The majority of these follow patterns similar to the textual construction of meaning within Internet slang—patterns such as phrasal compression (unique acronyms) and textual hybridization (marrying of words).[12] The ways in which these patterns have translated written language into the still image has varied. For example, as demonstrated by David McRaney, the phrase "laugh out loud" was converted into the widely used acronym LOL; this acronym became so ubiquitous that it became spelled out phonetically as if it were a word unto itself, *Lawl*.[13] This derivation of the original three-word phrase was then—within the visual space of the imageboard—replaced with an image that related to the *sound* of its acronym: a portrait of a one-time character featured on *Star Trek: Next Generation* (c. 1990) named Lal (fig. 28.3). Although the image of the character Lal did not spread widely or replace the use of the acronym, its circulation foregrounds the translational course of phrase to acronym, acronym to neologism, and finally, neologism to image, further codifying online language and offering a new potential for visual communication.

Another example illustrates how this same course of translation allows for more covert activity, taking advantage of the limited legibility of the image. The illicit and thus highly problematic term *child porn,* commonly trafficked in the form of its acronym, CP, was initially translated onto imageboards in the form of seemingly arbitrary pictures adhering to these letters, ultimately settling on any image of cheese pizza (fig. 28.3). This process was not unlike the use of other marginally known images such as Lal, but where the *Lal* image aimed to reinforce a comparatively benign culture of insiderism, *Cheese Pizza* aimed to function like a shibboleth, testing the user's familiarity with its meaning while allowing the "anon" posting the image to operate outside of criminal terminology.[14] Further, *Cheese Pizza* and its corollary images occurred simultaneously, introducing both a code word and a codified image to index child pornography: a translational course that took the phrase to its acronym, and then translated that back into a new text *and* image form of equal value within the online context.

Far less nefarious are the language-to-image translations born from the Internet

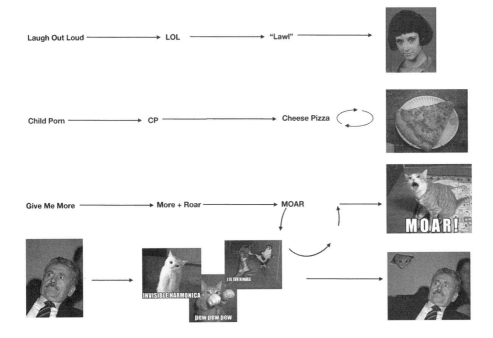

FIGURE 28.3

Translation examples. *Top to bottom:* "Laugh out loud" / LOL / *Lawl* / Lal image. "Child porn" / CP / Cheese Pizza image. "Give me more!" / *More + Roar* / MOAR! / image macro. Reaction face / lolcats / merged lolcats and reaction face.

slang of image macros—the images selected to activate neologisms. A good example can be found in the term *MOAR!* which began on 4chan and is a conversion of the imperative "Give me more" that merges the noun *more* with the verb *roar*. When visualized, *MOAR!* is imposed onto an image of a screaming (roaring) subject, most commonly a cat, which by way of lolcats, further embeds the term's translation into the vernacular of Internet culture, increasing its legibility and therefore its potential to function without textual imposition.[15]

Following the example of how the corollary image for *MOAR!* can also index the subgenre of lolcats to further its meaning, we can see how other fully established images can be modified to carry further subtexts. For instance, once the reaction face image of Massimo D'Alema became ubiquitous on imageboards, it began to be regularly modified to host an array of specific subjects, subcultures, macros, and other memes ranging from lolcats (fig. 28.3) to bronies to Pedobear. These variations on a fixed image (which already carries specific linguistic meaning) allow for the image to bend to cultural idioms and expand to broader topics.[16] This flexibility is important, as subcultures personalize images, shifting their meanings ever so slightly to operate within specific visual dialects. These shifts can be viewed as a process of transform-

ing an existing image circulating on 4chan, reorienting its contents to speak to cultures beyond its boards, and ultimately broadening the original macro's audiences and potential applications.

THE AUTHORED

On the other side of image exchange—where the terms are more explicitly defined, and the authorless image scarcely figures—a far more basic form of visual communication has been evolving: the photographic self-portrait, self-shot, or, as it has come to be known in popular terms, "selfie." It is important to note that the selfie, as both term and trend, is a very recent understanding of a form that has trafficked far longer than the image macro, and although seemingly ubiquitous, these newer solipsistic iterations of the form—dominantly dispersed through mobile technologies via social networks— have not yet greatly impacted the linguistic properties of authored images. Rather, it was the heterodox self-shot from which they were born, historically exchanged across personals sites and imageboards, that established the foundation and fueled the expansion of the authored-image lexicon.

An outgrowth of the analog process of suspending one's own image in time as both a record and a reminder, the online self-shot evolved into a tool of direct communication aimed at proving that the subject was both real and present at the moment of online exchange. The self-shot's aesthetic—initially circumstantial rather then circumscribed—was foreshadowed in the confessional photography of artists such as Nan Goldin, whose unflinching candor and reliance on available light implicated the viewer within the subject's immediate conditions (fig. 28.4, bottom left). Through what were arguably unconscious applications of the basic strategies of veracity established in Goldin's self-portraits, early forms of the online self-shot necessarily revealed both the camera and the mirror used to record the image. However, where Goldin's subject was profoundly alone, looking back at herself in the mirror, the self-shot presented its author within the context of an exchange—alone, yet looking outwards. The inherent form of the self-shot is to function in a socially active, dialogical manner.

In its earliest iteration, the online self-shot resided mostly on personals sites, where it operated as a means of stating "this is me," very much like its analog counterpart in the back pages of regional papers (fig. 28.5). Often digitized scans made from photographs (such as previously shot and lab-processed snapshots) taken outside of the site of exchange, these early online portraits functioned as a bridge between the analog and the digital. In this period, the author's technological limitations, both mechanical and personal, controlled the form and contents of communication. For example, the degree to which an image might be explicit, or specific to the dialogic nature of the exchange, was mediated by the author's inability to capture and upload his or her own image. However, as digital capture progressed—making digital cameras more commonplace—private image production and distribution became available, and the self-shot rapidly evolved

FIGURE 28.4

Examples of predigital printed personals ads. *Top row, from left:* Scratched-out studio portrait, origin unknown. Inked-out snapshot, origin unknown. Photograph produced for personals use, origin unknown. Examples of analog to digital self-shots. *Bottom row, from left:* Nan Goldin, *All by Myself* (detail), 1993–1996. © Nan Goldin; courtesy Matthew Marks Gallery, New York. Scanned self-shot from Craigslist personals posting under t4m in Casual Encounters section. Mirror self-shot from Craigslist personals posting under t4m in Casual Encounters section.

from the status of "this is me" to "this is me, right here, right now." At that point, image forms began to change radically.

Much like their analog and analog-to-digital predecessors, early digital self-shots rarely included the author's face, but unlike their predecessors' cropped or covered faces—which produced an altered, illicit effect in the gap between the original photograph and the actions taken to make it anonymous—the new, "homemade" self-shot introduced heightened explicitness without any sense of moral conflict. Often captured in a mirror's reflection (fig. 28.4, bottom right), these new images began to convey highly codified bodily expressions, creating a new aesthetic of anonymity that, as I will argue, increased rather than decreased the potential of such images to operate like language in both structure and content. In a short time, confidently presented figures inhabiting intimate spaces began to populate personals exchanges, resulting in a wave of expressive bodies in bedrooms and bathrooms posing for the receiver. These images conveyed signs of specific sexual desire or desirability, along with varying domestic circumstances, class conditions, and cultural orientations, depending on the quantity of visual information provided.

This new self, formed and framed for the Internet, exchanged on chat- and image-boards, and gradually evolving and thriving across its social networks, often continued to exist alone, either in a mirror's reflection or from the distance of the subject's own extended arm. These conditions are particularly important when comparing the linguistic properties of the authorless image to those of the authored image. For example, where the authorless image's appropriated forms operate within a "we" of shared idioms that are reused and modified from their "root" meaning, the authored image's private forms establish an "I": a first-person subject that is used only once and posted directly by its creator. This process involves the imposing of a codified pose—a private body language for the public eye—onto individualized circumstances of location and condition, resulting in the self-shot's entire picture plane forming its meaning, intentionally or not. Whereas the flatness of the image macro allowed for immediate legibility within a lexicon of shared meanings, the self-shot, due to its total complexity of subject, pose, and physical environment, requires a more nuanced, empirical assessment, or close read, in order to be legible.

However, because online truth and truthfulness are deeply complicated by proxy dynamics, issues of legibility and legitimacy comingle when interpreting the self-shot. Within more dynamic exchanges, therefore, the self-shot evolved an additional component: a written document, known as a "timestamp," that lists the time and place at which the image was recorded. One of the earliest formal elaborations—which remains in use—of such verification evolved within 4chan's Random board when a user posted the acronym TOGTFO (Tits or Get the Fuck Out) to demand that a user claiming to be female either post a self-shot of her breasts with a timestamp or leave the board (fig. 28.5, right).[17] Here, as with other requests for proof of the self-shot's authenticity, the timestamp functions as a further reinforcement of its subject's existence and is intended to counter the possibility of a requested image being false or fraudulent. Due to the ease with which any representation can be falsified within the context of image exchange, the self-shot became a near-requirement within dialogical activity on boards and forums, providing proof that subjects were both real and present. Such an expectation, in turn, reveals that at the core of the self-shot lies the notion of truth: the verified identity of the subject and of the subject's location in time and space.

As the self-shot continued to evolve, it became commonplace across all exchanges, fluidly varying in form depending on the regional vernacular of the different personals, boards, forums, timelines, and mobile apps it trafficked. As a result, the self-shot began to develop subsets perhaps best understood through systemic-functional linguistics,[18] which derives grammatical, syntactic, and textual structures from the ways in which language is used. Viewed through this lens, the evolving forms of the self-shot, based on their various locations and social functions, constitute a social semiotics—a resource people use to accomplish their purposes by expressing meanings in context.[19] For example, contextual variances could be understood in how the homoerotic gaze is authored (or self-imposed) in solicitation images (fig. 28.6, two left images), while the

FIGURE 28.5

Examples of the self-shot with timestamp. *From left:* A user being TOGTFO-compliant within /b/. Former New York representative Anthony Weiner's self-incriminating self-shot with a timestamp reading simply "me" accompanied by an upward arrow. The original post (OP) from a /b/ thread presenting a potentially barbarous scenario with a timestamp to prompt feedback; this example, which illustrates a common, but often ignored, tactic for a large number of responses, will often set a target number—for example, "49 tells me what to do next."

FIGURE 28.6

Examples of contextual variances. *Two left images:* Self-shots used for online solicitation. *Two right images:* Self-shots of Justin Bieber posted on his Instagram site.

heteroerotic gaze is projected (or externally imposed) for a nearly identical image form when its subject is teen pop star Justin Bieber (fig. 28.6, two right images).

When mobile applications tethered cameras to new communication platforms, the self-shot, which had come from private zones of intimate and anonymous discourse, went through the final threshold of popularization and destigmatization, taking the authored image from its heterodox beginnings into a fully normalized lexicon of public speech that ranged from highly complex modes of discourse, such as timestamps operating without a visible subject (fig. 28.5, right), to the most simplistic and solipsistic modes of self-presentation, such as the arm's-length images of celebrities capturing themselves among other celebrities while being broadcast for their collective celebrity. The constant throughout is the authored "I" and its first-person subject, which establishes a deictic center within the exchange and can appear—depending on the trustworthiness of its author—in the form of an anonymous self-shot, an identified self-shot, or a stand-alone timestamp.[20]

To understand the , we must first identify which of its foundational properties precede its digital status; then we must recognize its digital incarnation as a reflection of its authors' history, knowledge, and location; and, lastly, we must account for the multitude of users relying on and reacting to its form as a means of testing its functionality. Within this essay, the two forms considered—what I have called authored and authorless images—are heavily indebted to the radically experimental platforms of 4chan's /b/ and other sovereign sites across the Internet.[21] These locations of exchange bridged the programmer's sphere of activity (which started well before WWW) and the commercial or novice user's, bringing a subculture that had been formed through shared knowledge of code and codified processes into dialogue with the broader social vernacular. As one paradigm of communication collided with another, the perceived plasticity of code writing migrated to the realm of image sharing and interpretation: if everything online resided within and through code, and all code established rules, then all rules entering into code could be reassessed for their new potential value. Emerging from this cultural collision was a sort of *Lord of the* [online] *Flies* environment that was both fiercely intelligent and extremely immature, operating in an unmonitored and unmediated space where all new content could be reconsidered and all old concepts could be reenvisioned.

Neither artists nor linguists took part in the formation of this new visual language. Instead, the vanguard of online image use was shaped and inhabited by programmers, adolescent boys, and lonely adults forming images through endless play and tireless consumption. Their desires differed from those of others who have historically aimed to frame, capture, and experiment with the subjects of the world, because they were *not* part of that same world; they were within a world of the screen, forming a new discourse out of reckless curiosity, an insatiable need to connect, and profound loneliness. From its solitary space of origin to its eventual global legibility, the became a means of communication that far exceeded its analog predecessors, accruing validity through mass recirculation and reiteration while acquiring various forms of legibility in relation to its authors' application and reinterpretation of its form. Seen in this light, the was never really meant to be "looked at" in the traditional sense; instead, it was and is an operation to be interpreted, to be read, and to be put into active circulation.

Photography only has meaning if it exhausts all possible images.

Italo Calvino, *The Adventures of a Photographer*, 1958

29

SHARING MAKES THE PICTURE
2012

Barry Salzman

The importance of social media and its foundational ability to share
are highlighted by contemporary lens-based artist Salzman.

Photography has always influenced and shaped who we are, what we do, the communities we are part of, and the world we live in. Today that influence is more profound and pronounced than ever before because almost everybody on the planet is fast becoming both a creator and consumer of imagery in a borderless, global, and often immediate way. That has paved the way for the dawn of the newly coined "imagesphere," characterized by both the volume of digital pictures taken and a shift from purely taking images to sharing them and interacting with them. It is the next wave in the development of the content we create and share online following on from the blogosphere and the tweetosphere.

Digital cameras and camera-enabled mobile phones are becoming ubiquitous, and the global adoption of social media networks (SMNs) in recent years has created distribution platforms for literally hundreds of billions of photographs to flow from virtually anybody to almost everybody on the planet. We are living in a visually abundant world, where the image may be surpassing the word as the principle unit of communication in many conversations. The act of sharing images online is validating who we are, where we have been, and, indeed, our very existence in an increasingly socially networked world. The vast majority of pictures today are made with the express intention of sharing them across social networks of friends, colleagues, associates, and complete strangers. And the more images we share, the more information we share about who we are. The proliferation of shared images online has created a paradigm where more is in fact

more. As we share more and more, we shift the visual narrative from *what* we are to *who* we are.

Historically photography was primarily a means of documenting our life's experiences. Ironically, the reverse is often true today. We create experiences and engage in activities so we can document them. And we do so because we have immediate audiences to share that content with. That behavior is fueled by some of the most basic motivations and incentives that drive us as social beings.

FROM A LANGUAGE OF WORDS TO ONE OF PICTURES

In March 2013 Facebook CEO Mark Zuckerberg announced the first major redesign of Facebook since 2006, with an emphasis on giving pictures prominence.[1] That announcement was in recognition of the new pictures-first reality that we now live in and an acknowledgment by Facebook that the photographs users upload to its site are one of its most underexploited assets. Today half of all Facebook News Feeds are pictures, up from 25 percent a year ago.

In 2011 it was reported that 10 percent of all photos ever taken were taken in the prior twelve months,[2] a possible tipping point to anchor the birth of the imagesphere. Today 350 million photographs are uploaded to Facebook daily (more than a tenfold increase from the 31 million uploaded per day in 2009), for a total number of pictures on Facebook of over 220 billion.[3] And the growth continues to accelerate. Since Facebook has 1 billion users, it is fair to conclude that the data point to an undeniable societal shift to an increasingly visual language. Facebook, however, is not alone in this realization. To the extent that we can learn by following the money and the trends broadly embraced by the business community, it is worth heeding the report in *Adweek* that the "Internet titans are placing big bets on the 3 trillion (and growing) online images."[4] To put that into context, it equates to over 400 images per person on the planet.

Pinterest has quickly emerged as the third largest social network because of its unique focus on photo curation—collecting, assembling, and remixing the photographs taken by others. Twitter launched photo sharing in early 2012 and in early 2013 rolled out photo filters to compete with Instagram. Add to that the launch of Flickr's photo sharing app in February 2013, and together these strategic moves give us a good sense of big business's confidence in the opportunities that our increasingly visual means of communication are creating. Another, Vine, was launched by Twitter in January 2013. It is a mobile video-sharing app that allows its users to capture and share short, six-second looping videos. Snapchat is another image-based app, now in its second year and already has over 60 million snaps daily.[5] It allows users to take photos, record videos, add text and drawings, and send them to a controlled list of recipients and specify how long the recipient can view the content for, up to a maximum of ten seconds, before it is auto-deleted. There is likely to be an accelerating stream of new imaging apps that continue to come online fueled by investor capital, consumer adoption, the scale and

reach of the imagesphere, and the market penetration of camera- and video-enabled smartphones.

The two well-documented trends that enabled the recent wave of picture proliferation and birth of the imagesphere were the development of digital cameras (including camera-enabled phones) and the growth of SMNs that enabled the distribution of digital pictures. Together they have transformed the conventions of taking photographs and expanded the social uses of photography.[6] In addition to the seismic shifts in technology, or perhaps because of them, we have also seen parallel shifts in cultural rituals. In the analog days, the primary use of personal photographs was to mark and commemorate important events and life's milestones. They served as an aide-mémoire when engaging in the cultural ritual of reminiscing while browsing through family albums. Today, photography has fused with our everyday life, magnifying its intensity, from the most banal details to the extremes of nondirected self-disclosure. The personal photograph or video has become the social currency that buys us access and relevance in this new social machine, becoming part of an ongoing conversation with meaning attached to its "immediate experiential value."[7]

The public domain that is the Internet means that despite the short life of much newly posted content (the half life of a new photograph online is three days), many images also have a transient quality, with the creator (hopefully) recognizing that images can be downloaded, appropriated, manipulated, reused, repurposed, and retransmitted, shifting control from creator to user. Sites like Tumblr have image reblogging capabilities built in at the push of a button. This is fueling the creative process by making more inputs accessible to more people and giving creators access to an almost infinite amount of imagery as source material, whoever or wherever they may be. In many ways it is reconstituting the way we think about photography as both document and as art. It is feeding the collective creative process and raising group awareness and consciousness on a far-reaching range of social and political topics. There are detractors, although decreasing in voice and number as it becomes evident that this phenomenon is not reversible but has become an integral part of who we are and how we engage. They raise concerns about copyright infringement and warn against the risk of our digital finger print following us to the point of personal detriment. While valid, the solution to these challenges lies in education, not in attempting to force the genie back into the bottle or to regulate or curtail online behaviors.

As we move toward a unifying visual language, or more fully integrate it into the new definition of "language," we are transitioning from a phase where our physical experiences informed our usage of photography and digital behaviors to one where the reverse is taking hold. Increasingly we are creating experiences and undertaking activities with the express purpose of photographing them to share online. We are photographing subjects that we would never have photographed before, purely because we have a platform to share those images across our social graphs. In increasingly frequent ways the "dialogues and social experiences on the Internet can condition photographers'

expectations for their output, for their relationships with the objects to be photographed, and thus for their experiences with the physical places in which they circulate."[8] Today our online behavior and engagement often drives our offline behavior. The fact that we can share and post and that we have an immediate audience whose attention we desire has fundamentally changed taking, framing, showing, compiling, and looking at photographs. We are learning to look and see differently, driven by motivations and needs fulfilled in our digital lives that, until recently, fell beyond the frames of reference in our physical worlds.

MOTIVATIONS AND MEANINGS
OF PICTURE POSTING AND SHARING

Photography is, and has always been, primarily a social medium driven largely by the need to share one's experiences with others. That sharing was, until recently, manifested by family and friends gathering to view photos of trips and special occasions. As early as 1965, Pierre Bourdieu wrote in *Photography: A Middle-Brow Art,* "Photography owes its immense diffusion to its social function . . . more than any other cultural practices, the practice of photography appears to respond to a natural need." The power of photography's "social function" has, of course, been radically accelerated in recent years with the mass global adoption of online SMNs.

Nancy Van House and her colleagues, in addition to others, have done extensive research into the reasons we take and share digital photographs. In all instances, the typologies of personal photography motivations are relatively well aligned.[9] They include constructing personal and group memory, creating and maintaining social relationships, self-expression (giving voice to one's own view of the world), and self-representation (influencing others' view of the world), in addition to a range of functional motives (as an alternative to taking notes or writing to communicate information or ideas). Even a few short years ago, it was impossible to predict today's levels of adoption and ubiquitous use of SMNs. In fact, today it is reasonable to posit that image sharing is *the* primary motivation for personal photography. As the *New York Times* art critic Karen Rosenberg wrote, "The act of snapping a picture is no longer enough to confirm reality and enhance experience; only sharing can give us that validation."[10]

There are, however, fundamental differences between sharing photos online and sharing them in a physical setting. First, online sharing is asynchronous in that the sharer and viewer are typically not in the same space and usually are not viewing the images at the same time; second, online sharing enables participatory interaction such as liking, tagging, or commenting on others' photos; and third, online photos may be seen by a much larger audience than that intended by the photographer.[11] These differences fuel the motivations we have seen for the tidal wave of images being created or digitized and then posted online, documenting every facet of our lives and redefining established boundaries between our public and private selves. It is clear that the behav-

ioral motivations must lie beyond the mere "because we can" as enabled by technological innovation. In fact, the reasoning resides deep in the human psyche, as nourishment for some of the core needs and motivations that define our essence as social animals—identity, affiliation, aspiration, sensation, and participation. Chris Schreiber synthesizes his research findings into three categories of factors that drive online sharing.[12] Not surprisingly, they closely parallel the factors that drive our everyday behavior too. They are:

1. *Functional stimuli:* Relate to the individual's ability to complete the task and the simplicity of the task.

2. *Rational stimuli:* Involve self-interest and other achievement motives, both professional and educational, including financial incentives and rewards, and accumulation of status and power.

3. *Emotional stimuli:* Include arousal, altruism, self-identification, empathy, connectedness, and passion, or evangelism.

Many observers have commented on the sheer quantity of deeply personal pictures posted online or pictures containing problematic or incriminating content revealing facets of life or insights into people's personal lives that we did not have a window into prior to the widespread adoption of SMNs.[13] The definitions of what constitutes provocative or personal imagery in the new normal are influenced by a set of subjective and cultural values held by both the sharer and the viewer. danah boyd and Nicole Ellison define it as content or imagery that discloses personal information that can cause damage to one's reputation or the risk of physical or emotional harm.[14] That definition too is somewhat nebulous. However, whatever one's personal definition of provocative content is, there is a plethora of content online that falls at the extremes of provocation, and so the question of what motivates people to post such content remains valid, irrespective of one's subjective values. Rebecca Gulotta, Haakon Faste, and Jennifer Mankoff emphasize that the value of sharing such information lies in its criticality to the understanding of how we manage personal aspects of our identity.[15] They reiterate a key reason for photo sharing from the work of Van House and her colleagues: people share photos to define and record their identity, maintain relationships, curate and cultivate their self-representation, and express themselves by sharing their work.[16] Digital photo sharing is particularly important to self-expression (in contrast to types of analog photo sharing) because of the freedom and opportunities for connectedness enabled by SMNs.

It is no coincidence that a dominant genre of imagery posted or streamed on the web is self-portraiture, giving rise to the colloquial term *selfie.* Not long ago the self-portrait was the domain primarily of art photographers. This reflects a major social change in embodiment processes and the shaping of self-perception. Guy Stricherz, author of *Americans in Kodachrome, 1945–65,* states in a *New York Times* article that he reviewed one hundred thousand pictures from five hundred families over seventeen years in compiling his book and found fewer than one hundred self-portraits (approximately one-tenth of a percent).[17] Today, even a brief scan of a few Facebook pages will

yield by orders of magnitude more self-portraits, relative to the total universe of images posted online. Although technology may explain some of that increase, there is clearly something else at play. In the 1960s, such behavior would have been thought of as too self-aggrandizing, but today it is considered an integral part of identity development, offering the promise of impact, relevance, connectedness, and meaning. If you are not seen, you are not there. This representation of the self, often sexual in nature, has blurred the already fuzzy line between public and private. These self-portraits (still or moving) are often made in the "privacy" of the bedroom or bathroom but then posted or live-streamed onto one or more of thousands of public access websites, the equivalent of a global Main Street. The once-private home domain has now become a stage for webcam performances.

Some thinly veiled false perception of privacy may remain when we engage in mediated intimate exchanges from behind our computer screens, perhaps because of available tools to control audiences. It may be naiveté that enables the self-rationale for broadcasting our most intimate and vulnerable moments into the most public of domains; however, the more likely explanation is that the motivations and rewards that drive the new behavioral paradigm of online sharing trump all prior concerns about privacy and perceived risk.

FROM DEMOGRAPHICS TO PSYCHOGRAPHICS: THE NEW PICTURE PROLIFERATION CHANGES EVERYTHING

The adage "a picture is worth a thousand words" has been in our vernacular since the early twentieth century.[18] As a society we largely subscribed to it in disciplines ranging from journalism to advertising, in the arts and entertainment, and in our personal lives as we capture moments for the family album. So if a single picture is worth a thousand words, the 3 trillion photographs online are priceless in terms of the collective data they impart about the world and its inhabitants, about who we are and what we do, the places where most of us live, and the places on the planet that are largely uninhabited. David Crandall shows how the images we share are generating vast repositories of online data about the state of the world and the behavior of its people. In his research he used geo-tagged Flickr photographs to identify the most-photographed places on Earth and to infer the names and visual representations of those places. He also was able to build 3-D models of highly localized scenes by combining the information from thousands of 2-D photographs taken by different people from different vantage points, creating an accurate rendering of something the viewer may never have seen.[19]

The examples of how online imagery has contributed to the transformation of politics and wars, toppled dictators, and started revolutions have been well documented. In recent years we have witnessed major events with global ramifications that were substantially influenced by imagery shared across social media, including the tortures at Abu Ghraib (2004), the Arab Spring (2011), and the attacks on the U.S. mission in Benghazi

(2012). In countless smaller ways, seemingly much more trivial but touching the lives of individuals in personal and profound ways are Facebook examples like "A Million Likes for a Kidney for Matthew," where a seven-year-old is trying to get a kidney transplant so he can live, or "Two Girls and a Puppy," where the girls' parents agreed to let them adopt a puppy if they got one million "likes," and they did. Indeed it does change everything, from what we eat to what we wear, from where we go and who we go with, to our thoughts and feelings, and the issues we advocate for and those that we oppose. It enables dreams and aspirations for things that may never have seemed possible before.

Historically photographs existed in the sphere of the demographic. They told us *what* we are, as defined by quantifiable statistics like gender, age, ethnicity, occupation, and location. They have now transitioned to the domain of the psychographic. Collectively they tell us more about *who* we are, shedding light on the personalities, values, attributes, interests, and lifestyles of those that share them and those that engage with them through liking, tagging, commenting, and reposting. This transformation and the accompanying abundance of valuable data to mine is directly attributable to the hundreds of billions of images that people share online every year—images that depict every facet of life and corner of the planet. These collective data are giving us access to a more verifiable psychological understanding of behavior types and patterns than ever before.

The relationship between content sharing and risk is at the root of the ongoing debate about what is acceptable to share online. The news media increasingly cover stories about the repercussions people face when sharing sensitive information online, but these are clearly an infinitesimally small number relative to the volume and ubiquity of sensitive picture sharing online. Angela Paradise suggests from her research into college students' experiences on Facebook, that they are fully aware of the risks and yet continue to post depictions of alcohol use, drug use, and sexual promiscuity without experiencing any serious negative consequences.[20] Rebecca Gulotta and her colleagues in their research observe conflicting motivations for posting provocative pictures online: the desire to explore and expand one's personal sense of identity or that of one's group versus the desire to protect one's identity (or that of others) from possible harm.[21] In many ways, however, the debate about the pros and cons or risks and rewards is a moot one. Whether we are in favor or against, this behavior has become our new normal. It is here to stay and is already embedded into our cultural and normative behaviors. The more relevant issues therefore relate to what to do with this imagery, how to use it, and how to manage it, both as sharer and viewer.

CONCLUSION

The motivation for sharing imagery online that documents every facet of our lives parallels our most basic needs as social beings, but importantly the virtual world has also evolved as our personal laboratory. It is there that we are creating, shaping, and redefining our identities and transforming our most intimate spaces and actions into public

spectacle. We are creating new personas, trying them on to see what fits, becoming the people we always wanted to be, or those that we think others want us to be. We are exposing ourselves on a global stage and forging new mediated intimate relationships, both realized and fantasized. In the process, we are redefining our sense of public and private spaces and challenging our own definitions and perceptions of reality and fiction, and of fact and fantasy.

The sharing of images across SMNs has become a significant driver of the growth in digital photography. SMNs are providing not only the distribution platform but also a communication context around photo sharing with embedded tools for liking, commenting, and reposting images. By so doing, they have become the new creative interlocutors and in the process have transformed personal photography into an independent medium for personal communication. Increasingly we go about our activities in the physical world in order to create the content that enables us to be better recognized and validated in the virtual world. This begs the question about what constitutes true "reality." It is no longer that which purely exists in the physical world but in large part also comprises the lives we have created for ourselves in the digital world, which are often more complex, fantastical, and revealing than our physical lives. We are now at a crossroads that necessitates a redefinition of *reality*. Our new reality comprises our physical experiences as well as our digital experiences. They inform one another, are iterative and deeply interconnected. Together they define the new real.

At its root *photography* means "writing and drawing with light. . . . It is about an attempt to communicate,"[22] yet photography education is dominated and constrained by instruction in tools and mechanics instead of fostering "as much freedom as the spirit is capable of."[23] While photography education focuses on its rich heritage and the masters that preceded us, it is critical to remember that they are our *predecessors*. It is not enough to do what they did (albeit with different tools). At this juncture the possibilities and challenges are much greater than at any other point since photography's beginning. There is, arguably, little more to contribute to the photographic discourse or to the world by going out and taking more photographs. As a short exercise, I attempted to re-curate Robert Frank's *The Americans,* using only photographs I found on Flickr taken over the last decade. Many of the images I included directly referenced those in *The Americans*; however, with more thorough scrutiny of pictures posted on SMNs, I am certain I could have found many more direct references to *The Americans* (or any other subject of interest) that would have been indistinguishable from those taken by Frank to all but the most well-trained eye. That short exercise was disconcerting in a way. It highlighted a new and still uncomfortable truth for today's photographers. The picture you are after has almost certainly already been taken and is there to be appropriated, curated, reworked, reignited, and redistributed. What we do with the more than 3 trillion photographs online (and growing rapidly everyday) will likely do more to determine the future of our medium than any individual body of newly shot pictures.[24]

Visual literacy, while increasingly critical to life in our complex information age,

continues to be underdeveloped in almost everybody, relative to our linguistic literacy because of our cultural and educational emphasis on writing. Given the abundance of imagery being created and shared and the information it contains, it is perhaps fitting to close with a warning from Oliver Grau and Thomas Veigl that we "cannot progress without new technologies of image collection management, new forms of distribution within a global community, and new forms of analysis."[25] In fact, while visual literacy is still in its infancy, it is already time to move beyond that into the domain of virtual literacy, a skill that needs to become as elemental in our education system as instruction in the three Rs of reading, writing, and arithmetic.

. . . we have extended our central nervous system itself in a global embrace, abolishing both space and time. . . .

Marshall McLuhan, *Understanding Media*, 1964

30

POSITS AND QUESTIONS
2014

Fred Ritchin and Brian Palmer

Excerpted from a series of seminar discussions at the School of Visual Arts are a few salient pronouncements and questions from a pioneer critic of the digital image and a working independent journalist.

FRED RITCHIN: I think we need to acknowledge that all media are environments. We think of them as tools, like you have a camera, and it is a tool, but photography becomes an environment that surrounds you.

. . .

BRIAN PALMER: My background is as a traditional photographer and photojournalist. Moving into this new environment has been incredibly difficult. . . . While technology allows us to reach out infinitely, most people were using technology to reach into their own circles. . . . We're fragmented. We're getting our information from sources we have an affinity for, and we've become islands. The technology might in theory allow us to reach beyond those islands, but most tend to stay isolated.

. . .

FR: You're all publishers. You now have blogs and other platforms, but where do you want to go with it? Ask yourself where you want it to be in five years, or ten years, or fifteen years. I used to think that education was teaching process—as in soccer, where you kick to where you think the runner should be running, not to where he or she is now—but I realize you have to reinvent the game. That's exciting and dangerous and frightening and wonderful. It's also an opening of possibilities.

BP: The platform matters, but the person matters more than the platform. In terms of the issue of community, those intentional communities are really wonderful things, but I go back to the issue of self-interest. The media has changed. It's fragmented. I was a little child during the Vietnam War, but it is my understanding that many people were motivated by the draft. Many people were motivated to act because their asses—or theirs kids'—might get sent to Vietnam. That to me is a powerful incentive to become involved in civic discourse.

FR: We desperately need filters. We need people to tell us what to look at—someone who comes from a region, someone who knows a region to tell us that these are the important images and stories that we should be looking at. It's not just about more access; it's also about less in many, many respects to get to a place where we know more.

I think that the great paradox of a consumer society is that they tell you all the time that they're offering you all these choices, but they're not asking you what you want. We don't ask ourselves what we want and how we're going to get it. Where do we want to get? And how do we want to get there? I don't want to be force-fed something else. But we don't take the power.

BP: Beneath all the media literacy concerns, there is an assumption that people want to be literate. A small percentage of people actually do, but for most people images are fantasy or they are not the truth anymore, because we're not in the 1930s.

Fixating on the systems doesn't work. I tend to want to drag things back to the ground level because that's where I am, and that's where I work. It's great to talk theory because theory informs practice, but I'd rather start with the practice and let it grow out to the theory.

FR: I'm in favor of freedom of information and multiple sources, but what I miss most is more thoughtful communication and a community of people interested in discussing current issues and events. I want someone to talk to about a common front page, whatever that front page might be. We are all very esoteric now.

The freedom to follow one's own interests is fantastic, but the difficulty is in establishing a common framework within which to make decisions as a community. A *makh-san*, which is a warehouse in Arabic and Hebrew, became a *magasin* in French, which is a store, which then became a *magazine*. So a magazine is a curated version of a warehouse, but now, with the Internet, we are all back in the

clutter of a warehouse. In this new media environment we refuse to let others choose for us, but in fact they are doing it all the time.

. . .

BP: Students should ask themselves how they want to be part of the discourses that are going on out there. Do you perceive yourself as part of a discourse? Do you have enough money that you don't need to be part of a discourse? You have to make an informed choice. That for me would be what a great curriculum would be about.

I think it also has to do with an issue of integrity, which is at the core of what I want my practice to have. To make yourself receptive and vulnerable to people, to get close to people, ask questions, and risk them saying, "Get the hell out of my face" or "Where do you come from?" or "Let's talk." That's the core of what I'm talking about, and how to use social media to do that, as well as how to determine if social media is doing that.

31

CAPTURE/CURATE </> TOUCH/PLAY
Reality Is the New Fiction
2014

Claudine Boeglin and Paul Pangaro

Pangaro, a cyberneticist, and Boeglin, a journalist, consider the ethical obligations and issues surrounding multiplatform and multiuser journalism in the twenty-first century.

PRE-ROLL

Newsreel Short Subject: *Media on the March;* Claudine Boeglin narrates:

2000+

Some tattoo their bodies, printing more than 70 percent of their skin surface as a radical statement of freedom and belief in individuality.[1] Others spray their trademark on urban large-scale narratives, redefining public space as open-source art, assaulting real estate when galleries became too exclusive.

2005+

Social media blossom: music frees up on MySpace, pictures cascade on Flickr, cat videos invade YouTube, animations overtake Vimeo, Facebook hijacks the word *friends,* reaching 500+, while Twitter adjusts its corset into 140 characters and a credo: "Constraints inspire creativity." "Share" will soon become dogma.

The page is never virgin nor is it always checked, but we're all onstage, connected, interacting, tweeting, hacking, opinionating—constantly polishing our digital identity. In the beehive's cacophony, silence is the ultimate bad review.

"Social magazines" polish their design on tablets and Flipboard. iPhone apps rush into the candy store. WikiLeaks ruins diplomatic relations. Government secrecy is no longer taboo. The Spring becomes Arab. "Occupy" gives its first assignment to citizen journalists. From its high castle of hype, Hipstamatic dims up the world's reality into "awesome" pictures with vintage patina. Beards grow longer.

Bipolar world or just puzzled? *Selfie* (self-portrait photography) is the sacred international word of the year in Oxford Dictionaries. Pope Francis tweets, "Let us leave a spare place at our table: a place for those who lack the basics, who are alone." Syrians are alone—with a shattered identity soon replacing the Afghans as the world's largest refugee population.

Hypnotized by Vpeeker's perpetual loop, by Buzzfeed's WTF, we don't hear. Preoccupied by our self-obsessed digital replicas, we fear the faux pas. Any gossip can bounce on the sociosphere at the speed of light and ruin a decade-built digital reputation. Little space is left on our screens for "the others," rather than another picture of ourselves, taken close-up from our most coveted comfort zones. We're emotionally blank. In denial.

2014+ A TURNING POINT?

Facebook just turned ten with the worst video diary ever produced. Its founder changes his title, "philanthropist," to few comments. The kids have left anyway, streamlining their friends and narratives on Instagram. Words have been pushed back. Lens + screen intertwine. After the cacophony, English will soon become the new Latin.

Visual storytelling is preparing an era of ultra-curation and white space. An era of digital "erotism": poetic, authored, investigative. The desire to meet others will get people off the suffocating digital "campuses." Now marketers call Facebook a "data platform." In ten years, the mega-friend market has built a wealth of in-depth knowledge of human behaviors ready to be shelved into consumption profiling.

Isn't it time to escape now and turn the lens the other way? To look up, step out, capture a reality with imagination? Draft its change? Reality is our new fiction narrative.

INTRO

PAUL: What do you think we should mean by "lens and screen"?

CLAUDINE: One is the tool; the other the display. Record < / > Publish. The fundamental difference? Now we share lenses and screens with everybody. A great playground and inspiration rather than a threat.

Lenses and screens have a reciprocity in their borders: through the lens, through the photographic composition, we define and frame a virtual territory—

we make a decision, we edit reality. It's our own perception of a moment in the past. The screen itself is fenced; a defined and limited surface. And it requires a set of decisions. Who is the recipient? Screens had different audiences in different times:

> Cinema locks strangers in a dark room.
>
> Television gathers relatives on a couch.
>
> Computer screens lead to prone onanism.

Now if we are focusing on lenses (capturing) and screens (showing) and on our current shared video displays (Vimeo and YouTube), isn't there a risk that sharing an identical format among visual storytellers with no distinction between fiction and nonfiction, editorial and advertising, showcases and advocacy, music videos and computer graphics, and so on has consequences for objectivity versus subjectivity and for digital manipulation? And how prepared is anyone with a DSLR hybrid camera to become a documentary director? Debates arise.[2]

If we look at some of the latest examples of visual storytelling, the documentary form with the director being the fly on the wall is morphing to stronger authorship and presence, such as *Dirty Wars*.[3] It seems that more often the subject and the director are sealing a collaborative form of storytelling. Complicit diary or activism? Creative authorship or a new form of firsthand investigative journalism? The debate might become louder in these coming years.

How will objective, neutral, nonbiased, and fact-checked content comprising a series of angles and sources be preserved? And will it need to be preserved?

PAUL: You are conjuring journalism without yet naming it. The process called "journalism" fits into this same Lens < / > Screen model, but are more steps required? More values and qualities? Objectivity has always been a hazy illusion. The placement of the camera, the configuration of the lens are already choices of a point of view different than other possible choices. That's been true—and known, forever.

CLAUDINE: Agreed. Some of the best photographers have operated with strong (sometimes disguised) authorship. Any creative/thoughtful choice is triggered by ethical questions and also liberates itself from it: what enters in the frame and who/what is left out of the frame are infinite decisions asked in fractions of second. Photojournalism is the result of an empirical experience: "living" an event rather than just the factual description of an event. It is a document of evidence (the event took place) colored with an individual perception, such as Burt Glinn's in Cuba—the expression of not just the facts but what it felt to be in that moment.[4]

There isn't such a thing as an objective reporting of an event. At least I don't believe in it. We all come in with our cultural baggage and clichés, our emotional background and our beliefs, and that will transpire through the lenses and, most of the time, will remain in the editing because it is simply more vibrant.

What needs to be framed in a series of clear and fair rules or conventions (accessible to all) is where to place the cursor when documenting reality. Not to stage it? Not to falsify it? Not to digitally transform it? What are the ethical "borders" to balanced narratives? An open debate needs to take place now for the next generations of storytellers to acknowledge and value these codes.

But let's be clear: building a voice and a creative signature will be even more important now that the storytellers are gaining in number. Isn't there an intangible balance and possible intersection between facts and perception or empirical experience, between a balanced reporting and a clear intention behind the construction of a story?

PAUL: I think you're asking, can that ever be resolved? Or, are we losing ethics?

CLAUDINE: Who will have the "final cut"? Will that still be a relevant question in the next decades? If so, why not draft a code of conduct modernized to current circumstances with a consortium of independent journalistic instances, to be agreed upon and shared universally? Why is it still so important for each media authority to veil itself behind its own bible? What is the added value of such protectionism in our sharable times? If constitutions can be written in collaborative forms, why couldn't a common code of conduct for at least the main and agreed fair rules be signed off on and shared widely?

Paul, we had raised these questions in our 2010 *Global Reporting Room.*[5] Is there still a need for a growing platform to share knowledge and concerns for quality journalism? Or is it even an emergency?

PAUL: The cynical question is, so what? We might want these things, and yet there are countless individuals engaged in the processes of media creation that formerly were the purview only of journalists, because only journalists had access to the mechanisms of media capture and distribution channels . . .

CLAUDINE: . . . and to exclusive sources, an essential point. You were the sum of your sources, when now access to sources and data is much easier. If the process of gathering stories and reporting is accessible to almost everyone (especially coders), and a direct cause of fact-checking, ethics, and objectivity no longer being a priority, what will replace the journalistic authority? The self-proclaimed "trusted source"? Is it still relevant today? And if so, to whom?

PAUL: So let's back up; can we agree on a working definition of journalism?

CLAUDINE: Finding and presenting information: researching, investigating, reporting, curating/editing, publishing. Journalism is the result of that workflow. Its necessary elements are access, sources, ethics, accuracy, conversation (for the alterity), final cut (the editor), and post. We know what has changed: access and publication are no longer limited. The values of journalism have to be shared in new creative ways.

PAUL: Let me ask you, Claudine, being so close to journalism for so long: In the face of what has changed in society and also in journalism, what do we want to stay constant, to conserve, in the journalistic process?

CLAUDINE: To be recognized: clear authorship and intentions, fair approach to the subjects recorded, protection of any source that could be harmed through exposure, no digital falsification, careful and thoughtful editing with gathered feedback for a comprehensible and balanced story to be told and shared, accurate contextualization, design quality, optimized user experience, and to be shared widely so it can lead to an inclusive conversation. What can we do together? To support change is a collective process.

Some will call that approach "activist journalism." I prefer to define it as "active journalism" or "engaged storytelling." And that is possible now because the user has a medium to research, participate, debate, answer.

PAUL: *D'accord.*

CLAUDINE: As people working closely with technology but vigilant about what capitalism tends to bring into it, what ought we to want from technology?

PAUL: What I hope for is vigilance about what we want and a design ethic to bring that desire into practice, as we design technology and also integrate it into our lives. For example, can we make a technology interface to check data sources a reason to believe, a combination of reason and trust? I hope for a pendulum to swing back to those values. We need a partner that counters Google to search for ethical reasons, otherwise we cede to their opacity.

CLAUDINE: What about all the other steps in the workflow of journalism? Can we improve what comes in between intention, process, accuracy, responsibility, and so on? Can technology be used to preserve and enhance quality in nonfictional accounts?

PAUL: Yes, I feel so, and we must work at this. But I want to start with that meta-intention: transparency, to expose reasoning and build trust. And what other intentions?

CLAUDINE: To facilitate informed action.

PAUL: We've just moved from facts beyond the boundaries of journalism into societal action, and journalism connects deeply there. Can we, by design, observe the disrupting forces of technology at every stage in the workflow and add mechanisms to counter them, to lower the effort required to achieve the values of journalism—technology to counter technology? For example, could we have a technology interface that not just encourages but makes graceful this desire for checking a multiplicity of data sources?

CLAUDINE: Absolutely. Google has built an empire in searching and providing data; we need new and neutral entities to process the verification of the data.

PAUL: And ethically it should be an independent partner to Google rather than one that benefits Google's business model. Can we reveal the underlying data so that the

individual can come to trust rather than have the algorithm embody (and hide) the trust? We want broad technical tools for minimizing the loss of journalistic values. What about these?

· A graph for journalists, where the connections of sources can be checked back to their affiliations (such as a collective and safer version of Mark Lombardi's Conspiracy Art);[6]

· A way of tracking and exposing assumptions in clear contrast to palpable occurrences, hearsay versus sourced statements, reports versus arguments;

· A browser interface for collective collation of media in any format;

· Shared production and distribution that resist control by any source, author, publisher, or state; this trend is already in full swing but alternatives need to constantly mutate—resilient, global tools for real-time sharing of events and outcomes and post hoc processing, reflection, and recursive action.

CLAUDINE: Can we also find palliatives for the time pressures of continuous news coverage and delivery? How could we make our actions and reactions become sharper within these condensed time frames—helped by technology, not blown out of all reason with hasty conclusions and wrong indictments? What would these tools be? What would be the workflow, the control-check tools that would allow us to seize this shorter timing without feeling like we were slipping on a banana peel?

PAUL: We can have what we want. Humberto Maturana contradicts the nonsense idea that technology "wants" anything.[7] We can get what we want from the technology that we make by being responsible for our actions! And we can decide what we consciously want from journalism, from a participatory form that takes into account these problems with time and all the rest of it, so that we can preserve quality and democracy.

But for me, the core is still transparency of data, which leads to transparency of logic, argumentation, opinion, distortion, obfuscation, motivation, trustworthiness.

Any decision for action is complicated by the data deluge brought on by technology. Is there a journalistic process to manage and also harness the data deluge in service of this societal need for journalism?

CLAUDINE: This will be done particularly in data journalism and data visualization. Data sourcing, collecting data should be an exposed and transparent workflow, not only to show its validity but also to keep it susceptible to comment and debate or complemented by new findings.

PAUL: What makes "data journalism" different from the rest of journalism?

CLAUDINE: Perhaps to the traditional "nose for news" and ability to tell a compelling story, it adds the sheer scale and range of digital and offline information now commonly available. Its raw exposure is a first level of information access, but its collecting, its comprehensive analysis, and its tamed visualization will increase its impact and audience reach.

PAUL: And those possibilities can come at any stage of the journalist's process: using programming to automate the process of gathering and combining information from local government, police, and other civic sources, like Adrian Holovaty did with crime data in Chicago.[8]

CLAUDINE: This is probably—along with visual storytelling—one of the most interesting areas of active journalism: active as opposed to reactive journalism, the traditional servitude to the breaking news. It can tease and consolidate our knowledge and scrutinize the world before things "break" and question its viability. It is also appealing, as it is a savant team-play and collaborative effort between data journalists, coders, and designers for a story to become a curated visual ensemble. More importantly it is the area that can develop in the most inclusive way, with the viewer to become the player and navigate through that form of investigation, even through gaming and through annotations.

We therefore will need to hijack the scripts, the knowledge, and the tools of the most thoughtful and creative game designers, to render complex issues into digestible and entertaining visualization and nonlinear storytelling. A great number of creative people and developers will join this field and support the journalism process. And that will also change the nature of gaming itself. My friend Chris Hurtt, a character animator, sees gaming as a limited pleasure because its navigation and rules are defined.[9] Data journalism instead could generate games as imaginative in their decision making as the Danish Lego. The player is offered the chance to be the architect of multiple variations and hypotheses as opposed to being constrained by a set of tele-guided actions (killing zombies, etc.). Games could activate the brain instead of sending it into sleep-walking mode.

In 2013, a panel debated about violence in the twenty-first century and its patterns. If the number of civil wars has declined after World War I, criminal violence, such as drug-related violence and human trafficking as well as street-level and ethnic-based violence, has increased. And the intersections between these forms of violence need to be investigated. The way transnational and transglobal forms of violence spread could be a great data project along with documentary narratives. The founder of Cure Violence, Dr. Gary Slutkin, a physician and epidemiologist, maintains that violence spreads very similarly to infectious diseases and affirms that most often people do what their friends do.[10] Based on this assertion, he makes the point that terrorism has spread thanks to open-source tools, using the chain effect of friends convincing friends until reaching momentum in a cluster of violence.

These types of investigations—facts paired with visual storytelling—could capture patterns and recurrence of rooted and new behaviors. Most interestingly, this type of investigation could bring together neuroscientists, anthropologists, psychologists, and grassroots activists. Journalists could become catalysts and alchemists, creating labs around these major topics.

For journalism to adapt to its time, it needs a new mind-set and collaborative architecture: transversal, in-depth, catalytic, and challenging our common thinking. What is coined "solution-journalism" could become a global lighthouse with a series of radar sensors to help identify needs in the use of resources, in relationships, in trade, in aid, and so on. And that has to be around expertise, technology, and most importantly around new workflows and creative thinking.

PAUL: I think your insight is powerful for two big reasons. First, you are asserting a form of journalism that is looking actively into the future, toward action—with action as the ultimate purpose. Second, your scope is systemic and therefore you are seeking broad variety in the journalistic conversation—the capacity and capability not of an individual but of a consortium, an activated network or small team working inside solution-journalism. Variety in the conversation delimits what's possible: a conversation of only journalists can only yield reporting. The idea of case studies to generate action plans—this is the activation of democracy. Today's technology paired with our intentions give us means to go from local to regional to national to transglobal journalism. I love your word *transversal,* which is also about capacity—the same way that terrorism can spread epidemiologically through the "tubes" of the Internet because it connects everywhere to everywhere. What is the role of transversal journalism to counter it?

CLAUDINE: If we don't think of journalism as transglobal, we will lose the battle. That is why we should bring the documentary storytellers' voices and wealth of experience into tamed and cross-referenced platforms. Most have taken incredible risks to cross borders and resistances to tell their stories. Most have done it for very little financial reward, forcing life adjustments. Their collections of evidence as well as their recollection of events with possible patterns could be an infinite source of knowledge if finally given proper screen space to be voiced, debated, and watched as Magnum in Motion is aiming to do.[11]

PAUL: Who is in the conversation and where the conversation takes place has changed. The twentieth-century workflow of journalism was not transversal: it was linear and controlled. And its conversations and criteria were not accessible; they remained inside the hierarchy of production (in this way, Google is also twentieth-century technology). But the discovering and the researching, and the investigating and the reporting, are "all across" and "trans" now. Even the curating and publishing can be "trans." What values for journalism can be preserved across all these differences?

CLAUDINE: What has changed is the nature of the circle. Family-based and geography-based communities will enlarge into communities with shared points of interest. The Internet is a product of democracy—an open space to share, express, digress, create.

PAUL: If we impose the journalistic model on the top of these modern habits and technologies, it will have more democratic resiliency. But we lose some of the discipline and "value" of the journalistic process. Too much data, no imposition of ethics, or concern for deliberate fact-checking—that may cause us to make a greater effort for transversal journalism, where we create software, image browsers, lowering the effort to fact-check, etc.

CLAUDINE: New journalism and remastered democracy will generate civic responsibilities no longer tied to a nation but to shared values and agenda: climate, urban violence, women's rights, wars and conflicts, corruption and trafficking, for instance.

PAUL: We agree that more will participate. In the case of Hurricane Sandy on the East Coast of the United States in 2012, there weren't just three photographers but thousands who were subjects in what happened in the hurricane. Here we have the occurrence of the event, the conversation around the event, and the implication of the event . . .

CLAUDINE: Does history begin when the thousand of images are taken, or is it when they are shared? Or when a few of them are made iconic through curation or lasting memory? The question remains.

PAUL: I would go at it differently. We've said that technologies transform the nature of journalism. For one thing, the unification of technologies (same camera, same format, same distribution mechanisms) makes creation and distribution fabulously cheaper and easier. As a result, participation has changed and the whole workflow has changed, and therefore the meaning and values of journalism are in danger of transforming so much that many of us worry that the value of journalism and democracy is being lost or is being narrowed.

Can we—using the same metaphor and the same mechanisms and technologies—interpose transversally and *by design* an awareness of the value of journalism, as well as the means to evolve it? Think of the Hurricane Sandy example: Can we create an immersive experience of an otherwise unwieldy collection of images that allows many photographers to share points of view *such that* experiences of values and value arise, without a central curator, without a hierarchy of decisions, and with a limited channel of flow? So there arises a new space of understanding between everyone seeing one thousand pictures and everyone seeing the iconic representation of an event on the "front page" in a single picture. In that space, we move in a flow of conversation and co-evolution, exploring the values we want: democracy, transparency, variety.

CLAUDINE: Yes. It is what the documentary photographer Gilles Peress calls "radical interpretations."[12]

OUTRO

PAUL: How do we summarize?

CLAUDINE: With more questions?

What is news? When does information become news? How is it expressed? What is its journey from that first blogger or tweet to the news that is declared "trusted news"? What is the process, the timing, the actors-in-presence?

When does news become global news? When does news become viral—when it sparks our senses? When it's improbable? Epic? Fantastic? Mysterious? Morbid? When it touches idols? And what will make it bounce, resonate, sink, and then be renamed "archive"?

Is the DNA of digital news any different?

In the face of what has changed in journalism—speed of channels, deluge of data, expectation of 24/7 updates—what has thus far stayed constant? And changed radically?

Thinking without prejudice about the technology we have today, what do we want from any technology? Assuming it is possible to get that from technology, who do we need in the conversation for making it?

Have we redefined history when we have defined the engines of retrieval?

What do we have: the occurrence of the event, the conversation around the event, and the implication of the event?

Isn't there also a sort of intangible balance and intersection or connection between facts and opinion, empirical experience and analysis? The need of the duality?

MENTIONED MEDIA SITES

BUZZFEED.COM BuzzFeed defines itself as "the social news and entertainment company," providing "the most shareable breaking news, original reporting, entertainment, and video across the social web to its global audience of more than 130,000." It includes sections labeled "LOL," "WTF," and "Cute."

FACEBOOK.COM Facebook is an online social networking service, whose name comes from the directory given to students at some American universities; it was founded in February 2004 by Mark Zuckerberg at Harvard University.

FLICKR.COM Flickr (pronounced "flicker") started as an image hosting site, created by Vancouver-based Ludicorp in 2004; it was acquired by Yahoo in 2005.

FLIPBOARD.COM Flipboard is news aggregator application that collects digital media and packages it in a magazine format to "flip" through on a tablet. It was launched on an iPad in December 2010 in Palo Alto, California.

HIPSTAMATIC.COM Hipstamatic is a digital photography application for smartphones; its square format and vintage photography filters make it distinctive. The slogan of this Synthetic Corporation app is "Digital photography never looked so analog."

INSTAGRAM.COM Instagram is an online photo- and video-sharing social networking service that allows its users to build visual diaries with photo filters in a grid of square Polaroid-like formats. Video formats are limited to fifteen seconds. Launched by Kevin Systrom and Mike Kriege, in October 2010, it was acquired by Facebook in 2012.

MYSPACE.COM MySpace (rebranded as Myspace) is a social networking service with a strong music emphasis owned by Specific Media LLC and launched in August 2003 in California.

TWITTER.COM Twitter is an online social networking and microblogging service whose messages, called "tweets," are limited to 140 characters. Twitter was created in March 2006 by Jack Dorsey, Evan Williams, Biz Stone, and Noah Glass.

VPEEKER.COM Vpeeker shows newly posted Vines in real time. Vines are six-second looping video clips whose sharing-service app is owned by Twitter.

YOUTUBE.COM YouTube is a video-sharing website on which users can upload, view, and share videos. It was created by three former PayPal employees in February 2005 and has been owned by Google since late 2006.

32

A POST-PHOTOGRAPHIC MANIFESTO
2011

Joan Fontcuberta
(trans. Graham Thomson)

Fontcuberta's manifesto explores the polyphonic possibilities of the contemporary image and offers advice for moving forward in our "post-photographic" world.

THE HONG KONG SYNDROME

Not long ago one of the big Hong Kong daily papers fired the eight staff photographers who covered local news; at the same time the paper handed out free digital cameras to local pizza delivery riders. As a business decision it made perfect sense: it was far easier for the nimble *pizzeri* to learn to take pictures than for photographers to get through Hong Kong's diabolical traffic to a news scene on time. Of course, spokespersons for the profession were wailing and gnashing their teeth: how could the paper dispense with the quality guaranteed by seasoned professionals? It is incontestable, though, that a bad picture taken by an amateur has the edge on a gorgeous picture that never got taken. All hail the new citizen-photographer!

What can be discerned in this recent instance of technological Darwinism is a change in the photojournalistic canon: velocity trumps the sublime instant, rapidity trumps refinement. There had been precedents, of course: a few days into the war in Iraq the France-Presse agency, AFP, pulled out all its photographers, none of whom spoke Arabic. They then gave digital cameras to young locals, who not only had access to places that were off limits to Westerners but also felt comfortable photographing their neighbors, friends and—who knows?—accomplices. The AFP head in Baghdad boasted not only of cutting costs—foreign correspondents were paid up to thirty times more per day than the kids newly recruited as reporters—but also and above all of improving the journalistic quality of the shots thanks to wider and deeper access. In that case, however, no alarms went off.

In the heroic age of photo reportage, photographers had both time and resources at their disposal. When *National Geographic* celebrated its centenary, the editorial in the special issue took pride in the fact that the magazine's cossetted contributors enjoyed optimal working conditions: assistants, helicopters, luxury hotels. . . . Each commission generated an average of 27,000 photos, of which barely a dozen, evidently the crème de la crème, would make it onto the page. But those profligate times are long gone, left far behind by an increasingly cutthroat market and immersion in a new mediasphere. There has been much talk of the impact of digital technology on all areas of communication and on our daily lives; for the visual image and for photography in particular it clearly marks a before and an after. It wouldn't be unreasonable to compare digital technology to the meteorite that caused the extinction of the dinosaurs and paved the way for the emergence of new species. For some time the dinosaurs were perfectly unaware of the catastrophic collision and carried on as contentedly as ever, passive—and no doubt bewildered—witnesses to the changes taking place in their ecosystem, under the enormous dust clouds that blocked out the sun's rays, with deadly consequences for plants and animals. Vanishing before our eyes today is a dinosaur photography that is giving way to successors better adapted to the new sociocultural environment.

What the Hong Kong syndrome indicates is that nowadays the image's urgent need to exist prevails over its qualities. That impetus ensures an unprecedented massification, an iconic pollution produced on one hand by the development of new devices for taking pictures and on the other by the enormous proliferation of cameras—whether stand-alone or incorporated into mobile phones, tablets, webcams, and surveillance systems. We are immersed in a world saturated with images: we live in images, and images live in us and make us live. Back in the 1960s, McLuhan foretold the predominant role of the mass media and offered the iconosphere as a model of the global village. What has changed in the meantime is that we today have concluded a process of secularization of visual experience: the image is no longer the domain of magicians, artists, specialists, or "professionals" in the service of centralized powers. Nowadays we all generate images spontaneously, as a natural form of relating to others; post-photography has emerged as a new universal language.

PERIPHERIES OF THE IMAGE

In setting out to analyze the current status of the image we must first survey the horizons of advanced scientific research, whose exploration of the mechanisms of perception often seems more like science fiction. When our parents were kids, a simple corneal transplant was a stretch of the imagination. Today's nanotechnology makes it possible to implant tiny ocular telescopes whose superpowers leave Clark Kent back there with Mister Magoo,[1] and enabled the Iraqi American artist and professor of photography at NYU Wafaa Bilal to have a micro camera surgically mounted on the back of his skull, and automatically take an endless succession of shots (this is fact, not a Hollywood script

idea, as can be seen on Bilal's website).[2] The project was an official commission from the Qatari government as part of the stellar inaugural exhibition at the Mathaf: Arab Museum of Modern Art in Doha. The idea is that Bilal's encephalocamera would take a picture every minute and that these would be viewed in real-time streaming on monitors in the museum: this set-up is likely to remind you of the 1980 Bertrand Tavernier film *Death Watch,* starring Romy Schneider and Harvey Keitel, about which more later. But certainly, for the uninitiated, the most mind-boggling, mold-breaking stuff is being done in high-tech centers like the CNS Computational Neuroscience Laboratories in Kyoto, whose Computational Brain Imaging and Dynamic Brain Imaging Departments, which monitor mental activity, are close to being able to extract graphic forms directly from the brain and project them onto a screen.[3] You may well rub your eyes, because this would open up a range of capabilities and possibilities only ever seen in fantasy films: filming with our eyes, recording our dreams and viewing them on-screen in the morning, coding emotions in order to translate them into images, or simultaneously sharing another person's visual perception. A few years ago now the neuroscience journal *Neuron* published a monograph on the subject entitled "Visual Image Reconstruction from Human Brain Activity."[4] Movies like Steven Spielberg's *Minority Report* (2002) or Christopher Nolan's *Inception* (2010) may soon look quaintly antiquated.

The goal, just around the corner, of achieving a truly holistic engagement with the image takes us far beyond the ontological transfer embodied in the substitution of silver salts by silicon and halide grains by pixels. Now that the old boundaries and categories have gone up in smoke, the issue of the post-photographic image far transcends an analysis limited to a mosaic of pixels whose graphical representation is *scriptural* in nature. Let's widen our focus to include a sociological perspective and note how at home post-photography is on all classes of Internet portals, the interfaces that connect us to the world and the platforms of so much of our activity. The crucial thing here is not that photography should have dematerialized into bits of information but how these bits of information transmit themselves and circulate at dizzying speed. Google, Yahoo, Wikipedia, YouTube, Flickr, Facebook, MySpace, Second Life, eBay, PayPal, Skype, and the rest have changed our lives and the life of photography. In fact post-photography is, quite simply, photography adapted to our life online, a context in which, as under the ancien régime of the image, there is a place for new vernacular and functional uses as well as artistic and critical uses. Let's talk about the latter.

POST-PHOTOGRAPHIC DECALOGUE

How does radical post-photographic creation work? What follows would be a plausible outline, at once pointed and succinct:

1. Concerning the role of the artist: It is no longer a question of producing "works" but of a prescriptive suggesting of meanings.

2. Concerning the actuation of the artist: The artist merges with the curator, with the collector, with the teacher, with the art historian, with the theorist . . . (every facet of art is chameleonically authorial).

3. Concerning the responsibility of the artist: An ecology of the visual will penalize saturation and encourage recycling.

4. Concerning the function of images: The circulation and management of the image prevails over the content of the image.

5. Concerning the philosophy of art: Discourses of originality will be delegitimized and practices of adoption (formerly known as "appropriation") will be standardized.

6. Concerning the dialectic of the subject: The author is camouflaged or up in the clouds (to reformulate authoring models: co-authoring, creative collaboration, interactivity, strategic anonymities, and orphaned works).

7. Concerning the dialectic of the social: There will be no more tensions between the private and the public.

8. Concerning the horizon of art: The ludic and playful will be promoted over a hegemonic art that has made anhedonia (the solemn + the boring) its credo and banner.

9. Concerning the experience of art: Creative practices that accustom us to dispossession will be privileged; sharing is better than owning.

10. Concerning the politics of art: Glamor and consumption will be renounced in favor of the active rattling of consciences. In a time when "art" has largely been converted into a mere cultural genre, obsessed with producing artistic merchandise and governed by the laws of the market and the entertainment industry, it would be a bad thing to drag it out of the spotlights and off the red carpet; get it back to the barricades.

The strong points of this Decalogue (new authorial consciousness, equivalence of creation and prescriptive proposition, appropriationist strategies of accumulation and recycling) bring us to what might be called an "aesthetics of access." The fundamental break we are witnessing is manifest in the extent to which the extraordinary deluge of images is accessible to everyone. Today, images are available to all. As the critic Clément Chéroux notes: "From the point of view of uses, it is a revolution on a par with the installation of running water in homes in the nineteenth century. Today we have a faucet of images in our homes, and this implies a new hygiene of vision." This aesthetic is magnificently exemplified by the work of Penelope Umbrico. Regarding the process of making Suns (from Sunsets) from Flickr, one of her most popular pieces, she has said that one day she felt the urge to take a photo of a romantic sunset.[5] It occurred to her to see how many photos there were on Flickr with the tag "sunset," and she found 541,795 delightful sunsets; by September 2007 the figure was 2,303,057, and in March 2008,

3,221,717 (when I had a look for the date of August 18, 2011, there were 9,613,978). On Flickr alone, using just one search language, the faucet supplies us with a multimillion-picture magma of sunsets. How much sense does it make to take another photo of a sunset? Will what we do contribute anything to what is already there? Is it worth adding to the existing graphic pollution? Umbrico said no, no, and no. And then she launched her personal environmental crusade: she took 10,000 sunsets from Flickr and recycled them to compose a mural with which she covered the walls of a museum. Obviously that irked the ingenuous Flickr users: "But, Grandma, what sharp search engines you have!" "All the better to prescribe to you with." The post-photographic joke here is that if we search for "sunset" on Flickr now, we also find Umbrico's compositions and the photos that visitors have taken of her exhibitions. Her symbolic gesture proves to be useless: there is no such thing as zero pollution; it's impossible.

THE AUTHOR UP IN THE CLOUDS

One of the most typically post-photographic fashions is the fad for photos taken by animals (irrational animals, to be clear). Historically, the pioneer in this field was the German photojournalist Hilmar Pabel, a freelancer for the weekly *Berliner Illustrierte Zeitung*. In 1935 he had the idea of giving Leicas to chimpanzees in the Berlin Zoo and asking their keepers to teach them to press the shutter release, mimicking the visitors, adults and children alike, who constantly snapped the chimps' monkey business with their own cameras. The model turned photographer. The weekly's editors were delighted and published the results. But when Pabel presented his bill, they were outraged: why should they pay him for pictures he hadn't taken? The real authors were the chimpanzees. It was no use arguing that he had conceived and orchestrated the project and it was irrelevant who had held the camera: what really mattered was the way the thing was invested with meaning. Pabel lost this battle but not the war: he renegotiated the story with *LIFE*, which published it on September 5, 1938, and credited it to him. Incidental anecdote aside, the Pabel case illustrates the location of authorial status not in the making but in the prescribing; in the assigning of value and meaning, in the conceptualization, which takes on tutelary relevance in the context of the Internet. In 1888 George Eastman coined the popular slogan—"You press the button, we do the rest"—that helped Kodak dominate the photographic industry; we now know that what matters is not who presses the button but who does the rest: who comes up with the concept and manages the life of the image.

Following in Pabel's wake but in all probability unaware of the historical precedent, in 1999 the Moscow-born, NYC-based artists Vitaly Komar and Alex Melamid, who in 1995 presented a project centered on Renee, the elephant painter, consecrated the Russian Pavilion at the 48th Venice Biennale to Mikki, the chimpanzee photographer. Since then it has been open season for animals, with photos taken by pets of all kinds, either on their own or with discreet support systems, inundating the Internet. The really

big names in this photographic bestiary—and there is no shortage of competition—are Rufus (a dog) and Nancy Beans (a cat), who provide picturesque documents from a canine/feline viewpoint of the urban communities of their owners (Reiji Kanemoto and Allen Christian, respectively). Goats, calves, and horses have also made a place for themselves in Daguerre's ark. I trust no one will suspect me of cynicism for noting a similar process with photos taken by children, blind or mentally ill people, Sunday photographers, advanced amateurs, commercial portraitists, scientists, police officers, firefighters, photojournalists, professionals, artists, satellites, traffic cameras, Google Street View, photo booths . . . the perversion in every case is the assigning of meaning to orphan works or the switching of the original meaning for another, in the manner of the Duchampian readymade. Obviously this act of transgression challenges the legitimacy of a certain status quo in the matter of intellectual property, raising a number of ethical and legal issues, and perhaps the final verdict can only rest on the competence of the results at a time when authors' rights copyright is up in the air because the authors themselves are up in the clouds. In parallel with the irresistible rise of cloud computing (with users accessing shared programs and databases via the Internet), this is a culture that effectively socializes authorship or simply uploads it to the clouds, where stuff is freely available to whoever needs it. Welcome to the world of Photography 2.0!

ATLASES AND SERENDIPITIES

A present-day Alonso Quijano would probably not drive himself crazy by devouring chivalric romances in the library but in front of the kaleidoscopic computer screen, a window that opens onto a symmetric double world such as Alice found through the looking glass, a parallel world in which we can live and have all kinds of adventures, and in which we can to a great extent bend reality to our desires. In the virtual realm we can be weekend watercolorists or conceptual artists, we can practice traditional documentary photography or anti-photojournalism. An example: for years now, Txema Salvans has been carrying out a highly methodical—and magnificent—project documenting prostitution along the highway between Barcelona and the town of Castelldefels; crouched behind a large tripod camera, masquerading as an innocuous surveyor, Salvans captures the loneliness of the girls abandoned to the roar of the traffic. For his part, Jon Rofman, without moving from in front of his computer screen in Montreal, has put together a similar series on the basis of street situations captured by Google Street View and accessible to any user. Their graphic quality aside, the projects coincide in intention and scope. From here on the documentary gaze can branch into two complementary methodologies that once again bring us into contact with the essence of the medium. Clues to the coming debate abound in the case of Michael Wolf, a photographer of the old school who studied under the legendary Otto Steinert and has a long career in documentary photography and book illustration. Like Rofman, Wolf has also undertaken projects using Google Street View; one of these, *A Series of Unfortunate Events,* consists

of incidents fortuitously caught by Google Street View cameras. Now, in 2010 this project received an honorable mention in the hugely influential World Press Photo contest, predictably causing general consternation among those in attendance. However, the honorable mention must be understood as a reluctant blessing: the archimandrites of documentary photography are beginning to bow to the post-photographic evidence.

Knowing that there are surveillance cameras and satellites photographing *everything* 24 hours a day invites us to wonder how much that is accidental and unforeseen that "everything" contains. One Google Earth community has identified 3,300 coordinates where airplanes in flight appear: if at a given moment there are thousands of planes in the air, it is logical and highly probable statistically that many of them will be inadvertently registered by the mechanical retinas of our new Big Brother. This delights the devotees of a novel Internet fad: safaris in search of the serendipitous, of surprises, of the bizarre. . . . The specter of Lautréamont rises up to invite internauts to seek out chance meetings on dissecting tables of sewing machines and umbrellas. One of the interesting questions here will be to see what values separate these new vernacular functions of the photographic image catering to freaky leisure from the serendipity that is the creative engine of artists like Joachim Schmid or Mishka Henner. Dismissed as "image scavengers" by those who still take pictures and like to think of themselves as authors, both Schmid and Henner sift through the dross of everyday phototrash or lumpen photography and come up with elegantly disconcerting discoveries, while indulging their fascination with accumulating and ordering: collections, lists, inventories, catalogs, and atlases of the most varied serendipities. Schmid, for example, takes pleasure in looking for football fields in the Third World, where any patch of ground is good for a distortion of the geometry of the official FIFA rectangle. Mishka Henner also scrutinizes the planetary epidermis through the eyes of Google Earth, hunting for censored portions of the Earth's surface we are not permitted to see, making them all the more interesting and mysterious. In the Netherlands, military zones are camouflaged with a mesh of irregular polygons whose sophisticated geometry and chromatic range would have delighted the neoplasticists. It seems that NATO has recruited a few Mondrians and van Doesburgs to work in military counterintelligence.

IDENTITIES À LA CARTE

Another of the great virtues of the parallel world of the Internet is the malleable nature of identity. Since time immemorial, identity has been subject to the word, the name that characterized the individual. The emergence of photography shifted the record of identity onto the image, the face reflected and inscribed. The arts of disguise and makeup led to a refining of biometric authentication techniques and the development of systems of iris recognition and forensic DNA testing to ensure greater reliability. But for the ordinary user, post-photography paves the way to a speculative *ballo in maschera* where each of us can invent how we want to be. For the first time in history we are in

complete control of how we appear and are able to manage this appearance as we please. Ever-multiplying portraits and, above all, self-portraits are posted on the Net, expressing a twin narcissistic and exhibitionist impulse that also tends to dissolve the membrane between the private and the public.

In these photos (the ubiquitous selfies that I like to call reflectograms when they are taken in front of a mirror) a spirit of play and self-exploration prevails over memory. Photographing oneself and displaying the pictures on social networks is part of the repertoire of seduction games and communication rituals of the new post-photographic urban subcultures, subcultures in which young adults and adolescents may take the lead, but in which most of us are involved. These are not memories to be treasured but messages to send and exchange; photos have become pure gestures of communication whose pandemic dimension can be attributed to a whole spectrum of motivations. Many celebrities have figured in cases that delineate some of the prevalent modes of the reflectogram. The political career of former Congressman Anthony Weiner, two-time Democratic candidate for mayor of New York City, was cut short by the scandal surrounding the public dissemination of his half-naked self-portraits taken in front of a gym locker-room mirror. Apparently Weiner had sexted these photos to several women, with intentions that seem to lie somewhere between harassment and complicity. The actress Demi Moore more or less regularly photographs herself in lingerie in front of her bathroom mirror and posts the suggestive portraits on Twitter, to the delight of her fans. Should we think of this as clinging to sexy stereotypes in an attempt to deny aging? More recently, other Hollywood celebrities, including Scarlett Johansson and Rihanna, have reported being targeted by hackerazzis who manage to break into the memories of their smartphones and steal private photos: many of these photos—which spread like wildfire on the Net—were erotic reflectograms. By contrast, the former president of the Catalan government Pasqual Maragall photographs himself with his mobile phone on doctor's orders, as it were. In one of the most moving sequences in Carles Bosch's documentary *Bicycle, Spoon, Apple*, Maragall explains that every morning when he gets out of bed he photographs himself in front of the mirror. The changes he has undergone as a result of Alzheimer's disease have made him afraid of one day not recognizing his own reflection. The photos shore up his sense of his appearance; they help him know and recognize himself.

From exhibitionism to personal tragedy, and thence to the metaphor of the post-photographic society; Anthony Weiner, Demi Moore, and Pasqual Maragall; young children, teenagers, adults—millions of us pick up a camera and point it at our double in the mirror: looking at and reinventing ourselves, looking and not recognizing ourselves. If, paradoxically, concealing ourselves may be how we reveal ourselves, the very fact of posing involves both putting ourselves onstage and putting on a mask: the self-portrait cannot help but question the hypothetical sincerity of the camera. Breaking away from its founding values, abandoning its historical mandates of truth and memory, photography has ended up passing the baton: what remains of photography is post-photography.

33

FEEDBACK MANIFESTO
2010

David Joselit

This epilogue from Joselit's book *Feedback: Television against Democracy* insists upon an understanding of and active engagement with the "image ecologies" of the world.

I am convinced that understanding the history of television, and its major influence over public discourse, is still acutely necessary today, even as its dominance is challenged by new and perhaps more egalitarian media like the Internet.[1] Artists can have a powerful role in such a project if they reach beyond the art market, whose booming economy is fueled by routinized and trivial novelty. As art marches in circles, politicians manipulate images more effectively than the legions of MFA graduates from prestigious schools like Art Center, Cal Arts, Columbia, and Yale. For this reason, I conclude my book *Feedback* with a manifesto—a challenge to artists and art historians alike, including myself—to make use of the tactics developed during television's first, or "network," era. Let's respond to a thirty-year-old call from Susan Sontag and take a stand against interpretation and in favor of action.[2] Let's put images in motion.

1. FEEDBACK. Don't produce art or art history by making a "new" move in the game of aesthetics you learned in school. Assess the image ecology you live in and respond to it. Learn the system and counter it—make noise. Practice eco-formalism.

2. CREATE A VIRUS. How is your image going to circulate? Use the resources of the "art world" as a base of operations, but don't remain there. Use images to build publics.

3. LOSE YOUR IDENTITY. Don't believe that you're a piece of property, a "gay man" or an "African American" whose "subject position" is the product of

market research. Use icons opportunistically, and share them with like-minded people. Make an avatar!

4. Imagine modes of art and art history that function as political science. Stop pretending to subvert commodification by demonstrating what everyone knows—that capital is everywhere. SEIZE THE WORLD AS A READYMADE and BREAK OPEN ITS CIRCUITS.

Find out what the next thing is that you can push, that you can invent, that you can be ignorant about, that you can be arrogant about, that you can fail with, and that you can be a fool with. Because in the end, that's how you grow.

Paula Scher, "Great Design Is Serious, Not Solemn," 2008

ANT!FOTO AND THE ANTIFOTO MANIFESTO
2013

Katja Stuke and Oliver Sieber

Artists Stuke and Sieber's graphic declaration takes us back to Moholy-Nagy's great visionary pronouncements and reframes them in a contemporary light.

WE LOVE PHOTOGRAPHY IN ALL ITS GLORY

A PHOTO IS A PHOTO IS DIGITAL, IS ANALOG, IS BLACK/WHITE & COLOUR; IS AN OBJECT, IS A BOOK, IS A BLOG, IS A NEWSPAPER, IS A MAGAZINE; IS A MOVIE IS A STORY, IS A STATEMENT; IS AN INSTALLATION, IS A SCULPTURE IS ALWAYS SOMEONE'S TRUTH; GETS LOST & FOUND; IS TECHNOLOGY IS AN ORIGINAL, IS A COPY, IS A REPRODUCTION, IS UNLIMITED PHOTOGRAPHY IS THE FUTURE & THE PAST – PHOTOGRAPHY IS A MEDIUM IN TRANSITION*

ONE SINGLE IMAGE IS ONLY THE TIP OF THE ICEBERG

USE PHOTOGRAPHY AS AN INTERNATIONAL LANGUAGE!

NEVER DISREGARD PROGRESSION

WE WANT TO SEE THE IMAGES WE ARE MISSING!

PHOTOGRAPHY IS TOO GOOD TO BE REGARDED AS ART ONLY!**

BECHERS VS. VICE MAG? TILLMANS VS. LINDBERGH? CAPA VS. MEISELAS? CALLE VS. ARBUS? SCHMID VS. FELDMANN? RUSCHA VS. BALTZ? ARBUS VS. TOSCANI? LEIBOVITZ VS. VON UNWERTH? KAWAUCHI VS. ARAKI? BALDESSARI VS. PETERSEN? TELLER VS. HIROMIX? SHERMAN VS. HOLDT? TEMPLETON VS. GOLDIN? NACHTWEY VS. WALL? FRIEDLANDER VS. GURSKY? SOTH VS. ADAMS? FONTCUBERTA VS. EPSTEIN? WINOGRAND VS. BARNEY? CAHUN VS. MAPPLETHORPE? RISTELHUEBER VS. GOLDBLATT? HUGO VS. SHIGA? SNOW VS. FREUND? HASSINK VS. MIKHAILOV? GRAHAM VS. PENN? AVEDON VS. MORIYAMA? MEISEL VS. RUFF?

! ANT!FOTO IS FOR ALL THOSE WHO WANT THIS, TOO!

CREATIVE INTERLOCUTORS
A Manifesto
1997

Charles H. Traub

In this manifesto written almost twenty years ago, Traub argues that the "creative interlocutor" is the true artist.

Art today, redefined by its relationship to technological innovation, changes both its meaning and many functions in the all-pervasive communications culture. Creative inspiration derives from many sources; we can no longer speak about imagery singly as art or design or communication. It is no longer a question of film versus video or painting versus photography. We can only conceive of the postmodern image as a child of multimedia that reflects the spirit of our time, without hierarchies and authoritative voices. This vision marks a new generation of artists sensitive to a multitude of possibilities for exploration in a media-conscious society. The best of them, inventive and politically and socially aware, will serve as creative interlocutors of our culture. The following are some maxims one might think about when engaging with the imagery and art of the computer age:

1. We want to believe that art is only output, that it consists of replaceable artifacts of the great evolution of image in the body of thought. But art is, in essence, process.

2. The digital world tells us unequivocally that not only is there no one-to-one correspondence between the image and the scene, but there is no original.

3. Originality resides with the receiver.

4. Creativity rests in exploring the potential and the consequences of this new geography of the imagination.

5. Imagery is the ectoplasm of our existence.

6. Cybernetics is the biosphere of the elastic mind.

7. The field of creativity resembles the collective metabolism of all human bodies.

8. We are now in an age of enlightened, enabled image-handling.

9. By our intervention in the image, we are made aware of the plasticity of our universe.

10. We cannot accept that imagery only records. We must comprehend that the virtual world is valid circumstance.

11. Scrutiny will bear witness to new truths. Fiction is its counterpart.

12. All we can really know of truth is our own reality.

The language of the computer—including the Internet, interactive multimedia, and other new digital forms and spaces—is a shared language for all of those who choose to partake in the discussion. There really is no longer a single artist, but rather a web of connections being woven that continually redefines a kind of collective creative genius. Talent, innovation, the avant-garde, and the cutting edge no longer define an elite. The new vision is defined by the simple notion that all communication from all of the previously defined components of cultural interchange—sound, music, word, text, drawing, photograph, file, folder, icon, symbol, metaphor, or image—are all reduced to the same common denominator: the digit.

At present what we are receiving as the product of the computer artist is a kind of primary experimentation and exploration. We are still in the most elementary stages of a great revolution, not only in communication, but in thought and creativity. Our culture has yet to fully understand the references and icons that are being defined and redefined before our very eyes. They are both new and repetitive, reconfigured, relative, and emerging. As our collective memory embraces them instead of rejecting them, we will be able to reach into the great depth and potentiality of hypermedia, virtual reality, interconnectivity, and new meaning. But this can be accomplished only by being informed, and that means understanding the historical antecedents that form culture, language, and image.

The charge here is to those engaged in the arts and humanities to embrace the technology, not with skepticism, but with the desire to enlighten it. The past celebrated great minds who reached outside the boundaries of their given disciplines to invent and relate to a larger field of human endeavor. The recent age of specialization has produced an elite practitioner and an impenetrable jargon that seals informational content off from the rest of the world. Meaningful creative practice should help to open the dialogue to all inquirers. The technology itself must be a reflection of a creative culture constantly seeking to integrate knowledge.

Technology is not just a tool, though we must initially approach it as one in order to learn it and feel comfortable, even unthreatened, by it. It should be seen as something that allows us to fulfill certain creative tasks with efficiency and simplicity. It extends existing tools and even makes some obsolete. As with any apparatus, there is a craft and technique to be learned. However, once several generations have grown up with the now-ubiquitous computer technology, its utility will change. It is likely that life in tomorrow's virtual worlds will be such that what was formerly perceived as a tool or a skill will have become an extension of our own humanness. In the past, we have described virtual worlds as if they were a form of practice for existence in the real world. At present it seems that we are practicing in the real world in order to exist in the virtual world. In the future there will be no demarcation at all. In other words, the way we think about our life with technology defines it.

Observation is at the core of understanding. The camera—indeed, any optically generated image—is a model of the extension of our senses through technology. Photography (and its related practices, film and video) is a kind of matrix for that which feeds into the computer from the outside world. Photographic media allow us to sample our outer environment, which constantly changes and must be organized by the creative information handler into meaningful hierarchies of ever-evolving experience. Through collecting, recording, sorting, connecting, transforming, and framing data, we maintain the keenness we need to serve as real-world witnesses.

Education in and with the new imaging technologies is a challenge that affects us all. There are issues that separate generations and classes, especially the estrangement that technology represents from older modalities of research and organization. There is a loss of object and a loss of tactility. The older generation has a steep learning curve to negotiate that the younger generation levels. This is the first moment in civilization when it might be said that the child has more to teach the parent than the parent the child. The child is enabled as the parent becomes crippled.

At this juncture in history, older forms of education must and will change. We can no longer function as artists through the propagation of single forms or movements, nor can we afford to keep art cut off from other areas of exploration and discovery. Just as we know that contemporary painting could not speak to us as it does without the invention of the camera, so too, photography must be translated and transformed by its relationship to the computer. Inevitably, this logic extends in the computer to a deeper connectivity between all disciplines of thought, communication, and creativity. The new artist is being born from the multiplicity of disciplines in which he or she is engaged.

This new artist, this creative interlocutor, helps to facilitate the exchange of ideas and information between one need and another. The best artists are those who can best help the users to find their own creative meaning in the interrelationship of ideas and forms. When we can cross disciplines with the facility of technology, when we can form

our own opinions from a fuller spectrum of options, we no longer need the mass media, the hype of the entertainment world, or the oppression of self-perpetuating institutions.

Learning should and can occur wherever there is a terminal. The artist, the receiver, and the user don't need a curator to be creative. Computer output is as mobile, transformable, and elastic as our willingness to engage our own creative force. What you are seeing from today's creative people working with the new technology is a sketch of the elaborate labyrinth of possibilities that still lies before us.

NOTES

FOREWORD

1. Chuck Close, interview with Chris Ekstein, *Artists & Alchemists*, directed by Chris Ekstein (Venice, CA: Market Street Productions, 2012), film.

2. See Trevor Paglen's blog posts on the Fotomuseum Winterthur's blog, *Still Searching*, beginning here http://blog .fotomuseum.ch/2014/03/i-is-photography-over/, and continuing here http://blog.fotomuseum.ch/2014/03/ii -seeing-machines.

INTRODUCTION

1. Fred Ritchin, "Fred Ritchin Awakens the Digital—Interview with Brian Palmer," *FOAM International Photography Magazine*, Winter 2009.

2. KEEP IT SIMPLE STUPID, JUST MAKE A GOOD PICTURE

1. Charles Darwent, "Out of Focus: Photography, Saatchi Gallery, London," *The Independent* (London), April 29, 2012.

2. Roland Barthes, *Camera Lucida: Reflections on Photography* (New York: Hill and Wang, 1981), 88.

3. Walker Evans, in *The Snap-Shot: Aperture 19:1*, ed. Jonathan Green (Millerton, NY: Aperture, 1974), 95.

4. Robert Adams, "Truth and Landscape," in *Beauty and Photography: Essays in Defense of Traditional Values* (New York: Aperture, 1981), 14.

3. EXCERPT FROM *A NEW HISTORY OF PHOTOGRAPHY*

1. Noam Chomsky and Edward S. Herman, *Manufacturing Consent: The Political Economy of the Mass Media* (New York: Pantheon, 1988). The quotation comes from this passage:

 In a totalitarian state, it doesn't matter what people think, since the government can control people by force using a bludgeon. But when you can't control people by force, you have to control what people think, and the standard way to do this is via propaganda (manufacture of consent, creation of necessary illusions), marginalizing the general public or reducing them to apathy of some fashion.

It's the primary function of the mass media in the United States to mobilize public support for the special interests that dominate the government and the private sector.

If you want to understand how a particular society works, you have to understand who makes the decisions that determine the way a society functions. In the U.S., the major decisions over what happens in a society (investment, production, distribution, etc.) are in the hands of a relatively concentrated network of major corporations, conglomerates, and investment firms. They're also the ones who staff the major executive positions in the government, and they're the ones who own the media, and are the ones who are in the position to make decisions. They have an overwhelmingly dominant role in the way life happens, what's done in this society.

2. Paul Krugman, *The Conscience of a Liberal* (New York: Norton, 2007).
3. Named after a defense strategy used by Dan White, who assassinated San Francisco mayor George Moscone and city supervisor Harvey Milk in 1978. During trial, in 1979, White's defense was based in part on his diet, which included Twinkies.
4. Eric Fromm, *The Sane Society* (New York: Henry Holt, 1990), 137.
5. See John Szarkowski, *The Photographer's Eye* (New York: Museum of Modern Art, 1966).
6. That gets increasingly sophisticated with new iterations of technology. The reasoned response to this might be that a photographer, not the camera takes the picture. This is true, but I wonder if, in most applications, it is not a "critical eye" that's called for but a competent shooter. I am afraid that for most uses the latter will not only suffice but will be encouraged. Technology increases the general level of basic competence, while the marketplace (i.e., established interests) frowns upon a potentially disruptive "critical eye."
7. American Academy of Pediatrics, Committee on Public Education. "Children, Adolescents, and Television," *Pediatrics* 107 (2001): 423–426.
8. Cumulative advantage/disadvantage is the concept that "success breeds success" and disincentivizes alternatives. It can be described by the precept that "the rich get richer while the poor get poorer." Also known as the Matthew Effect, the term was first coined by sociologist Robert K. Merton in 1968, taking its name from a verse in the biblical Gospel of Matthew (25:29) pertaining to Jesus's parable of the talents: "For unto every one that hath shall be given, and he shall have abundance: but from him that hath not shall be taken even that which he hath" (King James Version).

4. PHOTOGRAPHS ABOUT PHOTOGRAPHS

This essay originally appeared in *Lay Flat 02: Meta*, edited by Shane Lavalette and Michael Bühler-Rose, and including the works of the following artists: Claudia Angelmaier, Semâ Bekirovic, Charles Benton, Walead Beshty, Lucas Blalock, Talia Chetrit, Anne Collier, Natalie Czech, Jessica Eaton, Roe Ethridge, Sam Falls, Stephen Gill, Daniel Gordon, David Haxton, Matt Keegan, Elad Lassry, Katja Mater, Laurel Nakadate, Lisa Oppenheim, Torbjørn Rødland, Noel Rodo-Vankeulen, Joachim Schmid, Penelope Umbrico, Useful Photography, Charlie White, Ann Woo, and Mark Wyse.

1. Christopher Bedford, "Catherine Opie—Regen Projects," *Frieze Magazine*, no. 117 (September 2008): 189. Also see Bedford's article where he interviews Beshty, Quilan, and Deschenes, "Depth of Field," *Frieze Magazine*, no. 125 (September 2009): 113–17.
2. Charles H. Traub, a student and close friend of both Arthur Siegel and Aaron Siskind, personal conversation, October 2009.
3. Lyle Rexer's excellent book *The Edge of Vision* (New York: Aperture, 2009) offers a broad survey of photographic abstraction, which reveals its multifarious nature. His text also illuminates the international scope of this field—highlighting important figures such as Gottfried Jägar and Sigmar Polke (Germany), Ugo Mulas (Italy), Geraldo de Barros (Brazil), and Roger Catherineau (France).
4. Therese Mulligan, "More Than the Sum of Its Parts: The Photography Collection at the Norton Simon Museum," in *The Collectible Moment: Catalogue of Photographs in the Norton Simon Museum*, ed. Gloria Williams Sander (New Haven: Yale University Press, 2006), 30.
5. Thomas Barrow, "Thinking West," in *The Collectible Moment*, 103.
6. Therese Mulligan, "More Than the Sum," 32.
7. Gilles Mora, *The Last Photographic Heroes: American Photographers of the Sixties and Seventies* (New York: Abrams, 2007), 127–28. While Szarkowski's vision of photography dominated the field, important exhibits at MoMA did include many of these photographers—namely Peter Bunnell's *Photography into Sculpture* (1970) and Szarkowski's *Mirrors and Windows: American Photography since 1960* (1978). Other institutions were much more accept-

ing of the multivalent approach to photography at the time; the 1978 exhibit *Attitudes: Photography in the '70s* at the Santa Barbara Museum of Art by curator Fred Parker is one salient example.

8. Alex Klein, "Response," in *Words without Pictures*, ed. Charlotte Cotton and Alex Klein (Los Angeles: LACMA, 2009), 79.

9. Alex Klein, "Remembering and Forgetting Conceptual Art," in *Words without Pictures*, 122–23.

10. James Welling, "Questionnaire," in *Words without Pictures*, 61.

11. Charles H. Traub, "The Dos and Don'ts of Graduate Studies: Maxims from the Chair," in *The Education of a Photographer*, ed. Charles H. Traub, Steve Heller, and Adam Bell (New York: Allworth Press, 2006), 191.

12. Kevin Moore, "foRm," in *Words without Pictures*, 62.

13. Paul Graham, Soo Kim, and Anthony Pearson; Charlotte Cotton, moderator, "The Value of Photographs" (panel discussion), in *Words without Pictures*, 210.

14. Arthur Ou, Michael Queenland, and Mark Wyse; Charlotte Cotton, moderator, "Is Photography Really Art?" (panel discussion), in *Words without Pictures*, 36.

5. ON BOOKS AND PHOTOGRAPHY

1. Susanne Kippenberger, *Kippenberger: The Artist and His Families*, trans. Damion Searls (New York: J&L Books, 2012), 242–43.

6. STILLNESS, DEPTH, AND MOVEMENT RECONNECTED

The author would like to acknowledge Deborah Hussey, Don Byrd, and Lisa Ross for reading the text and making many valuable suggestions, and Caitlin Kilgallen of the School of Visual Arts library for locating a multitude of rare early documents.

1. Geoffrey Batchen, *Burning with Desire* (Cambridge: MIT Press, 1997), 97.

2. Jean Piaget, *Structuralism* (New York: Basic Books, 1970), 136.

3. R. B. Litchfield, *Tom Wedgwood: The First Photographer* (London: Duckworth, 1903), 122.

4. Elisabeth Theresa Feilding, née Fox Strangways, to William Henry Fox Talbot, transcript, May 19, 1817, document 767, Correspondence of William Henry Fox Talbot, University of Glasgow and De Montfort University, http://foxtalbot.dmu.ac.uk/letters/letters.html.

5. Léon Larue, *The Principles and Practice of Harmonious Colouring in Oil, Water, and Photographic Colors especially as applied to Photographs on Paper, Glass and Silver-plate by an Artist-Photographer* (London: W. Kent, 1859), 60.

6. Virgilio Tosi, *Cinema before Cinema* (London: British Universities Film & Video Council, 2005), 31.

7. Similar to a diorama, the silvered surface of the daguerreotype itself is a mirrored illusion. The spectator experiences an unstable image flickering between positive and negative states, even at times reflecting and superimposing the observer back upon the illusive image, thus creating an interactive and experiential sensory montage, a confusion of art and life. In essence, the animated day-and-night effects of a diorama are condensed into every daguerreotype.

8. Laurent Mannoni, David Robinson, and Donata Pesenti Campognoni, *Light and Movement: Incunabula of the Motion Picture* (Bloomington, IN: Indiana University Press, 1996), 329.

9. Arthur Gill, "The First Movie," *Photographic Journal*, January 1969, 25–29.

10. Claudet worked with Hippolyte Fizeau, the French physicist who had measured the speed of light in 1849.

11. Hermann von Helmholtz, "On the Telesteroscope," in *London, Edinburgh, and Dublin Philosophical Magazine and Journal of Science*, 4th ser., vol. 15 (London: Taylor and Francis, 1858), 19–20. Originally published in Poggendorff's *Annalen*, no. 9 (1857).

12. Because the stereoscope was invented before photography, the first stereographs were not photographs at all; they were drawings. Wheatstone's research into stereoscopic perception was made public in 1838, one year prior to the announcement of the original daguerreotype process. A typical stereoscopic drawing contained white lines drawn on a black ground and depicted figures from descriptive geometry. When the general public finally got to see stereo images in the *Illustrated London News*, they included "a bipyramidal dodecahedron-natural crystal of amethyst." There were also drawings from photographs of sculptures, the Crystal Palace itself, portraits, groups, and topographical hyperstereo views.

13. It's no coincidence that Claudet had also created the experimental, multi-image panorama of London that is known from the engraved version printed in the *Illustrated London News* of January 1843.

14. Tosi, *Cinema before Cinema*, 31.

15. The *Journal of the Royal Institution* published "An Account of a Method of Copying Paintings upon Glass, and of

Making Profiles, by the Agency of Light upon Nitrate of Silver. Invented by T. Wedgwood, Esq. With Observations by H. Davy." A reprint of this article can be found in R. B. Litchfield, *Tom Wedgwood: The First Photographer* (London: Duckworth, 1903), Internet Archive e-book, 188–95, https://openlibrary.org/books/OL7147151M/Tom_Wedgwood_the_first_photographer.

16. J. Beete Jukes and C. A. Browne, *Letters and Extracts from the Addresses and Occasional Writings of J. Beete Jukes* (London: Chapman and Hall, 1871), Google e-book, 33–34, http://books.google.com/books?id=C-cEAAAYAAJ&source=gbs_navlinks_s. In a letter to his aunt on March 14, 1839, Jukes, a renowned geologist and naturalist, describes Wheatstone showing him these photographs and Niépce's refusal to share the process with the Royal Society.

17. John Hannavy, ed., *Encyclopedia of Nineteenth-Century Photography* (New York: Routledge, 2008), 1377.

18. Walter Benjamin's famous essay "The Work of Art in the Age of Mechanical Reproduction" (1936) expands on the significance of this distinction.

19. The word *calotype* is derived from the Greek words *kalos* and *typus*, literally "beautiful image"; also called Talbotype and sun picture.

20. Mirjam Brusias, "Beyond Photography: An Introduction to William Henry Fox Talbot's Notebooks in the Talbot Collection of the British Library," *eBLF* article 14 (2010), http://www.bl.uk/eblj/2010articles/article14.html.

21. *Helmholtz's Treatise on Physiological Optics*, ed. James P. C. Southall, vol. 2 (New York: Dover, 1962), 483.

22. Selig Hecht and Ernst Wolf (Laboratory of Biophysics, Columbia University), "Intermittent Stimulation by Light: I. the Validity of Talbot's Law for Mya," *Journal of General Physiology* 15, no. 4 (March 20, 1932): 369–89, http://www.ncbi.nlm.nih.gov/pmc/articles/PMC2141171/; Edward P. Hyde, "Talbot's Law and His Rotating Doctored Disc Photometer," *Bulletin of the Bureau of Standards* 2, no. 1 (1906): 1–32; Chitra Ramalingam, "Stopping Time: Henry Fox Talbot and the Origins of Freeze-Frame Photography," *Endeavour* 32 (2008): 86–93.

23. *Strobic* comes from the Greek *strobos* for "act of whirling."

24. André Bazin, *What Is Cinema?* vol. 1 (Berkeley, CA: University of California Press, 1967), 17.

7. A LITTLE HISTORY OF PHOTOGRAPHY CRITICISM

1. Charles Baudelaire, "The Salon of 1846," in *Baudelaire: Selected Writings on Art and Artists*, trans. P. E. Charvet (Middlesex: Penguin, 1972), 51.

2. Baudelaire, "The Salon of 1846," 50.

3. Robert Hughes, *The Shock of the New* (London: Thames and Hudson, 1980), 7.

4. Margaret Fuller, "A Short Essay on Critics," in *The Writings of Margaret Fuller*, ed. Mason Wade (New York: Viking, 1941), 227.

5. Fuller, "A Short Essay on Critics," 229.

6. James Agee, *Agee on Film* (New York: Perigee, 1983), 1:22–23.

7. Susie Linfield, "Interview with Arlene Croce," *Dance Ink* 7, no. 1 (Spring 1996): 19. The performance to which Croce refers was the premiere of *Agon*, starring Maria Tallchief, Diana Adams, and Jacques d'Amboise.

8. Linfield, "Interview with Arlene Croce," 19.

9. Randall Jarrell, "The Age of Criticism" (1952), in *No Other Book: Selected Essays*, ed. Brad Leithauser (New York: HarperCollins, 1999), 294.

10. Alfred Kazin, "The Function of Criticism Today," in *Contemporaries* (Boston: Little, Brown, 1962), 500.

11. Kazin, "The Function of Criticism Today," 494–95.

12. Susan Sontag, *On Photography* (New York: Anchor, 1990), 3; 4; 7; 11; 14; 14; 21.

13. Sontag, *On Photography*, 6; 7; 7; 7.

14. Sontag, *On Photography*, 14–15; 24.

15. Sontag, *On Photography*, 13.

16. Roland Barthes, *Camera Lucida*, trans. Richard Howard (New York: Hill and Wang, 1981), 27; italics in original.

17. Barthes, *Camera Lucida*, 92; 106; 106; 4; 90; 96; 90.

18. Barthes, *Camera Lucida*, 107; 118.

19. John Berger, *Another Way of Telling*, photography by Jean Mohr (New York: Vintage, 1995), 83.

20. Berger, *Another Way of Telling*, 105; 108.

21. John Berger, "Photographs of Agony," in *Selected Essays*, ed. Geoff Dyer (New York: Pantheon, 2001), 280. McCullin was one of James Nachtwe's inspirations; for more on this, see Susie Linfield, *The Cruel Radiance* (Chicago: University of Chicago Press, 2010), chapter 8.

22. Berger, "Photographs of Agony," 280–81; italics in original.

23. Berger, "Uses of Photography," in Berger, *Selected Essays*, 288.

24. Roland Barthes, "Shock-Photos," in *The Eiffel Tower and Other Mythologies,* trans. Richard Howard (New York: Hill and Wang, 1979), 71.

25. Barthes, "Shock-Photos," 71.

26. Barthes, "Shock-Photos," 71.

27. Sontag, *On Photography,* 17.

28. Sontag, *On Photography,* 20–21. Sontag would rethink—and partially retract—this idea in *Regarding the Pain of Others,* but her original statements on this subject have made a far greater impact.

29. Allan Sekula, "The Traffic in Photographs," in *Photography against the Grain: Essays and Photo Works 1973–1983* (Halifax: Press of the Nova Scotia College of Art and Design, 1984), 101.

30. Douglas Crimp, "The Photographic Activity of Postmodernism," *October* 15 (Winter 1980): 98–99.

31. Rosalind Krauss, "A Note on Photography and the Simulacral," in *The Critical Image: Essays on Contemporary Photography,* ed. Carol Squiers (Seattle: Bay Press, 1990), 22, 24.

32. Postmodernism and poststructuralism are, of course, large and complex subjects, especially as they worked themselves out in philosophy and literature; here I discuss, specifically, their effect on photography criticism.

33. Abigail Solomon-Godeau, "Who Is Speaking Thus? Some Questions about Documentary Photography," in Abigail Solomon-Godeau, *Photography at the Dock* (Minneapolis: University of Minnesota Press, 1991), 176.

34. John Tagg, "The Currency of the Photograph," in *Thinking Photography,* ed. Victor Burgin (London: Palgrave, 1982), 122–23.

35. Martha Rosler, "In, Around, and Afterthoughts (On Documentary Photography)," in *The Contest of Meaning: Critical Histories of Photography,* ed. Richard Bolton (Cambridge: MIT Press, 1992), 321.

36. Andy Grundberg, *Crisis of the Real: Writings on Photography since 1974* (New York: Aperture, 1999), 9.

37. Fredric Jameson, "Postmodernism and Consumer Society," in *The Anti-Aesthetic: Essays on Postmodern Culture,* ed. Hal Foster (Seattle: Bay Press, 1983), 15–16.

38. Richard Prince, *Why I Go to the Movies Alone* (New York: Tanam Press, 1983), 63; italics in original.

39. See John Szarkowski, *Looking at Photographs: 100 Pictures from the Collection of the Museum of Modern Art* (Milano: Idea Editions, 1980).

40. Rosler, "In, Around, and Afterthoughts," 306.

41. Allan Sekula, "On the Invention of Photographic Meaning," in Burgin, *Thinking Photography,* 108.

42. Carol Squiers, "Class Struggle: The Invention of Paparazzi Photography and the Death of Diana, Princess of Wales," in *OverExposed: Essays on Contemporary Photography* (New York: New Press, 1999), 272.

43. Rosler, "In, Around, and Afterthoughts," 306; 207; 319; 325.

44. Many of the postmodern critics were women: photographs (and films) were also accused by some feminist critics of embodying the "male gaze"; see, for instance, Laura Mulvey's seminal 1975 piece "Visual Pleasure and Narrative Cinema" (collected in Mulvey, *Visual and Other Pleasures* [Bloomington: Indiana University Press, 1989]). For a wonderful counterexample of how that gaze can illuminate rather than objectify, see John Berger's "The Hals Mystery," in Berger, *Selected Essays.*

45. Mary McCarthy, introduction to *Mary McCarthy's Theatre Chronicles, 1937–1962* (New York: Noonday Press, 1963), xii-xiii.

46. Burgin, "Looking at Photographs," 147.

47. Burgin, "Looking at Photographs," 148; italics in original.

48. Burgin, "Looking at Photographs," 148.

49. W. J. T. Mitchell, *Picture Theory: Essays on Verbal and Visual Representation* (Chicago: University of Chicago Press, 1995), 369.

50. W. J. T. Mitchell, *What Do Pictures Want? The Lives and Loves of Images* (Chicago: University of Chicago Press, 2005), 26.

51. Nicholas Mirzoeff, "Invisible Again: Rwanda and Representation after Genocide," *African Arts* 38, no. 3 (Autumn 2005): 89.

52. Pauline Kael, "Trash, Art, and the Movies," in *Going Steady* (New York: Warner Books, 1979), 106–7.

53. Kael, "Trash, Art, and the Movies," 154. It's not that Sontag disagreed with this approach to art or criticism in general: after all, she had made her name in the early sixties by urging "an erotics of art" in *Against Interpretation.* And in a 1979 interview with *Rolling Stone,* she insisted, "One of my oldest crusades is against the distinction between thought and feeling . . . which is really the basis of all anti-intellectual views: the heart and the head, thinking and feeling, fantasy and judgment. . . . Thinking is a form of feeling; feeling is a form of thinking." It's just that, for reasons that we'll see later in this chapter, she abandoned this insight when it came to photography.

54. Jarrell, "The Age of Criticism," 294. "Sense of fact" comes from T. S. Eliot.

55. Kazin, "The Function of Criticism Today," 500.

56. Miriam Hom, "Image Makers," *U.S. News & World Report*, October 6, 1997, 60.

57. Ariella Azoulay, *The Civil Contract of Photography*, trans. Rela Mazali and Ruvik Danieli (New York: Zone Books, 2008), 519.

58. Charles Baudelaire, "The Salon of 1859," in Baudelaire, *Selected Writings*, 295.

59. Baudelaire, "The Salon of 1859," 295.

60. Baudelaire, "The Salon of 1859," 296.

61. Baudelaire, "The Salon of 1859," 296–97.

62. Baudelaire, "The Salon of 1859," 297.

63. Gustave Flaubert, *Bouvard and Pécuchet*, trans. Mark Polizzotti (Champaign, IL: Dalkey Archive Press, 2005), 316.

64. George Bernard Shaw, "On the London Exhibitions" (1901), in *Photography in Print: Writings from 1816 to the Present*, ed. Vicki Goldberg (Albuquerque: University of New Mexico Press, 1981), 224.

65. Shaw, "On the London Exhibitions," 231.

66. The quote is attributed to Shaw by Philip Jones Griffiths in William Messer, "Presence of Mind: The Photographs of Philip Jones Griffiths," *Aperture*, no. 190 (Spring 2008): 60.

67. Jane Welsh Carlyle, quoted in Helmut Gernsheim and Alison Gernsheim, *The History of Photography: From the Camera Obscura to the Beginning of the Modern Era* (New York: McGraw-Hill, 1969), 239.

68. Dominique François Arago, "Report," in *Classic Essays on Photography*, ed. Alan Trachtenberg (New Haven: Leete's Island Books, 1980), 19.

69. Louis Daguerre, "Daguerreotype," in Trachtenberg, *Classic Essays on Photography*, 13.

70. Lady Elizabeth Eastlake, "Photography," in Trachtenberg, *Classic Essays on Photography*, 40.

71. Sontag, *On Photography*, 115.

72. Walter Benjamin, "Little History of Photography," in Walter Benjamin, *Selected Writings*, vol. 2, 1927–1934, ed. Michael W. Jennings, trans. Rodney Livingstone and others (Cambridge, MA: Belknap/Harvard, 2005), 519; 523.

73. Walter Benjamin, "The Work of Art in the Age of Mechanical Reproduction," in *Illuminations*, ed. Hannah Arendt, trans. Harry Zohn (New York: Schocken, 1969), 224.

74. The veneration in which this essay is now held was not shared by all of Benjamin's contemporaries. Brecht regarded it as a kind of mumbo jumbo, writing in his journal: "It is all mysticism mysticism . . . It is rather ghastly."

75. Benjamin, "Little History of Photography," 518.

76. Benjamin, "Little History of Photography," 518.

77. Benjamin, "Little History of Photography," 510.

78. Benjamin, "Little History of Photography," 510.

79. Benjamin, "Age of Mechanical Reproduction," 51.

80. Benjamin, "Little History of Photography," 526.

81. Benjamin, "The Author as Producer," in Burgin, *Thinking Photography*, 24–25.

82. Benjamin, *The Arcades Project*, quoted in David Levi Strauss, *Between the Eyes: Essays on Photography and Politics* (New York: Aperture, 2003), 170.

83. Siegfried Kracauer, "Photography," in Kracauer, *The Mass Ornament*, trans. Thomas Y. Levin (Cambridge, MA: Harvard University Press, 1995), 57.

84. Kracauer, "Photography," 52.

85. Kracauer, "Photography," 51.

86. Johannes Molzahn, "Stop Reading! Look!" in *The Weimar Republic Sourcebook*, ed. Anton Kaes, Martin Jay, and Edward Dimendberg (Berkeley: University of California Press, 1994), 648.

87. Kracauer, "Photography," 58.

88. Kracauer, "Photography," 61–62; italics in original.

89. Kracauer, "The Little Shopgirls Go to the Movies," in Kracauer, *Mass Ornament*, 300.

90. Kracauer, "Photography," 61; italics in original. Kracauer's 1960 book *Theory of Film*, written in the far more benign atmosphere of postwar New York, adopts a kinder—and more limited—view of the role of film and photography.

91. Douglas Kahn, *John Heartfield: Art and Mass Media* (New York: Tanam Press, 1985), 64.

92. "Less than ever does the mere reflection of reality": Brecht in Benjamin, "Little History of Photography," 526. But with Brecht, nothing was simple. In 1955 his *Kriegsfibel* (War Primer), a book of assembled mass-market photographs that he had begun working on fifteen years previously, was published in East Germany.

93. Allan Sekula, "Dismantling Modernism, Reinventing Documentary (Notes on the Politics of Representation)," in Sekula, *Photography against the Grain*, 57.

94. Martin Esslin, *Brecht: A Choice of Evils* (London: Methuen, 1984), 209.

95. Martin Esslin, *Brecht: The Man and His Work* (Garden City: Anchor Books, 1971), 257.

96. Bertolt Brecht, "Of Poor B. B.," in *Poems: 1913–1956*, ed. John Willett and Ralph Manheim (London: Methuen, 1979), 107.

97. Brecht, "To Those Born Later," in Brecht, *Poems: 1913–1956*, 320.

98. Kracauer, "Cult of Distraction," in Kracauer, *Mass Ornament*, 327.

99. Adolf Behne, in Grosz and Heartfield, *Grosz/Heartfield: The Artist as Social Critic* (Minneapolis: University of Minnesota, University Gallery, 1980), 39.

100. Kahn, *John Heartfield*, 64.

8. IF YOU SEE SOMETHING, SAY SOMETHING

1. David Foster Wallace, "Plain Old Untrendy Troubles and Emotions," *Guardian US*, September 19, 2008, http://www.theguardian.com/books/2008/sep/20/fiction.

2. Sadie Whitelocks, "Henry Says Hold This Pose! Two-Year-Old Directs His Obliging Nanny for Hilarious 'Copycat' Photo Series," Femail, *Mail Online*, December 12, 2013, http://www.dailymail.co.uk/femail/article-2522573/Two-year-old-directs-obliging-nanny-hilarious-copycat-photo-series.html#ixzz2xYGC2qcQ.

3. W. J. T. Mitchell, "Showing Seeing: A Critique of Visual Culture," *Journal of Visual Culture* 1, no. 2 (August 2002): 166. doi:10.1177/147041290200100202.

4. Anne Bamford, "The Visual Literacy White Paper" (commissioned by Adobe Systems, Australia, 2003), http://wwwimages.adobe.com/content/dam/Adobe/en/education/pdfs/visual-literacy-wp.pdf.

5. Radoslaw Martin Cichy, Dimitrios Pantazis, and Aude Oliva, "Resolving Human Object Recognition in Space and Time," *Nature Neuroscience* 17 (published online January 26, 2014), doi:10.1038/nn.3635.

6. Mitchell, "Showing Seeing," 176.

7. "Session 4: Engaging in Visual Literacy," *Learning in the 21st Century Workshop Series*, Wikispaces, last modified April 28, 2010, http://learn21c.wikispaces.com/Session+4+-+Engaging+Visual+Literacy.

8. "The Coming World of Photography: Eliot Elisofon," *Popular Photography*, February 1944, reprinted at http://people.rit.edu/andpph/giants/POP-PHOTO-future-1944.html.

9. Erin Riesland, "Visual Literacy and the Classroom," Johns Hopkins School of Education, New Horizons, n.d., http://education.jhu.edu/PD/newhorizons/strategies/topics/literacy/articles/visual-literacy-and-the-classroom/.

9. EXCERPT FROM *VISION IN MOTION*

1. [Hermann von] Helmholtz used to tell his pupils that if an optician were to succeed in making a human eye and brought it to him for his approval, he would be bound to say: "This is a clumsy piece of work."

10. STILLNESS

"Stillness" is a chapter from my book *Photography and Cinema* (London, 2008). As you can probably tell from the writing, the book is richly illustrated. Moreover, the images were selected and sequenced in advance, to provide the structure for the writing.

1. Christopher Isherwood, "Goodbye to Berlin" [1939], in *The Berlin Stories* (New York, 1952).

2. Henri Cartier-Bresson, introductory essay in *The Decisive Moment* (New York, 1952), 2; reprinted in David Campany, ed., *The Cinematic* (London and Boston, 2007). The title *The Decisive Moment* was created with poetic license for the American co-edition instead of the French *Images à la sauvette*, a phrase that evokes chance as much as decisiveness.

3. He cites his key films: "*Mysteries of New York* with Pearl White; the great films of D. W. Griffith—*Broken Blossoms*; the first films of Stroheim—*Greed*; Eisenstein's *Potemkin*; and Dreyer's *Jeanne d'Arc*—these were some of the films that impressed me deeply."

4. An illuminating discussion of this duality is Thierry de Duve's "Time Exposure and Snapshot: The Photograph as Paradox," *October* 3 (1978); reprinted in Campany, *The Cinematic*, 52–61.

5. I discuss this in greater depth in "Safety in Numbness: Some Remarks on the Problems of 'Late' Photography," in David Green, ed., *Where Is the Photograph?* (Brighton, 2003), 123–32. For a more detailed assessment of cinema's reconstitution of time, see Mary Ann Doane, *The Emergence of Cinematic Time: Modernity, Contingency, the Archive* (Cambridge, MA, 2002).

6. Peter Wollen discusses the present-tense narration of the newspaper caption in "Fire and Ice" (1984), in David Campany, ed., *Art and Photography* (London, 2003), 218–20.

7. Cartier-Bresson made his first film in 1937, having been introduced to filmmaking by Paul Strand in 1935. He continued to make documentary films until 1970. For a summary of his work in film, see Serge Toubiana, "Film-making: Another Way of Seeing," in *Henri Cartier-Bresson: Man, Image, World; A Retrospective* (London, 2003), 348–55.

8. Launched in France in 1920 and manufactured by Debrie, the clockwork Sept became popular by 1922. It took seventeen feet (250 frames) of 35mm film and had seven *(sept)* functions. As well as shooting stills, short sequences, and movies, with the addition of a lamp housing, it converted to a contact printer, optical printer for filmstrips, projector, and enlarger. Sales were not sustained, as it was complicated to use. Rodchenko is known to have shot sequences of market traders with his Sept.

9. Jean-Luc Godard, "Introduction à une véritable histoire du cinéma," *Camera Obscura*, nos. 8–10 (Fall 1982): 75–88. See also "Angle and Montage," in Jean-Luc Godard and Ioussef Ishagpour, *Cinema* (Oxford, 2004), 15–18.

10. Dziga Vertov, "We" [1922]; reprinted in Annette Michelson, ed., *Kino-Eye: The Writings of Dziga Vertov* (Berkeley, 1984), 8.

11. Dziga Vertov, "Kinoks: A Revolution" [1922]; reprinted in Michelson, *Kino-Eye*, 17.

12. Alexander Rodchenko in *Novy Lef*, no. 4 (1928).

13. Helmar Lerski, *Köpfe des Alltags* (Berlin, 1931).

14. August Sander, *Antlitz der Zeit: 60 Fotos Deutscher Menschen* (Munich, 1929).

15. Siegfried Kracauer noted, "None of Lerski's photographs recalled the model; and all of them differed from each other. Out of the original face there arose, evoked by varying lights, a hundred different faces, among them those of a hero, a prophet, a peasant, a dying soldier, a monk. Did these portraits, if portraits they were, anticipate the metamorphoses which the young man would undergo in the future? Or were they just plays of light whimsically projecting on his face dreams and experiences forever alien to him?" Siegfried Kracauer, *Theory of Film* (London, 1960), 162. See also Helmar Lerski, *Metamorphosis through Light* (Essen, 1982).

16. Moï Ver, *Paris* (Paris, 1931). Born in Lithuania, Moï Ver studied at the Bauhaus and under the influence of László Moholy-Nagy and went on to École Technique de Photographie et de Cinématographie, Paris.

17. Siegfried Kracauer, "Photography" [1929], trans. Thomas Y. Levin, *Critical Inquiry* 19 (Spring 1993): 428.

18. Hollis Frampton, "For a Metahistory of Film: Commonplace Notes and Hypotheses," in *Circles of Confusion: Film, Photography, Video: Texts 1968–80* (Rochester, NY, 1983), 114.

19. See Victor Burgin's discussion of this in his introduction to *The Remembered Film* (London, 2005), 7–28.

20. Sergei Eisenstein would refer to the cinema of the long take as "starism" (stare-ism).

21. Wim Wenders, "Time Sequences, Continuity of Movement: *Summer in the City* and *The Goalkeeper's Fear of the Penalty*" [1971], in *The Logic of Images* (London, 1991), 3–6.

22. See for example Michelangelo Antonioni's loose trilogy *L' Avventura*, *La Notte* (both 1961), and *L'Eclisse* (1962).

23. In fact, Wearing hired actors to play police officers.

24. James Coleman, *La Tache aveugle* (1978–90).

25. See Campany, "Safety in Numbness." See also Peter Wollen, "Vectors of Melancholy," in Ralph Rugoff, ed., *The Scene of the Crime* (Cambridge, MA, and London, 1997).

26. Fredric Jameson sees Grant's movements as almost Brechtian in their estrangement. See his "Spatial Systems in *North by Northwest*," in Slavoj Zizek, ed., *Everything You Always Wanted to Know About Lacan . . . But Were Afraid to Ask Hitchcock* (London, 1992), 47–72.

27. Laura Mulvey notes that in the melodramas of Douglas Sirk, for example, the actors' performances are "slightly marionette-like . . . to privilege gestures and looks, suspended in time." Laura Mulvey, *Death 24x a Second: Stillness and the Moving Image* (London, 2005), 146.

28. Robert Bresson, *Notes on the Cinematographer* [1975] (London, 1986), 4, 22.

29. Cinema has endless versions of this scene. Two of the best known are from films by Michael Powell and Emeric Pressburger. In *Black Narcissus* (1946), Kathleen Byron plays a troubled nun with murderous passions. In the dénouement she bursts through a convent door and stands there charged with rage. Her habit and veil are gone and she stares wild-eyed into the camera, her hair dancing in the mountain air. In *A Canterbury Tale* (1944), Sheila Sim stops on a hilltop on the Pilgrim's Way, seeming to hear sounds from the time of Chaucer. In the wind, she listens intently.

30. Katherine Albert, "A Picture That Was No Picnic: Lillian Gish Has Something to Say about the Location Tortures Accompanying the Filming of *The Wind*," *Motion Picture Magazine* (October 1927).

31. Harold Evans, *Pictures on a Page: Photojournalism, Graphics, and Picture Editing* (London, 1978)

32. Mike Leigh presents a similar sequence in *Secrets and Lies* (1996) in which a High Street studio photographer provokes momentary mirth in his awkward or unhappy sitters. With practiced speed he snaps their smiles, fixing forever images of happiness that last barely longer than the camera's click.

33. Roland Barthes, "The Face of Garbo" (1956), in *Mythologies* (New York, 1972).

34. Truffaut was well aware of the potentially overpowering effects of the freeze but continued to explore its potential:

> It can quickly get to be a gimmick. I stopped doing it as a visual effect after a few films. Now I use freeze frames as a dramatic effect. They're interesting provided viewers don't notice. It takes eight frames for a [still] shot to be noticed. A shot under eight frames is virtually unreadable. Unless it's a big close-up. So what I try to do now—in *La Peau Douce*, which I find satisfactory is to freeze the image for only seven or eight frames instead of like here [Jeanne Moreau's frozen poses in *Jules et Jim*] which are frozen for thirty to thirty-five frames. So when it's a simple look frozen for seven frames it has real dramatic intensity. You can't say, just looking at it, unless you're an editor or director, "Hey a freeze frame! I'm interested in invisible effects now. (Jean-Pierre Chartier, interview with François Truffaut in the short film *François Truffaut ou l'esprit critique*, 1965)

In Truffaut's *Jules et Jim* (1962), Jeanne Moreau's character flirts with her boyfriends *and* the camera. She strikes a run of poses as if for a photographer and Truffaut freezes the frame briefly each time, catching the chance abandon in her hair.

11. THE ANNIHILATION OF TIME AND SPACE

1. Early on, someone asserted that Muybridge changed his name all at once upon emigrating in the 1850s, and this fiction has routinely been repeated since. Robert Bartlett Haas (*Muybridge: Man in Motion* [Berkeley: University of California Press, 1976]) and Gordon Hendricks (*Eadweard Muybridge: Father of the Motion Picture* [New York: Viking, 1975]) correctly point out that Muggeridge became Muygridge in the 1850s, and only in the 1860s Muybridge, but for unknown reasons they subscribe to the notion that he became Eadweard at the same time he became Muygridge (sometimes even putting "sic" next to a plethora of documents that give the photographer's name as Edward). Court documents, newspaper and magazine articles, Muybridge's own applications for patents, and letters in his own hand through the end of the 1870s refer to him as Edward, Edw., or E. J.; in Central America in 1875 he called himself, with his usual flourish, Eduardo Santiago Muybridge. Neither in signatures nor in advertisements and court documents does Eadweard appear until after 1881. He often chose to go by his surname alone—and having made it up himself, it was a sufficient distinction. Only Anita Ventura Mozley notes, in her introduction to the Dover *Muybridge's Complete Human and Animal Locomotion,* that Muybridge did not deploy the name Eadweard until then; she pinpoints it to his March 1882 presentation before the Prince of Wales in London. But in his 1883 lawsuit against Stanford and an 1883 patent he is still Edward, though the Anglo-Saxon spelling of the name crops up regularly thereafter and appears on his letterhead by the end of the decade and his later publications. For a certainty, he was an Edward while he was a Californian, and he was likely an Eadweard by the time he was a Pennsylvanian.
2. Tarkovsky, in Ian Christie, *The Last Machine: Cinema and the Birth of the Modern World* (London: BBC Educational Developments, 1994), 12.
3. "Like a bullet shot through a book" is a metaphor drawn from another photographer, Richard Misrach, whose Playboys series of photographs shows *Playboy* magazines used for target practice in the desert. Misrach has commented that in shooting at the women on the covers, the gunman or -men pierced the entire culture: his pictures show punctured landscapes, male celebrities, and more women.
4. Kingston details based on visit to the sites; Haas, *Muybridge,* and Hendricks, *Eadweard Muybridge,* accounts; and information from the Kingston-upon-Thames Local History Room.
5. Family details from letters from Norma Selfe in New South Wales to Robert Haas in the 1960s, now at the Kingston-upon-Thames Local History Room with the rest of Haas's extant Muybridge papers. Much of Selfe's correspondence consists of her hand-copied extracts from documents by Muybridge's cousin Maybanke Susannah Anderson.
6. Anderson, in manuscript copied out by Selfe.
7. Frances Ann Kemble, *Records of a Girlhood* (New York: Henry Holt, 1879), 283.
8. Much of the background on the transformative experience of the railroad comes from Wolfgang Schivelbusch's brilliant *The Railway Journey: The Industrialization of Time and Space in the Nineteenth Century* (Berkeley and Los Angeles: University of California Press, 1986).
9. Ulysses S. Grant, in Stephen Ambrose, *Nothing Like It in the World: The Men Who Built the Transcontinental Railroad* (New York: Simon and Schuster, 2000), 85.
10. Kemble, *Records of a Girlhood,* 298.
11. Kemble, *Records of a Girlhood,* 278.
12. Emerson, in John F. Kasson, *Civilizing the Machine* (New York: Grossman, 1976), 120.
13. See Leo Marx, *The Machine in the Garden* (New York: Oxford University Press, 1964), 194: "No stock phrase in

the entire lexicon of progress appears more often than the 'annihilation of space and time,' borrowed from one of Pope's relatively obscure poems ('Ye Gods! annihilate but space and time, / And make two lovers happy')."

14. Kemble, *Records of a Girlhood*, 284.
15. Scrope, in Claude C. A. Britten Jr., *The Abyss of Time* (San Francisco: Freeman, Cooper, 1980), 153.
16. Morse, in Michel Frizot, *A New History of Photography* (Cologne: Koneman, 1998), 28.
17. Karl Marx, *Grundrisse: Foundations of the Critique of Political Economy* (New York: Penguin, 1973), 539–40.
18. "The Nightingale": Hans Christian Andersen, translated by Zvi Har'El, found at http://HCA.gilead.org.il/nighting .html.
19. Marx, *Machine in the Garden*, 27.
20. Walter Benjamin, "Theses on the Philosophy of History," in *Illuminations* (New York: Schocken, 1968), 262.
21. George Eliot, *Adam Bede* (New York: Penguin, 1980), 557.
22. Holmes, in "The Stereoscope and the Stereograph," *Atlantic Monthly*, June 1859, 747.

15. FLATNESS/DEPTH. STILL/MOVING. PHOTOGRAPHY/CINEMA

1. Erwin Panofsky, *Perspective as Symbolic Form*, 5th ed., trans. Christopher S. Wood (Brooklyn, NY: Zone Books, 1991), 30–31. This work was written in 1924–25 and first published in 1927.
2. Panofsky discusses Van Eyck's *Madonna of Canon van der Paele*, http://commons.wikimedia.org/wiki/File:Jan_ van_Eyck_069.jpg. Panofsky, *Perspective as Symbolic Form*, 60–61.
3. For this photo, see Atlanta Celebrates Photography, "Abelardo Morell Exhibition Opens at High Museum of Art, Feb. 23," *ACP Blog*, February 19, 2014, http://acpinfo.org/blog/wp-content/morell_large.jpg. The image can also be found on Morell's own site http://www.abelardomorell.net/photography/cameraobsc_01/cameraobsc_12 .html and on the cover of Abelardo Morell, *Camera Obscura* (New York: Bulfinch, 2004).
4. For an image of the work, see Vera Lutter, "San Marco, Venice, III: November 9, 2005," *Venice, 2005–2008*, Works, http://veralutter.net/works_venice_6.php.
5. For an example of Wittgenstein's duck-rabbit, see http://worldthought.com/uploads/gallery/category_7/gallery _1_7_321.gif.
6. Ludwig Wittgenstein, *Philosophical Investigations*, trans. G. E. M. Anscombe, (New York: Macmillan, 1968), 194–96.
7. Richard Wollheim, *Painting as an Art (A. W. Mellon Lectures in the Fine Arts)* (Princeton NJ: Princeton University Press, 1987).
8. James J. Gibson, *The Ecological Approach to Visual Perception* (New York and London: Taylor and Francis, 1986), 291.
9. James J. Gibson, *The Senses Considered as Perceptual Systems* (Boston: Houghton Mifflin, 1966; Westport, CT: Greenwood Press, 1983), 33, 54.
10. For an image of the work, see Simon Norfolk, *Tibetan Refugees in the Dhauladhar Range, Himalayas, Northern India* (2004), http://www.artnet.com/artists/simon-norfolk/tibetan-refugees-in-the-dhauladhar-range-a- 190T7wXfakOgZ2-leH3XAA2.
11. Shigera Tsuji, "Brunelleschi and the Art of the Camera Obscura: The Discovery of Pictorial Perspective," *Art History* 13 (1990).
12. Friedrich Kittler, *Optical Media* (Cambridge, UK, and Malden, MA: Polity Press, 2010), 11.
13. Gibson, *The Ecological Approach*, 241.
14. Gibson, *The Ecological Approach*, (epigraph) 244.
15. J. J. Gibson, "Optical Occlusion and Edge-Information in an Optic Array" (unpublished manuscript, March 1967), http://www.trincoll.edu/depts/ecopsyc/perils/folder3/occlusion.html.
16. Gibson, *The Ecological Approach*, 265.
17. For examples from Gary Beydler's *Pasadena Freeway Stills*, see Benjamin Lord, "Gary Beydler (1944–2010)," *X-TRA* 13, no. 3 (Spring 2011), http://x-traonline.org/article/gary-beydler-1944–2010/.
18. Gibson, *The Ecological Approach*, 293.

17. MOVING AWAY FROM THE INDEX

1. Charles Sanders Peirce, "Prolegomena to an Apology for Pragmaticism," in *Peirce on Signs*, ed. James Hoopes, (Chapel Hill: University of North Carolina Press, 1991), 251.
2. *Philosophical Writings of Peirce*, ed. Justus Buchler (New York: Dover, 1955), 106–11.
3. *Philosophical Writings of Peirce*, 108.
4. In a series of carefully argued and provocative articles, historian and theorist of photography Joel Snyder has

questioned the usefulness of the index argument in describing photography: Joel Snyder, "Picturing Vision," *Critical Inquiry* 6 (1980): 499–526; Joel Snyder, "Pointless," in *Photography Theory*, ed. James Elkins (New York: Routledge, 2006), 369–400; Joel Snyder, "Res Ipsa Books Loquitur," *Things That Talk: Object Lessons from Art and Science*, ed. Lorraine Daston (New York: Zone, 2004), 195–222; Joel Snyder, "Visualization and Visibility," in *Picturing Science, Producing Art*, ed. Peter Galison and Caroline Jones (London: Reaktion, 1998), 379–400; Joel Snyder and Neil Walsh Allen, "Photography, Vision, and Representation," *Critical Inquiry* 2 (1975): 143–69.

5. Peter Wollen, "The Semiology of the Cinema," *Signs and Meaning in the Cinema* (Bloomington: University of Indiana Press, 1969), 125–26.

6. For a recent reevaluation of Bazin, once dismissed as a naïve realist, one could cite Philip Rosen, *Change Mummified: Cinema, Historicity, Theory* (Minneapolis: University of Minnesota Press, 2001), especially 1–42.

7. I use here the translation proposed by Daniel Morgan in his essay "Rethinking Bazin: Ontology and Realist Aesthetics," *Critical Inquiry* 34 (2006): 441–81, which revises the widely available translation by Hugh Gray: André Bazin, "The Ontology of the Photographic Image," in *What Is Cinema?* ed. and trans. Hugh Gray (Berkeley: University of California Press, 1967), 1:9–16. Gray translates this as "a decal or transfer" (Bazin "Ontology," 14). The original French is "transfert de réalité de la chose sur la reproduction" and "un décalique approximatif" (André Bazin, "Ontologie de l'image photographique," in *Qu'est-ce que le cinéma?* vol. 1, *Ontologie et langage* [Paris: Cerf, 1958], 16). Unless otherwise noted, translations are Gray's.

8. Again, this is Morgan's revised translation ("Rethinking Bazin," 450). Gray states, "The photographic image is the object itself, the object freed from the conditions of time and space that govern it. No matter how fuzzy, distorted, or discolored, no matter how lacking in documentary value the image may be, it shares, by virtue of the very process of its becoming, the being of the model of which it is the reproduction; it is the model" (Bazin, "Ontology," 14). Morgan discusses the misinterpretation inherent in Gray's addition of the phrase "and space" (absent in Bazin) in "Rethinking Bazin." The original French reads "cet objet lui-même, mais libéré des contingences temporelles. L'image peut être floue, déformée, décolorée, sans valeur documentaire, elle procède par sa genèse de l'ontologie du modèle; elle est le modèle" (Bazin, "Ontologie," 16).

9. Bazin, "Ontologie," 18.

10. André Bazin, "Theater and Cinema: Part Two," in *What Is Cinema?* ed. and trans. Hugh Gray, vol. 1 (Berkeley: University of California Press, 1967), 96. In the original French: "Le photographe procède, par l'intermédaire de l'objectif, à une veritable prise d'empreinte lumineuse: à un moulage. Comme tel, il emporte avec lui plus que la resemblance, une sorte d'identité . . . " André Bazin, *Qu'est-ce que le cinéma?* vol. 2, *Le cinéma et les autres arts* (Paris: Editions du Cerf, 1958–62), 91.

11. Wollen, "Semiology of the Cinema," 125–26.

12. Wollen, "Semiology of the Cinema," 126.

13. Thomas Gunning, "What's the Point of an Index? Or Faking Photographs," in *Still Moving*, ed. Karen Beckman and Jean Ma (Durham, NC: Duke University Press, 2008), 23–40.

14. Morgan, "Rethinking Bazin."

15. Bazin, "Ontology," 114.

16. Noel Carroll, *Philosophical Problems of Classical Film Theory* (Princeton, NJ: Princeton University Press, 1988), 10–15.

17. Quoted in Bernard Chardère, *Le roman des lumières* (Paris: Gallimard, 1995), 313.

18. Key essays by Dulac and Epstein can be found in Richard Abel, ed., *French Film Theory and Criticism: 1907–1939, A History/Anthology*, 2 vols., trans. Stuart Liebman (Princeton, NJ: Princeton University Press, 1988). An excellent selection of Eisenstein's essays is in *Eisenstein on Disney*, ed. and trans. Jay Leyda (London: Methuen, 1988); and Sergei Eisenstein, *Film Form: Essays in Film Theory*, ed. and trans. Jay Leyda (New York: Harcourt, 1949).

19. Germaine Dulac, "Aesthetics, Obstacles, Integral *Cinégraphie*," in *French Film Theory and Criticism: 1907–1929*, ed. Richard Abel, trans. Stuart Liebman, vol. 1 (Princeton, NJ: Princeton University Press, 1988), 394. The French original appears in Germaine Dulac, *Écrits sur le cinema, 1919–1937*, ed. Prosper Hillairet (Paris: Paris Expérimental, 1994), 98–105.

20. The recuperation of motion in contemporary film theory will immediately evoke Deleuze's two-volume philosophical work *Cinema 1: The Movement Image*, trans. Hugh Tomlinson and Barbara Habberjam (Minneapolis: University of Minnesota Press, 1986) and *Cinema 2: The Time Image*, trans. Tomlinson and Habberjam (Minneapolis: University of Minnesota Press, 1989). There is much to learn from this work, although its background in and understanding of itself as an essay in philosophy, rather than film theory or history, should be taken seriously. I do not want to undertake a full-scale discussion of Deleuze's work here, since I feel that would pull us away from the issue of movement to a consideration of Deleuze's methods, terms, and assumptions. As Deleuze announces about his work in his preface, "This is not a history of the cinema. It is a taxonomy, an attempt at

the classification of images and signs" (1:xiv). Although a number of Deleuze's taxonomic distinctions provide insights into cinematic motion, an in-depth discussion of them would lead us astray from this issue. I want instead to consider the discussion of cinematic motion that preceded Deleuze, emerging primarily from film practice and theory. Most of the issues I want to raise here, while having a relation to Deleuze, remain marginal to his discussions, while they are central to the earlier theorists I will refer to. The best treatment of Deleuze's book, fully informed of the history and theory of film, is D. N. Rodowick, *Gilles Deleuze's Time Machine* (Durham, NC: Duke University Press, 1997).

21. Notably, Deleuze devotes no real discussion to animation.

22. A key essay in this regard by Eisenstein would be "Methods of Montage," in *Film Form*, 72–83.

23. See also Maya Deren, *Essential Deren: Collected Writings on Film*, ed. Bruce R. McPherson (Kingston, NY: Documentext, 2005).

24. A fine collection of Brakhage's writing is *Essential Brakhage: Selected Writings on Filmmaking*, ed. Bruce R. McPherson (Kingston, NY: Documentext, 2001). See also the discussions of Brakhage in P. Adams Sitney, *Visionary Films: The American Avant-Garde, 1943–2000* (New York: Oxford University Press, 2001); and P. Adams Sitney, *Eyes Upside Down* (New York: Oxford University Press, 2008).

25. Siegfried Kracauer, *Theory of Film: The Redemption of Physical Reality* (Princeton, NJ: Princeton University Press, 1960), 41–45.

26. Kracauer, *Theory of Film*, 43–45.

27. Kracauer, *Theory of Film*, 27. Morgan's detailed discussion of the camera movement in Rossellini's *Voyage to Italy* in "Rethinking Bazin," 465–68, shows one way camera movement can function within Bazin's realist aesthetic.

28. Christian Metz, "On the Impression of Reality in the Cinema," *Film Language: A Semiotics of the Cinema*, trans. Michael Taylor (New York: Oxford University Press, 1974), 4–5.

29. Metz, "On the Impression of Reality," 6.

30. Bazin, "Evolution," in *What Is Cinema?* 1:36.

31. Metz, "On the Impression of Reality," 4.

32. Metz, "On the Impression of Reality," 5.

33. Metz, "On the Impression of Reality," 7.

34. Metz, "On the Impression of Reality," 8.

35. Metz, "On the Impression of Reality," 9.

36. Henri Bergson, *Creative Evolution*, trans. Arthur Mitchell (Lanham, MD: University Press of America, 1983), 308. The discussion of motion extends over pages 297–314.

37. Metz, "On the Impression of Reality," 13.

38. Metz, "On the Impression of Reality," 8.

39. Would a focus on movement entail a proscriptive definition that all films must include motion? Insofar as we are referring to the movement of the apparatus, the film traveling through the projector gate, this might be tautological. Duration as a measure of this motion of the film certainly provides the sine qua non for cinematic motion and all cinema, technically defined. However, I think we can certainly conceive of films that exclude motion, made entirely of still images. Interestingly, many films that use still images seem to do so to comment on movement. Clearly, the dialectical relation between stillness and movement provides one of the richest uses of motion in film. But I think it would be an essentialist mistake to assume a film could not avoid cinematic motion, even if the examples of such are very rare and possibly debatable.

40. Metz, "On the Impression of Reality," 15.

41. Eisenstein, *Eisenstein on Disney*, 27.

42. See my discussion of Gollum and CGI-generated characters in "Gollum and Golem: Special Effects and the Technology of Artificial Bodies," in *From Hobbits to Hollywood: Essays on Peter Jackson's* Lord of the Rings, ed. Ernest Mathijs and Murray Pomerance (Amsterdam: Rodopi, 2006).

43. Danto discussed this more than a decade ago at the Columbia Film Seminar in New York City. He specifically referred, as I recall, to the way Mickey Mouse and other cartoon characters often have fewer than five fingers but cogently convey the role of the hand in grasping. If my memory is faulty, I apologize to Mr. Danto (with humble admiration).

44. Eisenstein, *Eisenstein on Disney*, 21.

45. Metz, "On the Impression of Reality," 14.

46. Laura Mulvey, *Death 24x a Second: Stillness and the Moving Image* (London: Reaktion, 2006), especially 54–66.

47. Metz, "On the Impression of Reality," 15.

48. Kracauer's arguments for the realist mission of cinema, although also based in its photographic legacy, most certainly exceeds, if it implies at all, the index.

26. GOOGLE STREET VIEW

The subtitle is a paraphrasing of a John Szarkowski quote, "the world as a studio," from the documentary *Walker Evans's America*, spoken while the famous "STUDIO" picture is shown on the screen.

1. Stan Douglas, "Midcentury Studio" in Stan Douglas, *Midcentury Studio*, ed. Tommy Simoens, with essays by Christopher Phillips and Pablo Sigg (New York: Ludion, 2011), 6.

28. ON

1. The first commercially available professional digital camera was Logitech's Fotoman, introduced in 1990, followed by Kodak's introduction of the DCS-100 in 1991. However, by the mid-1990s, camera makers Fuji, Canon, Nikon, Olympus, and Minolta had all entered the commercial race with many new advancements. Further, electronic houses, such as Sony, and print-technology houses, such as Epson, had entered the market with competing models targeted to replace film cameras. A concise historical summary, "Photos: The History of the Digital Camera," by Rich Trenholm for CNET (November 5, 2007) can be viewed, as of August 2014, at http://www.cnet.com/uk/news/photos-the-history-of-the-digital-camera/.

2. Craigslist, which originated as an e-mail list in the San Francisco Bay Area in 1995, grew into a regional online site in 1996, and eventually went national in 2000, expanding globally over the following years. Although its personals section thrives today, its "adult services" section was removed in 2010 due to ongoing accusations that it facilitated illegal activities, specifically prostitution. Craigslist is critical as a hub for use of the self-shot, discussed later in this essay.

3. The key importance of the social network in the context of this essay lies in the dominant role of images within user profiles. Currently, Facebook reports over 60 billion images within its network; this is six times the number of images archived on Google image search. Further, the platform of social networks has proved to offer new avenues for image exchange, fadding, and trending, which this essay will look at more closely.

4. At first, there was only one true channel (or imageboard): 2chan, which had been launched in Japan in 1999. However, it could be argued that proto-chans existed on pre-WWW networks, and early WWW bulletin boards systems (BBS) that allowed for the posting of images and ASCII art. (ASCII, dating from approximately 1963, is a graphic design technique that uses computers for presentation and consists of pictures pieced together from the ninety-five printable characters.)

5. The term *image macro* can be traced back to Something Awful Forums, which used the term *macros* to refer to earlier applications of images on Usenet, a bulletin-board-like system that predates the World Wide Web.

6. Internet slang, also known as chatspeak, SMS (short message service) speak, IM (instant messaging) language, or leetspeak, is defined as written, abbreviated slang used to get common terms across faster; for example, "away from keyboard" became AFK.

7. The image macro's form commonly consists of a photograph with text (white, 48-point Impact font with a black five-pixel stroke) superimposed on an image via Photoshop.

8. There are conflicting histories of the origin of *O RLY?* However, the most reliable sources point to the Something Awful Forums as its initial incubator in August 2003. Nevertheless, it is logical to assume that the term was floating around on other boards at the same time and may have been used elsewhere at an earlier date. The photograph of the owl was originally taken by nature photographer John White in 2001 and posted on an animal newsgroup in 2001.

9. Here the word *complexity* means the quality of having "a group of culture traits relating to a single activity" (Merriam-Webster) as opposed to its analog use as a document or commercial representation.

10. The reaction face is also known by the acronym MFW (My Face When), which is an important distinction within a thread where reaction might relate only to prior posts. For example, the use of MFW allows the user to point to an issue outside of thread: for example, "MFW Jackson was pronounced dead."

11. The concept of the performative utterance was introduced by language philosopher J. L. Austin in his book *How to Do Things with Words,* wherein he defines a type of sentence that does something in the world rather than describing something about the world. A brief summary of Austin's position can be found at http://www.stanford.edu/class/ihum54/Austin_on_speech_acts.htm.

12. It is important to differentiate between the superimposition of slang onto an image, as in fig. 28.1, and the formation of images as language; the former is fundamentally illustrative, whereas the latter functions as an independent semantic unit.

13. David McRaney's very insightful and informative brief essay appeared on icanhascheezburger. The entire essay

can be read here: http://icanhascheezburger.com/2007/05/08/a-special-in-depth-analysis-by-david-mcraney-l337
-katz0rz/.

14. The use of "anon" here is a direct reference to user posting on 4chan, commonly regarded as "anon," for anony-
mous poster.

15. The removal of the imposed text from an image macro is a hypothetical occurrence based on pattern develop-
ment in slang. This position proposes that certain macros will shed their textual counterpart once fully estab-
lished. For example, the extreme smile paired with DO IT FAGGOT (fig. 28.1), or the screaming face paired with
MOAR! (fig. 28.3) will eventually operate without textual counterparts while maintaining their legibility.

16. Here "idiom" refers to specific visual cues that are proprietary to subcultures such as lolcats or bronies (for a
brony overview, go to Angela Watercutter, "*My Little Pony* Corrals Unlikely Fanboys Known as 'Bronies,'" *Wired,*
June 9, 2011, http://www.wired.com/underwire/2011/06/bronies-my-little-ponys/). "Broader topics" refers to
other macros, such as Pedobear (for Pedobear overview, go here: http://knowyourmeme.com/memes/pedobear)
or other trending/fadding/fanboy topics such as the movie *Avatar*.

17. The origin of the acronym TOGTFO can be traced to 4chan circa 2006 and was first posted in a response to a
woman posting a picture of herself, which could be followed by any kind of question or statement. The phrase's
misogyny is an outgrowth of "There are no girls on the Internet," a tongue-in-cheek adage that can be traced to
the male-prevalent days of Usenet, particularly to its virtual Multi-User Dungeons (MUDs), a genre of text-based
online role-playing games.

18. To understand the specifics of systemic-functional linguistics, see *Language as Social Semiotic: The Social Inter-
pretation of Language and Meaning* (Baltimore: University Park Press, 1978), wherein Michael Halliday proposes
that the semiotic resources of language are shaped by how people use them to make meaning, emphasizing their
social functions.

19. This brief summary is borrowed from Carol A. Chapelle's essay "Some Notes on Systemic-Functional Linguis-
tics," October 28, 1998, which can be read in its entirety here: http://www.public.iastate.edu/~carolc/LING511/
sfl.html.

20. A deictic center is a set of theoretical points to which a deictic expression is "anchored," in such a way that the
evaluation of the expression's meaning leads to the relevant point. As deictic expressions are frequently egocen-
tric, the center often consists of the speaker at the time and place of the utterance and, additionally, the place
of the discourse and relevant social factors. For a full explanation as it pertains to linguistics, see Stephen C.
Levinson, "Deixis," in *Pragmatics* (Cambridge: Cambridge University Press, 1983), 54–96.

21. The complete history of early BBS, forum, and chat spaces is extensive, and further reading is recommended.
However, for the purposes of this position, the culmination of many of these communities and their cultural
influences points to 4chan, specifically its /b/, or "random" page.

29. SHARING MAKES THE PICTURE

1. Somini Sengupta, "Facebook Shows Off New Home Page Design, including Bigger Pictures," *New York Times,*
March 7, 2013.

2. Jonathan Good, "How Many Photos Have Ever Been Taken?" *1000 Memories Blog*, September 15, 2011, http://
blog.1000memories.com/94-number-of-photos-ever-taken-digital-and-analog-in-shoebox.

3. Rich Miller, "Facebook Builds Exabyte Data Centers for Cold Storage," Data Center Knowledge, January 18, 2013,
http://www.datacenterknowledge.com/archives/2013/01/18/facebook-builds-new-data-centers-for-cold-storage/.

4. Chas Edwards, "Can Companies Create Engagement for the Exploding Imagesphere Online?" Voice: Moving
Pictures, *Adweek*, February 4, 2013, http://www.adweek.com/news/advertising-branding/voice-moving-pictures-
146975.

5. Billy Gallagher, "Snapchat Raises $13.5M Series A Led by Benchmark, Now Sees 60M Snaps Sent per Day,"
TechCrunch, February 9, 2013, http://techcrunch.com/2013/02/08/snapchat-raises-13-5m-series-a-led-by
-benchmark-now-sees-60m-snaps-sent-per-day.

6. Dong-Hoo Lee, "Digital Cameras, Personal Photography and the Reconfiguration of Spatial Experiences," *Infor-
mation Society* 26, no. 4 (July/August 2010): 266–75.

7. Connie Malamed, "Social Media and the New Meaning of Photographs," Understanding Graphics: Design for the
Human Mind, n.d., http://understandinggraphics.com/brainy/social-media-and-the-new-meaning-of-photographs/.

8. Lee, "Digital Cameras," 268.

9. Nancy Van House, Marc Davis, Morgan Ames, Megan Finn, and Vijay Viswanathan, "The Uses of Personal Net-
worked Digital Imaging: An Empirical Study of Cameraphone Photos and Sharing," *CHI 2005 Extended Abstracts
on Human Factors in Computing Systems* (New York: Association for Computing Machinery, 2005), 1856.

10. Karen Rosenberg, "Everyone's Lives, in Pictures," *New York Times*, April 21, 2012.

11. Anne Oeldorf-Hirsch and S. Shyam Sundar, "Online Photo Sharing as Mediated Communication" (paper presented to the Communication and Technology Division at the 60th Annual Conference of the International Communication Association, Singapore, June 22–26, 2010).

12. Chris Schreiber, interview by Grant Crowell, "What Motivates Us to Share Videos? The Psychology behind Social Video," ReelSEO, July 21, 2011, http://www.reelseo.com/social-video-psychology/.

13. Angela Paradise, "Picture Perfect? College Students' Experiences and Attitudes Regarding Their Photo-Related Behaviors in Facebook," chap. 13 in *Misbehavior in Online Higher Education*, vol. 5, *Cutting Edge Technologies in Higher Education* (Bingley, UK, 2012), 261–92.

14. danah m. boyd and Nicole B. Ellison, "Social Network Sites: Definition, History and Scholarship," *Journal of Computer-Mediated Communication* 13, no. 1 (2007): 210–30.

15. Rebecca Gullota, Haakon Faste, and Jennifer Mankoff, "Curation, Provocation, and Digital Identity: Risks and Motivations for Sharing Provocative Images Online" (paper presented at CHI 2012, Austin, TX, May 5–10, 2012), 1.

16. Nancy Van House, Marc Davis, Yuri Takhteyev, Nathan Good, Anita Wilhelm, and Megan Finn, "From 'What' to 'Why': The Social Uses of Personal Photos" (paper presented at CSCW '04, Chicago, IL, November 6–10, 2004).

17. Guy Stricherz, *Americans in Kodachrome, 1945–65* (Santa Fe: Twin Palms, 2002). Alex Williams, "Here I Am Taking My Own Picture," *New York Times*, February 19, 2006.

18. One of the first documented appearances of "Use a picture. It's worth a thousand words" was in a 1911 newspaper article quoting newspaper editor Arthur Brisbane discussing journalism and publicity: "Speakers Give Sound Advice," *Syracuse Post Standard*, March 28, 1911, 18.

19. David Crandall, "Networks of Photos, Landmarks, and People," *Leonardo* 44, no. 3 (2011): 240–43.

20. Paradise, "Picture Perfect?"

21. Gullota, Faste, and Mankoff, "Curation, Provocation," 3.

22. Fred Ritchin, interview by Brian Palmer, photographs by Mary Ellen Mark, "Fred Ritchin Awakening the Digital," *FOAM* 21 (Winter 2009): 22–26.

23. Ritchin, "Fred Ritchin Awakening the Digital."

24. Miller, "Facebook Builds Exabyte Data Centers."

25. Oliver Grau and Thomas Veigl, *Imagery in the 21st Century* (Cambridge, MA: MIT Press, 2011), 15.

31. CAPTURE/CURATE </> TOUCH/PLAY

1. Remastered Dreams collective (Claudine Boeglin, Peter Norrman, Todd Weinstein, and Steve Zehentner), *Skin Branding* (December 2006), Vimeo video, 20:23, accessed April 20, 2014, http://vimeo.com/32606215. *Skin Branding* was conceived as a participatory media around youth and subcultures. The video project initiates a conversation with eight people about their tattoos. The interviews, assembled into a twenty-minute short documentary, channel the voices of the youth to investigate social expression, cultural phenomena, and urban trends in real time.

2. Glenn Greenwald, conversation with Bill Keller, "Is Glenn Greenwald the Future of News?" *New York Times*, October 27, 2013, http://www.nytimes.com/2013/10/28/opinion/a-conversation-in-lieu-of-a-column.html?_r = 0. Conversation between journalist Greenwald, known for having broken the Edward Snowden news, and *New York Times* journalist Keller about "partisan journalism" versus non-bias journalism.

3. *Dirty Wars*, directed by Richard Rowley, written by Jeremy Scahill and David Riker (New York: Civic Bakery/Big Noise Films, 2013), various formats at http://dirtywars.org/the-film. *Dirty Wars* is an American documentary film based on the book *Dirty Wars: The World Is a Battlefield* by investigative journalist Jeremy Scahill; the film follows American covert wars in Afghanistan, Yemen, Somalia, and elsewhere.

4. *Cuba—1959: The Revolution*, photographs and comments by Burt Glinn (New York: Magnum Photos, 2006), http://inmotion.magnumphotos.com/essay/revolution. Magnum photojournalist Glinn left for Cuba in a tuxedo when he heard the news of the revolution at a party in Manhattan. In the midst of the protests, he was lifted up and lost his shoes. In his book *Havana: The Revolutionary Moment* (New York: Umbrage Editions; Manchester, UK: Dewi Lewis, 2000), he appears chewing a cigar and holding a gun over his head in sign of victory, which was a controversial statement in the world of non-bias journalism.

5. *Global Reporting Room*, creative director Claudine Boeglin, executive producer Paul Pangaro (New York: globalreportingroom.com, 2010), https://vimeo.com/channels/globalreportingroom. This web documentary brought together students in interaction design at the School of Visual Arts and experts in media to define journalism's future. The Global Reporting Room project aims to create a model ecosystem and an open source platform of growing knowledge in print, film, and digital and social media to empower citizen journalism.

6. Scott Macaulay, "Five Questions with *Mark Lombardi: Death-Defying Acts of Art and Conspiracy* Director Marieke

Wegener," *Filmmaker*, September 13, 2012, http://filmmakermagazine.com/51920-five-questions-for-mark-lombardi
-death-defying-acts-of-art-and-conspiracy-director-mareike-wegener/.

7. Humberto Maturana, "Metadesign," August 1, 1997, http://www.inteco.cl/articulos/006/texto_ing.htm. Maturana
is a Chilean biologist and cybernetician who has influenced the understanding of biology, cognition, language, and
social interactions. His conceptualization of the term *metadesign* is that we can determine what technology is and
does.

8. For more info on the now-defunct Chicagocrime.org, see Adrian Holovaty, http://www.holovaty.com/writing/
chicagocrime.org-tribute/.

9. Chris Hurtt: Character Animator, http://www.chrishurtt.com/CHRIS_HURTT/CHRIS_HURTT_-_CHARACTER
_ANIMATION.html.

10. Dr. Gary Slutkin (http://cureviolence.org/post/staff/gary-slutkin/) is a physician, epidemiologist, infectious
disease control specialist, and founder and executive director of Cure Violence. Recognized as an innovator
in violence prevention, Dr. Slutkin sees the issue of violence as fundamentally misdiagnosed. Cure Violence
approaches violence as a disease and uses the same science-based strategies used to fight epidemic diseases.

11. Magnum In Motion (http://www.magnuminmotion.com), founded in New York in 2004, is the multimedia
digital studio of Magnum Photos and assembles visual narratives using photography, audio, video, and motion
graphics.

12. Gilles Peress is a Magnum documentary photographer whose ongoing project is a cycle of documentary narra-
tives, *Hate Thy Brother*, that looks at intolerance and its consequences. It includes *The Silence: Rwanda* and *Farewell
to Bosnia*. His books include *A Village Destroyed: War Crimes in Kosovo*, *The Graves: Srebrenica and Vukovar*, and
Telex Iran: In the Name of Revolution. "Gilles Peress," Magnum Photos Photographer Portfolio, accessed April 20,
2014, http://www.magnumphotos.com/C.aspx?VP3=CMS3&VF=MAGO31_10_VForm&ERID=24KL53ZNTZ.

32. A POST-PHOTOGRAPHIC MANIFESTO

1. For an example of an ocular telescope, see Vision Care Corporate, "An Ophthalmic First," Vision Care Ophthal-
mic Technologies, 2014, http://www.visioncareinc.net/technology.

2. For more information on Wafaa Bilal's work, see his website: http://wafaabilal.com/.

3. For more information on CNS Computational Neuroscience Laboratories in Kyoto, see their website: http://
www.cns.atr.jp/en/.

4. Yoichi Miyawaki et al., "Visual Image Reconstruction from Human Brain Activity," *Neuron* 60, no. 5 (December
12, 2008).

5. Penelope Umbrico, *Suns (from Sunsets) from Flickr*, 2006–ongoing, http://www.penelopeumbrico.net/Suns/
Suns_Index.html.

33. FEEDBACK MANIFESTO

1. The Internet has been a more effective tool than I think television ever was, but TV remains a major source of
information that may restrict the Web's flexibility if the two systems one day merge. It is important to note that
the emergence of electronic media in the United States (radio, television, Internet) follows a similar pattern:
technological development funded in large part by the government, and particularly the military; dissemination
through "hobbyists" or ad hoc networks; and commercial consolidation by large corporate interests.

2. Susan Sontag, "Against Interpretation" [1964], in *Against Interpretation* (New York: Farrar, Straus & Giroux,
1966), 3–14.

CONTRIBUTORS

AI WEIWEI was born in Beijing, where he lives and works. He attended Beijing Film Academy and later, on moving to New York (1981–1993), continued his studies at the Parsons School of Design. Major solo exhibitions include Martin Gropius Bau (2014), Indianapolis Museum of Art (2013), Hirshhorn Museum and Sculpture Garden, Washington DC (2012), Taipei Fine Arts Museum, Taiwan (2011), Tate Modern, London (2010), and Haus der Kunst, Munich (2009). Architectural collaborations include the 2012 Serpentine Pavilion and the 2008 Beijing Olympic Stadium, with Herzog and de Meuron. Among numerous awards and honors, he won the lifetime achievement award from the Chinese Contemporary Art Awards in 2008 and the Václav Havel Prize for Creative Dissent from the Human Rights Foundation, New York, in 2012; he was made Honorary Academician at the Royal Academy of Arts, London, in 2011.

DOUG AITKEN is a video and installation artist who lives and works in Los Angeles and New York. His work has been featured in numerous solo and group exhibitions around the world, in such institutions as the Whitney Museum of American Art, the Museum of Modern Art, the Vienna Secession, the Serpentine Gallery in London, and the Centre Georges Pompidou in Paris.

GERRY BADGER is a photographer, architect, and photographic critic. He has written extensively for the photographic press and has curated a number of exhibitions, including *The Photographer as Printmaker* (1980) for the Arts Council of Great Britain and *Through the Looking Glass: Postwar British Photography* (1989) for the Barbican Arts Centre, London. His own work is in a number of public and private collections. Among his books are *Collecting Photography* (2002), *The Genius of Photography* (2007), *The Photobook: A History* (with Martin Parr; 3 vols., 2004, 2006, and 2014), and *The Pleasures of Good Photographs* (2010). *The Photobook: A History* was the winner of the Deutsche Fotobuch Preis and the Kraszna Krausz Prize in 2007. *The Pleasures of Good Photographs* won the Infinity Writers' Award of the International Center for Photography, New York, in 2011.

ADAM BELL is a photographer and writer. The coeditor of *The Education of a Photographer*, his writings have appeared in numerous publications, including *Afterimage*, *The Brooklyn Rail*, *The Art Book Review*, *FOAM Magazine*, *photo-eye*, and *Paper Journal*. He is currently on staff and faculty at the MFA Photography, Video and Related Media Department, School of Visual Arts.

CLAUDINE BOEGLIN is a creative director and digital media strategist. She has conceived editorial projects for prominent independent media groups and non-profit organizations such as Lemonde.fr, Magnum Photos, Human Rights Watch,

and the Thomson Reuters Foundation, building up and implementing emerging talents. Her creative palette is photography, video, and design; she uses text as screenplay. Her untraditional approach to journalism designed her for the current digital lab spirit. She was managing editor at *COLORS* (Italy, 1996), co-founder of *Parvaz*, a magazine for Afghan children (Kabul, 2002), co-founder of Magnum in Motion (New York, 2004), and created and directed a multimedia studio at the heart of the Thomson Reuters Foundation (London, 2011–13).

ROBERT BOWEN is an artist, educator, and visual effects expert. In school he studied sculpture, poetry, cinema, and computer science in that order, and immediately thereafter he spent a long time doing pioneering work in digital photography. Though his art is grounded in montage theory, which is also the subject of a class he teaches at the School of Visual Arts, his current projects all involve the problem of how a physical/cultural volume moves through time and space. He also has an interesting collection of pre-cinema devices, and in studying them he became fascinated by how parallax provides a key to understanding the history of visual media and how that concept can be explored computationally.

DAVID CAMPANY is a writer, curator, and artist. He writes mainly about photography, art, and cinema. His books include *Art and Photography* (2003), *Photography and Cinema* (2008), *Jeff Wall: Picture for Women* (2010), *Gasoline* (2013), and *Walker Evans: The Magazine Work* (2014). He also writes for *Frieze, Aperture, Art Review, FOAM Magazine, Source,* and *Tate Etc.* Recent curatorial projects include *Victor Burgin: A Sense of Place* (Ambika P3, London, 2013), *Mark Neville: Deeds Not Words* (The Photographers' Gallery, London, 2013), and *Anonymes: Unnamed America in Photography and Film* (Le Bal, Paris, 2010). Campany has a PhD and is Reader in Photography at the University of Westminster (London), where he teaches at all levels in both photographic practice and theory. He is a recipient of the ICP Infinity Award for his writings on photography.

JOAN FONTCUBERTA's artistic and theoretical activities have focused on the conflicts between nature, technology, and truth. In almost four decades of prolific dedication to photography, he has had solo shows at the Musuem of Modern Art (NY), the Chicago Art Institute, and the Paris MEP, among others. His work is in the collections of the Metropolitan Museum of Art (NY), the National Gallery of Art (Ottawa), and the Centre Georges Pompidou (Paris). He has authored over a dozen books about the history, aesthetics, and epistemology of photography and has curated international exhibitions, both historical and contemporary. In 2013 he was the recipient of the Hasselblad Foundation Award.

HOLLIS FRAMPTON (1936–1984) was a filmmaker, photographer, writer, and teacher. Along with Michael Snow and Stan Brakhage, he was one of the major figures to emerge from the New York avant-garde film community of the 1960s. His many films include *Surface Tension* (1968); *Zorns Lemma* (1970); the *Hapax Legomena* films (1971–72), which include *(nostalgia)* (1971); and the unfinished *Magellan Cycle.* In addition to his films, writing, and photography, Frampton was also an early pioneer in the field of digital art.

JASON FULFORD is a photographer and cofounder of J&L Books. He is a contributing editor at Blind Spot magazine and a frequent lecturer at universities. His monographs include *Sunbird* (2000), *Crushed* (2003), *Raising Frogs for $$* (2006), *The Mushroom Collector* (2010), and *Hotel Oracle* (2013). He is co-editor, with Gregory Halpern, of *The Photographer's Playbook* (2014) and co-author of the photobook for children *This Equals That* (2014).

BOB GIRALDI is an award-winning film and television director. His numerous film, music video, and advertising credits include Michael Jackson's "Beat It," the feature film *Dinner Rush,* and the popular Miller Lite commercials of the '80's. He is a member of the Art Director's Hall of Fame and was honored with the New York International Film Festival's first ever Living Legend Award in 2011. He is currently the chair of the MPS Directing program at the School of Visual Arts.

TOM GUNNING is Edwin A. and Betty L. Bergman Distinguished Service Professor of the Humanities at the University of Chicago in the Department of Art History and the Committee on Cinema and Media. He is author of two books, *D. W. Griffith and the Origins of America Narrative Film* (University of Illinois Press, 1991) and *The Films of Fritz Lang: Allegories of Vision and Modernity* (British Film Institute, 2000), as well as over a hundred articles on early cinema, the avant-garde, film genres, and issues in film theory and history. His publications have appeared in a dozen languages.

MARVIN HEIFERMAN is a curator and writer who has focused on the influence of photographic images on culture and history in projects such as *Fame after Photography* at the Museum of Modern Art, New York (1999) and *Image World: Art and Media Culture* at the Whitney Museum of American Art (1989). A contributing editor to *Art in America,* he

serves on the faculty of both the International Center of Photography/Bard College and the School of Visual Art's MFA programs in photography. He was creative consultant to the Smithsonian Photography Initiative from 2005 to 2011, during which time he conceptualized and curated *click! photography changes everything* (click.si.edu). He is the editor of numerous books on photography including the recent *Photography Changes Everything* (2012).

TOM HUHN is the chair of the Art History and BFA Visual & Critical Studies Departments at the School of Visual Arts in New York City. He received a PhD in philosophy from Boston University. His books include *Imitation and Society: The Persistence of Mimesis in the Aesthetics of Burke, Hogarth, and Kant; The Cambridge Companion to Adorno; The Wake of Art: Criticism, Philosophy, and the Ends of Taste;* and *The Semblance of Subjectivity: Essays in Adorno's Aesthetic Theory.* His writing has appeared in *New German Critique, Art & Text, Oxford Art Journal, British Journal of Aesthetics, Art Criticism, Telos, Eighteenth-Century Studies, Journal of Aesthetics and Art Criticism, Oxford Encyclopedia of Aesthetics, Philosophy and Social Criticism, Art Book,* and *Art in America.* Huhn is a former Getty and Fulbright Scholar.

ETHAN DAVID KENT is an award-winning creative director who has worked over fifteen years in the industry. In 2008 he was invited to join mcbarrybowen as executive creative director and helped lead them to AdAge Agency of the Year honors in 2009 and 2011. Within six short years he created everything from award-winning mobile apps to groundbreaking social programs to multifaceted cross-platform campaigns for clients such as J. P. Morgan, Chase, Chevron, Central Park Conservancy, Kraft, and the U.S. Olympic Committee. Kent is also an accomplished photographer. His first assignment was touring Cleveland, Ohio, with Randy Macho Man Savage as he promoted his first rap album. He currently runs his own advertising firm, the world is awesome, and lives in New York City with his wife and daughter.

LISA KERESZI grew up in suburban Philadelphia and in 2000 received her MFA from the Yale University School of Art, where she is currently on faculty as a lecturer and serves as the acting director of Undergraduate Studies in Photography. Her work is in many private collections, including the Whitney Museum of American Art, and has been shown in numerous solo and group shows. Her monographs include *Fantasies* (2008), *Fun and Games* (2009), and *Joe's Junk Yard* (2012).

WOLF KOENIG (1927–2014) was a Canadian film director, producer, animator, cinematographer, and a pioneer in Direct Cinema at the National Film Board of Canada (NFB). With a credit list of over 170 titles, Koenig's name is associated with some of the most prestigious films produced in the history of the NFB, including *City of Gold* (1957) and *Lonely Boy* (1962).

SUSIE LINFIELD is the author of *The Cruel Radiance: Photography and Political Violence* (University of Chicago Press, 2010). She writes about culture and politics for a variety of publications including the *Washington Post Book World, New Republic, Boston Review, Dissent,* the *Nation, Guernica,* the *Forward,* and the *New Humanist;* her work has also appeared in the *New York Times,* the *Village Voice,* the *Los Angeles Times, Newsday,* the *New Yorker, Rolling Stone,* and *Dance Ink.* Linfield was formerly the arts editor of the *Washington Post,* the deputy editor of the *Village Voice,* the editor-in-chief of *American Film,* and a critic for the *Los Angeles Times Book Review.* She has taught in the Cultural Reporting and Criticism program at New York University since its inception in 1995.

SCOTT MACDONALD has written fourteen books on independent cinema and in 2011 was named an Academy Scholar by the Academy of Motion Picture Arts and Sciences. His most recent books are *Adventures in Perception: Cinema as Exploration* (2009), *American Ethnographic Film and Personal Documentary: The Cambridge Turn* (2013), and *Avant-Doc: Intersections of Documentary and Avant-Garde Cinema* (2014). He teaches film history and curates cinema events at Hamilton College.

LEV MANOVICH is the author of *Software Takes Command* (Bloomsbury Academic, 2013), *Soft Cinema: Navigating the Database* (The MIT Press, 2005), and *The Language of New Media* (The MIT Press, 2001). Manovich is a professor at the Graduate Center, CUNY, and a director of the Software Studies Initiative, which works on the analysis and visualization of big cultural data. In 2013 he appeared on *Complex Style*'s list of 25 People Shaping the Future of Design (between Casey Reas at no. 1 and Jonathan Ive at no. 3).

CHRISTIAN MARCLAY is a London- and New York–based visual artist and composer whose innovative work explores the juxtaposition between sound recording, photography, video, and film. Born in California and raised in Geneva, Switzerland, he studied at the École Supérieure d'Art Visuel in Geneva from 1975 to 1977. From 1977 to 1980 he studied sculpture at the Massachusetts College of Art in Boston and was a visiting scholar at Cooper Union in New

York in 1978. A dadaist DJ and filmmaker, his installations and video/film collages display provocative musical and visual landscapes and have been included in exhibitions at the Whitney Museum of American Art, Venice Biennale, Centre Pompidou Paris, Kunsthaus Zurich, and San Francisco Museum of Modern Art.

LÁSZLÓ MOHOLY-NAGY (1895–1946) was a photographer, filmmaker, typographer, painter, sculptor, writer, graphic designer, stage designer, and teacher. A professor at Bauhaus from 1923 to 1928, Moholy-Nagy moved to Chicago in 1937 to start the New Bauhaus, later the Institute of Design in Chicago. A tireless innovator and visionary, Moholy-Nagy was the author of numerous books, including *Painting Photography Film* (1925), *The New Vision* (1930), and *Vision in Motion* (1947).

WALTER MURCH has been honored by both the British and American motion picture academies for his picture editing and sound mixing. In 1997, Murch received an unprecedented double Oscar for both film editing and sound mixing on *The English Patient* (1996) as well as the British Academy Award for best editing. Seventeen years earlier, he had received an Oscar for best sound for *Apocalypse Now* (1979), as well as British and American Academy nominations for his picture editing on the same film. He also won a double British Academy Award for his film editing and sound mixing on *The Conversation* (1974), was nominated by both academies for best film editing for *Julia* (1977), and in 1991 received two Oscar nominations for best film editing for the films *Ghost* (1990) and *The Godfather, Part III* (1990).

TREVOR PAGLEN's work blurs lines between science, contemporary art, journalism, and other disciplines to construct unfamiliar, yet meticulously researched ways to see and interpret the world around us. Paglen's work has been exhibited at the Metropolitan Museum of Art, the Tate Modern, the Walker Arts Center, SFMOMA, the 2008 Taipei Biennial, the 2009 Istanbul Biennial, the 2012 Liverpool Biennial, and numerous other exhibitions. He is the author of five books and holds a BA from UC Berkeley, an MFA from the Art Institute of Chicago, and a PhD in Geography from UC Berkeley. Paglen is based in New York.

BRIAN PALMER is a photojournalist and documentarian based in Hampton, Virginia. During his twenty-plus-year career, he has photographed conflicts, connections, politics, activism, and much more around the world. His photos have appeared in the *New York Times, Fortune, U.S. News & World Report, Pixel Press, Politiken* (Copenhagen), *ColorLines, Die Zeit,* and other publications. His documentary *Full Disclosure,* which appeared in 2011 on the Documentary Channel, and several magazine articles and photo exhibitions grew out of three news media "embeds" in Iraq with U.S. Marines. Before going freelance in 2002, he was a CNN correspondent and was a Beijing bureau chief for *U.S. News & World Report.* He is currently working on a documentary, *Make the Ground Talk,* about an abandoned African American burial ground within the confines of a classified U.S. military base.

PAUL PANGARO works at the intersection of technology and humanities as an entrepreneur, teacher, and performer. His career is focused on human conversation as a means to improve human/computer interaction, organizational effectiveness, and design practice. He has lectured in Brazil, Europe, and North America; has taught at Stanford University and School of the Visual Arts (New York); and has had consulting relationships with DuPont, Alcatel-Lucent (Paris), Samsung, Nokia, Citigroup, Intellectual Ventures, and the Poetry Foundation. He earned a PhD in cybernetics from Brunel University (UK) and a BS in computer science + humanities/drama from MIT.

PIPILOTTI RIST, born in Rheintal, Switzerland, wrestles with the formal properties of video, purposefully emphasizing its pixels, colors, and visual texture. Drawing on the traditions of performance and self-portraiture, she creates shape-shifting psychological dreamscapes in which she often plays the protagonist. Her works have been exhibited widely at museums and festivals throughout Europe, Japan, and the United States, including the biennials in São Paulo, Venice, Istanbul, the Caribbean, and Santa Fe. She was awarded the Joan Miró Prize in 2009 for her unique creative activity and her outstanding contribution to the current artistic scene. In 2009 she also released her first feature film, *Pepperminta,* the story of an "anarchist of the imagination" who lives according to her own rules. The film was screened at film festivals and theatres around the world.

FRED RITCHIN is the author of numerous books including *Bending the Frame: Photojournalism, Documentary, and the Citizen* (Aperture, 2013), *After Photography* (Norton, 2008), and *In Our Own Image: The Coming Revolution in Photography* (Aperture, 1990, 1999, 2010). He has also contributed essays to numerous monographs and catalogs on photography. Ritchin is the director of the online magazine *PixelPress,* creating websites, books, and exhibitions investigating new documentary and promoting human rights. He is also the former picture editor of *Horizon* and the *New York Times Magazine,* former executive editor of *Camera Arts* magazine, and the founding director of the photojournalism and documentary photography educational program at the International Center of Photography.

He also created the first multimedia version of the daily *New York Times* in 1994–95. In 2012 he was given a lifetime achievement award in Tucumán, Argentina, at the Documentary Photography Biennial. Ritchin is a professor and co-director of the Photography and Human Rights Program at New York University and lectures and conducts workshops internationally on new media and documentary.

BARRY SALZMAN, born in Zimbabwe, is a New York artist, working in video and photography. He began photographing thirty-five years ago in South Africa's shantytowns to try to make sense of the racial inequities that surrounded him. After a career in the Internet industry, he transitioned to working as a full-time artist. Today his work continues to build on the need to understand the world around him, much of it focused on community, heritage, and identity. Salzman has an MFA in photography, video, and related media from the School of Visual Arts, an MBA from Harvard Business School, and a bachelor of business science from the University of Cape Town.

KEN SCHLES is a photographer and writer who has written for *Aperture* and as foreign correspondent for the *FOAM* blog. He is the author of *Invisible City* (1988, 2014), *The Geometry of Innocence* (2001), *A New History of Photography: The World Outside and the Pictures in Our Heads* (2008), *Oculus* (2011), and *Night Walk* (2014). Cited by the *New York Times* as notable and referred to in many histories of the medium (Parr and Badger, Auer and Auer, 10x10), his photography books have been issued by the foremost publishers of our time, including Steidl, Hatje Cantz, and Twelvetrees Press. A former New York Foundation for the Arts fellow, Schles currently resides in Brooklyn, New York.

AARON SCHUMAN is an artist, writer, and curator. His photographic work is held in numerous collections and exhibited internationally, and his written work regularly appears in books, catalogs, and publications such as *Aperture, FOAM,* the *British Journal of Photography, Time, Hotshoe,* and *Photoworks.* Exhibitions Schuman has curated include *Whatever Was Splendid: New American Photographs* (2010), *Other I: Alec Soth, WassinkLundgren, Viviane Sassen* (2011), and *In Appropriation* (2012), and he served as chief curator of Krakow Photomonth 2014. He is also the founder and editor of *SeeSaw Magazine* and a senior lecturer at the Arts University Bournemouth and the University of Brighton.

ARTHUR SIEGEL (1913–1978) was a photographer and educator. He studied photography at the New Bauhaus (later renamed the Institute of Design, Illinois Institute of Technology) with László Moholy-Nagy and György Kepes. After working as a freelance photographer, he was hired in 1945 by Moholy-Nagy to head the newly formed photography department at the Institute of Design and to develop the pioneering course New Visions in Photography. After serving as the program head for three years, he resigned to pursue various personal and commercial projects. He was invited back to Institute of Design by Aaron Siskind in 1967 and became the chair of the photography department in 1971, where he taught for the remainder of his life.

SHELLY SILVER is a New York–based artist primarily working with still and moving images. Her work explores contested territories between public and private, narrative and documentary, and—increasingly—the watcher and the watched. Her work has been exhibited worldwide at such venues as the Museum of Modern Art, New York; Tate Modern, London; Centre Georges Pompidou, Paris; the Museum of Contemporary Art, Los Angeles; and the Yokohama Museum, and it has been screened at the London, Singapore, New York, Moscow, and Berlin film festivals. Her broadcasts have been aired on BBC, England; PBS, United States; Arte, Germany, France; Planete, Europe; RTE, Ireland; SWR, Germany; and Atenor, Spain. She is currently chair of the Visual Arts Program at Columbia University.

REBECCA SOLNIT is the author of thirteen books about art, landscape, public and collective life, ecology, politics, hope, meandering, reverie, and memory. They include *Infinite City: A San Francisco Atlas; A Paradise Built in Hell: The Extraordinary Communities That Arise in Disaster; Storming the Gates of Paradise; A Field Guide to Getting Lost; Hope in the Dark: Untold Histories, Wild Possibilities; Wanderlust: A History of Walking; As Eve Said to the Serpent: On Landscape, Gender, and Art,* and *River of Shadows: Eadweard Muybridge and the Technological Wild West* (for which she received a Guggenheim, the National Book Critics Circle Award in criticism, and the Lannan Literary Award). She has worked with climate change, Native American land rights, antinuclear, human rights, antiwar, and other issues as an activist and journalist. A product of the California public education system from kindergarten to graduate school, she is a contributing editor to *Harper's* and a frequent contributor to the political website Tomdispatch.com and has made her living as an independent writer since 1988.

ALEC SOTH is a photographer born and based in Minneapolis, Minnesota. His photographs have been featured in numerous solo and group exhibitions, including the 2004 Whitney and São Paulo Biennials. His numerous books include *Sleeping by the Mississippi* (2004), *NIAGARA* (2006), *Fashion Magazine* (2007) *Dog Days, Bogotá* (2007), *The Last Days of W* (2008), and *Broken Manual* (2010). Soth has been the recipient of numerous fellowships and awards, including the Guggenheim Fellowship (2013). In 2008, he started his own publishing company, Little Brown

Mushroom. He is represented by Sean Kelly in New York and by Weinstein Gallery in Minneapolis, and is a member of Magnum Photos.

KATJA STUKE and **OLIVER SIEBER** both live and work in Düsseldorf, Germany. They work independently on their own photographic projects. Under the label Böhm/Kobayashi, they have an extensive range of personas: photographers and artists, curators and exhibition organizers (ANT!FOTO), designers, and art book editors and publishers. During recent years they have exhibited at Kunsthalle Bremen; Museum für Photographie Braunschweig; Museum for Contemporary Photography, Chicago; Fondation d'entreprise Hermès, Bern; the Photomuseum Antwerp; Florence Loewy, Paris; and Museum Folkwang, Essen.

AMY TAUBIN is a contributing editor for *Film Comment* and *Sight and Sound* magazines and is a frequent contributor to *Artforum* and Artforum.com. Her book *Taxi Driver* was published in 2000 in the British Film Institute's Film Classics series. Recently, she co-authored the monograph *James Nares* (Rizzoli, 2014). She teaches at the School of Visual Arts in New York City, in both the undergraduate Art History and the MFA Photography, Video and Related Media Departments. She is a member of the National Society of Film Critics and the New York Film Critics Circle.

CHARLES TRAUB is chair of the MFA Photography, Video and Related Media Department at the School of Visual Arts in New York City. He holds an MS from the Institute of Design at the Illinois Institute of Technology and a BA from the University of Illinois. A founding chairperson of the Photography Department at Columbia College in Chicago, he also organized the development of its Museum of Contemporary Photography. Formerly the director of the prestigious Light Gallery of New York, he is now president of the Aaron Siskind Foundation for support of creative photography. He is one of the co-founders of *here is new york: a democracy of photographs*. His books include *Beach, Italy Observed, The Education of a Photographer, In the Realm of the Circuit,* and *Dolce Via: Italy in the 1980s,* and his writings have been published in *Connoisseur, Fortune, Newsweek, Aperture, U.S. News & World Report, Afterimage, Popular Photography, American Photographer,* and the *New Yorker*.

CHRISTOPHER WALTERS started making movies when he was seven, had a public access show at age ten, a profitable industrial-video company when he was twelve, and on his eighteenth birthday he moved from Nova Scotia to New York City. As a cinematographer, Walters has lensed hundreds of television commercials and five feature films, and in 2009 he won an MMVA for Cinematographer of the Year. He is a partner in a production company, the founder of an augmented reality tech-venture, and is currently preparing to shoot a science fiction film for Academy Award–nominated director Sergei Bodrov. Walters lives in New York City.

GRAHAME WEINBREN's practice ranges from artists' cinema works to television documentaries as well as writing about cinema, media art, and the philosophical issues generated by emerging technologies. He is the senior editor of the *Millennium Film Journal* and a member of the graduate faculty of the School of Visual Arts in New York City.

CHARLIE WHITE is a Los Angeles–based artist and associate professor at the Roski School of Art and Design at the University of Southern California. White's work spans photography, film, animation, writing, and experimental pop music. White's photography has been exhibited widely, and his films have been featured at the Sundance Film Festival and Director's Fortnight at Cannes. In addition to his studio work, White's writing has been published in *Artforum*, and his essay "Minor Threat" was included in the publication *Words without Pictures* (Aperture). White's most recent monographs include *American Minor* (JRP Ringier, 2009) and *Such Appetite* (LBM, 2013).

OFER WOLBERGER is an American artist based in Brooklyn, New York, where he publishes books under his own Horses Think Press imprint. In 2012, he completed *12 Books,* a series of self-published artists' books that explore through bookmaking the current state of photography. In 2012 he received Printed Matter's Award for Artists and had his work featured in a solo exhibition at the Anne R. Worrell Fine Arts Center in Bristol, Virginia. In 2013 his book projects were featured in *DIY: Photographers & Books* at the Cleveland Museum of Art as well as the ICP Triennial *A Different Kind of Order*. In 2013, he was an artist in residence at Light Work in Syracuse, New York. He is presently working on a series of paintings and photographs titled *Flat Fix*.

CREDITS

The following authors and publishers have graciously granted permission to print or reproduce material. Works are listed in the order that they appear.

PART 1. FROM THE LENS

Arthur Siegel, "Photography Is," *Aperture* 9, no. 2 (1961). © Arthur Siegel, with permission of Irene Siegel.

Ken Schles, "Excerpt from *A New History of Photography*," from *A New History of Photography* (Köln: White Press, 2008). © Ken Schles, reprinted courtesy of the author.

Adam Bell, "Photographs about Photographs," *Lay Flat: 02 Meta*, ed. Shane Lavalette and Michael Bühler-Rose (New York: Lay Flat, 2010). © Adam Bell 2010, reprinted courtesy of the author.

Susie Linfield, "A Little History of Photography Criticism; or, Why Do Critics Hate Photography?" *The Cruel Radiance: Photography and Political Violence* (Chicago: University of Chicago Press, 2010). Reprinted courtesy of University of Chicago Press.

Marvin Heiferman, "If You See Something, Say Something: Why We Need to Talk about and Teach Visual Literacy, Now." © Marvin Heiferman 2014.

PART 2. VISION AND MOTION

László Moholy-Nagy, "Excerpt from *Vision in Motion*," from *Vision in Motion* (Chicago: P. Theobold, 1969). © Hattula Moholy-Nagy.

David Campany, "Stillness," *Photography and Cinema* (London: Reaktion Books, 2008), 28–59. © Reaktion Books.

Rebecca Solnit, "The Annihilation of Time and Space," *River of Shadows: Eadweard Muybridge and the Technological Wild West* (New York: Viking, 2003). © 2003 Rebecca Solnit. Used by permission of Viking Penguin, a division of Penguin Group (USA) LLC, and Hill Nadell Agency.

Wolf Koenig, "On Editing and Structure," excerpted from Tammy T. Stone, "Candid Eye and Lonely Boy Unit B: Interview with Wolf Koenig," *Take One*, May 2002. © 2002 Tammy T. Stone.

Ai Weiwei, "Flickering Screens," *Ai WeiWei's Blog: Writings, Interviews and Digital Rants, 2006–2009*, ed. and trans. Lee Ambrozy (Cambridge: MIT Press, 2011), 141–43. © 2011 Massachusetts Institute of Technology, by permission of The MIT Press.

Hollis Frampton, "A Lecture," *On the Camera Arts and Consecutive Matters: The Writings of Hollis Frampton*, ed. Bruce Jenkins (Cambridge: MIT Press, 2009), 125–30. © 2009 Massachusetts Institute of Technology, by permission of The MIT Press.

Tom Gunning, "Moving Away from the Index: Cinema and the Impression of Reality," *differences* 18, no. 1 (2007): 29–52. © 2007 Brown University and *differences: a Journal of Feminist Cultural Studies*. All rights reserved. Republished by permission of the copyright holder and Duke University Press.

Walter Murch, "Seeing around the Edge of the Frame," *In the Blink of an Eye*, 2nd ed. (Los Angeles: Silman-James Press, 2001). © Walter Murch. Reprinted with permission from Silman-James Press.

Doug Aitken and Pipilotti Rist, "Reconquering Space and the Screen," from Doug Aitken, *Broken Screen: Expanding the Image, Breaking the Narrative* (New York: DAP, 2006). Reprinted courtesy of D.A.P./Distributed Art Publishers and Doug Aitken.

Christian Marclay and Amy Taubin, "It's about Time." © Christian Marclay and Amy Taubin.

PART 3. OLD MEDIUM/NEW FORMS

Lev Manovich, "There Is Only Software," *Nam June Paik Reader—Contributions to an Artistic Anthropology*, ed. Young-chul Lee and Henk Slager (Seoul: NJP Art Center, 2009), 26–29. © Lev Manovich, reprinted courtesy of the author.

Joan Fontcuberta, "A Post-photographic Manifesto." Originally published in Spanish in *Culturas*, the weekly supplement of the newspaper *La Vanguardia* (Barcelona), May 11, 2011; trans. Graham Thomson. © Joan Fontcuberta.

David Joselit, "Feedback Manifesto," *Feedback: Television against Democracy* (Cambridge: MIT Press, 2007), 171. © 2007 Massachusetts Institute of Technology, by permission of The MIT Press.

Katja Stuke and Oliver Sieber, "Ant!foto and the Antifoto Manifesto," *The ANT!FOTO Manifesto* (Dusseldorf: Böhm/Kobayashi, 2013). © Katja Stuke and Oliver Sieber.

Charles H. Traub, "Creative Interlocutors: A Manifesto," *Leonardo* 30, no. 5 (1997). Reprinted courtesy of the author.